THE NIGHT CRAWLER KING

THE NIGHT CRAWLER KING

Memoirs of an Art Museum Curator

William Fagaly

University Press of Mississippi / Jackson

The University Press of Mississippi is the scholarly publishing agency of the
Mississippi Institutions of Higher Learning: Alcorn State University, Delta
State University, Jackson State University, Mississippi State University,
Mississippi University for Women, Mississippi Valley State University,
University of Mississippi, and University of Southern Mississippi.

www.upress.state.ms.us

The University Press of Mississippi is a member
of the Association of University Presses.

Photographs courtesy of William Fagaly unless otherwise noted
Warhol photograph courtesy of DeDeaux collection

Cover photo © 2020 by Dawn DeDeaux
Artwork on jacket cover photograph clockwise from lower left: (on stack
of books) Aristides Logothetis work on paper, (on mantlepiece) Keaka,
Mummuye and Montol Nigerian artists' figurative sculptures, (on wall)
Lynda Benglis sculpture, two J. B. Murry works on paper, (on other stack
of books) Noah Edmundoson whirligig, (on table) Yaka artist face mask,
(behind author's head) John Waters photograph

First printing 2021
∞

Library of Congress Cataloging-in-Publication Data available
Hardback ISBN 978-1-4968-2981-8
Epub single ISBN 978-1-4968-2982-5
Epub institutional ISBN 978-1-4968-2983-2
PDF single ISBN 978-14968-2984-9
PDF institutional ISBN 978-1-4968-2985-6

British Library Cataloging-in-Publication Data available

When I contemplate the immense advances in science, and the discoveries in the arts which have been made within the period of my life, I look forward with confidence to equal advances by the present generation; and have no doubt they will consequently be as much wiser than we have been, as we than our fathers were, and they the burners of witches.

—JON MEACHAM, *Thomas Jefferson*

CONTENTS

LAGNIAPPE

OVERTURE

I collect art, and I cherish each piece. Those objects speak to me more than just aesthetically. On the other hand, I collect people whose friendships and acquaintances I care about deeply. Art and people and my experiences with each—that is what this book is about.

Writing my memoirs has given me an enormous amount of pleasure and amusement. At the outset, there were never any plans for them to be published. As they were being written, I had no idea who would be the eventual readership. Would anyone be interested? It really didn't matter to me. This is about my childhood as a small boy growing up in rural Indiana at the time of the Second World War and my metamorphosis as an adult curator at an art museum in the South. It is about my cherished memories and the wonderful people who have touched my life and made it richer for me. I hasten to point out these profiles of individuals are not intended to be biographies. My portraits are just sketches of that period of time in their lives when I made their acquaintance and we shared experiences. While I am privileged to have met a number of well-known people, I don't want this to be construed as a name-dropping opportunity.[1] I just feel my experiences could be enlightening and of interest to some. These are true recollections as I remember them. I am certain others reading this will remember things differently than me . . . and they well may be right. But this is my story, and I'm sticking to it. As someone said, "The facts just cloud the mind."

Putting together my experiences has meant reaching back into my history, similar to the Hubble telescope peering back ever more deeply into space to discover the origins of the universe. I have attempted to look back further and further to my life as a young boy. It portrays a picture of another person from whom I was to become and what my later adult life came to be. Old photo albums, fifty years of annual calendar appointment books, and personal journals written while traveling

abroad have been extremely helpful in my attempt to recall memories. The veracity of my mental recall of factual data easily could be confirmed or rejected by a simple referral to these available written documents. One of my proudest achievements in telling you about my life is that all the stories are true, trust me, and nothing is fabricated or embellished.

Oh, the stories I *could* tell. However, the malicious dirt and scandalous truths and vicious gossip, the mean and deceptive persons, the cheating, the lies, the hate, the secrets are not a part of these casual recollections. I know where the bodies are buried, and all that will be in volume 2!

One of the most difficult aspects of this project is assigning it a title. The ones I have seriously considered but ultimately discarded are: "You See What I'm Sayin," "That's What I'm Talkin' About," "My Life Is Better than Yours," "130,506 Words," "Unanswered Thoughts," and "Footnotes to an Autobiography."

When all is said and done (and it isn't), there will be those I will look back upon as individuals who helped define my life. Those countless people I have known and loved over the years all contributed to who I am, including my wonderful initial editor, Taylor Murrow, who makes me look better in print. Ultimately however, my memoirs are dedicated to the memory of my parents, Dorée and Bill Fagaly, who shaped my life and made all of this possible.

PREAMBLE

December 7, 1941
June 6, 1944
August 6 and 9, 1945
November 22, 1963
April 4, 1968
July 20, 1969
August 9, 1974
January 1, 2001
September 11, 2001
August 29, 2005
January 20, 2009
February 7, 2010
January 20, 2019
the year 2020

The day Pearl Harbor was attacked, the D-Day invasion began, the first atomic bombs were dropped on Hiroshima and Nagasaki, JFK was assassinated, MLK was assassinated, the first men landed on the moon, Nixon resigned the presidency, the third millennium began, the World Trade Center was attacked, Hurricane Katrina hit New Orleans and the federal levees broke and nearly destroyed the city, the first African American was inaugurated as president of the United States, the Saints win the Super Bowl and nine years later the Saints denied the opportunity to play again in the Super Bowl by the NFL no call and worldwide pandemic—fourteen defining moments when the world as we knew it changed forever, and all occurred in my lifetime.

At the time I entered the world, President Roosevelt had asked for more money for defense as Austria had just been seized by the Nazis, and all Europe was being threatened by Hitler and his Third Reich. A

world war was imminent. It was a time when there were no available televisions, computers, internet, social media, cell phones, microwaves, automatic dishwashers, automatic clothes washers and dryers, stereo sound, LPs, CDs, DVDs, automation, commercial jet airliners, manned space exploration, space satellites, on and on. In that sense, life was simpler then.

Two-thirds of my life has been spent working at the art museum in New Orleans, the Isaac Delgado or, as it was later renamed in 1971, the New Orleans Museum of Art. (Contrary to the rumor, Isaac and I never met.) There have been only three directors during those years—Jim Byrnes, John Bullard, and Susan Taylor. When I arrived in August 1966, there was a total of a dozen employees, counting the director, curators, administrators, secretaries, preparators, custodians, and guards. At that time, the building was simply the small original Delgado box which Director Jim Byrnes had so rightly quipped was "a great entrance to a museum." But it *was* the museum; there wasn't any more than that. My beginning *annual* salary as the registrar was $4,500.

SEGMENT 1

Episode 1

Growing Up in Southern Indiana

I'm not from Louisiana—I'm a Hoosier. I was born to Dorothy Rae (Wheeler) and William James Fagaly on March 1, 1938, at my parents' new home at 57 Oakey Avenue in Greendale, a hamlet suburb of the town of Lawrenceburg, Indiana, itself a suburb of Cincinnati, Ohio. I was delivered by my paternal grandfather, Arthur Thomas Fagaly, who was a general practitioner doctor for more than fifty years in this small rural community where he had delivered more than 2,000 babies during his lifetime. When I wanted to have my astrological chart done, it was important to know what time of day I was born. I went to the source, my mother, and asked her. Her response? "I have no idea." I was shocked and responded, "Mother, how could you not remember? Wasn't that a significant event in your life?" The only clue to the answer to that question is that my sister, Pat, recalls waking up at night and hearing a baby crying. Therefore, I must assume it was after midnight in the early hours of the first day of March.

Located on the Ohio River in the very southeastern corner of Indiana at the juncture of both Ohio and Kentucky, Lawrenceburg, surrounded by a modern levee, is the Dearborn County seat and boasted two movie theatres, two banks, three doctors (the two Drs. Fagaly were the most revered), several drug stores, and the county fairgrounds and racetrack (for quarter horses and harness racing and later midget and stock cars races). Founded in 1803, the town was populated with stark unadorned early buildings and many grand Victorian river houses and mansions. The few Blacks who were residents lived in a segregated part of town. Lincoln once stopped on a train to deliver a brief speech on a campaign tour. The town has had several distinguished citizens. It

was the birthplace of the famed nineteenth-century civil engineer and inventor James Buchanan Eads, designer and builder of the Saint Louis Mississippi River bridge named for him. Another former resident was the Hollywood actor, writer, and producer William H. Wright, whose mother lived one door away from my parents' house on Oakey Avenue.

The community is located above a deep underground river that supplied pure water for then three major distilleries: Seagram's, Schenley (a.k.a. Old Quaker), and James Walsh, which were the town's major identifying features in the twentieth century and dominated the skyline with their looming, cubic redbrick plants and warehouses. During their distilling process, discarded wastewater was dumped into Tanner's Creek, which polluted the stream, created an unbearable stench, and killed fish, bringing them to the surface. All three plants are now closed.

In the early nineteenth century, my paternal ancestors immigrated to America from the Bavarian area of Germany/Switzerland and Anglicized their name from the patronymic Voegele. Sometimes when introduced, people recognize the origin of the name and smile, "Oh, Little Bird!" which inspired me, ever so briefly, in the 1970s to consider legally changing my name to "Billy Little Bird." But then I would have been mistaken as Native American. It was a bad idea.

Preschool and Grade School

I was born in 1938 as America was slowly recovering from the disastrous economic Great Depression. Simultaneously, America was preparing for another worldwide war resulting from the growing double threat of Adolph Hitler and his Nazi regime invading Europe and the Japanese Imperial Army of Emperor Hirohito advancing throughout Asia and the Pacific. It was a grim time, not only in the world but locally. In Indiana, the citizens of our small community were slowly putting their lives back together after the devastating 1937 Ohio River flood, which had forced the evacuation of both my parents and grandparents from their inundated houses in downtown Lawrenceburg. It was not a happy or prosperous time for anyone. Fortunately, my parents were in the process

of building a new brick and shingle-sided Tudor-style house in the small adjacent community of Greendale, located on a higher ground and away from the potential ravages of the river.

Soon, it was the early 1940s and it was wartime—the Big One, World War II. When I was only three years old, Daddy was reluctantly recruited into the army. He was too old, but doctors were sorely needed, and so he was sent to Casablanca, where he ultimately saw no action but was badly injured in a Jeep accident, resulting in a broken shoulder and collar bone. Mother was left at home in their brand-new house with two small children to raise alone. My sister was six and a half years older, and my father's absence left a hollow void in our lives.

The early 1940s was a time of making do and conserving during the war: saving tinfoil and string into balls, growing our own vegetables in our home Victory Gardens, and the national rationing of gasoline and food with special stamps for my grandfather as doctors were given an extra allotment. Mother wrote a poem, "Beautiful Trash," which was published in the local newspaper, promoting the recycling (much before her time) for the war effort. Grains for making whiskey were also in short demand, so the Schenley distillery resorted to substituting potatoes for the scarce grain, which created the foul odor of rotting potatoes throughout town. My friend Jim Grace remembered filling empty canteens with water that were handed out military train windows by soldiers during their brief stops in town.

It was a time of periodic blackouts and air raid drills. With roaring sirens breaking into the silent, still night, the houses and trees were only in silhouette against the dark sky. During the cold winter months, Mother went daily to the basement to remove unwieldy, red-hot clinkers from the coal-burning furnace and then would shovel in a new supply of more dirty, sooty coal. Sightings of a prowler at night in the neighborhood, including our backyard, kept everyone on edge. Mother kept a loaded revolver in her bedside table drawer; my sister and I were forbidden to even touch it. Nightly sounds of exploding test bombs at the secretive Jefferson Proving Ground fifty miles away near Madison added to the frightening atmosphere. Occasionally, the detonations shook the ground in Greendale. In the evenings, for security, entertainment and

companionship, the three of us gathered in my mother's bedroom and listened to the popular radio programs at the time: *Amos and Andy, Lux Presents Hollywood, Mr. and Mrs. North, Bob Hope Comedy Hour, Edgar Bergen and Charley McCarthy, The Jack Benny Hour, Baby Snooks,* and, my favorite, *Fibber McGee and Molly* and his famous closet. To amuse myself while listening to our radio programs, I demonstrated an early talent as an artist by faithfully copying in crayon and pencil pictures of Walt Disney characters and John James Audubon birds on a makeshift Masonite drawing board propped on the arms of my chair.

On the other hand, in the late forties and early fifties, life for me had certain aspects of the simple, innocent, bucolic world of *Leave It to Beaver.* For instance, when I got sick, Mother lovingly made me milk toast (lightly toasted white bread topped with sugar, cinnamon, and pats of soft butter floating in a pool of warm milk). Everyone knew me as Billy simply to distinguish me from my father, Bill. As a small, shy boy I would hide under women's skirts when people admired me as they met me on the street. My father charged three dollars for a doctor's office visit and four dollars for a home visit. He received patients in his office without appointments from 8 to 9 a.m., 2 to 4 p.m., and 7 to 8 p.m. Picking up the telephone receiver, one told the operator the number one wanted to call. My daddy's office number was simply 27, while our home was 69. We ate frozen chicken pot pies or Swanson TV dinners on individual folding tables in front of the television set. Gasoline was normally twenty-nine cents a gallon, but during a periodic rival price war, it dipped to eleven cents! No one locked the doors to their house unless they were going out of town on an extended vacation. The only time they locked their cars was when they were traveling. It was a time when electric clothes washers had a hand-cranked wringer on top, and the clean clothes were hung outdoors on the clothesline to dry with wooden clothespins (or on lines strung in the basement if it was raining).

White oleomargarine, resembling a lady's cold cream, came in a sealed clear plastic bag with a color bead attached. This color bubble had to be broken to release the bright orange liquid in it to mix together with the white "cold cream." By squeezing the bag vigorously with your hands, a uniform and acceptable pale butterlike hue was achieved to

make this fake butter more appealing to the taste buds. This became a good job for "sous-chef" Billy to do along with whipping the cream with a hand-cranked mixer or baking dinner croissants out of the refrigerated roll of dough triangles in a tubular package.

As I grew older, I wanted to create more in the kitchen, but Mother wouldn't allow me to cook. Her excuse was I would "leave a mess in the kitchen" even though I promised that I would clean up. In retrospect, I strongly feel that she felt that cooking was not a manly thing to do. Male chefs were not as well known and respected as they are today, certainly not in rural Indiana in the 1940s and 1950s.

We had a live-in house maid named Alwena. Among her irritating habits was to rush to the front door to fetch the mail the moment she heard it drop on the foyer floor from the mail slot. After retrieving it, she would stop, read, and, with unsolicited commentary, hand it piece by piece to my mother. "Here is a postcard from your uncle who says he is having a wonderful time on his vacation." "Here is the bank statement." "Here is a bill from Sears." "This is an ad for a sale at the drugstore." One day, my mother spent a great deal of time and effort in the kitchen making homemade noodles. She was quite proud of her labor-intensive achievement, and we were all waiting with eager anticipation to taste the dish. As Alwena was bringing the finished hot, buttery pasta to the table that evening, she spilled the whole glorious platter on the floor with an ungracious splat.

My neighborhood pals were towhead Elinor Sedam, brunette Suzanne McCandless, and freckle-faced Larry Zernach. We were inseparable and played together in the backyards, sandboxes, nearby woods, and cornfields and on the streets and sidewalks from early morning until our mothers called out the door for us to come home for lunch or dinner. In the summertime, we were outdoors again until after dark. From late spring until early fall, we were barefoot. We built environments in the sandbox for our trucks and dolls; we put on Judy Garland/Mickey Rooney–like impromptu shows in the yard; we played doctor/nurse and house; and we played cowboys and Indians, Tarzan and Jane, cops and robbers, Red Rover, and hide and seek. We captured lightning bugs in glass jars, chloroformed and mounted monarch and tiger swal-

lowtail butterflies and night flying moths (especially cecropias, sphinx, and lunas), and collected caterpillars in the hopes they would make cocoons and emerge later as butterflies.

One of my highly anticipated daily treats was the visit of the bakery truck traversing the neighborhood streets selling freshly made confections. My favorite was the horns-of-plenty filled with meringue. In the summertime, Larry's mother would recruit us to pick her laden ripe cherry trees, and as a reward for our labors, she made the best home-made cherry pies I've ever tasted. We had a grand time together. We were the Four Musketeers. On VE and VJ Days, we paraded up and down the sidewalks on our tricycles and wagons wearing handmade patriotic hats and waving American flags, beating our toy drums and blowing whistles. When President Roosevelt died, we solemnly marched down the street with our small flags on display.

Every year, my buddies and I looked forward to the Dearborn County Fair at the permanent fairgrounds "in the bottoms," a low-lying plain near the edge of the Ohio River. Special treats were eating cotton candy and being mesmerized by a fast-talking man who deftly demonstrated the wonders of the Veg-a-matic chop, cut, slice, dice any number of edibles for cooking. You just *had* to have one! However, I, as a child, was not allowed to go with the adults when they went to their special treat at the tent featuring a "girlie" show.

Another thrill was going to the fairgrounds when the Clyde Beatty Circus arrived in town. Of course, I showed up very early in the morning in the hopes of being selected to assist in the setting up of the tent and tending the animals. For my labors, I was rewarded at the end of the day with a free pass to that evening's performance. Boy, was I important!

Christmas was always a big deal, of course, and many of my presents became my favorites while growing up. After reading the books about Uncle Wiggily and Nurse Jane one year, I received wonderful stuffed dolls of each of them. They were special and became my friends. Other memorable toys were Tinker Toys and especially an Erector Set, which I played with for many hours, days, and months. I loved the sense of creating and building in three dimensions. (Little did I know at the time that this fascination would lead to my later interest in architecture and

sculpture.) Another toy I cherished was my View Master stereopticon with its 3D pictures of faraway places, possibly a precursor to my later bent on travel. One year I received an authentic Roy Rogers outfit complete with cowboy boots and hat. Boy, was I a hit at school with my super of-the-moment duds. Of course, I loved the wonderful complete Lionel electric train with all the bells and whistles.

Like neighboring Cincinnati, many in Lawrenceburg had German ancestry and at Christmastime the local German bakery made special cookies following their old-world traditional recipes. There was always a rush to the store before to get some of the highly sought after *springerle* (an anise flavored square white cookie with images stamped on the top), the *pfeffernusse* (spicy gingerbread domes with powdered sugar dusted on top) or *lebkuchen* (gingerbread).

The O'Shaughnessys, our next-door neighbors, owned the James Walsh distillery in town, and Mrs. O'Shaughnessy and her daughter Celeste designated Saturday as the traditional day for baking for the week . . . mostly the desserts. When in season they made gooseberry and boysenberry pies with berries harvested from their backyard. They would purposely make a little extra so they could call me over in the late afternoon and lick the bowls, . . . sample raw pie, cake and cookie dough, and the icings were the best. It was an event I relished and eagerly anticipated.

Our family always had pets as my parents encouraged me and my sister to learn about and respect all animals in whatever form. I had an animal cemetery under a large wild cherry tree in our backyard. In addition to the prerequisite gold and tropical fish, mice, hamsters, rescued baby squirrels, birds, turtles and rabbits, there were dogs. Our first pet was a red cocker spaniel, Dixie, followed by a coal-black cocker, Cricket. Later, there came a Siamese cat named Tallulah. The O'Shaughnessys had a beautiful German Shepherd police dog named Happy who evidently decided I was his owner or that I needed protection. He went with me everywhere even following me every morning as I walked to school. He would patiently wait all day outside the school building and then escort me home in the late afternoon. It became a little embarrassing, but the O'Shaughnessys were understanding and somewhat amused that their dog was insistent on taking care of me.

Despite the fact that my grade school report cards frequently had the handwritten comment, "Billy often does not finish his tasks," my second-grade teacher Ms. Nora Nead asked me to create a room-sized mural on a large sheet of paper rolled out and attached to the wall in the classroom. The subject was to be George Washington, Mount Vernon and chopping down the cherry tree. Other students were assigned to assist me in completing this large commission in celebration of the President's birthday. Perhaps this was the first recognition I had a predilection for art and could make it.

After the war, my father finally came home. One Sunday afternoon while the family was out driving our four-door Packard automobile on rural gravel roads through the Indiana countryside, I realized the rear door on my side was ajar. I dutifully informed my parents sitting in the front seats and then proceeded to correct the problem. On this pre-war model the rear doors were badly designed and flew open to catch the wind while the vehicle was moving. When I opened the door, it took me with it! I landed in the dirt and gravel with a thump, only to look up and see our car disappear over a hill in the road. My first thought was, "Oh, I am never going to see my family ever again!" As they drove on, my sister looked over where I had been sitting next to her, and announced, "Billy's gone!" As luck would have it, they came back to get me, and the extent of my injuries consisted of cuts, scrapes and bruises.

With my father home, the family ventured by car on several memorable vacations. For a couple of years, we traveled to the Traverse City area in northern Michigan to a small quaint resort in the woods on Loon Lake called Wildwood. A series of small Spartan cabins were situated throughout the heavily forested area. Dirt paths all led to a dining room where the three meals of the day were announced by the ringing of a large iron bell just outside the main door. Days were spent leisurely fishing, hiking, reading in this quiet oasis away from the highway, save for the occasional loon's mournful call on the lake. On Sunday at dusk a special treat was the showing of a movie outdoors on a screen in front of several rows of simple wooden benches lined up for viewing. Occasional junkets were made into town or to a daytime rehearsal at the famed Interlochen Music Camp. The demands were simple and life was easy and relaxed.

In rural Indiana, hunting was what all men and boys were expected to do; therefore, there came a time when Billy should learn how to hunt. I was not too keen on taking part in this manly ritual but reluctantly went along with the idea to please my parents. On my inaugural outing, my father and I went into the woods hunting for squirrels one early, chilly fall morning. It didn't take too long before we spotted some squirrel activity high in the trees. Following my father's whispered instructions, I carefully and quietly got the little animal with the fluffy red tail scampering through the tall branches in my BB gun's sights and slowly squeezed the trigger. BANG! and like a lead balloon, the squirrel came crashing down through the branches to the ground with a dull thud. He was dead. Rather than being elated by my triumph, I began to cry. I had just killed something. It was an awkward moment. I felt I had failed and let my father down. However, he empathized with me and quietly took me home. He never offered to take me hunting again.

As a family physician, my father was occasionally paid for his medical services by his poorer patients with food stuffs they had either hunted, grown, slaughtered, or made: rabbits, squirrels, deer, fish, beef, pork, chickens, eggs, ducks, geese, garden vegetables, pies, cakes, jams and jellies, homemade pastries, canned fruits and vegetables. These were special treats for our family that made for a varied menu at the dinner table.

As I was growing up, my parents had their individual interests and hobbies, which I believe influenced my sister and me later in life. Mother loved fine old things and greatly enjoyed getting dressed up in her Davidow suits, veiled hats, Persian lamb jacket, or stone martin stole and attending the seasonal antique shows at Music Hall in Cincinnati. One of her passions was collecting antique dolls, which she shared with Pat, who ultimately inherited them and continued to collect with great discrimination. While some were made of wood, wax, cloth, composition, china, and mechanical, it was the French bisques that were the prizes: specifically, the manufactories Jumeau and Bru.

As I accompanied Mother on these forays to antique shops and shows, collecting was engrained into my young life and continued unabated throughout adulthood. Stamp, coin, "Indian relic," and sea shell collections were amassed. Glass and clay antique marbles were

special finds at the shows and shops. I spent a vast a number of hours searching for Native American artifacts in the cornfields around the vicinity of Lawrenceburg, where much earlier the Hopewell and Adena peoples had occupations, and Indian mounds abounded.

As I matured and approached adulthood, I began collecting art. While still in high school, my initial venture into this world proved years later to be regrettable. My first acquisition, a color print of Aristide Bruant by Toulouse-Lautrec, from Walter Johnson, a Cincinnati antique dealer, I later discovered was a fake! Admittedly, all collectors throughout their careers make mistakes; that's part of the experience. But to have your initial purchase turn out to be fraudulent was embarrassing and discouraging. However, my second serious acquisition, a color lithograph—signed in pencil by Joan Miró and purchased in my college days from the reputable Baltimore print dealer Ferdinand Roten—has thus far proven to be legitimate.

My father was an only child (a brother died in infancy) and consequently spoiled by his adoring parents. He had his strong interests and studied them at length. Locomotives and trains were his passion; he eventually became an honorary engineer and once was allowed to drive a train. He was obsessed by the possible existence of Unidentified Flying Objects as either visitations from outer space or a highly secret American government project of some nature. Along with my mother, he loved birds and spent hours setting up feeding stations outside our breakfast room window for our family to enjoy and study the dining habits and social "pecking order" of our feathered visitors. Hunks of suet were secured to a nearby tree trunks in wintertime. Wren houses hung from several trees in the backyard for spring- and summertime residents. He adamantly claimed that wrens would only accept houses whose openings were the size of a silver quarter—anything larger would allow unwanted squatters or guests to enter. He became extremely concerned about the extinction of the whooping crane, which at the time numbered less than two dozen on the entire planet.

Later in his life, with an alcoholic beverage in his midst, he faithfully listened to the radio broadcasts by the legendary announcer Waite Hoyt

of the Cincinnati Reds and later every Sunday during football season watched the NFL games on television.

Everyone called my mother Dorée. Orphaned at a young age, she and her sister, Esther, and two brothers, Ben and Knute, were separated and distributed to relatives to be raised. She was an avid gardener and took great pride in her backyard displays. Among my favorites of her flowers and bushes were the spirea, hollyhocks, forsythia, crocuses, irises, daffodils, and most especially the flowering dogwoods and red-bud trees, peonies, lilacs, and lilies of the valley. One of her passions was a wildflower garden under a dogwood tree in the back of the yard. We made special trips into the countryside forests just to gather plants for this reserved space.

The garden was always a challenge, and rarely without any assistance other than from me, she tried to keep up with it all. From early spring through the summertime until the fall, she would neglect her housework, let the newspapers and magazines pile up, and be out in her beloved garden from sunup to sundown, in spite of her allergy to the sun, which required her to keep her skin fully covered. It became a never-ending battle, but one that gave her hours of pleasure though hard labor.

As a small child, my aspirations were first to be a railroad conductor and ride in the caboose, and then to be a garbage collector. Later, I thought it would be cool to be a highway architect planning where new roads would go. Somewhere along the way, in one of my early conversations with my mother, she advised me, "You know, you can be anything you choose to be when you grow up. I don't care what it is, even if it's a tiddlywink player. If that's your decision, then you must become the best tiddlywink player there is!" It wasn't until after my first year at college that my vocation would suddenly become apparent and take shape.

Lawrenceburg, Indiana, has always identified with Cincinnati, Ohio. Being only twenty miles as the crow flies from downtown Fountain Square, we listened to the city's radio stations, watched its television, and read its newspapers. We truly were a suburb of the big city upriver and often went to Cincinnati to shop, eat in restaurants (our favorites were the classy Italian Caproni's, the English-style pub the Cricket, and

the 150-year-old German Mecklenburg Gardens in the city's hills out-side of downtown) or see movies or traveling Broadway plays.

Living in a community on the Ohio River presented a number of memorable experiences as a child. Several times, the winters were so severe the river froze over, creating a jagged jumble of ice and allowing people to walk all the way across to the Kentucky shore. One summer, a showboat docked at Lawrenceburg, and we eagerly crossed the levee at the foot of High Street to spend an evening of a rather amateur-ish, forgetful live production. On the Fourth of July crowds lined up at Greendale Park to take a round-trip ride from Greendale Park across the Ohio River on an amphibious World War II supply transport DUKW vehicle, commonly known as Ducks and based on those built by Higgins Industries in New Orleans. Later, waterskiing on the Ohio was a fun but dangerous sport as the swift current and floating logs and other debris were a hazard.

One of my thrills as a small boy was taking the *Island Queen*, a pseudo sidewheeler excursion steamboat which would periodically dock at Lawrenceburg levee and cruise up the Ohio River to Coney Island amusement park located on the other side of Cincy. Later, when I was old enough, I would spend a Saturday taking the Trailways bus from Lawrenceburg to downtown Cincinnati to see shows and just be "grown up" on my own. On one memorable solo excursion, I saw the latest new sensational comic team at the time, Dean Martin and Jerry Lewis, appearing in person at the beautifully ornate movie palace, the Albee, on Fountain Square. Later, when I entered high school and began driving, we would double date and go up to Moonlight Gardens at Coney Island to dance to such big-name orchestras as Ray Anthony, Count Basie, and Duke Ellington. Once, I caused a stir by wearing a seersucker suit with Bermuda shorts.

Like most young boys growing up in the Midwest, I did other expected kid things to earn money: getting up before dawn to deliver early-morning newspapers and being a clothes checkroom attendant in the bathhouse at the neighborhood swimming pool.

My first entrepreneurial venture in my pre-teens turned out to be more lucrative than anyone would have thought—selling nightcrawlers

(for the cultured, they are earthworms on steroids). After the war, my father was an avid sports fisherman, and once, when he returned home from a Canadian fishing junket with his fishing buddies, he brought with him a batch of these worms and "planted" them in the yard around our house. I'm told that Canadian nightcrawlers are the supreme deluxe of worms, mainly because of their unusually large size. For fish, these huge squirming morsels must be the equivalent to prime rib. Over the years, the worms on our property (to the chagrin of the neighbors) flourished, making the ground and lawn uneven and hard to walk on with the little mounds of mud they build, somewhat like crawfish holes.

In Midwest tradition, fishing was a popular recreation in southern Indiana, and so ten-year-old me decided to take advantage of this potential gold mine in our backyard. My parents encouraged me to try to harvest these fat, juicy delectables for profit. As the name "nightcrawler" suggests, they only come out of the ground at night, particularly after a rain. As rain is intermittent and not a daily occurrence, to lure these creatures out after dark, I watered the lawn thoroughly with a sprinkler at dusk, which, unbeknownst to me, resulted in an inflated monthly water bill. I perfected the technique of catching these slimy worms in the darkness by moving very slowly and carefully in a crouched-down hunker, slipping and sliding on the muddy ground, holding a flashlight obliquely as not to scare them back in their hole, to which they could dart at lightning speed. With my deft fingers attacking with the swiftness and accuracy of the lash of a snake's tongue, I grabbed ahold firmly, but not too firmly as I didn't want to squish them, then gently pulling them out of their holes without breaking them in two. There is definitely an art to catching worms! Sometimes two worms from different holes would hook up above ground to mate. This was a real prize—two in one strike. Carefully laying the flashlight down and directing the beam so I could see what I was doing, I would pounce on my unsuspecting, amorous pair. Bingo!

My parents allowed me to put up a homemade wooden sign in front of our house "WORMS FOR SALE." At first, I had a few nibbles, so to speak, and then over time I became well known throughout Dearborn and neighboring counties for the excellent quality of my product.

"Billy Fagaly has the best worms!" Business was flourishing. My business made the editor's column of the local weekly newspaper several times. My supply stock was kept in the garage in a large wooden box filled with rich, moist earth enriched with peat moss. My customers supplied their own containers for their purchases, and if I was not at home when someone would come for a purchase, my mother would have to dole out the desired amount and collect the money. This whole venture had other drawbacks for my family. Their friends would telephone and jokingly ask if we had worms. The lawn suffered from my nightly tramping, and the house often had mud tracked through it. But my mother and father gamely put up with my enterprise more than I knew at the time. After several years, I had made quite a nice little sum for my worm bank account, but probably not enough to have covered the increased water bills my parents endured.

What this newfound wealth *did* do was create a revolution in the Fagaly household. In the late 1940s, after the war, television was introduced on the mass market, and programming was in its infancy. My friend Jim Noyes had bought himself a TV and installed it in his bedroom. Every weekday evening at 6 o'clock, he and I would lie in his bunk beds and await with excited anticipation the Wagnerian theme from *Der Fliegender Hollander*, announcing the Captain Video serial program, which would reveal the latest installment of our space hero and his Video Rangers' courageous exploits against the evil Dr. Pauli. Captain Video was the progenitor to Buck Rogers, Star Trek, and Star Wars. What fun! Soon, my parents complained that I was never home in time for dinner, so I asked if they would buy a television for our house. No way. They were too expensive, the programs were uninteresting, it would mar the décor of the living room, and, what's more, TV was just a passing fad. After much pleading and begging, in 1949, I decided I would buy a set with my nightcrawler earnings and put it in my bedroom! That way, my parents wouldn't be bothered by it cluttering the house and disturbing everyone. They reluctantly agreed, and there it was, at the foot of my bed, with a large antenna tacked on outside my second-story window. Many an hour was spent checking the black-and-white

test patterns on the screen until the station in Cincinnati went on the air in late afternoon.

It didn't work out like we all thought it would. My parents became fascinated with this new marvel of moving pictures, only in black and white, inside our home. Soon, they were spending increasingly longer periods of time watching boring and trivial programs just because that was all there was to watch. "Professional" wrestling became a national fad, and in the Cincinnati area came on television late in the evening and dragged on way past my bedtime. Out of necessity, I learned to go to sleep through my parents' cheers and jeers as the matches between such muscled heroes as Gorgeous George (with his peroxide locks and flashy satin capes) and Native American chief Don Eagle (with his feathered war bonnet and trademark Mohawk haircut) went on into the wee hours. After a while, my parents realized this was not a good situation for me, who was being deprived of sleep on school nights, and sheepishly admitted my TV should be moved down to the living room.

Other early childhood memories consist of the silly popular music of the era. I was fascinated by lyrics such as "Boop boop saditem datem whatem choo" by Three Little Fishes, the nonsensical lyrics of the satirical arrangements by Spike Jones and his City Slickers and the comedian with the ridiculous name Ish Kabibble. Later television favorites included Jerry Lester's late-night Broadway Open House with the talents of Dagmar, his blonde-bombshell sidekick, and the giddy routines of the genius Ernie Kovacs, particularly the Nairobi Trio.

Health

From birth, my health has not been all that good. As an infant, I had to have blood transfusions in my ankle, and I remained anemic most of my childhood. Perhaps my earliest vivid memory is when I was in the hospital for an emergency appendectomy on my third birthday. However, the basis for the ongoing condition of my health has been a congenital defect known as Hirshsprung's disease, a rare ailment that plagued me

all during infancy and early childhood. Because of a blockage from my stomach to my intestinal system, it required my mother administering enemas to me daily the first six years of my life. The doctors in Cincinnati had told my parents that they were unable to do anything but to bring me back to see them when I was six "if he is still alive." When Mother and Daddy returned with me then, they were told I was doing as well as could be expected, but they couldn't do anything surgically at that young age. Time went on, and all through my schooling, I was able to manage, but not without difficulties.

Finally, when I went to college, and I didn't have the time to devote to taking care of myself as in the past, the condition became unlivable. I withdrew from college, and, in 1959, my parents took me at twenty-one years old to the Mayo Clinic in Rochester, Minnesota, to see what, if anything, could be done. The doctors said they had not seen a person live that long with that condition as it had a history of being fatal before a child reached puberty. I was miserable and was willing to try anything to alleviate my suffering. Historically, all past surgeries for this condition had ended in failure. After consulting with my father, the Mayo physicians decided that a new, untested surgical approach would be tried. I was told that this radical surgery might not work either, but I was in such discomfort I knew I couldn't continue without trying something. So the doctors and I took a Hail Mary pass. Dr. Charles William Mayo ("Dr. Chuck") was a member of the surgical team led by Dr. Edward Starr Judd Jr. The surgery was a success, and I was told I would not have lived another six months if I hadn't come to Rochester. There were unexpected complications requiring four additional operations led by Dr. Raymond Joseph Jackman over the next year and half. The initial procedure made history as a "cure" for this ailment, and I was the first to be able to live a relatively normal full life. That brush with death made me cherish the gift of life all the more and for me to live every day to the fullest.

Another milestone in my health history was my decision to enroll in the smoking clinic at Ochsner Hospital in New Orleans. I had been "giving up" periodically since college, but it never lasted. So, on February 19, 1979, I showed up at their headquarters on Jefferson Highway for

the first of five daily one-hour group sessions. These meetings entailed a number of harsh exercises such as uncomfortable forced smoking, excessive cigarette-smoke endurance, light shock treatments, demonstrations with actual diseased lungs, and post-hypnotic suggestion. The week-long hourly meetings were a success. Even though I will never have another cigarette in my life, I still crave smoking a cigarette today.

Episode 2

What Am I Going to Do with the Rest of My Life?

The College Years

Making a decision early on not to follow in my father and grandfather's footsteps to be a doctor was a shock to the people of Lawrenceburg. It was broadly assumed I would continue the century-old family tradition. However, I knew I did not have the stomach for dealing with sick bodies and, in particular, the sight of blood. To my surprise my parents did not object to my decision as they felt that the profession was changing drastically. They felt that socialized medicine was on the horizon, as it was in England, and that doctors would not be their own bosses and be free to create their own practice and destiny. As college approached and a decision of what direction I should go was rapidly pressing on me, I entered Indiana University in Bloomington with the thought of becoming a chemist since I had flourished in that subject and took a liking to it during my senior high school years. So, off I went taking various chemistry courses and higher mathematics such as advanced calculus. I was doing well with my studies along these lines, and then I took a course in organic chemistry. That's when it all began to fall apart. I soon realized I had met my match and didn't have the foggiest idea what I was doing. After flunking my major subject, I quickly came to realize I was not meant to be a chemist. So much for that. What to do?

My sister, Pat, had graduated from Indiana University several years prior to my arrival and had a successful four years majoring in art. Among her professors were the sculptor George Rickey and the painter

Alton Pickens, and the yet unknown painter James McGarrell was her fellow student. The temporary World War II–era Quonset hut buildings that served as the art department were directly next door to the chemistry building, where suddenly I realized I did not belong.

In a mysterious epiphany moment, I wandered next door and announced I wanted to study art history to prepare me to work in an art museum! Where did *that* come from!? I have no idea other than my sister had been there happily, and I had demonstrated considerable talent as a practicing artist as a child and young adult. But work in an art museum? That came out of left field. After all, the *only* art museum I had ever been in was a forty-five-minute whirl through the National Gallery of Art in Washington, DC, on my high school class's trip to the nation's capital in 1954. Much to my class's annoyance, I held them all up as they were all back in the bus five minutes after our arrival at the art museum. What is even more baffling is that I readily admitted I did not know what people did working in an art museum, but I was sure that that was what I wanted to do. Shortly after having this revelation in 1958, I visited the Cincinnati Art Museum and saw the great Robert Lehman Collection before it was bequeathed to the Metropolitan Museum of Art in New York.

Thus, I rescued myself and quickly switched my major and enrolled in courses in art, both studio and art history. I fell into my element and enjoyed this new world of art and artists. These were my people, even though I don't believe the faculty really gave much credence or interest to my declaration to want to become an art museum curator. Just as I had let it be known to my parents that I didn't want to pursue a career as a doctor, when I informed them of my decision to become a curator, my mother's first comment was, "Well, you know you will never be rich."

My undergraduate years at IU were during the second administration of the Eisenhower presidency—a time of relative worldwide peace and innocence. The Korean conflict was over. The Cold War era had begun with communist Soviet Union and communist China virtually shut off from the rest of the world by the Iron Curtain. All in all, these years at IU during the late 1950s were by and large uneventful. At the time, fashions on campus were much more a matter of dressing up than today. To prepare for my college years, my parents bought me a new

wardrobe at the fine men's store Dunlap Clothes Shop, on Vine Street in downtown Cincinnati. The Ivy League style was *de rigueur*—Hart Schaffner & Marks, Brooks Brothers, and Gant were the labels to wear. However, it wasn't fashionable to be caught wearing new clothes, so we preaged them after bringing them home, much like today's fad of distressed jeans. The collars of our new button-down-collar blue Oxford cloth dress shirts were immediately sandpapered to give them a worn look, and all-wool white athletic socks were dyed in a pot of tea to create a sweaty, aged patina.

During this time, there was pressure to join a fraternity, both from my family and also from social expectations. So, to please others, I went through motions of being "rushed" by fraternities on campus. One Sunday afternoon, I was asked to come for a coffee at the Alpha Tau Omega house on Third Street. They were considered high on the social ladder at IU, so I went. Evidently, each member of that chapter was assigned to a specific invitee, and the guy delegated to me was quite charming and a quite a talker. Upon arriving, he asked if I would like some coffee. Since that was ostensibly why I had been invited, I accepted, even though up until then, I had never drunk coffee. It smelled vile. How was I going to drink that awful stuff? My quick solution was to put a lot of sugar in it; that would make it more palatable. During this entire ritual, my frat companion was closely watching me, all the while rattling away nonstop, telling me about the virtues of his fraternal organization. To get through this experience, I decided the best way was to gulp the coffee down all at once and be done with it. So I did. UGH! That was the nastiest stuff I had ever tasted. Never again. Finally, my host took a break, poured his coffee, added sugar, and took a sip. He quickly spit it out and asked how my coffee was. Not knowing how coffee was supposed to taste, I told him, "Fine." When he regained his composure, he announced, "That wasn't sugar in the sugar bowl; it was salt!" Needless to say, I was not asked to become an ATO.

However, I did become a Sigma Chi and lived in the fraternity house for a while and did all the expected "college things." One popular activity, unique to IU's campus, was to drive out of town to the various limestone quarries surrounding the area to drink beer and swim in the ice-cold water even though it was illegal and dangerous climbing on the rocky

cliffs surrounding the water. The largest and one of the most desirable was the Empire Quarry south of Bloomington. It was so named because all the Bedford limestone quarried there was shipped to New York City to build the Empire State Building.

I continued my studies and took both studio art and art history courses. I gravitated toward graphic design and photography in the studio, enjoying and doing quite well in both. But there wasn't as strong a focus in the art history courses offered other than modern art. As time went on, it became apparent to me I had to make a choice: practicing artist or art historian. I felt I couldn't do both, as much as I would have liked to. However, I delayed my decision even into graduate school. I became what was known as a "professional student" who had too much fun and switching my major back and forth to avoid graduation.

Along the way, while taking a course in Italian Renaissance, taught by a prominent art historian, the teacher was abruptly dismissed from the university. A new man was quickly brought in to fill that vacancy, and he taught something quite removed from the previous teacher's specialty—African art of all things. His name was Dr. Roy Sieber. As it turned out later, Sieber would have the distinction of being recognized as the first formally educated African art historian in the United States, studying with the legendary anthropology professor, Melville Herskovits, at Northwestern University in Chicago. While studying cultural anthropology with Herskovits, Sieber recognized the objects being studied were more than mere "specimens" and were indeed works of art and deserved to be studied as such. Sieber approached his professor and convincingly made the argument that he wanted to study these objects exclusively for their aesthetic value. Herskovits recognized the merits of his student's plea and agreed to devise some special courses with emphasis on that aspect. This milestone series of events became the incubation and birth of the study of African art as a legitimately sanctioned discipline in the history of world art. Roy Sieber is now universally recognized as the first formally trained African art historian in America. And I was one of his first students.

Taking a history course in African art—what a novel idea! Why not? As it turned out, I loved the subject of African art, and I thoroughly

enjoyed Roy. The combination of the two made my life as a student an altogether pleasant experience. As time moved on, there came a time when the faculty put pressure on me to declare, if indeed I was going to major in art history, what my specialization would be. After carefully reviewing the alternatives, I chose African art. I liked the subject, and part of its appeal was that since it had only recently been accepted as a bona fide field of art history, new information was coming forth at a rapid pace. It was not a field that had been studied excessively with little opportunity for new discoveries. What better subject to introduce to art museums, those august institutions, most Eurocentric in their emphasis and practice, where even possessing an African art collection was rare, let alone designating gallery space for its display?

Roy was a fatherly sort of fellow. Understanding my desire to become a museum curator, he spent long evenings into the night with me pouring over African art auction catalogs, discussing the merits, the weaknesses, the rarity of each lot being offered. Not only did he teach me the history and ethnography of African art, but he also taught me the connoisseurship of the sculptor's prowess, the sculpture's surface patina, the uniqueness of the object itself. He cultivated my eye for my job ahead, something that would not have been so important for his other students who were pursuing teaching careers in academia. Roy was devoted to his students and went to great lengths to work with them. However, he is quoted to have remarked, "I'll go so far, if necessary, to bottle feed my students, but I'll be damned if I will breastfeed them!"

Another manifestation of Roy's personal training devices was to encourage me to visit the dealers in New York who were showing African art. One dealer Roy highly recommended was George Juergens on Third Avenue, who had a small undistinguished curio shop with ethnographic objects of exceptional quality and modest prices. It was the perfect place for a student to learn connoisseurship from a dealer and even possibly purchase something. The big dealers—Julius Carlebach, Henri Kamer, J. J. Klejman, Mert Simpson, and Mathias Komor—all had reputations for being rather formal and not readily accessible, except if you were a young college student who mentioned to them that you were a student of Roy Sieber! That piece of information certainly opened

doors and melted cold facades. Upon learning this, Klejman and his wife generously asked if I would like to see the basement storage room after surveying the pieces displayed in the gallery. Opening the door and turning on the light, they invited me to go downstairs unattended and have a look. I later learned that this was unprecedented, and few believed they had allowed me this rare privilege.

Mathias Komor's style was more old-world gentility. Upon entering his elegant gallery in an old brownstone on the Upper East Side, Komor greeted me in a room with no art on display. After awkward polite formalities concerning the nature of my visit, it was only when I identified that I was a student of Roy Sieber that I was ushered into the next draped salon, again devoid of any art, and given a seat. Standing in front of me with his hands clasped, he inquired what in particular I wished to see. Not knowing what he had to show, I didn't know how to adequately answer his question. Finally, I just made up something and said, "I would like to see Bambara," and he exited the room and returned with a magnificent example by the Bambara peoples of Mali, and placed it on a pedestal in the center of the room with spotlights directed on it for a dramatic presentation. After discussing its merits and admiring its beauty, he asked what I'd enjoy seeing next. After seeing a succession of outstanding works, I thanked him for his kindness and time and left (empty handed) knowing I would never have been given such a generous performance if I had not told him I was studying with Roy Sieber.

Somewhere along the way, I acquired the nickname "Intrepid" from Roy, but he would never divulge the reason why I had been given this appellation. His house with his wife, Sophie, on the outskirts of Bloomington was the unofficial clubhouse for his students to congregate and hang out. Sophie was Roy's designated gatekeeper, and she was the person anyone had to get past to have access to Roy after you were forced out of the nest; that is, graduated and moved on. Roy and Sophie remained my good friends until their deaths, and they visited and stayed with me at my New Orleans house several times. Roy was an insatiable collector and would wear me out visiting every antique shop, junk shop, auction house, thrift store he could find in the city. It was uncanny how quickly he could spot a hidden treasure among a dusty, poorly lit heap

of discarded objects in shops. Once in 1978 I took them to visit the then mostly unknown African American folk artist David Butler at his house in Patterson, Louisiana. They were enchanted. It is one the few times where I felt I had introduced Roy to something he knew little about. He was truly pleased to learn more of this obscure art form with hints of possible African origins in its ancestry.

While studying art history at IU, I also developed a special interest in modern and contemporary art. This led me to Albert Elsen, the internationally recognized scholar of Auguste Rodin. Elsen taught a variety of courses on twentieth-century art. His personality was distinctly different than the "teddy bear" of Roy Sieber. Elsen was arrogant and was well-known for being rough and aggressive with his graduate students, and would select one in particular to pick on each semester. As a teaching assistant for his introductory art survey courses one semester, I became his chosen one.

There was an established pattern of behavior throughout that spring semester. Elsen always arrived late to my classes, quietly slipping in the back door and sitting at the rear of the darkened room after I already had made certain cogent points in my lecture. To make certain he understood the context of my previously presented thoughts, I would reiterate and summarize what he had missed before proceeding with the remainder of my lesson for the day. Following every lecture, I would be summoned to Elsen's office, where I would be critiqued with no holds barred. He dissected and decimated my lectures point by point. Puffing his smelly pipe and with legs crossed and propped up on the edge of the desk in his dark, claustrophobic office, he was ruthless, ripping me to shreds. I could not quarrel with him, because most of what he said could not be denied. He was unrelenting. This went on day after day, week after week. I was becoming an emotional wreck and my fellow graduate students were most sympathetic. I felt I was on the verge of a nervous breakdown. One day during one of these tyrannical assaults, he hit below the belt and said, "Bill, you know what your problem is—you are not in love with art." With his complete denunciation of my character and questioning my commitment to art, he had crossed the bounds. That was it; I was not going to take this abuse anymore!

With that, I slowly leaned forward, looked him straight in the eye and pointed my finger at him and said that was absolutely not the truth. I proceeded to give him a piece of my mind in no uncertain terms as he continued to quietly puff on his pipe. When I finally finished with my outburst, he calmly responded, "Bill, that took a lot of courage and I applaud you for saying it. I believe you, and I would like to help you in your pursuit." From that moment on, Al Elsen was on my team! It was a watershed moment.

In hindsight, I realize that he was testing me to see what I was made of. Did I have in his eyes what it takes to succeed? Evidently, I proved it to him, but at what a price! Even though his motives were well intentioned, I do not think his methodology was admirable, to say the least. My siege with him cost me dearly emotionally. On the other hand, he showed moments of benevolence. Shortly before this horrible episode, I was traveling in Europe with my fellow student Jack Nichelson. One morning in the summer of 1962, we had just completed our visit at the Rodin Museum in Paris and were taking a short break in its gardens. Who should appear but Al Elsen. He seemed pleased to encounter two of his IU students there and offered to take us on a personal tour of the museum. Even though it would repeat our visit, what a treat it was for us, getting fresh new insights and observations from the recognized Rodin authority explaining other little-known facts about the artist and his work.[1]

While at IU, I was the typical Pisces and couldn't make up my mind whether I wanted to major in studio (specifically photography and graphic design) or art history. Right away, this rivalry and mutual disdain between disciplines among my fellow students put me in no man's land. I never understood this conundrum and still don't. As a studio major, wouldn't you want to know something about the history of your craft, and vice versa, wouldn't the art historian want to know something about how your subject was made?

At one point, I thought possibly I could combine both interests by being an exhibition designer at an art museum. While driving curator Peter Selz from the Museum of Modern Art (MOMA) on a trip from Bloomington to Indianapolis, I had the opportunity to question him

about the qualifications and jobs of the exhibition designers at MOMA. He was puzzled and said they didn't have any such positions there. He further explained that the curators themselves were the sole designers of their own exhibitions. However, he applauded my idea for such an occupation and encouraged me to seriously consider such a career path.

Consequently, I became somewhat of a "professional student," switching my major back and forth every couple of semesters. I think the faculty finally came to this conclusion and decided to just go ahead and give me a degree and shove me out the door. Therefore, I earned a Master of Arts degree majoring in African art history.

I had several notable roommates who shared a garret apartment on North Fess.[2] Tom Solley, heir to the Eli Lilly pharmaceutical fortune, was being groomed to be the future director of the yet to be built IU art museum. Living in Indianapolis with his family, he only needed a place in Bloomington several nights a week as he took courses in art history. He later became the director of the new I.M. Pei-designed museum and was one of its major benefactors with many significant gifts of art and money.

Fellow art history student Jim Riggs shared the apartment with me for several years. At the time, Jim was serving as art curator at Alfred Kinsey's fabled Institute for Sex Research on campus. Because of the nature of its contents, the security system consisted of buzzing locked doors and other sophisticated alarms. Jim had access to the collections' library and would read bawdy passages at the evening dinner table from his latest find there. On occasion, Jim and I would be invited by the director of the institute to dinner at her house across campus. Cornelia Christensen was an older woman with her gray hair tied in a bun and wore matronly dresses with laced collars, a stereotype of a sweet grand-mother. The table was formally set with lace tablecloth, fine china, and crystal. This idyllic setting was the scene for some of raunchiest, lewdest conversations with her and her guests, discussing subjects and language that would make a sailor blush. Many years later, Jim, in his nineties, a retired Russian Orthodox Bishop, lived quietly with his beloved dogs on the West Bank of New Orleans until his death in March 2018.

I was a teaching assistant for several undergraduate graphic design courses. One of my students was the wife of the chairman of the univer-

sity's archaeology department. Through her, I learned that every sum-
mer her husband led an archaeological dig of a large ancient Native
American civilization of the Middle Woodland Period dating circa 200–
500 CE. This news intrigued me. As a child, I collected "Indian relics"
and was what is derisively referred to as "a pot hunter." The site, named
the Mann Site after the name of the landowners, was located in the
extreme southwest corner of Indiana near the confluence of the Wabash
and Ohio Rivers, not far from Evansville. I applied for the field course
there that following summer of 1964 and was readily accepted. Perhaps
my admittance was based on me not being an archaeology major but
an art history student who could provide another perspective on the
artifacts found.

For the next eight weeks, our group was housed in an attic dormi-
tory of a large farm house on the outskirts of the historic town of New
Harmony, a utopian community established in the early nineteenth cen-
tury. In 1825, Robert Owen purchased the entire ten-year-old village,
Harmony, added "New" to its name, and established the social experi-
ment community, the Owenites, which ultimately was an economic fail-
ure. However, its legacy is rich. Among the many achievements of the
community's citizens in science and education was the establishment of
the first free library. One of Owen's sons, Robert Dale Owen, initiated
legislation which founded the Smithsonian Institution.

What an eventful summer that was for me and my fellow diggers!
That Spartan environment had been maintained and was essentially as
it was when it was founded so many years ago. The small community
boasted, at the time, a population of around five hundred, and there
was a single flashing caution signal hanging over the main "downtown"
intersection. The simple unadorned houses, the large clapboard men's
and women's dormitory buildings, and the complex boxwood labyrinth
made up a bucolic setting in which to spend a quiet summer. At least
that was what we anticipated. As we soon discovered, this community
was populated with unique and fascinating individuals who got a little
wild and crazy doing salacious things at night. I guess there was noth-
ing else to do, and the introduction of our group that summer added a
new element for them.

The tradition of intellectual achievements begun in the early 1800s has continued to the present. In 1941 Robert Owen's single living descendent, Kenneth Dale Owen, married Jane Blaffer, Houston oil heiress whose father and grandfather were founders of the companies that would become Exxon and Texaco.[3] Jane's lifelong dream was to revitalize this small historic Indiana town that she passionately loved. Through her visionary ideas, enthusiastic drive, cultural connections, and deep pockets, her early accomplishments included commissioning Philip Johnson to design the Roofless Church there with its fluted shingle dome sheltering a major bronze sculpture by Jacques Lipchitz. This open structure featured a simple grass lawn expanse enclosed by a low brick wall that created a space of uncanny peace and tranquility. The gentle country breezes off the banks of the Wabash added to the serenity of one's visit to this special sanctuary for quiet contemplation and solace. Through her tireless efforts, New Harmony would become a center for the arts, science, and religion attracting such people as theologian Paul Tillich and architect Paul Rudolph.

Jane's larger-than-life personality and character were legendary. A deeply religious woman, she and the CEO of Tiffany's and father of the Metropolitan Museum of Art, Thomas Hoving, held daily early-morning prayer services via long-distance telephone. She was frequently seen riding her bicycle or, later, a canopied, electrified golf cart around the village. Being a popular draw at the Sunday services at the local Episcopal Church, she made appearances wearing oversize straw hats to testify in the pulpit.

While our student group spent the summer in the community, Jane graciously offered us the use of her own house, gardens, and swimming pool while she was away. What an oasis that was from the swelteringly hot long summer days in the field unprotected from the sun, and the cramped sleeping quarters in the farmhouse's attic dormitory! The cool evenings poolside in the Picasso-walled living quarters were most welcome after days spent in breezeless cornfields. One day, our professor, who came to know me from my days as a jacket-and-tie instructor in the art department, spied me, caked with mud from the combination of sweat and dirt, sitting in the shade under a tree eagerly devouring my

bologna sandwich on plain white bread. He shook his head and declared, "Oh my gawd, Lord of the Flies!" It was a most memorable summer.

One of the sideline events that summer had a most unexpected ironic twist for me. Through my association with the archaeology department, I learned that they had their eye on the football practice field on campus in between the field house and the art department for their envisioned Glenn Black Archaeology Museum. I also happened to know that was the plot of ground that Henry Hope, the art department's chair and founder of the university art museum, had plans to build the IU art museum for its collection. Early that fall, I met with Hope and told him what the archaeology department was planning. Unaware of this news, he said, "Oh my, I have to go see Hermie about this right away," referring to the university's esteemed president, Herman B Wells. Today, architect I. M. Pei's beautifully designed art museum is next to the art building right where Hope intended it, and the archaeology museum was built later on the lot at 915 North Fess, the address of my old apartment building!

Henry Radford Hope[4] was a distinguished art historian well known and respected on the art world stage. He was a discriminating connoisseur, and his own vast art collection ranged from sculptures of ancient Egypt, Greece, and Rome to paintings by Picasso, Matisse, and Kenneth Noland. Being a neophyte art collector myself, he was my hero. My admiration and respect of him were boundless. He often hired me to serve as bartender at cocktail parties entertaining visiting dignitaries in his art-filled home.

On one occasion, he demonstrated his trust in me and my own aesthetic eye. When I showed him an Indian miniature I had recently purchased for a modest price on Madison Avenue in New York, he asked me if on my next trip I would buy one of my choice (within a certain price range) for his own collection. Later, after a subsequent trip, he was most grateful for my choice. Looking back, I now realize that his faith in me, along with those of Albert Elsen and Roy Sieber, was yet another demonstration of my IU instructors believing in this budding young, inexperienced art historian/curator.

One of the reasons I decided to become an art historian is that I have an insatiable curiosity and multiple, diverse interests. How does

one begin to satisfy those needs and desires? To my mind, the profession that covers a gamut of disciplines at one time or another is the study of the history of art. In their work, scholars occasionally touch upon world history, aesthetics, philosophy, religion, archaeology, psychiatry, anthropology, ethnography, physics, mathematics, biology, theater, sociology, law, medicine, literature, business, chemistry, architecture, athletics, geography, and on and on. I would be hard put to name another profession that involves such a wide spectrum. Maybe law. On the other hand, I've always admired a Barnett Newman quote, which I think says it very succinctly: "Aesthetics is for the artist what ornithology is for birds."

In retrospect, one of the major regrets of my life has been that I did not have the computer at my disposal at the beginning of my career as a tool to assist me in my writing, my research, and my organization of exhibitions. I feel I could have accomplished so much more. I look back now at the laborious and time-consuming task of writing everything by hand on reams of yellow notepad paper, hand it over to a secretary to untangle all the inserts, and the rearranging of texts with arrows and crossing out the deletions. Then she gave it back to you to further edit and return to her for yet another draft. This exhausting system could go on and on for innumerable edits and rewrites, making one feel bogged down and disinterested in the creative process.

SEGMENT II

Episode 3

Becoming an Art Museum Curator
in New Orleans

Openings and closings, beginnings and endings. Everything in between passes as quickly as the blink of an eye. An eternity precedes the opening and another, if not the same, follows the closing. Somehow everything that lies in between . . . seems for a moment more vivid. What is real to us becomes forgotten, and what we don't understand will be forgotten, too.[1]

Moving South

In the mid-60s, it was an employee's market in the art museum field. Trained art historians who were seeking positions were in demand. I had been considered by the University of Connecticut art museum and had been offered positions as the coordinator of the then much-bally-hooed Art on Wheels traveling program at the Virginia Museum of Fine Arts, Richmond. One enticement at the John and Mable Ringling North Museum of Art in Sarasota was the perk of a rent-free, newly renovated attic apartment in North's fabulous palazzo residence Ca' d'Zan on a nearby ocean beach. However, the interview in Sarasota did not go well. When I expressed an interest in the Circus Museum on the Ringling campus and inquired about buying a recording of calliope music, their art museum director was disdainful of my plebeian, gauche interests.

I remembered my IU advisors Henry Hope and Albert Elsen's suggestion that if I wanted to learn the museum field, I could do no better than working with Jim Byrnes at the Delgado Museum in New Orleans,

who could teach me the "museum business." He and Roy Sieber for-
mulated my destiny. They are the ones who I am convinced decided it
was not in my makeup and intellect to pursue a doctorate but make a
master's my terminal degree and undertake a career as art historian and
museum curator, as I had expressed to them when I first walked into the
doors of the art department nearly a decade earlier. Also, they knew I
would be incapable of any arduous field work in Africa as a result of my
physical handicap from extensive surgery at the Mayo Clinic.

My interview was not going well at the Ringling, so I telephoned
Byrnes one evening when I was in in Sarasota and asked if I could visit
while in the neighborhood. "Sure, come on over" was the immediate
response. Registrar at the Delgado was the lowest paying job I had been
offered anywhere, but I knew immediately New Orleans was the place
for me. I realized there is much more to life than a job. In addition,
Byrnes shared my desire to build an African art collection in an art
museum in a major Southern city whose majority population was Afri-
can American. I instantly fell in love with the city—its architecture,
food, music (Fats Domino lived here), and climate (I deplored those
freezing, snowy Midwest winters). I found it basically a conservative
city while at the same time being permissive and promiscuous. (I am
convinced this unique dichotomy is a by-product of Mardi Gras). Last,
I realized the Delgado had great potential for growth. It was the right fit.

The uneventful trip from Bloomington to New Orleans in my used,
lime-green Mercedes, purchased from Mel Driver,[2] was an unexpected
wake-up call to the reality we were experiencing in this country at that
particular time. A college classmate had agreed to help me make the
move by convoying with me pulling a U-Haul trailer containing all my
worldly possessions. There we were—two young, college-type white
men with Indiana license plates driving a Mercedes through the South
in the late summer of 1966. Even though we were fully aware of the fight
for civil rights that was deeply troubling the country and tearing it apart,
this was a reality check. Crossing the Mason-Dixon Line, we could feel
the discord and suspicion and outright disdain of our presence in this
bucolic countryside, particularly in the states of Tennessee and Mis-
sissippi. The tension was palpable. Stopping at rural roadside diners

and staying in cheap motels were not the smartest decisions we could have made. After all, it had been only two summers since the murder of three civil rights workers, James Chaney, Andrew Goodman, and Michael Schwerner, by the sheriff in Philadelphia, Mississippi. It was one year since the three bloody marches from Selma to Montgomery and the very same summer that James Meredith was shot during his "March Against Fear" from Memphis to Jackson in support of Black voting rights. Even though the prevailing upbeat number 1 rock song on the car radio that beastly hot August was "Summer in the City" by the Lovin' Spoonful, the reality was that opposition to the Vietnam war along with discrimination against Blacks, women, and gays was the prevailing mood in American cities.

Catching the New Orleans Spirit

I arrived in the Crescent City less than a year after it had been devastated by Hurricane Betsy, and the damage was still very much evident. After moving into an apartment in Mother Cabrini's former schoolhouse on Governor Nicholls in the Vieux Carré, I was immediately swept up and intoxicated by the spirit of the city and, eventually, south Cajun Louisiana. Those cultures were radically different from the environment and lifestyle of the Midwest, where I had been born and raised. I became caught up in the landscape, the food, the music, the architecture, the people, the weather, the ambience. I soon felt the *laissez le bon temps rouler* atmosphere.

After settling in, I began my exploration of all the tasty treats and temptations New Orleans had to offer: the smoky, late-night music clubs (Tipitina's, Jimmy's), dive bars (La Casa de Los Marinos, the Seven Seas, the Acropolis), the gay bars (Café Lafitte in Exile, the Caverns, the Golden Lantern, Pete's, Jewel's Tavern, the Bourbon Pub, and Parade Disco), even bowling alleys that had live music and dancing (Rock 'n' Bowl). And then there was the panoply of restaurants from greasy-spoon diners (Clover Grill, Camellia Grill, Rocky and Carlos) to the large seafood family emporiums built overlooking Lake Pontchartrain

in Bucktown (Bruning's, Fitzgerald's, Sid-Mars, Deanie's Seafood, Maggie and Smitty's) to the temples of haute cuisine (Galatoire's, Antoine's, Brennan's, Commander's Palace). I was drinking it all in and having a wonderful time. Toto, I don't think we're in Indiana anymore.

Around this time, in the late 1960s and early 1970s, there was a movie house, Plaza Art Theatre, on Magazine Street near State Street that offered a vanguard midnight underground cinema series. Offered were new films by young artists such as Stan Brakhage, Bruce Conner, Stan VanDerBeek, and Andy Warhol. A couple of friends and I faithfully attended these trailblazing movies shortly after they had been completed. After the screenings, we headed downtown to La Casa for much dancing and boozing until the wee hours of the morning. Often, I walked home on the deserted streets of the French Quarter as the sun was coming up and the birds were singing their first songs of the day.

My exploration of the haunts was not limited to the city limits. Soon, I was heading out of town each weekend with an undetermined destination to discover the unique, fully developed lifestyles and cultures of the peoples in Texas, on the Mississippi Gulf Coast, and especially south Louisiana. I met and fraternized with the people, each with their own cuisines, listened and danced at their music clubs, drank and smoked their weed. It was a time for me to submerge myself into their lifestyles, get lost, and partake by total immersion of the unique Gulf Coast culture and its *joie de vivre*.

The Delgado and James B. Byrnes

I reported for my first real full-time job at the Delgado Museum on August 26, 1966. Curiously, my first job at the Delgado was a continuation of my last task as the assistant registrar/student intern at the art museum at IU. Jim Byrnes at the Delgado had made arrangements to show the entire art collection of Mr. and Mrs. Frederick M. Stafford, who lived in a town house hotel on Rue de George V in the heart of Paris. This was after they had been "evicted" from the palace they had leased in Neuilly from Aly Kahn and Rita Hayworth's daughter, Prin-

cess Yasmin, when she became of age and wanted to live in her father's grand residence. Fred's wife, Mimi, was the former New Orleanian, Hazel Mueller, and this monumental exhibition to be shown in every Delgado gallery was to be titled *Odyssey of an Art Collector*.[3]

The Stafford collection was encyclopedic, starting with three Cycladic marble figures (the style of one is known as the "Stafford type") to a major polished bronze and marble sculpture of Nancy Cunard, *The Sophisticated Young Lady*, by Constantin Brancusi.[4] Ironically, 24 of the 219 works scheduled to be in the exhibition were loans from the Indiana University Art Museum, a result of Henry Hope's ingenuity and persistence with arranging these gifts from the Staffords years before. While I was at IU's museum, I had prepared all of the loan request forms, arranged the packing of these two dozen ancient Mediterranean terracottas, works from the Near and Far East, ethnographic wood and sculptures from Africa and Oceania, and fourteenth- and fifteenth-century French works and shipped them to New Orleans to be received a couple of months later at the Delgado by their brand new registrar—me!

Those early days at the Delgado were frantic as we received all the loans from Indiana as well as the Staffords' own collection housed in Paris and New York. The Delgado was not prepared to mount such a large and comprehensive exhibition of world art on such short notice. Myriad details had to be attended to simultaneously to reach our November 11 opening deadline: sorting the art into workable categories that outlined the history of art (which this collection remarkably did), researching and writing entries for each piece included for catalog entries and wall labels, having maps made and pieces photographed, plus ALL the galleries in the original Delgado building had to be cleared of the collections on view to make room for this exhibition. Lighted display cases had to be designed and built, mounts for objects improvised, cloth chosen to fabric wood decks and blocks for presentation of objects, track lighting installed, draped walls sewn and mounted, electrical wiring installed for the cases, plus a lavish catalog had to be printed in France and numerous other details. And all this to be accomplished by a staff consisting of the director, two curators, two secretaries, an accountant, a librarian, a sales manager, and five multitask preparators/guards/janitors.

Many late nights became early mornings for the staff during this period. We were all exhausted. One night, I was rigging up lighting, and I accidentally cut through a live wire and got a terrible jolt. Jim Byrnes was annoyed by my clumsiness, and I quickly reminded him I was trained as an art historian not as an electrician! Nerves were on edge. Numerous times, Jimmy's wife, Barbara, was there to help out. She was constantly giving him instructions and advice about how to do this, how to do that. Many were losing their patience with her constant nagging and well-intentioned suggestions. Jimmy was too. Finally, he blurted out, "Barbara, why don't you go get your own museum!" (And she did. She became shortly thereafter the second director of the original Jazz Museum housed in the basement of the Royal Sonesta Hotel on Bourbon Street. Clay Watson was the founding director.)

All the while, the Women's Volunteer Committee was planning a gala event to inaugurate and preview this magnificent exhibition. It would be a black-tie ball with lavish food and dancing with full orchestra. A favorite local caterer, Christopher Blake, was engaged to prepare the food. A month before the event, Blake's business took a downturn, and all his catering equipment was confiscated for nonpayment of bills. What to do?! Chris was so determined to keep his agreement, as it was well advertised, he would be the caterer, and everyone was eagerly anticipating what he would produce. For weeks, he cooked it all in his own small kitchen and froze everything until the big night. He came through with flying colors and was widely hailed for his Herculean effort. Thus, on November 11, 1966, with the glamorous, elegant Mimi and Fred center stage, the black-tie first Odyssey Ball was launched, which netted $14,000 for the museum.

Barbara and Jimmy Byrnes immediately took me under their wings. Jim's quips were memorable and right on. "Complicated bachelors" was a term Jim used to refer to gay men, which I thought was amusing with a certain amount of truth. Shortly upon my arrival in the Big Easy, he counseled me with the thought, "Keep in mind that what Tennessee Williams and William Faulkner did wasn't really art, it was just strict reporting!" At that time, I was invited to a party one evening at the Byrnes' home on Bourbon Street to celebrate Jim's fiftieth birthday party, where

an attractive and stylish artist, Zella Funck, approached me. Wearing a large picture hat and dragging on a cigarette with the alluring air of Tallulah Bankhead or Mae West, she introduced herself and asked who I was. Discovering my recent move, she slowly and deliberately looked me up and down from head to foot and declared in her seductive voice, "You have *GREAT* potential." Toto, I don't think we're in Indiana anymore.

Jim proclaimed, as my boss, he didn't care what I did in New Orleans. What I did in my private time was my business. However, he did have one rule that he strongly urged I obey: the bar La Casa de Los Marinos on Decatur Street was off limits, and I was not allowed to go there as it had the reputation of being a den of iniquity. Well, as you can surmise, that was my signal to go check it out and found it was quite the fun hangout for the young, hip crowd, particularly artists and musicians. (Little did he know there were other places I frequented in the Quarter which had much more checkered reputations). Months after his admonishment, I was at a dinner party at the Byrnes' for the visiting art historian and former director of the J. Paul Getty Museum Paul Wescher and his wife, Mary. Mary commented after eating that she would love to go dancing. Contemplating where to go, I spoke up and said I would take her to La Casa. The Byrnes' eyes popped open at that suggestion. Uh oh, the cat was out of the bag! But I don't think he really cared.

As it happens, I was invited to dinner parties around town. On one occasion, I was asked to bring an hors d'oeuvre. Once, I decided on a homemade chicken liver pâté. I was friendly with Irving Isenberg's elderly mother (he owned the kitchen shop La Cuisine Classique on Royal Street), and so she agreed to show me how to make it from scratch the Old World way. Before the era of Cuisinart, she and I laboriously chopped chicken livers and chicken fat for hours and hours. But the effort was worth it; the finished dish was delicious! Before taking my pâté to my scheduled event that evening, I first stopped by the Byrnes' to give them a sample of my precious delicacy. Tasting it, they were duly impressed, and at one point, Barbara carefully put some on a toast point and extended her hand down and exclaimed to her French poodle, "Here Tutu, would you like some pâté?" All that effort was definitely not meant for Barbara's dog!

During the Byrnes' years, the museum was offered several buildings around the city that could be utilized as satellite museums. Gallier Hall, the old city hall in the Central Business District, was a most attractive location. Another desirable location was the French Quarter, where two buildings became available at different times: the United States Mint and the current Eighth District police station on Royal Street. With the Mint, the Delgado would be situated at both ends of Esplanade Avenue and could provide a shuttle service.

Later under John Bullard's directorship of the New Orleans Museum of Art (NOMA) (the Delgado was renamed in 1971), the old American Can Company, which was being refitted into commercial and residential units, was considered as additional gallery space for the museum's ever-growing collections of photography and self-taught art. Yet another idea was put forth: making the Edgar Stern home, Longue Vue, an adjunct part of NOMA as its Center for Decorative Arts. All in all, feasibility studies were made of each potential site, all in the end without positive results, mainly due again to the lack of funding to adapt these locations as museum facilities and to maintain their existence.

The Byrnes era at the museum had moments that were particularly memorable. I liked to think I rose up through the ranks; however, the problem was there weren't any ranks. Architect Arthur Feitel, a trustee and volunteer "ran" the museum for many years with a long-time secretary/artist Ethel Hutson before the appointment of Alonzo Lansford as the first professional museum director. Feitel lived alone in the Lower Pontalba Apartments, dined every evening at Antoine's, and is well known for his many "USO parties" for the soldiers visiting in New Orleans during World War II. Through his efforts and friendship with Rush Kress, he secured an excellent selection of Italian Renaissance paintings on long-term loan and promised gift from the famed Samuel H. Kress collection.

Upon my arrival in 1966, the institution had only around a dozen individuals on staff. A few of those individuals stood out for me. One guard, Mr. Matherne, was known to leave work at the end of the day and head for the French Quarter, where he often moonlighted starring in pornographic movies. Jim Byrnes' secretary arrived each morning to the

museum and would plunk down her heavy satchel on her deck, revealing the recognizable clink of bottles inside containing her refreshments for the day, and I don't mean iced tea. Another was Connolly Faust, a bright, vivacious young curator whose mother had been Huey Long's "Gal Friday" as he held forth doing the governor's business in his suite at the Roosevelt Hotel.

Perhaps the most memorable person was nighttime janitor Bernard Maniscalco, a quiet hulk of a man with a minimal education, who, upon the approach of Saint Joseph's Day, would unpack his supplies to erect an altar in the Great Hall of the Delgado. This popular tradition has been carried out in private homes and churches throughout the city for many years. Bernard's altar was especially beautiful as a result of his annual telephone call to one of New Orleans's revered patrons of the arts and longtime trustee, Mrs. William Helis. He would request donations for his display, and thereupon she would send copious fruits and Italian pastries and breads with her chauffeur for Bernard's impressive and highly anticipated presentation. Where else does the janitor of an art museum curate an annual exhibition prominently featured in his workplace and underwritten by a wealthy patron?

Third-class refrigeration engineer Marc Brasz resigned his position at the NOMA to become the chairman of the art department at Dominican College across town. When he left Dominican, he headed for the troubled South Bronx in New York City to hook up with his pals the well-known graffiti artists Crash, Daze, and Lady Pink. His artwork was represented by legendary dealer Sidney Janis and was included in a 1980 group exhibition *Fashion Moda* at the New Museum. African American Joe Lewis and Austrian Stephan Eins of *Fashion Moda* cocurated in June 1980 the landmark *Times Square Show* on West Forty-First Street, which at the time was the rage in New York. Through all these connections, a branch was formed in New Orleans, Fashion Moda of the South, with artist Dawn DeDeaux. These were heady times, and I was happy to be hanging out with these subculture dudes and their trendsetting activities.

One of the most bizarre instances to occur during my early days at the Delgado involved the museum's accountant, Edith (last name

deleted to protect the guilty). Each Monday morning, she would spread out the few dollars and coins collected at the museum shop the previous weekend to count for bank deposit. In those days, there was no admission charge. One morning, I entered her office, and eyeing the booty on her desk jokingly said, "Edith, let's skip town and go to Mexico." She laughed and responded, "Oh no Bill, let's wait for the big stuff!" Little did I know how serious she was. Shortly thereafter, office manager Barbara Neiswender noticed the books were not balancing and realized Edith was embezzling funds. When confronted, she denied the accusations. However, the next night, the rear door to the museum was firebombed, and Edith was apprehended by the City Park police at the far end of Roosevelt Mall behind the museum. No formal charges were ever pressed, and she was dismissed and left town.

New Orleans is known as a party town, and the museum's staff duly participated in this activity whenever any proper occasion arose. Jackie Sullivan, who was John Bullard's first "acquisition" for the museum when she was hired as an accountant in 1973, tells a story that speaks volumes. Gladys Landry, a sweet, gentle, grandmotherly woman who tied her gray hair in a bun, lived on Broadway Street uptown, across the street from what is now Lambeth House. As the membership secretary and "librarian," she commuted to work each day via RTA bus. Whenever there was a need for a special celebration such as an upcoming holiday or anniversary, Gladys would carry on the cross town bus the supplies she would need at 4 o'clock that afternoon.

On Jackie's first day reporting to work, at the appointed hour, Gladys cleared her desk and broke out all her needed equipment and proceeded to concoct with much ceremony and anticipation her famous Old-Fashioned cocktail replete with simple syrup, maraschino cherries, and fresh orange slices. Jackie was dumbfounded by such behavior in the workplace during normal office hours and wondered to herself, "Who are these people, and what have I gotten myself into?" What prompted this special party? It was March 1, and it was my birthday!

After establishing myself at the Delgado in New Orleans, I trailblazed by attempting to draft a first-ever art museum curators' code of ethics for the newly formed American Association of Museum Cura-

tors. I was rather naive and had no idea what a quagmire of ethics, traditions, opinion, and attitudes I was getting myself into. However, it was a beginning effort. My old college professor and nemesis Al Elsen got wind of my project and contacted me as he was now a professor at Stanford and collaborating with a law professor there on ethics in museums. He started again to attempt to interfere with what I was doing. While I appreciated his input and told him so, I realized I did not have to "obey" him and was no longer under his sovereignty.

John Bullard

The Bullard era of thirty-seven years at the New Orleans Museum of Art is filled with many triumphs and advancements. Two of the most significant came soon after he became director in 1973. In a sense they quickly defined his career and cemented his reputation. Among the first batch of congratulatory letters he received when appointed was from a gentleman, unknown to the museum at that time, named Victor K. Kiam. His now well-known modern masters and ethnographic art was later bequeathed to the museum.

A couple of years later, through a rather bizarre set of circumstances, Bullard scored another coup for the museum. At the time, the Egyptian government was extremely grateful to a New Orleans engineer for his difficult job of successfully clearing the canal of blocked wreckage and sunken ships after the short-lived Suez War. In essence, his wish was their command. The engineer's request was for their government to allow the exhibition *Treasures of Tutankhamen*, planned to make an American tour, to come to his hometown museum. The idea appealed to the Egyptians for additional unforeseen reasons. Both New Orleans and Cairo were located on great rivers of the world and at the same 90-degree parallel line on world maps. The Egyptians agreed, and consequently, NOMA was by far the smallest of the six major American museums to host this unprecedented blockbuster exhibition, which brought 890,000 visitors to the museum in the four months it was presented here.

The son of a successful swimming pool contractor in Los Angeles, John was a California surfer in his youth before serving as Carter Brown's assistant for special projects at the National Gallery of Art. NOMA was his first and only museum directorship. He was my second boss, and we soon became fast friends. However, John remains today one of the most complex individuals I've ever met: compassionate, loving, generous, ornery, mischievous, audacious, capricious, witty, funny, snobby, bossy, tolerant, and often the life of the party.

As the director, he was a benevolent dictator with his staff and even his board. John was always supportive and encouraged his curators in their work and endeavors. For years, he brought his rescued greyhound dogs to hold court every day in his office. They were fawned over by staff and guests. He had a special skill of knowing how to treat the rich, particularly women who collected art. Muriel Francis, Shirley Kaufmann, and Sunny Norman were his early champions and dear friends; later, Françoise Richardson was his favorite. He relished being in charge and was naturally bossy, especially with people of power and influence. He had a special facility of being able to tame and strike fear into the most difficult bitches and bastards. He had the remarkable patience of Job in dealing with the likes of Clarence John Laughlin and a certain few self-centered, demanding, irritating, pompous trustees and donors. I once asked him how he could endure such unpleasant people. Without any hesitation he responded, "It was easy . . . they had something I wanted!"

His knowledge of art and its history is encyclopedic. I marveled at his capacity to quickly learn and absorb new fields of study. In an amazingly short period of time, he would become a discriminating connoisseur and could stand his own in learned discussions with specialty scholars with his newly acquired knowledge of art history, particularly in the fields of photography, Japanese painting, American studio ceramics, sub-Saharan African art, and American and European decorative arts. He had "a great eye." Without ever seeking recognition for his laborious efforts, as director, he heavily rewrote and edited other people's manuscripts of poor scholarship and writing for NOMA's catalogs when necessary. The original author whose project had been rescued by John was the sole recipient of all the accolades for a magnificent job well done.

John and his partner, Robert Cousins, bought a saltbox style house on Deer Isle in Maine in the 1970s. When he took the job as director, the trustees told him they did not meet during the summer months; therefore, he could take that time for a vacation. He literally took them at their word and consequently spent at least six weeks in Maine each year while director. He became the envy of all other museum directors nationwide as they jealously wondered how he could get away doing that each year. Now in retirement, he has extended his stay to his beloved island home for five months annually. With his rescued dog as traveling companion, he makes the drive from Louisiana to Maine in a marathon drive with one (sometimes two) overnight layovers.

John became the great host when in Maine. He has kept a tradition of welcoming each new houseguest on the first night of their stay with a traditional lobster dinner at home. He relishes keeping his many houseguests (an assortment of trustees, friends, relatives, art dealers, and artists) entertained, whether visits to Stonington, the island's fishing village, or to Blue Hill, the tiny coastal town on the mainland. Of course, one of the main attractions in those communities (and surrounding areas) is frequenting the restaurants, from small diners to posh inns. On the island, the famed Haystack Mountain School of Crafts, with campus designed by architect Edward Larrabee Barnes, is a must see for all visitors, as is a Sunday afternoon concert at Kneisel Hall Chamber Music School in Blue Hill.

Shortly after his retirement, John proclaimed, after many years of having almost continuous houseguests every summer: "NO MORE HOUSEGUESTS, ONLY BLOOD RELATIVES!" I believe this was his way of being able to eliminate a couple of people who expected to be invited each year and then while there were rudely difficult and demanding, trying his patience to the limit. As expected, that rule has been softened after the first few years.

Since retirement, John has become obsessed with collecting American studio pottery from the 1940s through the 1960s. In the manner of mega collectors Joe Hirschhorn and Fred Weisman, rarely does a day pass without him buying yet more pots. Both his houses in New Orleans and Deer Isle are overloaded with his purchases to the point

that navigating through them is highly reminiscent of the treacherous narrow pathways of Bert Hemphill's New York apartment. Recently, one early morning around 2 a.m., I received a text message asking me where I wanted to have our weekly lunch date the following Monday. When I immediately responded, he was flabbergasted. I had just returned from a lengthy dinner party at Dawn DeDeaux's Camp Abundance, and John was at that early hour buying more pots on e-Bay.

Early in 2013, Barbara and Wayne Amedee casually suggested to John that my seventy-fifth birthday was coming up in March, and they should probably think about doing something to celebrate the occasion. By merely putting the bug in his ear, he immediately suggested they do a party . . . and that a committee should be appointed! A committee! Under his leadership, the event quickly mushroomed. Joining him and the Amedees were a bevy of artists, art collectors, and art enthusiasts: Kent and Charlie Davis, Dawn DeDeaux, Mignon Faget, Sharon Litwin, Arthur Roger, Elizabeth Shannon, Stephanie Smither, Jackie Sullivan, and Catherine Tremaine. With that assembled group, it was guaranteed to be a success as they all certainly know how to get things done.

When informed of this impending casual cocktail/buffet barbecue, John asked me if I had any suggestions where it could be held. He hastened to add that it needed to be a large space to accommodate a crowd. Immediately, I responded, "The Marigny Opera House." "Where's that?" he asked. Formerly Holy Trinity Church in the Marigny, this beautiful, old deconsecrated church with high-vaulted ceilings, domed apse, crumbled plaster, and peeling paint had the feel of old Mexico. After John went to inspect and approve it, plans proceeded in earnest.

John gave each member of the committee a task for the evening. Dawn and Elizabeth were put in charge of decorations. A multitude of candles were placed throughout the building and huge palm fronds were lashed to the columns of the former church. A continuous display of photographs surveying my life from childhood was projected across the huge expanse from the choir loft in the rear to the apse.

What an evening! From California to Wisconsin to New York, friends and family flew in for the party. Some came from Houston,

Saint Louis, and Chicago. Even a grade school chum from Lawrenceburg made the trip. Marc Dobriner and a group of musicians played. A few days later, pictures of guests appeared in the Sunday *Times-Picayune*, and Nell Nolan mentioned in her social column my cats as they had appeared with me in the beautiful invitation.[5] Now how many cats get mentioned *by name* on the society page of the newspaper! I now refer to them as my society cats. Eliza was also a calendar girl.

At the time of the 2003 exhibition *What a Wonderful World*, which attempted to recreate my house and collection at the CAC, I wrote an essay on my thoughts about collecting. In that essay, I begin by talk about "my own sense of curiosity, wonder and stimulation about that awesome phenomenon called 'art.'" I conclude that writing,

> A collection invariably is a visual manifestation of the one who created it, and mine is no exception. I have made a conscious effort to surround myself with those things that intrigue and energize me. For this art installation at the Contemporary Arts Center I have tried to suggest and recreate that atmosphere, that ambience.
>
> It is my hope that those who view this exhibition will be provoked to contemplate the aesthetic and humanistic contributions of art to our world. And quite possible the viewer will be inspired to embark on that infectious journey of collecting for themselves. It's fun.[6]

On opening night, John moderated a Charlie Rose–like interview with me in their theater to a standing-room-only crowd. We wanted it to be good fun, so there was a bottle of wine and two glasses on the table between our two overstuffed arm chairs. We had a wonderful time, and the audience did too. At one point, John said to me, "Bill, you have been in New Orleans a number of years before I was appointed director of NOMA."

"Yes, that's true." In an aside, I leaned toward the audience and quipped, "When he arrived, I taught him everything he knows."

John's quick rejoinder to the audience: "Yes, that's true, especially the New Orleans genealogical charts!"

The Vieux Carré Riverfront Expressway, Duncan Plaza, and Son et Lumière

A year or two after moving to New Orleans in 1966, I became aware of a brewing controversy concerning the construction of an elevated expressway above the railroad tracks running along the river from the International Trade Mart building at the foot of Canal Street to Elysian Fields Avenue through the French Quarter. This cockamamie scheme had been dreamed up years before by the "great" urban planner Robert Moses supposedly to relieve the rush-hour traffic from the Central Business District to the suburbs. This is the same "genius" who proposed to bisect Lower Manhattan from the Hudson to the East River with an expressway through Soho. Fortunately, wiser heads prevailed, and that bad idea was scuttled.

The Stern Family Fund retained the services of Bill Borah and Dick Baumbach, authorizing the young attorneys to continue their opposition to the elevated Vieux Carré Riverfront Expressway and to undertake a national effort to change transportation policy—thus opening up federal money to support alternative forms of mass transportation as well as interstate highways. The Stern offices on Royal Street, across the street from the Stern-owned WDSU-TV, was the scene of innumerable meetings of concerned citizens and interest groups opposing the Moses highway. At one gathering it was suggested that everyone there make an effort to talk to civic leaders about opposing this proposal. When I said that I was new to the community and really didn't know anybody, popular TV personality Terry Flettrich immediately responded, "Well, that's a good way for you to meet people!"

Under the leadership of Baumbach and Borah, our renegade group came up with the idea of making large banners that would be hung from the wrought-iron balconies in the Quarter. Taking our queue from one of New Orleans's unofficial mottos "The City that Care Forgot," our banners would read "The City that Forgot to Care." However, we had no place to actually spread out the cloth to paint our signs. Since I had keys to the art museum, we covertly fabricated our banners nightly on the floor of the Great Hall[7] at the Isaac Delgado Museum of Art, some of whose board members were well-known supporters of the Moses

program to construct the Riverfront Expressway. When dozens of these banners appeared on wrought-iron balconies throughout the streets of the Quarter, the message was received loud and clear.

Realizing that the Riverfront Expressway could not be stopped at the local or state level, Baumbach and Borah traveled to the nation's capital to retain the services of a Washington lawyer to represent concerned citizens before the newly created Department of Transportation. After several interviews, Louis Oberdorfer, former assistant attorney general in the Kennedy administration, was chosen to represent aggrieved New Orleanians. To prepare for the April 1967 hearing before Lowell Bridwell, newly appointed federal highway administrator, Oberdorfer requested that highway opponents prepare graphics that would illustrate that the Louisiana Department of Highway renderings of the elevated, six-lane highway in front of Jackson Square were false and misleading.

Following Oberdorfer's marching orders, Baumbach, Borah, and a small core of freeway opponents formulated the idea of documenting the to-be-built roadway with photographs as it would appear from the foot of Andrew Jackson's monument in the center of historic Jackson Square. To accomplish this, our group, which was nicknamed "The Fagaly Gang" (Borah and Baumbach, Lucia Heyerdahl, Nell Nolan, Lynne Farwell, and I me), fabricated in a French Quarter courtyard a very tall pole made up of lashing a number of bamboo poles together and then attaching balloons at the points where the top and the bottom of the proposed expressway would be. We walked this ungainly construction through the Quarter streets to the railroad tracks next to what is now the Moon-walk. Luckily, there were boxcars standing on the tracks. Trespassing, we climbed on top of the train and hoisted our pole into an upright position, so our hired photographer, who was poised to document the scene, could provide for the first time a sense of what this constructed monstrosity might look like piercing the French Quarter skyline.

Following the Bridwell hearing, and a visit to New Orleans by James Braman, assistant secretary in the newly elected Nixon administration, on July 1, 1969, US Secretary of Transportation John Volpe canceled the Vieux Carré Riverfront Expressway, saying it "would have seriously impaired the historic quality of New Orleans's famed French Quarter."

The thirteen-year battle to stop the elevated highway in front of Jackson Square was over. The preservationists had won what has been described as the first segment of the 42,500-mile Interstate Highway System to be canceled for "environmental reasons." The party was on, and highway opponents partied into the night—many nights.

Regrettably, Dick Baumbach died, but Bill Borah went on to be a leading force in the city in his "lifelong dedication to fighting for preservation, for good urban planning, and for better land use policies [to] make New Orleans a better place today."[8] I continued to have high admiration of Bill and was privileged to be his friend. Bill died on September 29, 2017, sixteen days after he attended the dedication of a bronze plaque erected on the riverfront in Woldenberg Park that reads, "Honoring William E. Borah and Richard O. Baumbach, Jr. Whose Leadership in Defeating a Proposed Riverfront Expressway in 1969 Enabled the Opening of the Vieux Carré Waterfront to the Public."

Several years after the Riverfront Expressway incident, then mayor, Moon Landrieu, thought it would be a good idea to build a sound and light show, *Son et Lumière*, recreating for tourists the Battle of New Orleans nightly in Jackson Square. The subterranean conduits were covertly installed beneath the streets surrounding the square, and the crescent shaped amphitheater seating (now the stairs from Decatur Street to the Moonwalk) was designed and built in what is now Artillery Park on the riverside of the square. When questioned about how this show would be seen by the spectators, it was revealed the trees in Jackson Square would have to be cut down! Apparently, little if any thought or sympathy had been given to the New Orleanians who live in the Pontalba Apartments on either side of the square and would have to endure flashing lights and loud booms of simulated cannon fire. However, a group of us preservationists vigorously fought this ill-devised scheme, and it was ultimately abandoned.

Those of us who live in the Quarter feel that politicians and other greedy people have little respect for New Orleans's historic treasure. It is unique, and all efforts should be made to protect it from destruction for personal gain. If not, it will be "killing the goose that laid the golden egg." That fight continues.

Another brilliant idea, this time put forth by Mayor Dutch Morial, sounded great at the outset. In 1979, he gathered a group of art collectors, curators, and city planners and informed us he often looked out his window at city hall down on Duncan Plaza and was unhappy with what he saw. He gave us the charge to find some art to fill this uninteresting space. He emphasized that we had carte blanche in our mission. He wanted something big and bold that could become a symbol for the city and likened his idea to the Saint Louis Arch by Eero Saarinen.

Our committee, the Duncan Plaza Project chaired by art collector Dr. Richard Levy, teamed with the UrbanDesign/Duncan Plaza Committee, enthusiastically accepted his request, and diligently got to work. We received a grant from the National Endowment for the Arts to put out a national call for proposals and to conduct a twenty-four-hour charrette studying artists' submissions. Sol Lewitt, Mary Miss, Martin Puryear, Robert Irwin, and Lloyd Hamrol were the finalists and came to town to defend their projects. I chaired the selection panel, which included Diane Vanderlip, curator of contemporary art at the Denver Art Museum. We were dazzled by all the proposals, but, in the end, Robert Irwin was our final choice.

Los Angeles writer Lawrence Weschler described Irwin's bold plan, which proposed partnering with Audubon Zoo and local landscape architects: "Basically, Irwin proposed a gently angled pyramid, rising above the entire triangular wedge [of the plaza], consisting of compacted, grass-covered earth toward the base and then close-knit metal screening for the upper two-thirds. The base would be landscaped with very formal, French garden–style promenades. The pyramid would be hollow: inside, visitors would find a lush, tropical rainforest and an aviary populated by a dazzling array of birds: flamingos, parrots, hummingbirds, birds of paradise. From the other side of city hall, a pedestrian skyway would vault out from the nearby sports arena, across parking lots and city streets, angling gently downward, piercing the city hall itself at the level of the second floor (just to the side of the mayor's office, which would be visible through a window), emerging from the municipal building and continuing across the street and into the upper

reaches of the aviary, then slowly angling to ground level at the far end of the pyramid."[9]

Our original committee convened with the mayor and proudly announced our final decision. Much to our surprise and anger, Morial was not pleased and unequivocally vetoed it and dismissed the group without an explanation. We had been led down the garden path by the mayor who we suspected expected something on a pedestal. Our many months of volunteer work went down the drain without a proper thank you. Needless to say, Irwin was not happy and we were embarrassed.

Subsequently, the mayor commissioned New Orleans architect Arthur Q. Davis to design the plaza. He constructed a shingle-roofed shelter, in the style of Africa House at Melrose Plantation, that is surrounded by gently rolling grassy knolls and several sculptures by local artists.

Cajun Christmas Eve Bonfires and Courir de Mardi Gras

My friend Syndey Byrd, a photographer, and I often enjoyed attending local annual events unique to the colorful culture of south Louisiana. Particularly fascinating were the lighting of the bonfires on Christmas Eve along the Mississippi River levees in Saint James Parish between New Orleans and Baton Rouge; the Cajun Mardi Gras in small country communities such as Gheens and Church Point; and the Black Hawk evening feasts in New Orleans honoring this rebellious Native American hero who is worshiped by African American spiritualists in their churches.

There is debate concerning the origin of the Christmas Eve bonfires and why the tradition has lasted more than a century. Some say it is a carryover from rural French and German customs of friendship and a successful harvest. Others believe it stems from the lighting of the way for horse-drawn carriages carrying celebrants to church services or visiting neighboring plantation holiday parties. Still others feel it is to light the way for the new Christ Child. The most popular belief, however, is that the fires guided Papa Noel, the Cajun Santa Claus, through the fog on his annual journey down the river.

The building of the structure to be lit on Christmas Eve is begun around Thanksgiving. The traditional fire is constructed by young men of the community into a pyramid or conical tepeelike form from willow logs harvested from nearby marshes. However, in the mid-1980s, the Gramercy Fire Department broke tradition and started fashioning its structures in recognizable sculptural forms such as a Cajun log cabin, a shrimp boat, a vintage fire engine, or a full-scale replica of New Orleans's famous Saint Charles streetcar. To many, the ultimate bonfire occurred one year when a smaller replica of the Louisiana state capitol was set afire to a roaring approval of the assembled crowd. I wrote an article on this on-going tradition with photographs by Syndey for *Folk Art* magazine.[10]

Rural Cajun Mardi Gras, known as Courir de Mardi Gras (Cajun French for "Fat Tuesday Run"), practiced throughout South Louisiana, differs considerably from the urban New Orleans celebration. Each community has its own local variation of the ritual. For instance, in Church Point, Mamou, and a few other neighboring towns, Mardi Gras begins in the early morning with the macho men of the community wearing traditional costumes meeting on horseback and proceeding out of town in pursuit of food offerings from the local farmers during their day-long galloping ride across the countryside jumping fences and, in general, causing terror and havoc. They are followed by two large wagons, one for the gathered foodstuffs, the other for those too inebriated to stay on their horse. In late afternoon, they make a triumphant, heroic reentry into town, standing on their horses and with their gathered loot in the wagon, which is delivered to the women waiting at the community hall for them to prepare a gumbo, which will be served that evening followed by dancing to a live Cajun band.

In Gheens, the ritual is different. A nice little country parade through town in the morning is followed at midday by an outpouring of food served back at the residents' homes, all the while nervously anticipating what will transpire later in the afternoon. After the hearty feast, the town folk reconvene on the major street in town. Tension mounts. Meanwhile, outside at a rural church parking lot, teenage boys have gathered and stand in the back of pickup trucks awaiting their entry

into town, carrying whips to terrorize the assembled. Chaos ensues. There is a demand for individuals to drop to their knees, and, with hands clasped, they plead for forgiveness in French—"Par-don!, par-don!"—to escape a dreaded whipping. The younger children taunt the whippers and run while being pursued up trees, over fences, and across roofs. Bedlam persists until peace is restored.

Black Hawk Feast

The tradition of honoring Black Hawk was brought to New Orleans from Chicago in 1920 by the founder of the faith, a woman named Mother Leafy Anderson, who had African and Native American ancestry. The focus of her church was the spirit of a radical Indian leader who defied white pioneers attempting to settle in his native territory in the 1830s and the federal troops opposing his warlike actions. He is worshipped today and called upon to give protection to ward off any potential or perceived enemies.

Syndey and I attended several of these traditional sacred ceremonies, which are unique to New Orleans. Upon one particular occasion, December 9, 1988, we entered the Israelite Universal Devine Spiritual Church at the corner of 3000 Frenchman Street and Annunciation and were impressed by large folding tables covered with red-and-white-checkered paper tablecloths set up in a cruciform shape in the aisles of the church. In the center of the long table extending the length of the center aisle was a carefully arranged bounty of objects, including glasses filled with parsley, homemade white layer cakes, pumpkin pies, glazed rolls, whole coconuts, bottles of wine, and dishes of hard candies. The head table in the front aisle was laden with the same in addition to three vases of yellow chrysanthemums alternating with bottles of red wine and a glass bowl of apples, oranges, and bananas hiding a half-pint of liquor. Around the perimeter of the cruciform table were individual place settings, each with an apple, an orange, a banana, and a spray of evergreen. Ears of Indian corn with the shucks tied back were interspersed throughout. At the intersection of the tables, a large poly-

chromed plaster figure of Black Hawk with headdress was standing on a raised pedestal. In one hand, he carried a tall spear while the other was raised to his forehead shielding his eyes from sunlight to look in the distance. In front of him were heaps of the same three fruits and three tall burning candles in red, white, and blue glass jars.

With the pews of the large church half full, Archbishop E. J. Johnson in crimson robe and red and purple bishop's cap presided over the evening service. A robed organist played rocking gospel music accompanied by a young boy on drums. A preacher in his twenties dressed in a red robe and black collar chanted, "Black Hawk is a watchman. He is on the wall." The strong smell of a sweet incense filled the air as both clergymen played tambourines and rattles.

"Black Hawk is a beautiful saint."

"He'll take of you a beautiful saint."

"Black Hawk will take you home."

"Let us give Black Hawk honor."

"He rides his horse."

An eighty-three-year-old woman approached the podium and testified: "All you have to do is give him three raps. He is the watchman on the wall." Women in robes and chignons with large cross pendant necklaces around their necks were called up one by one and testified.

"Ask him what you want him to do, but no dirt."

"He will fix things in your house."

"He comes early in the morning and late at night. We thank God for the spirit of Black Hawk."

"He has healing powers; he will protect you."

Women professed to have seen Black Hawk standing in doorways, hearing his heavy footsteps outdoors or in the hallway, or his horses in the attic, or sitting in the back seat of the car with his beautiful white feathers.

"If you don't believe Black Hawk is a watchman, try him sometime."

"No sugar in the tank of her car, Lord. Protect my daughter's car from putting sugar in the tank."

When someone testified that Indians are on the street in the spirit world, the archbishop responded, "That's alright, God is in the blessing business." Then he reminded the parishioners, "Black Hawk, Black

Hawk, Black Hawk, but don't forget Jesus, He comes first." Then he invited the few white people in attendance to come forward and testify, but no one accepted his offer.

The female Bishop Dixon spoke, followed by Archbishop Johnson, followed by an offering collection of a donation of $5.00 for the candles (ordinarily $3.00 during the week). Next, the people in attendance filed to the altar for the archbishop's prayer "Somebody Touch Me."

"Black Hawk is one of many colors."

"He'll watch your house for you."

"Lord is in the warning business."

As the service concluded, everyone attending was invited to take the food and spirits on the tables. In addition, each person was instructed to take a brown paper bag containing the apple, orange, and banana at each place setting. As the people filed outside, they were handed a covered Styrofoam container heaped with red beans and rice, dirty rice, French bread, and a half ear of corn. Two paper cups, one with fruit punch and the other with banana pudding with Nilla wafers, were given to each parting guest.

The Contemporary Arts Center

Traditionally, the art season sharply winds down during the summer months in most cities, and New Orleans is no exception. Previews of new art exhibitions at art institutions and commercial galleries become a rare occurrence. The whole social season in general slows during the hot, steamy months. After a while, people become restless and bored and are looking for something to do, someplace to go. Such was the case in the summer of 1976, when the New Orleans art world was invited to a gathering on an otherwise quiet Saturday evening June 19th in the studio of Robert Tannen and Jim Lalande on the corner of Chartres and Franklin Avenue in the Faubourg Marigny. An overflow crowd of artists, collectors, dealers, curators, critics, and anyone else who was interested jammed into the cavernous, un-air-conditioned space and flowed out onto the streets. As usual, there were the hangers-on who were look-

ing for a place that might serve a free drink or where they might meet someone new and attractive for the evening. It was an overwhelming success, just what everyone was looking for on a hot Saturday evening. It was a memorable gathering.

Some of us commented that night on how many people there were who had been drawn together for a contemporary art event here in New Orleans. There was a definite awareness and buzz in the air that there was an audience and thirst for contemporary art. I was aware of that as I, filling in the void of a curator of contemporary art at NOMA, could not begin to satisfy all those demands made upon our museum. NOMA is a general art museum focusing on the whole history of world art, not just contemporary.

Early the next week, Luba Glade, a former pioneering art dealer championing contemporary art and the current art critic for the evening *States-Item* newspaper, reported on that special evening and made a strong pitch that there was a need for an institution that could focus on not only the local contemporary art but national and international as well. That evening plus her article definitely struck a chord with a number of people. A flurry of telephone conversations later, a small group of interested parties met to discuss this profound notion of an ongoing space suggested by the newspaper critic. An unpredictable group—lawyer Harry Zimmerman, director of the Historic New Orleans Collection Stanton "Buddy" Frazier, TV journalist Jeanne Nathan, artist and urban planner Robert Tannen, *Times-Picayune* editor Jim Amoss, artist Dawn Dedeaux, *Times-Picayune Lagniappe* editor Jeannette Gottlieb Hardy, writer Chappy Hardy, and I—met at the Glade's house on Dufossat Street in the Uptown area. It was curious that there were many more media people than art people in attendance.

After that first gathering there, we agreed to get together again to further develop the ideas brought forth that night. While we all had a common interest and goal in mind, those numerous early meetings sometimes became contentious. One of the overriding issues was whether this new institution should be a facility for the visual arts only with no permanent collection—a *kunsthalle* model similar to the Contemporary Art Museum in Houston—a contemporary museum with

a permanent collection or an all-encompassing center for all the arts, visual and performing arts (theatre, music, dance, film).

What it ultimately boiled down to was a heated debate between Luba Glade and Jeanne Nathan, respectively representing *all* the arts versus just the visual arts. I was supportive of the latter. Those two women were at loggerheads, and the group was at an impasse. Behind the scenes was Sunny Norman, a prominent local art collector, who didn't attend the meetings but was taking an active interest in the progress of these get-togethers. To help break the stalemate, Sunny, who sided with Luba, and I, who agreed with Jeanne, the two of us would negotiate on the telephone in the evenings to see if we could find some common ground. Finally, it was conceded that all the arts were to be included, and the institution would be called the Contemporary Arts Center rather than the Contemporary Art Center.

But where was this new institution going to be? Again, Luba to the forefront. With her characteristic chutzpah, she went to see her old friend of many years Sydney Besthoff and asked if we could use his vacant K&B warehouse on the corner of Camp and Saint Joseph Streets. He agreed, and over night we had a home! With that achieved, we decided to stage an inaugural event in Sydney's building. It would be a collaboration, inviting anyone who wanted to participate in an exhibition centered around the theme of communication and transportation. Tannen did an installation based on the security Plexiglas walls with turnstile trays installed in his neighborhood convenience store; Dawn DeDeaux did a piece based on then-popular CB radios in eighteen-wheel trucks; I arranged for us to borrow Fats Domino's pink Cadillac with gold bumpers and accessories. We also got large Peterbilt truck cabs and local tattoo artists to participate.

But we didn't have any money to get things started. Our other Jewish mother besides Luba was Sunny, who stepped up to the plate and offered us $500 as seed money to buy postage stamps and other office supplies, so we could give birth to our new baby, the CAC. To my mind, Luba and Sunny are the true original founders and should be honored because of their encouragement and determination, with a healthy nod to Sydney for providing us a home. Jeanne and Bob were at the forefront of those who worked ceaselessly to make the dream a reality. It could not and would not have happened without all of them.

In his remarks in the printed brochure in conjunction with my art installation *What a Wonderful World* at the CAC in 2003, executive director Jay Weigel wrote, "Bill is a founder. Bill was one of the original group of individuals who conceived and gave birth to the CAC. He was in the thick of it all—discussing (to put it mildly) what should and shouldn't be included in this institution."[11] It amuses me (and annoys me at the same time) that today everyone claims to be one of founders of the CAC. Amy Mackie, the former curator of visual art at the CAC said shortly after arriving in the city that she was going to print a T-shirt proclaiming "I was a Founder of the CAC" as she knew she could make a fortune!

The beginning of the Contemporary Arts Center was a true community effort, a coalition of many dedicated persons both in the art world and other civic leaders. As with anything worth doing, it did not come easy or overnight. Those involved were willing to give their time and energy, their talent, their money, and even their property for a cause whose time had come. It was certainly a moment in the history of the city, and little did many of us know at the time how important this new art center would become to so many.

One the CAC's early activities was the formation of its own Mardi Gras organization, the Krewe of Clones. Formed by a small group of artists led by Denise Vallon, this motley group's intent was to mock the more traditional Uptown krewes each year by selecting as outrageous, sacrilegious, bawdy, and scandalous a theme as possible, a precursor to the later Krewe du Vieux and Krewe of Chaos. One year's theme, Art Disasters, inspired NOMA's staff to participate in the Clones parade through the CBD and Warehouse District as "Van Gogh's Ear." Each of us wore a large ear sculpted of foam rubber sheets and led by our director John Bullard as the artist himself with a bloody, bandaged head.

First Southern Rim Conference

The invitation began, "As 'art conferences' go, the Southern Rim adventure is definitely a non-conference. There are no concomitant obligations to showing up, no non-refundable fees, no mandatory showing of

slides, no guest speakers. You're only to bring whatever you need and prepare to contribute whatever you think timely and appropriate."[12]

In the fall of 1976, Mississippi-born North Carolina artist and professor Bill Dunlap, as official coordinator and host of Southern Rim, brought in art historians Jane Livingston, at the Corcoran Gallery of Art in Washington, DC, and Marcia Tucker, (soon to be fired by Tom Armstrong at the Whitney Museum of American Art and to move on to found the New Museum in New York), to lead a three-day meeting at the somewhat Spartan environs of Camp Broadstone, a former boys camp owned by Appalachian State University in Valle Crucis in the Blue Ridge mountains of western North Carolina, not far from Boone.

As Livingston proposed, "The idea of this three-day conference is to bring together a number of artists, all of whom are either presently living in the South and making important art; or are from the South, have close ties there, and make their work in and about the South."[13] That all sounded reasonably good and had the prospect of stimulating thought-provoking conversations with an agreement of tangible conclusions.

Among the impressive list of attendees who showed up were, in addition to Dunlap, Livingston, Tucker, and me, James Surls and "his woman," Charmaine Locke; John Alexander; Terry Allen; James Hill; Jim Roche and Alexa Kleinbard; Bill Christenberry; William Eggelston with Warhol Superstar Viva O'Dare in tow; Ed McGowin; Nate Shiner; North Carolinians Larry Edwards and Jerry Noe; and Houston's Contemporary Art Museum's fledgling young curator, Paul Schimmel.

There definitely was an immediate and prevalent "good ol' boys" subcurrent to this gathering, beginning once the Piedmont Airlines plane touched down at the Hickory airport, and we were whisked away to our first stop at a country roadside tavern in the wooded mountains for an afternoon brew. A popular neighborhood watering hole, the bar had been sponsoring a "ham shoot" consisting of a crudely cut out gray cardboard wheel divided by several dozen pie-shaped wedges drawn in ballpoint pen and mounted prominently on the wall behind the bar. To participate in this game of chance, you paid a dollar to sign your name to a wedge. After weeks of participants adding the names, all the wedges had been claimed except one. Even though I'm personally not into gambling, I was

strongly encouraged to pay a dollar and sign the last available slot, which I reluctantly did. After all, it was Sunday afternoon, and the locals were getting anxious to conclude this prevailing contest. The wheel, now fully loaded with signatures, was taken outside and with great ceremony and anticipation; someone shot their gun at the target. BANG! Who won? Looking closely at the target nailed to a fence post, the name "Fagaly" was announced! "Who's that?" the locals wondered. I sheepishly revealed to them it was me, and they were not happy campers. How dare some "furiner" come in and steal their frozen ham! At first, I had no idea what I would do with this prize. Then my fellow conferees agreed we should take it to our abandoned boy's camp site and cook it for one our evening meals.

This rendezvous turned out to be less than idyllic. Miserably cold and rainy that entire late October weekend, we were assigned to sleep in barrackslike dormitories. It was not a pretty picture. The participants huddled in the dining hall to bullshit and reminisce about many clichés of the South: kudzu, the Klan, chickens, snakes, the Civil War, Blacks, religion, death, food, Faulkner, rural life, guilt, all the while ingesting vast quantities of Dixie beer, Jack Daniels, pot, and other drugs of choice. One trait of the South that quickly became evident was Southerners' penchant for bull shittin', telling outrageous tall tales, which took on the traits of a competition. In the end, nothing definitive was agreed upon and no conclusions made.

One of the most memorable moments for me and others occurred during a late-afternoon break from the rambling discussions as the group gathered around one of the long dining-hall tables to view a new body of process color prints by William Eggelston, which he was show-ing publicly for the first time. There was much excitement to see what he had recently produced. As we all hovered closely around the table to see the unveiling of these prints that Bill ceremoniously spread out for all to see, Jane accidentally spilled her drink (I say it was a bottle of beer; she says a glass of bourbon) on these mint-condition prints! Everyone was horrified, and Jane, mortified. What an awkward moment. Surprisingly, Bill took the incident quite well under the circumstances.

While a lot of good times were had fraternizing with old and new friends, the gathering amounted to no more than just a lot of hot air and

grandstanding. Even today, the mention of its name makes the partici-
pants' eyes roll with mixed emotions of mirth and agony. It has become
known as Camp Death. There was a second follow-up conference in
Birmingham in 1983. I did not attend. The most positive memorable
experience during these inclement days was being entertained several
evenings by Terry Allen, who sang and played his guitar to an appreci-
ated audience of old and new friends crowded around a warming fire in
the fireplace.

Sometimes It Isn't Easy Being a Curator

During my tenure, I was subjected to a lie-detector test at the NOPD
headquarters when an African gold work of art disappeared from the
gallery; was refused admittance into Turner Catledge's home, the retired
editor of the *New York Times*, even when I had an appointment, as his
wife, Abby, thought I was a burglar (well I *did* have a beard); had a seri-
ous bout of mononucleosis while spending many days drinking beer and
watching baseball games with Charles Henderson at his house while
attempting to do research on the museum's second catalog of their col-
lection; was the curator and author (by default) of the first museum
catalog of the Matilda Geddings Gray collection of works by Peter Carl
Fabergé even though my training and specialty were African art; cleaned
up a highly odoriferous preborn nutria fetus thrown by a disgruntled
visitor into the crowded gallery during a Triennial preview; and vacu-
umed the gallery carpets and cleaned the Plexiglas vitrines twice a week
at six o'clock in the morning for four long months during the run of the
Tutankhamen exhibition, to name a few experiences.

My Discovery of the Little-Known World of Self-Taught Contemporary Art

Sister Gertrude Morgan and E. Lorenz "Larry" Borenstein

Shortly after arriving in New Orleans in 1966, I made the acquaintance of E. Lorenz Borenstein. He was the founder of Preservation Hall and a pre-Columbian dealer in the French Quarter, mainly offering terracotta sculpture from Western Mexico. He had an unorthodox look and took pride in his unique image: corpulent, slovenly, with a tiny Hitlerlike black mustache and wearing black trousers and black T-shirts. I was drawn to him because of the music at "the Hall" and the ethnographic art he sold in his gallery. He prided himself as the renegade and representative of the antiestablishment. We became friends in spite of his constant needling me, who to him represented the establishment because of my association with the museum. His taunts fell like water off a duck's back.

Each year, Larry would throw an all-day party on Mardi Gras. He sent out invitations with a gate key to the lock wherever the event was taking place, usually on the second floor with balcony overlooking Bourbon or Royal Street. He owned numerous buildings in the Quarter, so he had many locations from which to choose. On Ash Wednesday, the day following, he simply had the lock changed, and all our keys were nonfunctional. For several years, I was foolish enough to have an open house on Mardi Gras. I would lose total control with maskers coming in off the French Quarter streets.

Larry opened Preservation Hall in 1961 and, then a short time later, hired a young, recent graduate from the Wharton School of Business,

Allan Jaffe, as the Hall's business manager who eventually became co-owner of the Hall with Larry. On Mardi Gras Day, Allan would drop in on friends in the neighborhood with Harold Dejan and his Olympia Brass Band to play a miniconcert, often with New York photographer Lee Friedlander in tow. I was honored and privileged to be included! As was the case so often, Lee documented the scene photographing the place, the ambience, the experience.

In 1969, the contents of the historic Melrose Plantation House and the adjacent support buildings on its grounds, all located south of the city of Natchitoches in mid-state Louisiana, were being put up for auction. This historic event drew a wide variety of prominent historians, dealers, collectors, and museum curators from all over the country. *Tout* New Orleans interested in history and art was there en masse. To accommodate the large crowds, the bidding was conducted on the expansive lawn in the blazing Louisiana, July sun unprotected by the shade of any trees. We stood for hours sweltering in the unrelenting heat exacerbated by oppressive humidity.

In my youthful days, I could easily accommodate wearing a sleeveless tank top shirt to cope with the heat on such taxing occasions. Besides, it also was considered somewhat of a fashion statement for young men at the time. I was comfortable wearing it. However, little did I know that my sentiments were not shared by all those attending. After a while, Larry came up to me and admonished me, reporting to me that everyone was talking about my brazen, uncouth appearance as a representative of the New Orleans museum, and he was clearly jealous. His own slovenly appearance usually was what everyone normally would be talking about. I politely, but firmly, responded that he should tell all those who were offended by my nonregulation uniform that I was not representing the museum that weekend. I was representing myself!

Larry was a risk taker and, as such, decided he would try his hand at selling African art. After all, it was just another kind of ethnographic art. He had received a shipment and asked me if I would help him identify it. I agreed but was not expecting him to call *early* New Year's morning to come to his gallery to assist him. Having spent a celebratory evening the night before which stretched until the a.m., I reluctantly got out of

bed to accommodate my friend and went to meet him and vet a carload of crap. Toward the end of a long morning, I saw a group of Ashanti goldweights and admired them. When I found one I particularly liked, I asked him how much it would be. He thought a moment and quoted me a price of twenty-five dollars. Now, mind you, I was not charging him for my professional services that bright, new day. Needless to say, I did not buy the goldweight, and it's the only time I was ever offended by Larry.

Over the years, I learned a lot from Larry, not all commendable. By far one of the most important was bringing Sister Gertrude Morgan and her artwork to my attention. As I have outlined in my book on her, Larry can take full responsibility for the public's awareness of her and making her an "art star." In 1973, through his efforts, an exhibition of her work and that of Bruce Brice and Clementine Hunter was arranged at the then-named Museum of American Folk Art in New York. I was appointed curator of *Louisiana Folk Painting* (not a title I chose), wrote the catalog, and worked with their registrar, Bruce Johnson, a bright young man who loved motorcycles. Arrangements for the exhibition were progressing smoothly except for the interference of their director, Joseph Doherty, who was not qualified to run the museum. He was an amateur who didn't know what he was doing. I became increasingly annoyed by his behavior and contacted the museum president, Barbara Johnson, who was the mother of my friend Bruce. She understood what I was telling her, and the upshot resulted in his being fired, much to everyone's pleasure.

The exhibition opened, and Bruce Brice and I went to New York for the opening. It had been arranged that we would be on the *Today* show the next morning, but as it turned out, the program's producers only wanted Bruce. He went on the air, while I watched the interview in the Green Room with Malcolm Muggeridge, the English journalist and satirist who was to appear later on the program. Shortly after the opening, Bruce Johnson was killed in a motorcycle accident. Later, in his memory, I donated to that museum a large whirligig by David Butler that had been in David Driskell's *Two Centuries of Black American Art* exhibition at the Brooklyn Museum.

Larry would regularly go visit Sister Gertrude at her Everlasting Gospel Mission at 5444 North Dorgenois in the Lower Ninth Ward

and often asked if I would like to accompany him. He would take her art supplies, food, and money from his sale of her work and pick up new artwork for him to put in his gallery. Invariably, she would offer to have a prayer service for us on the spot. We read scriptures from the Bible, and she would sing her own original songs. After one of these sessions, Larry and I prepared to leave. As we were walking to the door, Larry gently tapped me on the shoulder and indicated I had failed to make a donation for her services. Understandably remiss, I got out my billfold to find to my shock I only had a high denomination bill. What to do? After a moment's hesitation, I put the bill on her white wooden table and left. When we were safely driving away, Larry exclaimed, "Bill, you are going to be saved for a LONG time!"

On another occasion in the early 1970s, Larry and I had been talking on the phone for a while as we did from time to time. We were getting ready to end our conversation when I inquired about how Sister Gertrude was doing.

"Oh Bill, something terrible has happened!"

"What!?"

"The Lord has told her she is to stop painting!"

"Larry, that is terrible news. The Lord is giving her bad advice."

"Well, it isn't the first time, Bill. He told my people left instead of right, and look where we ended up!"

With this shocking revelation, Larry lost interest in his business venture with Sister. Keeping the mother lode of her best works for himself and Allan, he eventually sold much of his remaining stock in her work along with business records, photographs and other memorabilia to Chicago collector Susann Craig, who I became acquainted with on one of her frequent visits to New Orleans at one of Larry's Fat Tuesday bashes.

I felt that Sister needed to have more exposure in her new home town. In 1988, a small exhibition I did at NOMA only whetted my appetite to do a larger, more comprehensive one. My friend Bob Bishop, director of the then Museum of American Folk Art, located in the old brownstone buildings on West Fifty-Third in New York agreed with me and offered to mount one there. I was thrilled. However, he said he didn't have the funds to do a catalog. After months attempting to raise

the needed funds for a publication, he said he was unfortunately unsuccessful but would let me do the exhibition anyway. I couldn't agree to do that, and he understood. Bob tragically died sometime later, and so did the project.

The Museum of American Folk Art was in the throes of relocating, tearing down the old brownstones and building a brand-new museum on that site designed by the well-known architects Todd Williams and Billie Tsien.[1] Gerald Wertkin, Bob's deputy director, succeeded him as the new director. Shortly after his appointment, he called me and asked if I still wanted to do the Sister Gertrude exhibition. I eagerly responded in the affirmative and voiced my desire to have a catalog. Because of the small scale of her work, I told him that the exhibition had to be in the new building, not their current cavernous hall at Lincoln Square on West Sixty-Sixth Street. He agreed to both requests! I was off and running.

Working with their curator, Brooke Anderson, I began my research in earnest. I was having trouble locating Sister in the Alabama census records. While in Chicago, I was rifling through Susann's newly acquired papers from Larry and came upon a simple yellow piece of paper with the words "Gertrude Williams born in Alabama." Eureka! Morgan was not her birth name as she apparently had married someone named Morgan. Returning to Alabama, I quickly found a record of her birth when she was only two and half months old. Everything fell in place from that point, including records of her marriage to Will Morgan when she was twenty-eight years old.

In doing my research, I came into contact with two individuals, both from Los Angeles, who made my work more interesting and, at the same time, challenging. I enjoyed meeting both of them, but in the end, they really didn't help that much with my research.

The first was a man who was known as Magnificent Montague. During the 1950s and 1960s, he was a very popular DJ on the radio in LA. One of his signature on-air wails was "Burn, Baby, Burn" after hearing a song sung beautifully by a great singer such as Sarah Vaughn.[2] He had visited New Orleans and visited with Sister and acquired a number of her works. He had amassed over the years an important, rare collection of African American historical documents, memorabilia, recordings,

and assorted objects. He was elusive and intermittently helpful, then noncooperative. I finally tracked him down after a lengthy search and arranged a visit with him in Las Vegas, where he had retired and kept his massive collection in a high-security warehouse with everything housed in special Salander acid-free boxes on several aisles of metal shelving. I was impressed by the quantity and quality of the material. In the end, he was unwilling to lend any of his pieces.

The other gentleman was poet Rod McKuen. While visiting New Orleans, he had become aware of Sister's artwork through the Borenstein Gallery, bought quite a few pieces, and visited her at the Everlasting Gospel Mission whenever he was in town. He was so inspired by her and her art that he published a small volume titled *God's Greatest Hits*, entirely illustrated with her paintings accompanied by biblical verses. I visited him and his brother in their lavish, gated mansion in Beverly Hills several times. During the visits, Rod was most cordial and eager to cooperate with me on my quest. However, whenever I was in touch with him later by email, he would not agree to the things I had asked from him. On subsequent visits, I pointed that out to him, and he promised he would not let that happen again, but true to form, he did. Most frustrating! On the last visit, he announced he had just found a package in the house that had been sent to him many years before from Sister Gertrude with her return address, and it had never been opened. Upon opening it, he found a number of art pieces she had given him. In the end, he did not cooperate and lend to the exhibition.

Each year in the fall, the *New York Times* publishes its three art critics' predictions of what they feel will be the most anticipated art exhibitions for the upcoming season in New York. I was flabbergasted when I saw that critic Holland Cotter selected my exhibition and said, "[The exhibition] is almost certain to be wonderful. As a painter she was richly imaginative, as a believer she was enthusiastic and unswerving. Put these two persuasive ingredients together, and you have a powerful, in this case powerfully American art."[3]

When the exhibition was nearly completed, I was told that the chief art critic at the *New York Times*, Michael Kimmelman, would be stopping by to review the show. I was disappointed as he had a reputation

for not liking self-taught art. Also, I was told not to approach him while he was looking at the art. During his tour of the exhibition, he asked to speak to me. How unusual! We had a good time talking about Sister. He was definitely intrigued. The staff said he had never requested to speak to the curator before. The next day, as I was walking on the street in Chelsea, he called my cell phone to check the facts before publishing. Then he read me the review and asked if he had gotten the story straight! When I told people who knew him, they said he never had done that before!

The exhibition opened in late February 2004 in the newly built American Folk Art Museum on West Fifty-Third in New York, next door to the Museum of Modern Art. It was my shining hour. Kimmelman's review was glowing on the front page of the weekend arts section with an illustration of a bright red New Jerusalem with angels overhead radiating the entire "above the fold" of the paper. He began his lengthy article with, "If you wonder what it means to say that art is a calling, don't miss the ethereal '*Tools of Her Ministry: The Art of Sister Gertrude Morgan*' at the American Folk Art Museum" and concluded, "It would be heaven if works like hers were eternally before our eyes. The world not being heaven, this is your opportunity to see them. The day has come, as Sister Morgan might say."[4] As a follow up, he invited me to come back later to New York for a live interview on his Sunday cable TV program.

That isn't the only *Times* coverage Sister's exhibition got. On the Sunday prior to the opening, art writer Tessa DeCarlo gave Sister and her artworks a full page of color illustrations with extended descriptive cut lines.[5] Later in August, while the exhibition was still on view, Hilarie M. Sheets wrote in the *New York Times Book Review*, referring to me, "[He] gives a terrific portrait of this self-taught artist, who looks to us as both endearing and egotistical, a bit spooky and as loud and commanding as her art."[6]

Ms. Sheets's comment about Sister's egotism is corroborated by the solving of the mystery of why Sister painted over her own image in the portrait seated in her booth at the New Orleans Jazz and Heritage Festival in 1973 by Louisiana photographer Harriet Bloom. This

peculiar painted-over photograph was chosen by Rizzoli for the cover of my book *Tools of Her Ministry*. It was only after the book had gone to press that the truth was revealed. The original print disclosed Sister Gertrude preaching and singing and holding a large white conical paper megaphone suspended by cloth and string from the roof of the booth. The megaphone obscured the viewer from seeing her head, face, and upper body. Sister "corrected" that with her hand-painted portrait and even going so far as to paint out the lengthy cloth/string from which the megaphone was hanging.

The *Tools of Her Ministry* exhibition engendered another breakthrough in journalistic art criticism. For the first time, the prestigious *Artforum International* magazine published a review of an exhibition on self-taught art. Jenifer P. Borum wrote, "This retrospective, which featured the paintings, sculpture, writings, and music of New Orleans-based self-taught visionary artist Sister Gertrude Morgan (1900–1980), reflected a recent shift within the hybrid field of folk-outsider art from the market-driven sensationalism toward critical self-awareness and increased curatorial accountability . . . This exhibition refrains from discrediting Morgan's claim or laughing it off with patronizing disclaimers but rather honors her as a consummate mystic."[7]

One aspect of the exhibition I was particularly proud of was the inclusion of a short film on the artist produced by the multi-Emmy-award-winning director Gail Levin. Commissioned by the museum, she interviewed a number of persons who knew Sister and showed locales where she worked and lived, including the house at 5444 North Dorgenois Street.

While I was pleased it was the second exhibition in their new building, I soon realized it was not the easiest space to work in. Galleries seemed to get second consideration over the architectural features of a grand staircase surrounded by hallways that served as gallery space and a few small rooms for mounting art.[8] After the opening, it was apparent to me that many people passed by the museum without realizing it was there. At my suggestion, the museum installed speakers on the front facade of the building that played Sister's *Lets Make a Record*. Now the New Orleans street preacher was holding forth on the streets in mid-Manhattan.

While working on the exhibition for New York, I had a vision that some kind of theatrical production about Sister Gertrude and Larry would work in that city. I had always referred to them as the original odd couple—a rich, Jewish, white male atheist and a poor, Christian, Black female prophetess. What a pair they were. I thought the concept of these two opposites who both in so many ways benefited from and, in a sense, used each other for their own gains had legs.

I approached my friend Vernel Bagneris, who had had much success with his productions *One Mo' Time*, *Jelly's Last Jam*, and *Staggerlee*, all about New Orleans's music culture. I particularly thought he was appropriate as Vernel certainly knew both quite well; Vernel had waited tables at Larry's restaurant Vaucresson Cafe on Bourbon Street, where Larry allowed Sister Gertrude to perform. Vernel took my manuscript for the book and my notes and began working on it. He had a brilliant idea that our friend Odetta, the famed folk singer, would be perfect in the Sister role. When she was in New Orleans, another friend of hers, Reverend Mike Stark, and I had dinner with her at JoAnn Clevenger's Upperline restaurant to discuss Vernel's idea. She was definitely interested and wanted to see what Vernel came up with. Finally, after months of silence, I asked him how he was coming along. He said he was still working on it. Much later, Vernel admitted to me that he just could not do it. When asked what the problem was, he said, "It's just too religious for me!" Even though years have passed, I still dream of something developing from this vision.

There is one note about Sister Gertrude that I felt could not be in my Rizzoli book, *Tools of Her Ministry: The Life and Art of Sister Gertrude Morgan*. From my research, I had come to the conclusion that Sister must have had some kind of autism. She was so directed to her teachings about the Lord and the *Book of Revelation* that one could not carry on a normal conversation with her without her reverting back to religion, sometimes in midsentence. This phenomenon also appears in her writings. I am convinced she incorporated lengthy scriptures in written form simply as a part of her artwork, and she did not refer to the Bible. She just wrote it out from memory. Since so many of her works quoted passages from many parts of the Bible, she must have memorized the

entire book. One other clue that corroborates my contention is that occasionally her text was slightly off from the King James Version that she knew. My contention is that if she had been transcribing directly from the Bible as she read it, why would she have made these errors?

I desperately wanted to include these conclusions in my book, but I knew I would be crucified for having the temerity to make this diagnosis. I knew I was right, so I consulted with my friend John MacGregor, the art historian/psychiatrist who did the pioneering work on Henry Darger, another self-taught artist who it has been speculated may have suffered from some sort of mental illness. He felt as I did and suggested I read about Asperger's syndrome. After reading it I was even more convinced.

While researching Sister Gertrude for the exhibition and the book, I made the shocking discovery that after her funeral at the House of Bultman, a prominent funeral home on Saint Charles Avenue, her internment in Providence Memorial Park in Metairie was unmarked. Wishing to rectify this distressing fact, a small group of Sister's admirers donated money to have a proper brass plaque installed over her grave. In the opening remarks of my introduction and acknowledgments in my book on her, I write:

April 7, 1997, was a beautiful day in New Orleans. Most likely, Sister Gertrude had arranged it with the Lord. At four o'clock on that bright, sunny afternoon in the outskirts of the city, a small service was held dedicating a bronze plaque for Sister Gertrude's unmarked grave in the fenced-off potter's field section of a large cemetery near the airport. The day would have been her ninety-seventh birthday. The Preservation Hall Jazz Band [with leader Ben Jaffe] led the attendees down the road to the gravesite with "Just a Closer Walk with Thee" played as a solemn dirge. Three or four dozen former students and acquaintances, art collectors and dealers, admirers and artists gathered for this service with her friend Rev[erend] Michael Stark officiating. Via a tape recording, Sister sang one of her own compositions, He Wrote the Revelation. This ceremony was a special occasion. The (New Orleans) Times-Picayune newspaper sent a reporter and a photographer to cover the event. Photographer and documentary filmmaker Guy Mendes brought his family from Kentucky. Collector

Robert A. Roth rode the train down from Chicago to attend. A professor of philosophy from a University in Georgia made a point of coming. At the end of the service, in typical jazz funeral tradition, the band broke out in a rousing and festive version of "A Closer Walk," followed by the traditional "When the Saints go Marching In"[9]

Tools of Her Ministry came to NOMA and was the featured exhibition for the museum's annual gala fundraiser Odyssey Ball in November 2004. Sandra and her son Bengy Jaffe offered to do a concert of Preservation Hall Jazz Band greats in the museum's auditorium as the show was winding down. On a Sunday afternoon in January a standing room only audience was treated to a who's who of living jazz musicians: Lucien Barbarin on trombone, Joseph Lastie on drums, Walter Payton on bass, Ricky Monet at the piano, Donald Vappie on banjo, and band leader John Brunious on trumpet. The following Sunday, Lois DeJean's Johnson Extension Gospel Choir brought the exhibition to a close with a rousing performance in the museum's Great Hall.

At the time, I considered the *Tools of Her Ministry* exhibition and catalog another instrument and extension of Sister's evangelical work, and I wrote in the catalog, "May the power of her presence and those teachings continue."[10] In the intervening years, my dreams have been fulfilled more than I ever imagined. In 2005, Philadelphia record producer King Britt created an album, *King Britt Presents: Sister Gertrude Morgan*, utilizing her own record *Let's Make a Record* as a basis with a hip-hop overlay recording.[11] Portions of that album were broadcast in the HBO television show *True Blood* and included in Michael Mann's 2006 film *Miami Vice*. As the marching crowds slowly emerge over the horizon of the Edmund Pettus Bridge in the climactic scene of the 2014 film *Selma*, Sister Gertrude is singing her forceful "New World in My View." New York artist Leslie Dill has created a multifaceted room-size installation based on Sister's writings and teachings. Berkeley student Elaine Yau received her PhD writing her doctoral dissertation on Sister Morgan, while performer Imani Uzuri received her master's degree in African American studies at Columbia University in 2016 with her thesis "'Come in My Room, Come on in the Prayer Room:' Sister Gertrude

Morgan's Subversive Salvation." A gentleman in North Carolina is studying the poetry of Sister Gertrude. One of the chapters of my friend Jason Berry's latest book *City of a Million Dreams: A History of New Orleans at Year 300*, which was published November 2018, is centered around Sister Gertrude. Sister's contributions and teachings continue to live on and inspire. Most recently, I have learned that a full documentary movie on her and her work is in the planning stages, with filming to begin in early 2020. Predating all of this is editor in chief Rosemary Kent's feature article on Morgan in the premier issue of Andy Warhol's Interview magazine in 1973.[12] The power of her presence is here today and will continue into the future.

In 1988, when I organized a smaller exhibition of her work at NOMA, my friend Dr. Kurt A. Gitter and I had several conversations about his interest in diversifying his art collection beyond the best Japanese art, particularly screens and scrolls of the Edo Period. As he was a friend of painter Philip Pearlstein and owned a scrap-metal sculpture by Richard Stankiewicz, he toyed with the idea of contemporary art. However, when he saw my Morgan exhibition, he told me he was enchanted by her work. He responded favorably to it and asked how he could acquire some. Fortuitously, I was aware at that time that Regina Perry had her most impressive collection of Sister Gertrude's work for sale. Regina, who Sister often referred to as her "darling little daughter," had a close relationship with Sister over the years and acted informally as her agent/dealer. I told Kurt he was in luck as Regina's collection was available. As a result, he bought the collection, lock, stock, and barrel. After that, he and his wife, Alice Rae Yelen, were off and running and accumulated a most significant collection while becoming personal friends with many self-taught artists, including Purvis Young, Jimmy Lee Sudduth, and Willie White.

Around the time I was planning the large *Tools of Her Ministry* exhibition at the American Folk Art Museum, I received a request from that institution wanting to borrow Sister's *The Revelation of Saint John the Devine*. Measuring 47 ½ x 83 7/8 inches, this large magnum opus in NOMA's collection was desired for the exhibition *Millennial Dreams: Vision and Prophecy in American Folk Art* which director Gerry Wert-

kin was curating. I told them I was planning on using that magnificent piece for my show, which directly followed Gerry's, and I was extremely reluctant to have it appear in two consecutive shows back to back. They insisted it was badly needed for their earlier show, so I caved in to their wishes and agreed to the loan. Later, I was informed by their registrar to my great horror and disgust that Sister's great work was missing. A massive search was undertaken within the offsite storage facility where it had been delivered. The staff was interrogated thoroughly and the premises completely searched. It clearly had vanished. It was finally concluded that since the oversize crate containing the painting on plastic window shade was too large to fit in the museum's secured bin, the crate was left outside in the hallway next to their secure bin. Storage workers, thinking the crate was empty as it was not in a storage bin, most likely destroyed it.[13]

This magnificent piece had been given to NOMA in 1984 by Maria and Lee Friedlander and was one of the museum's most cherished pieces. It was unique. This gift came along with a whole group of outstanding works by Sister. Lee often spent time working and enjoying the city and friends he came to know here including Sister Gertrude.

Hebert Waide Hemphill Jr.

As *Connoisseur Magazine* so correctly tagged Bert Hemphill on its cover, he was "Mr. Folk Art." Bert literally was a major force in defining this new discipline of American art history with his trailblazing 1974 publication *Twentieth Century American Folk Art and Artists*. His knowledge was encyclopedic and equal to his untiring quest for learning more. He was a founder of the fledgling Museum of American Folk Art and its sole curator in its initial location in a brownstone building on West Fifty-Seventh Street, several doors away from MOMA.

I became a member of a small "subversive" group of odd people interested in this "odd" art, with Bert as our leader at our unofficial club den on his ground-level apartment on East Thirtieth. The first floor was so crammed with art it was an adventure just navigating through a nar-

row path to the tiny staircase leading to his cramped living quarters in the basement, also overflowing with art treasures. Sleeping on a sofa in the corner of his "living room," filled with more art hanging on every inch of wall space and next to the closet-size kitchen, Bert lived his passion of folk art.

Over the years, Bert and I had the pleasure of spending many evenings talking on the telephone in seemingly endless conversations, sharing news and his wealth of knowledge, comparing notes, gossiping and giggling. As the time passed during these marathon phone visits, he would frequently excuse himself for several minutes while I heard the clinking of ice cubes in the distance as he refreshed his drink.

Bert loved nothing better than to go exploring, looking for the next undiscovered master or just revisiting the myriad self-taught artists who knew and loved him. He often stayed at my house when in New Orleans. After exhausting the folk-art scene visiting artists, galleries, and collectors, I was hard put to know how to keep him entertained. Finally, one day I had an idea I thought he would enjoy. First, we went for a ride on the beautifully restored antique carousel in City Park, and then we went to a small traveling circus performing in a tent out in the suburbs. To cap the day off, we got take-out barbecue and took it to eat on a picnic bench on Lake Pontchartrain. He had a ball doing things a child would love to do. That was Bert, an adult kid, and I loved being with him.

Phyllis Kind

In the late 60s, when looking through the avalanche of junk mail received daily by the Delgado Museum, I found a simple printed postcard announcing an exhibition of folk art at the Phyllis Kind Gallery in Chicago. Since calling long distance on the telephone was expensive for the museum, and email did not exist, I used the conventional means of communicating at the time by writing the gallery a note, informing them we had some of that kind of art here in Louisiana. A few days later, I received a telephone call from the gallery's director, Phyllis Kind, who was intrigued by my proud declaration. I was astonished when she told

me she would like to come to New Orleans to investigate. I was pleased by her bold decision but, at the same time, a little nervous that my pronouncement would not live up to her expectations. Little did I know that that fateful meeting would result in a lifelong friendship.

Eventually, Phyllis introduced me to other people who were interested in this art which at that time was not recognized by most in the art world. There were only a few of us—Bert Hemphill, Estelle Friedman, Jan and Michael Hall—and it seemed we were a clandestine cult whenever we met, usually in the basement living quarters at Bert's house on East Thirtieth Street in New York. I met other New York dealers offering folk art—Cavin/Morris, Luis Ross, Ricco/Johnson, Epstein/Powell—all of whom introduced me to the work of other artists. They sold me some of my earliest and best acquisitions for what was to become a large collection of American self-taught art. I have remained committed to this wonderful art form from that time onward as it has given me much pleasure and opened many doors to an aesthetic and culture I had not known existed. Self-taught art has led me to meet and become personal friends with wonderful artists as well as collectors and curators with a like interest. However, one of its overriding charms and attractions has been the purity, honesty, simplicity, and many times innocence this art represents. I like to call it "art from the heart."

If Bert Hemphill was "Mr. Folk Art," Phyllis was "Mrs. Folk Art." When I introduced her with that moniker at Intuit's gala benefit honoring her, she loudly protested, "I was never married to Bert!!" In spite of her denial, she was a pioneer in the field of contemporary American self-taught art as we know it today. It's true she was not legally married to Bert, but she certainly was in spirit.

When she finally closed her gallery in New York at the end of July 2009, the gallery issued a press release that succinctly summed up her career.

Phyllis Kind opened her first gallery in Chicago in 1967, initially exhibiting master prints and drawings. At that time a group of young artists were emerging in Chicago who were making personal, complex, narrative statements at a time when critical attention in New York was mainly directed

at "mainstream art." It was this very exciting ground-breaking phenomenon in Chicago that prompted Ms. Kind to become involved with living artists. By 1970, she had established a stable of artists there, many of whom later became known as the Chicago Imagists or The Hairy Who.

By the time Phyllis Kind opened in Soho in 1975, her stable had become finely honed. Early in her career, Ms. Kind developed an interest in contemporary American and European Art Brut. She began using the gallery as a showcase to investigate and promote Outsider Art within the context of the contemporary art dialogue, and it was this investigation that became the core of her concentration. Her gallery was the first to promote such work, including artists such as Martin Ramirez, Adolf Woelfli, Henry Darger, Howard Finster, Joseph Yoakum and Carlo Zinnelli.[14]

The press release concludes with the statement that capsulizes her personal philosophy as an art dealer. "From its inception and throughout its over 40 years, the Phyllis Kind Gallery continually searched for work that was unique and as transformational as possible, with well-crafted and personal elements, Phyllis sought to promote artists, schooled and unschooled, who have developed a personally consistent vocabulary of form that was both complex and wide-ranging. She has always believed in the primary individuality of human creatively which is never without reference to its time."[15]

I am privileged to be able to declare her a friend. She was a pioneer and leader in her field. Among my fond remembrances, I cocurated the exhibition *Preacher Art* with Phyllis in her gallery on Greene Street in Soho.[16] As part of the deal, she was to pay me an honorarium. Remembering the old adage "a bird in hand is worth two in the bush," I decided to ask if I could take my fee in an art trade. She readily agreed, and I now have a wonderful, large Hawkins Bolden.

When the Kohler Art Center Foundation in Wisconsin acquired the site-specific installation of Kenny Hill in Cocadrie in south Louisiana and hired Phyllis to do a monitory appraisal and assessment of the needed restoration, we spent the day surveying this marvelous, largely unknown site. That evening, we watched the razor-thin returns of the presidential election of George W. Bush over Al Gore.

When cleaning out her basement store rooms in preparation for closing the gallery, I received a package with a small wall sculpture and attached note: "I don't know who did this, but it looked like you." I puzzled a moment then realized it was an O. J. Stephenson from North Carolina.

On another occasion, when the Folk Art Society had its annual meeting in New Orleans, I threw a party at my house. As I was not a member of this august group of enthusiasts, it was an opportunity to visit with my attendee friends. Many had never been to my house or hadn't been for some time. I saw Phyllis out of the corner of my eye carefully examining my collection. She had just taken on the estate of the recently deceased J. B. Murry and was then promoting his work. Upon leaving, she whispered in my ear with apparent surprise and a tinge of jealousy, "Bill, you have *very good* J. B.s." I whispered back, "I know, Phyllis."

David Butler

In those days, my discovery of the world of folk art led someone to tell me about an African American man in Patterson in south Louisiana who had filled his yard with his own sculptures. I was intrigued but for some time didn't make the two-and-a-half-hour trip. Located on the Bayou Teche near the Gulf of Mexico and in the heart of Cajun country, Patterson is a small town of a couple of thousand residents with offshore oil, lumber, and sugar cane farming as the main source of the economy in the region. When I finally made the trip, I went to the filling station on the main thoroughfare running through town and asked if they knew this man. When it registered to them whom I was seeking, they informed me since it was the first day of the month (which indeed it was), Mr. David would have just received his monthly pension check, cashed it, and gone to the store to buy candy. They told me I would find him riding his bicycle around the streets distributing his purchased treats for the small children in town. Sure enough, I found him on his bicycle decorated with whirligigs, reflector buttons, and cut-out tin figures and animals. He was a gentle, elderly man wearing a hat

and paint-stained shirt and pants with a kind face and eyes that were wide open with inquisitiveness. His most significant physical features to me were his unusually large and powerful hands, beautiful but not calloused. What a touching sight!

When he finished his monthly distribution, we returned to his house, and I was overwhelmed. It was truly an enchanted garden—a magical fairyland. It took my breath away, and I instantly knew I was in a very special place with a very special person. There were large whirligigs with intricate parts. The mobile wheels became Ferris wheels with movable bucket seats. There were covered lawn benches, shrines, bird feeders, and bird houses, all adorned with painted cut-tin animals and mythic creatures—skunks, birds, rabbits, fish, roosters, camels, elephants with wings, mermaids, and seven-headed monsters. No area of the long, narrow lot from the street to the back fence was untouched, not even the neat vegetable and flower garden in the center of the backyard. These large, painted constructions with moving parts were awkwardly jerking and jangling in the breeze. Makeshift cut-out tin awnings on the windows deflected the Louisiana scorching afternoon sun and depicted such subjects as the Nativity and the Three Wise Men riding camels. In a small wall niche decorated with colored lights near the front door, an altarlike shrine featured a plastic bust of John F. Kennedy, small American flags, and other patriotic emblems. I was to learn this was a changing seasonal display and recognized major holidays and other significant events for the artist.

I was enchanted with David Butler and his art. After the initial meeting and later getting to know each other, we became friends, and our visits were mutually enjoyable. His way of innocent thinking appealed to me. This was at a time when it was popular for one to have a guru, and I quickly decided I could have no better one than David. Even though he was not a worldly individual, he had an honest wisdom, which I admired and learned to pay attention to. On many occasions, his simple statements, observations, or refreshing insight caught me off guard and made me reflect. At times, his cosmic questions gave me pause. For instance, one day, as we were standing in the yard, a small flock of vocal crows flew overhead. He looked up and in the most quizzical

voice quietly said, "I wonder where they're going?" Admittedly, it was an intriguing question. It made one pause. On another occasion during a visit with him in the summer of 1969, I brought up in conversation the recent manned moon landing and what an extraordinary achievement that was. "Oh, that didn't happen!" he exclaimed. When I argued that we all had seen it on television and in the newspapers, he calmly explained that what we saw was made up in a studio here on earth and not on the moon. Hmmm. . . . Yet another time, he explained to me why it was necessary to put salt on the outdoor doorsill to keep "the witches from coming through the key holes and getting in the house." When pressed about his thoughts about this, he was vague and didn't want to discuss it. A bit of voodoo, perhaps.

David was born October 2, 1898, in Saint Mary Parish in the town of Good Hope near Patterson. The eldest of eight children born to Edward Butler, a free-lance carpenter, and his wife who performed religious missionary work in the community and parish, David helped his parents with the daily chores and cared for his five younger brothers and two sisters. As a young boy and man, he spent his free time drawing subjects familiar to his environment—people picking cotton or fishing, shrimp boats, sugar-cane fields—and whittling wooden boats and animals. His adult life was spent working for sawmills in the area performing a variety of jobs such as cutting grass, building roads, shipping lumber on railroad cars, or working a drag line.

I made pilgrimages to David's house every few months. He had no telephone; therefore, I could not call ahead and make arrangements for a visit. I just had to make the long drive and take my chances he would be there. If I couldn't find him outside, I would call out for him, and he would call back from inside, informing me he was resting and that he would be out shortly. And that's what we did. In the course of our conversations, I inquired how he had begun to make art. It seems he was working for a lumber mill logging on the water, fell, and hit his head. From his unclear explanations, I gathered that he was taken to the hospital in Lafayette, where he was given shock treatments. He was forced to retire, and after his wife died, he started making visual items to enjoy when he looked out his kitchen window. When these handmade things

attracted attention in the neighborhood, particularly with the children, he continued working on other sculptures.

David told me he got his ideas for the artwork while lying in his bed. The tin sculptures were cut out by laboriously pounding with a hammer on the head of a hatchet with the dull blade making the cuts. He used old, weathered corrugated tin that he salvaged from discarded roofs. The cut-out pieces were then colored with house paint and sometimes embellished with reflector buttons, plastic trinkets, and twist ties from bread bags from the grocery. He made holes in the attached plastic ornaments by heating a wire over a gas flame of his stove and punching it through by melting the plastic.

On my next trip, I proudly brought some supplies that I thought would be of assistance to him: tin sheets and new tin snips from the hardware store. Fortunately, he knew what he was doing, and I didn't. The new tin was not right; it had to be old tin. And those tin snips, they just wouldn't do. In my naivety, I just hadn't realized that his tools created the cut line he wanted, and the new tools made another kind of edge, which was unacceptable.

However, he did accept eagerly the twist ties and other small trinkets and objects I brought him. Once, I took him an old umbrella handle, thinking he might find some use for it in his artwork. Boy, did he ever know how to create something out of that: the celebrated and much published figurative *Walking Stick* in my collection. Another time, I returned a small whirligig I had acquired from him because I had left it out in the courtyard of my house, and the weather had damaged it. He readily agreed to repair it, and when I returned at a later date and saw his "repairs," it was embellished and had morphed into an even better piece than the original. The wheel of the windmill had been fixed and was now adorned with a smaller windmill piggyback atop the structure of the original—sort of a double-decker whirligig . . . a twofer.

Whenever I visited him, David was fascinated with my Porsche 914 convertible and loved riding in it. I always brought an armload of old name-brand dress shirts, which he loved receiving. I was always pleased to see him wearing them on my subsequent visits.

Naturally, when I first met and became acquainted with David, I wanted to acquire a piece of his art for my collection. When I inquired

if he were willing to sell something, his response was immediate and negative. When I inquired why, he said he didn't have a license to sell. When I explained that was not necessary in order to sell his own art, he still would not acquiesce. However, he told me he would like to give me a piece. While appreciative of his generosity, that gesture on his part was not satisfactory to me. When I suggested I make a monetary donation to him in exchange for his gift, he thought that would be perfectly acceptable. So that's how it was to be. Whenever he "gave" me a piece, I would make a "donation." These transactions between friends were not considered sales but exchanges.

However, over time, David began to complain that people were removing art from his yard. I told him he could refuse to allow pieces to be taken away, but because of his kind, generous nature, he couldn't say "no" to anyone. When I consulted with Wilson Krebs, an attorney in Patterson who knew of David and admired his work, he felt the best solution was to find someone who could act as David's agent. Algertha Wilson, David's niece, who worked in the local school cafeteria, was located, and she agreed to assist.

The plan was when anyone came to David and desired acquiring a piece, he would refer them to Algertha, who would arrange to sell the piece. The attorney and I would be available to her for any possible consultation needed. Legal papers were drawn up to that affect, but David, suspicious of signing anything legal, in the end reluctantly agreed when reassured it was in his best interest. Even though he could write his name, he only signed with an "X." Problem solved, or so we thought. In the future, anyone wishing to acquire an artwork from David would be referred to his niece/agent to negotiate a sale. As time passed, we discovered David would not do his part and refer anyone to Algertha. So nothing changed, and another solution was needed.

David informed me that he made a trip to New Orleans once a year to Charity Hospital for his annual physical. It was necessary for him to take a Greyhound bus from Patterson late at night in order to be at the doctor's office early the next morning. He admitted the trip was not easy, sleeping all night on the bus. When I offered to come get him and take him home again, he refused. I also told him to call me when he was in town, and I would meet him and show him the place where I worked

and hoped to show his work. He did not want to do that either. David was set in his ways and could not be deterred.

In 1975, I wanted to introduce David's art to a much larger audience with a solo exhibition at the New Orleans Museum of Art, which subsequently traveled to the Morgan City Municipal Auditorium in nearby Patterson. To me, this art was important, and I wanted to share my discovery with others. This would be his art's first exposure anywhere outside the confines of his modest fenced-in yard tucked away in rural south Louisiana. However, I was fearful that once I had introduced David's art to the world, the folk-art community would descend upon this simple, unsuspecting individual, and his life would forever be disrupted. At a loss for what to do, I consulted with my good friend and folk-art collector Bert Hemphill and artist and art professor David Driscoll and asked their advice on how I could make provisions to protect David before introducing him publicly. They were sympathetic to my dilemma, but after long discussions about possible scenarios, they could offer no helpful advice for a viable solution.

With some trepidation, I went ahead and put together the exhibition with David's full cooperation. After it opened in early 1976, I received word that the congregation of David's church, the Good Hope Baptist Church in Patterson, was organizing a trip to New Orleans to see the exhibition at the museum. To raise the necessary funds for their rented school bus transportation, the church ladies had put together bake sales and other money-raising events in the community. And in my preparation of their arrival, I contacted my lovely friend Daisy Young. Daisy was the president of the local chapter of Links, Incorporated, an international African American women's service organization. She also was mother of former Atlanta mayor and United States ambassador to the United Nations Andrew Young. I told her about the group from Patterson coming to New Orleans and asked if Links could cohost with the museum a reception upon their arrival. She readily agreed, and on the appointed Saturday morning, when the school bus from Patterson arrived in front of the museum, we were prepared with coffee and pastries.

When our visitors saw David's name printed in large letters on the entrance wall, the enormous blowup black-and-white photographs of him and his yard, a projected video interview of him talking about his

work, and his artwork itself arranged throughout the gallery, they were overwhelmed. "Oh look, there's Mr. David" was heard over and over. Our visitors were so excited to see their beloved neighbor getting the "star treatment" in the big city art museum. In the end, the visit was a huge success for everyone involved except one. It was only David who had declined to make the trip and who refused to accept or show interest in this recognition of his very special talent as a creator of wonderful things. This event was not just about his art but about people's validation of this man's humble unsung contributions to his community. Following the New Orleans showing, the exhibition was presented in Morgan City, but David showed no interest in going to see it there either, even though it was only twenty minutes from his house.

I pursued several avenues to help David ensure that his yard installation would be preserved after he was gone. On David's behalf, I applied for a National Endowment for the Arts' Folk Art Fellowship. I contacted Nick Spitzer, who was the founding director of the Louisiana Folklife Program and Louisiana State Folklorist in Baton Rouge.[17] When I told Nick of my plan and asked if he would write a supporting letter, he became rather combative and said that was not possible as David was not qualified because he was not a folk artist. After a heated debate, he claimed no visual self-taught artist could be considered a folk artist as only makers of baskets, musical instruments, and other assorted crafts were true folk artists.

I was more than disappointed at Nick's reaction and, to me, misguided beliefs. The consequence was David never received a fellowship for whatever reason. Another time, I approached Nick about another concept that was then being seriously discussed: a national park created throughout parts of south Louisiana that would be named after the pirate from that area, Jean Lafitte. This park would have parts not necessarily contiguous to each other, and I thought David's environment would be an excellent candidate for consideration. In that way, his artistic contribution could be preserved and admired for years to come. Alas, the park was created, but David's yard was not included.

My enthusiasm for David and his art led me to tell others about my wonderful discovery. Whenever friends came to visit in New Orleans, I would invariably schedule a trip to David's house and yard. Among

those who had the pleasure of meeting David and seeing his creation through our pilgrimages to Patterson were Roy Sieber, my African art history professor; New York folk art collector Bert Hemphill; and New Orleans art critic Luba Glade. However, a few of my introductions ultimately ended up making problems.

A few years after getting to know David, I met Emily Cyr Bridges, who owned Albania Mansion outside Jeanerette, not too far from Patterson. Little did I know that for some time she had "commissioned" David to turn out work, which she acquired, painted, and then sold. I never knew if or for how much she was paying him. Her meddling and imposing her own hand in his creations was most unacceptable, and when I found out what was going on, I told her in no uncertain terms to "cease and desist." After her death years later, piles of unfinished cutouts by David's hand were found stored in Albania's attic and upon the dispersal of her estate sold at Neal Auction Company in New Orleans.

I also told sculptor John Geldersma about David, and they soon became friends. What was bothersome to me was their "collaborations" and the many two-person exhibitions together which John arranged including spaces in New York. To my mind, David didn't need a collaborator, and his work was being tainted. Even today, those jointly made works are sometimes mistakenly identified as solely by David.

Somewhere along the way, someone expressed to me an interest in buying one of David's most important pieces—his decorated bicycle. When I was asked if it was for sale, I answered emphatically, "No." When I asked David if he would be willing to part with his bike, he responded as I had. Therefore, I told him that he should definitely keep it as long as he wanted and needed it. At the time, there were ongoing discussions in Morgan City about creating a regional museum in their community, and those people organizing that project agreed with me that David's bike would be a wonderful addition to that collection after his death. That was the plan. But it was never realized because unbeknownst to me, John Geldersma bought the bike, put it on the market, and sold it to a New York collector! In summation, the museum in Morgan City never came to pass, and I felt I had long protected that bike from leaving the

area, and I could have acquired it for NOMA but strongly felt it should stay in David's neighborhood.

My worst fears were being realized. David was becoming a victim of the art world. David continued to complain to me about people who were taking things from his yard. There was one couple, "the people up North," who evidently returned numerous times with a truck and hauled away art. He didn't know their names but, when questioned at length by me, said he had an envelope they had sent him containing money. He showed it to me, and I realized that they were major known collectors of self-taught art.

David needed help, and I, from a distance and with a full-time job, was not able to protect this innocent, unsuspecting old man's interests. The possible solution with Algertha had failed from the beginning. Enter Richard Gasperi, an established, reliable art dealer in New Orleans who specialized in the work of self-taught artists. Richard was delighted to take on the responsibility of becoming David's exclusive dealer and would give the situation some stability. David was happy, Richard was pleased, and collectors benefited from this arrangement.

However, problems persisted for David. Miss Lillian, an elderly woman who lived directly behind him, died. She was totally devoted to David and daily prepared hot meals for him for a number of years. With her passing, he was forced at his advanced age to live with a niece, Beverley, in Morgan City, where he could be cared for, but his yard and house were left unguarded. When Richard Gasperi and I made a trip to see him in his new home, we were told he didn't want to see us. We persisted and were finally allowed to meet with him. He was despondent, and when we quizzed him, we discovered that he was virtually being held a prisoner and forced to cut out sculptures that the niece's young sons would sell to raise money to buy "clickems," which we were to learn were joints laced with cocaine. We told him he didn't have to do that and that he should go on strike! And he did just that!

Janice Merritt, another niece and a Morgan City police officer, was eventually put in charge of him, and David's last days were spent at the Saint Mary Guest Home in Morgan City, approximately ten miles from Patterson. Elizabeth Shannon and I visited him there. Before going

to the guest house, we went to where he had created that bewitching environment on Louisiana Avenue, newly renamed Martin Luther King Jr. Avenue. The tall trees were the only recognizable element. Sadly, the front and back yards that he so richly populated with his glorious sculptures were barren, and his small house, which he decorated, was stripped of its painted tin sculptures and had burned down. Janice Merritt and her husband had built a house on the site. While there, I talked to several neighbors who walked by. All spoke lovingly of David. Mr. Monroe, his next-door neighbor, told me David used to give ten- and twenty-dollar bills to children who visited him. Juanita Henderson said that the children affectionately called him "the witch doctor" because he made all the wonderful things for his yard.

Upon our arrival at the nursing home in the early afternoon, Elizabeth and I were told he had taken off his clothes and put on his pajamas and gone to bed for the day. Evidently, this was not an uncommon habit for David. We were sorely disappointed that we could not see him. When we persisted, an attendant allowed me to go back to his room and see if he would receive us. Upon seeing me, he agreed to get up. He was genuinely happy to have visitors, and we all had a good time that day. He reminisced about his sculptures and how he made them, his seven brothers and sisters, and Miss Lillian. I showed him the *Passionate Visions* catalog that our museum had published recently with his sculptures illustrated in color. He was interested in the photo of himself and those of his pieces, but he was not impressed that he was famous and included in that large book. Officer Merritt gave me permission to take pictures of David.

He died quietly in his sleep on May 16, 1997, four months short of his ninety-ninth birthday.

Black Folk Art in America, 1930–1980

All of my introductions to David and his art did not turn out badly. In the mid-1970s, my friends Linda Cathcart, curator at the Albright-Knox Gallery in Buffalo, and Jane Livingston, curator at the Corcoran Gallery of Art in Washington DC were visiting New Orleans at the

same time. As had become my ritual, I took them to Patterson to meet David. They thoroughly enjoyed seeing this folk art, which was foreign to their world of contemporary American art. A few years later, Jane returned with John Beardsley, an art historian and author of numerous books on recent landscape architecture, as they were in the throes of putting together what would be a milestone exhibition *Black Folk Art in America 1930–1980* at the Corcoran. None of the artists featured, including David Butler and Sister Gertrude Morgan, was well known. This exhibition was phenomenal in that it set the stage for self-taught art being introduced and recognized by the contemporary American art world as a rightful art form.

People still talk about the opening of that exhibition in Washington in January 1982. I was there and will never forget that memorable (and miserable) day and night. My plane arrived with a tremendous blizzard in progress at National Airport early in the afternoon on the day of the opening. Upon landing, I took a taxi to the East Building of the National Gallery of Art to spend the afternoon. Thirty minutes after I crossed the Fourteenth Street Bridge from the airport, an Air Florida flight, blinded by the snow, crashed into that very bridge and fell into the Potomac, killing everyone on board. When the National Gallery closed at 5:00 p.m., I gathered my luggage and stepped out into the deep snow that had accumulated and was still falling. There were no taxis to be had; in fact, all traffic throughout the city had come to a standstill. Washington was paralyzed. The only thing to do was trudge with all my belongings up a hill several blocks to the nearest Metro station. Exhausted and finally getting to the loading platform packed with the wall-to-wall rush-hour commuters, we waited and waited crushed together like sardines for the trains, but none came. Then word came that there had been a subway collision with fatalities somewhere else in the system! We were stuck, and there was nothing to do but bide our time. Finally, after an interminable wait, a train came, and we were packed into a car. At last, there was some movement and apparent progress. When I eventually emerged from my underground prison at Dupont Circle, I miraculously was able to hail a cab and went directly to the Corcoran as the scheduled opening was about to begin.

Needless to say, the Corcoran was disorganized as many of the guests and staff for the special preview dinner had not arrived nor, for that matter, had the caterer's truck, as it had run off an icy road into a snow bank. I quickly changed into my party attire in a restroom and rushed to run through the exhibition. David's installation was wonderful, with a forest of his sculptures mounted on a raised platform in a large gallery. Sister Gertrude had an entire room, painted all white, that was devoted exclusively to her work. She had the largest number of pieces of any of the artists in the exhibition.

Many who were to attend the dinner that evening never made it to the museum. However, in a nearby building, a jury panel of the National Endowment for the Arts was reviewing artists' grant applications had to cancel their dinner plans because they had to fill empty seats at the Corocoran.[18] By this time, everyone was "making do" with their scrapped plans, and we "survivors" bonded quickly under the circumstances. At last, we were seated for the planned preview dinner, but under highly modified agenda and formality. I had artists Chuck Close seated on my right and Robert Colescott across the table, both from the NEA panel. Given the upheaval and readjustment of everyone's original plans, we, a motley assemblage at that point, were just glad to be safe and secure in the company of fellow art-world perseverers. In spite of all we had been through that day, we had a wonderfully lively evening together eating and drinking heavily. After dinner, a lot of us went to the Hotel Washington to hang out with the featured folk artists, among them Sam Doyle, Nellie Mae Roe, and Mose Toliver, who had made the trip for this special exhibition. David Butler was not there, and Sister Gertrude had died two years earlier. That memorable evening came to a close with another artist, Son Ford Thomas, playing his guitar for a small impromptu gathering in his hotel room.

That evening marked a milestone event in American art. *Black Folk Art in America* opened the next day and became an instant hit. The *Washington Post* art critic Paul Richards raved, as did John Russell in the *New York Times*. After the Corcoran, the exhibition traveled to many American museums and eventually was reviewed by Robert Hughes, a leading critic at the time, in *Time* magazine. When one of David Butler's

pieces was illustrated in color with his review, I was flabbergasted and ecstatic. Later, I excitedly showed this to David and told him, "Look, one of your sculptures is in color in *Time* magazine!" When I explained that Hughes was considered a noted art critic, and he was writing favorably about his work, David couldn't care less, didn't mean a thing. Even seeing it for himself, he was not impressed or even seemed interested. How could that be? Was it shyness? Embarrassment? It was just the way he was—quiet, not one to let his new notoriety go to his head.

This milestone exhibition is widely considered today almost single-handedly to have launched what I refer to as the modern folk-art movement in the United States. It was the first time the so-called mainstream contemporary art world sat up and took notice and gave serious recognition collectively to the work of self-taught artists in America.

There is one footnote to this whole episode of which I am most proud. Much later, Jane Livingston and I were reminiscing about the events that had transpired. With sincerity and gratitude, she acknowledged to me how my taking her to visit David years before had first given her the idea for doing the Corcoran exhibition. For my part, I can say in all truthfulness that knowing David enriched my life and, I think, made me a better person. He was very special and I learned a lot from my guru.

Episode 5

My Art: My Exhibitions

Changing Times at the Delgado

In 1970, the museum was beginning to embark on an ambitious building project, adding expansions to both sides and to the rear of the original Samuel Marx–designed square box perched on a slight mound a short drive from the entrance to City Park at Beauregard Circle on Bayou Saint John. These would be the first significant alterations to Marx's building "inspired by the Greek [but] sufficiently modified to give a subtropical appearance,"[1] built sixty years earlier.

Our visionary director, Jim Byrnes, wanted to make the ground-breaking ceremony a memorable event besides the usual obligatory dignitaries and politicians wearing hard hats and turning over a shovel of dirt for the cameras. We wanted it to be somehow an art event as well. We decided that it would be appropriate to invite an Earthworks artist, whose work was an integral part of this movement, currently the rage *du jour* in the art world. I located Dennis Oppenheim, and he agreed to come to New Orleans and work with us. Upon his arrival in the city, we showed him where the groundbreaking would be taking place at one side of the Delgado building. He was not impressed or inspired. However, upon his plane's landing at Moisant Field in Kenner, he was awed by the vast cypress marshland his plane had just flown over at low altitude. But that wasn't where we were building additions to the museum! With this impasse, we decided to think about it overnight and try to find a solution the next day.

The next morning, we couldn't locate Dennis and thought perhaps he had just gone out on a toot on Bourbon Street the night before and

would show up later. But he didn't appear all day, and neither did our registrar, John Geldersma, an artist himself. Finally, our suspicions were confirmed when they finally showed up triumphant but wet, exhausted, and covered in mud. Dennis and John had been up since dawn gathering tools and heading out into the marshes just across the chain-link fence into Saint Charles Parish from the west runway at the airport. Sloshing through the water and mud all day, they had rearranged the existing environment without introducing other elements and constructed an earthwork consisting of a large square arrangement of piled-up cypress logs defining an enclosed space devoid of objects, thus creating an open pool of water just off axis from the straight-line pavement of the airport runway. Dennis named this completed work *Concentration Pit (Dedicated to Keith Sonnier)*.

Well, this isn't exactly what Jim Byrnes and I originally had in mind, but we happily accepted the artist's creation. There it was for all those who flew into New Orleans and happened to look out the airplane window to see: a mysterious square pool of water in the natural marsh environment of standing and fallen trees.

Still, we wanted something a little more tangible at the museum and on site. Since Dennis had some extra time before he was scheduled to depart the city, he agreed to do another piece. He asked one of the museum guards to go into the meadow across the street from the museum and simply walk the route he normally executed during his daily routine surveillance of the museum's galleries. It was titled *Energy Displacement*. At that point in Oppenheim's career, he informed me that he predicted the next art movement after Earth Art would be Body Art, for which he was already doing pieces. He considered *Energy Displacement* one of those pieces.

Both of these conceptual pieces exist in the museum's permanent accession records with empty folders labeled 70.32 and 70.33. The museum hired a filmmaker to document the one-time performance in the meadow. For *Concentration Pit*, the work Oppenheim had made in the marsh, officials at the J. Ray McDermott Company in the city donated the services of one of their small planes and the same photographer to fly over the site with the artist and me. It was a beautiful sight

to behold. In retrospect, I'm sure we broke many FAA regulations flying repeatedly over this site directly in the path of larger aircraft using the neighboring runway. But we had accomplished our intended goal of archiving these two important pieces for the future. Or so we thought. I cannot begin to report my frustration and anger when, after repeated requests for this footage, the photographer announced he had lost it all![2] There was nothing, and it was too late to attempt to reconstruct the whole operation that Oppenheim had dutifully executed for us.

However, Oppenheim's pieces became an integral part of another exhibition I did that coincided with the museum's expansion.

Moon Rock and Earthworks

Around the same time of the groundbreaking in early 1970, the Delgado had a most unusual offer from a most unusual source. The federal government's National Aeronautics and Space Administration's Michoud facility in New Orleans, where the large fuel tank for the Apollo manned space flights had been constructed, had been loaned a moon rock brought back by the *Apollo 11* astronauts from their historic first landing there less than a year before. The loan of the "lunar sample" from NASA to the Delgado would be one of the very first public displays of a piece of the earth's moon anywhere in the world. Since the Delgado was a museum dedicated to showing works of art, showing a moon rock had little if any relevance to the mission of our institution. However, the moment was just too great to pass up. With strong reservations concerning the appropriateness, we rationalized that the moon had "belonged to the artist before the scientist," and we should seize the opportunity and have an exhibition of earthworks in association with the rock.

To that end and to make this proposition palatable for the art museum, I hastily put together an exhibition entitled *Moon Rock and Earthworks*. Working with Bill Smollen, Michoud's PR guy, I was given access to the thousands of color negatives taken on all Apollo 7 through Apollo 12 missions, including those taken by Neal Armstrong, Buzz Aldrin, and Michael Collins while circumnavigating the moon and while

on its surface. I spent several days reviewing myriad photo contact sheets, and then Michoud made spectacularly beautiful blowups of the dramatic images I had selected for display at the Delgado.

This "out of the blue" proposal from Michoud was timely as the Earthworks movement was at its height in the art world. We had already engaged Dennis Oppenheim to come to New Orleans to participate in the museum's groundbreaking ceremony. As the offer from NASA was only good for a limited time, I hastily contacted a number of other Earthworks artists and/or their dealers and explained that I needed material for this imminent exhibition. On a moment's notice, the final roster of artists who graciously contributed photo documentation of their site-specific pieces were Dennis Oppenheim with his two commissioned pieces; John Baldessari's boundary line between Mexico and the United States, invisible from ground level but clearly delineated from space; Claes Oldenburg's *Placid Civic Monument* installation in New York's Central Park; Christo's wrapped Australian Coast project; Walter de Maria's *Mile Long Drawing* in the desert; Al Ruppersberg's multiobject *Floor Piece*; Robert Rauschenburg's lithographic suite *Stoned Moon*; Peter Hutchinson's underwater works; Douglas Hueber's *Location Piece #1 New York-Los Angeles*; and Robert Morris's ten lithographs *Earth Projects*. Michael Heizer, Robert Smithson, and Carl André's works were only represented in color slides simultaneously projected with views of the earth and lunar surface from space. To my great regret, there was no time to put together a catalog, let alone a pamphlet of this assemblage of artists for this unique exhibition. The *Times-Picayune* art columnist, Alberta Collier, headed her less-than-favorable "review" or puzzled understanding of Earthworks with the banner headline "A 'Found Object' Is Top Attraction at the Delgado."[3]

Moon Rock and Earthworks was put together at the behest of NASA. The rock was only available for three days in late February 1970, and then it was gone, while the remainder of the exhibition was on view for another month. During the short stay of the rock, thousands of visitors lined up on the sidewalk circling the museum for the extended hours of ten o'clock in the morning until ten in the evening each day. The lines filed in the front door, across the Great Hall where the case holding this

golf-ball sized space rock was prominently positioned, up the grand staircase and around the mezzanine where the Earthworks art was on view, and then down the staircase and out the front door. Single-day attendance records were shattered until another unlikely pairing of two simultaneous exhibitions I curated was presented three years later, the jewels of Peter Carl Fabergé and Salvador Dalí.

New Orleans Collects

A year and half later, Jim Byrnes and I cocurated *New Orleans Collects*, a large exhibition to celebrate the greatly expanded and renamed New Orleans Museum of Art. Jim and I worked diligently to uncover art treasures in our midst and to convince others to part with their beloved pieces for this special occasion. The exhibition really was a smorgasbord of world art from East and West Hemispheres. The painters represented with fine examples of their work included El Greco, Teniers, Courbet, Monet, Caillebotte, Fatin-Latour, Bonnard, Braque, Rouault, Tanguy, Leger, Modigliani, Schmidt-Rottluff, Kirchner, Nolde, Soutine, Ernst, Morandi, Hartley, Calder, Rothko, Rivers, Copley, and many, many more. Sculptors included Picasso, Laurens, Lachaise, Moore, Hepworth, Gabo, Arp, Smith and Segal not to mention the many fine drawings and prints. It was a glorious assembly of first-rate art.

However, much to my distress, most people coming to the museum were only interested in the jeweled works by Dalí and Fabergé. Everything else was just passed by. When Jim was abruptly dismissed, and I was appointed along with the museum's administrator acting codirectors, it fell upon me to take on all the curatorial chores. When the decision had to be made what the featured exhibition for that year's Odyssey Ball would be, I quickly chose to give the public what they seemed to hunger for: jewels by Dalí and Fabergé.

Treasures of Peter Carl Fabergé and Other Master Jewelers/Jewels by Salvador Dalí

Working with the Owen Cheatham Foundation, where the bulk of Dalí's precious stone miniature sculptures were, and Harold and Matilda

Stream, whose foundation possessed one of the largest private collections of Fabergé outside of the Queen's, the 1972 Odyssey Ball opened with the first ever public viewing of the Matilda Geddings Gray Foundation collection of works bought by the elder Matilda and bequeathed to her namesake niece, Matilda. There were three imperial eggs and the famed lilies-of-the-valley basket arrangement.

For security reasons, I devised a special floor plan within the newly built, six-thousand-square-foot Ella West Freeman Galleries. Each of the exhibitions was enclosed in its own specially built smaller gallery within the confines of the much larger space. They were separated by a wide corridor starting at the entrance to the larger EWF Galleries. These dual exhibitions, virtually across the hall from one another, were wildly popular as expected. This configuration also served as an effective device for crowd control. I was very pleased that my earlier *Moon Rock* exhibition and the current jewel show both broke all attendance records for the museum. They were only surpassed when the all-time record-breaking *Treasures of Tutankhamen* came to NOMA five years later.

As a result of this phenomenal popularity, the Streams decided to allow the collection to tour after closing in New Orleans. Another determining factor was the IRS requirement that private foundation collections must be on public view at all times. After being shown at a number of venues for several years, a theft and some damage occurred while on the road in Wisconsin. This unfortunate incident prompted the Streams to offer the precious collection on extended loan to NOMA, where it again was one of the most popular attractions in its own specially designed gallery for many years. Later, their son Spook was given custody, and his wife withdrew the Gray holdings from NOMA to be put on view at Cheekwood in Nashville, where they were then living. At present, the collection is on view in a broad hallway of the Metropolitan Museum of Art in New York, where Spook currently resides down the street on Fifth Avenue.

Shortly after opening the Dalí jewels exhibition, I was in New York, and through arrangements with the people at the Owen Cheatham Foundation, I was invited to have cocktails with Salvador Dalí and his wife, Gala, at the St. Regis bar in New York, their residence whenever they were in the city. The small gathering consisted of the couple from

the foundation and me in a small private room off the main bar. I was astonished to have this legendary figure sitting next to me for an afternoon drink. The most memorable part of that visit was when the imperious maestro became extremely agitated as I was failing to comprehend his answer to my question about his description of his current work. His accent was just too strong. Finally, in exasperation to my ignorance, he took his beautifully silver-knobbed cane and with a dramatic flourish began beating me repeatedly over the head. (As if that would make me understand any better.) I created another dreadful *faux pas* during this otherwise pleasant visit when I was unaware that Gala had entered the room behind me and was the only one who failed to instantly stand up.

I still wonder what art he was currently working on.

Five from Louisiana

During my first years in Louisiana, I made frequent trips south and west of New Orleans to explore the swamps, bayous, and prairies of Cajun country and meet the people and experience their food and unique music. I admired their way of life; they worked hard, and they played hard. Along the way, I met a couple, artists Tina Girouard and Dickie Landry, who were living both in New York City and Cecilia, Louisiana. Dickie played several musical instruments, primarily the saxophone and flute, and was one of the founding members of the Philip Glass Ensemble. Represented by the prestigious dealer Holly Solomon, Tina was a painter, who also was doing performance and installation art and was one of the pioneers of the pattern-and-design movement in vogue in the 1970s New York art world. The two of them were well connected there, and through them, I met a number of their artist friends many of whom were just emerging and struggling to receive some notice and recognition: Susan Rothenberg, Mary Heilmann, Gordon Matta Clark, Jackie Winsor, Keith Sonnier, Laurie Anderson, Lawrence Weiner, Joseph Kosuth, Alan Saret, Phil Glass, as well as neighbor Bill Wegman and his dog, Man Ray. Dickie and Tina often would cook up a gumbo or an étouffée, either at their roadside/storefront building in Cecelia or their loft literally in the shadow of the newly built World Trade Center

in downtown New York. We hung out at Max's Kansas City, attended artist's performances, and partied in studio lofts. In Louisiana, there was even more cooking, eating, dancing, partying. It was a heady time.

Along the way, it occurred to me that Louisiana was well represented in the New York art world but not in Louisiana and thus merited some special attention. Besides Dickie and Tina, there was Keith Sonnier, who was born and raised in Mamou, and Lynda Benglis from Lake Charles. Both the latter two were already making waves in New York, and their careers were well on their way and represented by leading art dealers, Keith by Leo Castelli and Lynda by Paula Cooper. After tossing around the idea of an exhibition focusing on their Bayou State roots, they suggested their celebrated friend Bob Rauschenberg should be included even though he was born in Port Arthur, Texas. He and his family moved to Lafayette while he was a small boy, and he spent his early childhood and teenage years there. When I specifically asked Bob at his New York studio on Lafayette Street (of all places) if he felt comfortable being included, his response was an instant "Absolutely! I *am* from Louisiana." That was good enough for me—he's in. My next stop was an appointment with Bob and Keith's dealer, Leo Castelli, who had moved to 420 West Broadway in Soho. Leo approved my plans and gave his blessing on the venture.

The one missing ingredient was Lynda. When I finally met her in her Baxter Street studio in New York, we hit it off immediately. She took me under her wing, and we went around the city, where she introduced me to her artist friends and her boyfriend, Klaus Kertess, cofounder with Jeff Byers of the now legendary Bykert Gallery in the Upper East Side.

Now with all the artists identified and agreed to execute new work for their first major exhibition back in their home state, I proceeded to get it booked on NOMA's exhibition calendar for January 1977 and to receive a large National Endowment for the Arts grant.

One night in New York, I was having dinner with *Art News* editor Tom Hess, and I was telling him of my plans for the exhibition. I was complaining that I felt the concept of all art exhibition catalogs was predictable, and I wanted to do something different. His response was, "Publish it in the newspaper!" Enthusiastic about this suggestion, I made

an appointment to see Norman Newhouse, local publisher of the *Times-Picayune*, and told him of this unorthodox idea, to which he surprisingly agreed. As a consequence, on the opening weekend, the catalog for *Five from Louisiana* had an edition of 323,000 and was inserted as a rotogravure magazine in the Sunday edition of the daily. Not only did Norman agree to do it without any cost to the museum, but he waved the standard $7,000 insertion fee for a supplement. To this day, I firmly believe that large edition number for an art museum catalog has never been exceeded.

Not being a curator of contemporary art but of African art, when I conceived the exhibition, I decided to ask each of the participating artists to select whom they would prefer to write about them for the catalog. Their selections were, to my mind, most enlightening. Keith Sonnier invited his former university art professor Calvin Harlan; Richard Landry picked his fellow musician Philip Glass; and Tina Girouard named *Avalanche* art-journal editor Liza Baer. Bob Rauschenberg wanted Robert Hughes, who after accepting later backed out claiming, "I have nothing more to say about Bob—I just wrote the cover article about him for *Time* magazine." Needing a writer quickly, I asked Hughes who he would suggest as a substitute, and his immediate answer was Calvin Tompkins. Both Rauschenberg and Tompkins agreed.[4] When I asked Lynda Benglis for her choice, her immediate response was, "I don't want anyone from the art world; I would like someone from the theater." Somewhat taken aback, I gave her three choices, all of whom I knew I could deliver—Truman Capote, Rex Reed or Tennessee Williams. Again, without hesitation, she wanted Tennessee. Her wish was my command.

All the artists cooperated beautifully to produce new works for the exhibition in addition to numerous other existing works which were brought in. Keith built a huge neon and glass sculpture on site, a part of his continuing BA—O—BA series. Another site installation by Sonnier was housed in a large gallery that was walled into two enclosed sections for a live sound installation. Consuming the entire Great Hall of the museum was an onsite collaboration by Lynda with her former profes-

sor at Newcomb College Ida Kohlmeyer. *Louisiana Prop Piece* consisted of oversize papier mâché constructions selected by Lynda and Ida from Blaine Kern's gigantic Algiers warehouse of Mardi Gras parade figures. Prior to that piece's installation, Tina did a four-person performance piece, *Pinwheel*, which was videotaped and shown for the duration of the exhibition. Dickie performed the ninety-minute solo concert *Quadrophonic Delay Suite* in the museum's auditorium.

Bob Rauschenberg made a sixteen-foot-long piece from his Spread series called *Opal Reunion*. It was agreed that, because of its size and fragility, it would be cheaper for me to fly to Florida, pick up the piece in a U-Haul truck, and drive it to New Orleans. Upon arriving in Fort Myers, I called Bob to get directions to his studio/compound on Captiva Island and asked if I could get anything for him at the store before making the trip. "Yeah, pick up two quarts of Jack Daniels."

After my arrival with the Jack in hand, Bob's boyfriend, Bob Peterson, gave me a tour of the huge facility, which consisted of Bob's main studio and home on a sandy white beach. Later, Bob Rauschenberg prepared a midnight grilled shrimp dinner, and I settled in for an overnight stay. But first there was work to be done. Little did I know I would assist until the wee hours of the morning with the two Bobs, his assistants, and fellow guest Texas-born Anne Livet dyeing leotards in many large kettles filled with boiling Rit dye in preparation for an upcoming dance performance collaboration with John Cage and Merce Cunningham in New York.

Back in Louisiana, the after-hours party for *Five from Louisiana* was at the fledgling Contemporary Arts Center in the K&B warehouse on Camp Street. For that occasion, NOMA sponsored one of the first fundraising events for the four-months-old CAC. The public paid five dollars a person to eat Popeye's fried chicken, drink Dixie beer, and dance to the live music of "King of Zydeco" legend Clifton Chenier. It was quite an evening! New York art world luminaries Keith Sonnier, Dickie Landry, Tina Girouard, Lynda Benglis, Joseph Kosuth, Paula Cooper, Holly Solomon, Stanley and Elyse Grinstein, Lisa Baer, Jackie Winsor, Lucy Lippard, and Norman Fischer were all there.

He's the Prettiest: A Tribute to Big Chief Allison "Tootie" Montana's Fifty Years of Mardi Gras Indian Suiting

In the early 1990s, I wanted to do an exhibition at NOMA recognizing the unique phenomenon in New Orleans of African American men making by hand elaborate costumes reminiscent of the traditional nineteenth-century dress of the American Plains Indians. These beautiful costumes, called suits, were traditionally worn on Mardi Gras Day and a couple of other times throughout the year, specifically Saint Joseph's Day evening and Super Sunday. While the definitive history has yet to be researched, documented, and written with authority and veracity, the popular consensus was that the tradition began over one hundred years ago as an acknowledgment by Blacks of Native Americans' helping runaway slaves during the first half of the nineteenth century.

Mardi Gras Indians have had a long history of being ignored, disrespected, and harassed by the City of New Orleans Police Department and city hall itself. This came into focus for me once again after awarding the top award to Larry Bannock, big chief of the Golden Star Hunters, at a street art fair in Kenner, and later in the day upon returning to his booth to chat with the winner and watch him sew, he reminded me that Indians received little or no respect in their own community. I concurred. They had to go outside the city for that. He went so far as to inform me, "Those people at the New Orleans Museum of Art don't even know we exist!" I asked him if he knew who I was. "No." He was somewhat startled upon learning my identity. It was then I became more determined to do something in my capacity as a curator.

This lack of understanding and disrespect was the result of lingering racial tension and ignorance of this very special event only to be found in our city. Instead of being abused, it was an occurrence that should be applauded and celebrated for the singular cultural achievement that it is. What better place than do it than at one of the city's agencies, the New Orleans Museum of Art?

How to accomplish it and in what form were two of the questions lingering on my mind for some time. Factors to consider: there are several dozen individual tribes or gangs as they sometimes refer to themselves at

any given time. Some come together and then disband or disappear for a few years, only to reappear or regroup under a different name and leader. Being competitive among themselves, it would have been difficult to have all tribes agree at the same time to participate in an exhibition together. Just having costumes, or suits as they prefer to call their creations, available from each group for one occasion would have been almost impossible. Another factor to consider: for economy's sake, many disassemble their suits each year to reuse the materials in the next year's creation. It was frustrating for me as the subject was an ever-moving target.

The solution became instantly apparent while I was visiting in 1996 for the first time the preeminent recognized senior leader among the Indian tribes, Big Chief "Tootie" Montana. A lather by profession, he was well known and beloved by all the Uptown and Downtown big chiefs. In our conversations, Tootie proudly announced that he would be suiting for the fiftieth and final time the next year. It would be his crowning achievement (no pun intended). Eureka! I had the solution to my lingering problem. I was confident all Mardi Gras Indian tribes could embrace this recognition, and I wouldn't be criticized for not including other gangs as Tootie was universally accepted as the unofficial chief of the big chiefs. After all, many of the prominent big chiefs currently leading offshoot tribes of Tootie's Yellow Pocahontas included Joe Pete Adams of the Seminole Indians, Larry Bannock of the Golden Star Hunters, Ferdinand Bigard of the Cheyenne Hunters, Monk Boudreaux of the Golden Eagles, "Lil" Walter Cook of the Creole Wild West, Emile "Bo" Dollis of the Wild Magnolias, Lawrence Fletcher and the late Jake Millon of the White Eagles, Victor Harris of the Spirit of Fi-Yi-Yi, Donald Harrison Sr. of the Guardians of the Flame, George Landry (known as Big Chief Jolley) of the Wild Tchoupitoulas, Percy "Chief Pete" Lewis of the Black Eagles, and Charles Taylor of the Yellowjackets. This legendary pantheon of men was keeping this tradition alive and looked to Tootie as their spiritual leader.

I eagerly asked Tootie if he would be interested having an exhibition at the New Orleans Museum of Art celebrating that historic moment in his long, distinguished career. Not known for being modest, he thought it was an excellent idea and would give me permission to go ahead with

the project. But Tootie being Tootie, he did have some specific provisos I must agree to. First, the essay for the catalog must be written by his official biographer, Kalamu ya Salaam. Agreed. Second, the only photographs used in the project must be by his official photographers Chandra McCormick and Keith Calhoun. I had no problem with that either as I had given this husband and wife team their first serious exhibition at NOMA several years earlier. Done deal.

I had firm beliefs why the exhibition should be done at NOMA. First and foremost, at long last, the city, through its city agency, would be giving official recognition to the Indians. Second, the Indians are to my mind among the most original and successful self-taught artists New Orleans has ever produced. Third, I applaud the achievements that Tootie had brought about over the years. When his father ended his own fifty-year tenure as big chief, the prevailing atmosphere among the highly combative tribes was one of confrontation and warring factions on the streets. Weapons and fights made the performances on the streets dangerous and forbidding. Slowly, as years passed, Tootie, through his artistic and tactful skills, was able to turn this competitive aspect from one of danger and aggression to one of beauty and respect. Violence was no longer an accepted element in the equation. And fourth, I feel that in this age, witnessing the dissolution of the nuclear family unit and the everyday use of drugs and violence on the city's streets by today's youth, the institution of Mardi Gras Indians is instilling a positive, constructive alternative for children by making an activity that the whole family can participate in and take pride in.

One of my endearing memories of this experience is showing up at Tootie's house at 1633 North Villere in the Seventh Ward in the evenings of early 1997 to learn how to sew and tip feathers. The Montanas had a double shotgun home, one half serving as living quarters for Tootie and his wife, Joyce, while the other half was used as storerooms for his earlier suits, which were all mounted on makeshift two-by-four-inch wood armatures. Their living and dining room were furnished with modern reproductions of late eighteenth-century French Rococo furniture and figurative porcelains. All available surfaces were covered with bits and pieces of what would later be assembled to become Tootie's suit: the

crown, the collar, the apron, the cuffs, and the boots. The family—son Darryl and his wife, Sabrina; daughter Denise and her husband, Ned; small grandchildren Chance and Chelsi; and at the head, Tootie—was gathered around the dining room table, each laboriously working on the small patch assigned to them, while Joyce, taking a break from her sewing duties, was in the kitchen filling the house with the smell of fried chicken, turnip greens, and fresh baked cornbread, all to be accompanied by a side salad. Of course, later, there was piping hot bread pudding for dessert. It was a collective activity much like a sewing bee or quilting party. The dedication of each was unwavering. There was a mission and a goal to be achieved as the clock ticked down to the final hour before Tootie finally would make his first public appearance on his front porch on Mardi Gras morning resplendent in the finished suit consisting of hundreds of finished parts assembled into a breathtaking work of art.

That is how it was supposed to happen that Mardi Gras in 1997. With a beautiful colored banner, painted by Douglas Redd and donated by the Tambourine and Fan organization, attached to the pillars of the gallery of Tootie's house, a large crowd had assembled in the street that unusually humid February 11th morning waiting for his appearance at the announced 10 o'clock hour. No one was particularly worried when he was late coming out; that was to be expected. The only activity noticeable from our street-side vantage point was an occasional family member or someone else going in and out of the front screen door. People mingled, arrived and went away, and continued to wait. A couple of more hours passed, and still no Tootie sighting. In another part of the city, seemingly worlds away, both Zulu and Rex had paraded down Saint Charles Avenue onto Canal Street for their annual midday processions. We patiently stood on North Villere biding our time. Anticipation mounted. In the early afternoon, Darryl showed up in a pickup truck and unloaded his suit into the other half of the shotgun. Time wore on, and Tootie's audience became restless and concerned. Where was he? Is he all right?

Late in the afternoon, the front door slowly opened, and the Man of the Hour stepped out onto the gallery wearing a stunning white suit with gold accents. It was dazzlingly beautiful with an apron made up

of three-dimensional volutes in a flowering circular pattern, a collar encrusted with tiers of large gold-colored rhinestones and terminating with bejeweled white boots. Among a billow of fluffy white feathers, he took on the appearance of a cloud floating through the congregation of admirers. Someone followed behind carrying an equally splendid crown. But Tootie looked tired and dejected. He didn't smile as his subjects cheered and applauded. Something was wrong. When he was assisted by Fred Johnson and others placing the enormous, heavy crown atop his head, it would not stay in place, and pieces of the complicated structure came loose. It became apparent, only then, that in his rush to complete his final masterpiece working overnight, the weather's humidity had defeated him in the end. The glue would not dry.

But he was determined to continue. So, taking some time for photos, he proceeded to slowly walk down the street with the crown carried by Fred alongside him, followed by a small band of admirers and family. Darkness had set in. In other parts of the city, Mardi Gras was pretty much over, and people were heading home. We stopped to serenade his mother around the corner, a few blocks away. We made our way to Saint Bernard Avenue and then walked up the street turning onto North Villere. When we arrived back at our starting point, the assembled broke out into lengthy singing of the moving Indian prayer "Indian Red." There was not a dry eye among us. For us, Tootie came out victorious, if only a little late.

On July 11, 1997, *He's the Prettiest: A Tribute to Big Chief Allison 'Tootie' Montana's Fifty Years of Mardi Gras Indian Suiting* had its evening preview in the main galleries at the New Orleans Museum of Art. There were more than a dozen of his fine suits on display, representing his excellence in design and craftsmanship, which I attribute, in part, to his skill as a professional lather. He had become known for his pioneering breakthroughs with the three-dimensional innovations taking on the sculptural aspects to his suits rather than the more conventional two-dimensional pictorial multicolor beaded panels of his Uptown fellow tribesmen. The opening was a very festive occasion with Mayor Marc Morial's chief of staff Marlin Gusman and a couple of city council persons in attendance. Tootie wore his favorite patterned lavender shirt, and he was pleased. Joyce was beaming.

Eight years later, there was yet again another ugly confrontation between the New Orleans Police Department and the Indians celebrating on Saint Joseph's evening, March 19, near A. L. Davis Park Uptown at the corner of Washington and Dryades Avenues. Numerous news outlets later reported very similar descriptions of what transpired on what was planned to be a festive evening. "NOPD officers, [spectators] say, drove at high speeds on crowded streets, used foul language, and treated people roughly. One big chief's son, who alleges that he was manhandled by police officers that night, suffered tissue damage in his arm and is facing surgery . . . Among the Indians in the streets were highly respected chiefs who have celebrated St. Joseph's night in their handmade suits for more than 30 years. Old or young, Indians say they were given two choices: 'Take off your fucking feathers or go to jail.'"[5]

Many in the city were horrified that this type of outrageous behavior had happened yet again. On the evening of June 27, the city council convened a special hearing to address this ongoing problem. The council chambers were overflowing with many big chiefs and their gangs, including Tootie and members of his Yellow Pocahontas tribe. The mood was tense. This was not Tootie's first appearance at the podium before the council. As a result of his 1994 protest of police harassment of the Indians, the council declared they would from that day forth officially support Mardi Gras Indians. Once again, eleven years later, with an assembly of other big chiefs standing behind him for support, Tootie gave another lengthy and impassioned lecture to the council members. At one point, his son, Darryl, leaned forward and whispered in Tootie's ear. Then, with his arm upraised and finger pumping to emphasize his point and looking directly at the council members and top police officials, Tootie shouted, "This has got to stop!" At that dramatic moment, he collapsed to the ground, and everyone in the room gasped in horror. Nearby, Joyce called out his name over and over. However, paramedics were not able to save him.

On July 9, the entire city focused on Allison "Tootie" Marcel Montana's solemn funeral at the oldest Black Catholic church in the city, Saint Augustine in the Tremé. The much-loved Reverend LeDoux presided over the three-hour service in the un-air-conditioned sanctuary.

I was honored to be seated with all members of the city council and other dignitaries in the first row. There was a moving singing of "Indian Red." After the Mass, his coffin was placed in a horse-drawn hearse totally surrounded by a protective sea of yellow, red, green, aqua, purple, and orange Indian suits. Captured by TV cameras, a slow procession led by the family, many other gang members, and thousands of mourners wound its way through the city's streets to Hunter's Field on North Claiborne under the I-10 overpass for a chant of "Golden crown, golden crown—Big Chief Tootie's got a golden crown." A cacophony of tambourines, cowbells, beer bottles, and a brass band accompanied the twirling of umbrellas and waving high white handkerchiefs in a traditional Second Line procession to a reception at the Tremé Community Cultural Center on North Villere at Saint Philip. When I later asked Darryl what he had whispered into his dad's ear during his vehement lecture to the city council, he responded, "I said 'Dad, you've got to wrap this up.'"

Tootie Montana's legacy lives on as "the chief of chiefs." It appears that his memorable appearance before the city council that fateful evening may have been the turning point towards a new respect and appreciation of this unique culture in the city. His life and dedication are enduring symbols of this New Orleans tradition. Where else in the world would you find groups of macho, straight, adult African American working-class males spending large sums of money they could not afford to sew seriously every evening at home after a hard days' work at their day jobs? For them, being an Indian is a total commitment and requires their passionate devotion at all costs.

The New Orleans Annual/Biennial/Triennial Series

After my arrival at the Delgado in 1966, one of the first responsibilities Jim Byrnes turned over to me was the Artists Annual, begun in 1886 by the Arts Association of New Orleans. It had gone a number of formats over the years. Beginning in 1967, it became a biennial with its juror Mac Doty, curator at the Whitney Museum of American Art in New York.[6]

That format was changed once again in 1980 to become a triennial. John Bullard was now the director, and our reasoning was that art does not change that much from year to year or even every two years. However, making it a triennial made more of a statement of the condition of contemporary art and also allowed the museum to raise the funding to carry out such a large, expensive venture.

I would apply to the National Endowment for the Arts for a grant to help defray expenses for each iteration of this series. Each time, our grant application was turned down. After a while, I came to the realization that I was using the wrong terminology. For the next application, I used the term "guest curator" instead of "juror" and the phrase "acquisition purchase" instead of "purchase prize." Well, that did the trick, and we were awarded grants for the next exhibitions. Nothing had basically changed except the now accepted wording.

Another major change from a biennial to a triennial was how the artists would be selected. At that time, before computerization, artists submitted slides of their work to be considered by the juror, who made selections, and then the winning and losing artists were notified and preparations begun for the shipping, producing an illustrated catalog with a juror's statement and the other usual processes in mounting and opening an exhibition.

It became clear to me that slides alone were not the perfect way to judge artwork. The juror could benefit greatly from actually visiting the artists' studios. From 1980 forward, this new system was inaugurated. Under this new format, guest curator Marcia Tucker, director of the New Museum in New York, and I were "on the road" together for nearly a week. Naturally, this increased the exhibition's budget greatly since the curator and I as the museum coordinator would travel by car, airplane, truck, and even ferry boat to reach our destinations, which averaged around twenty to twenty-five visits every exhibition cycle.

As arduous as this intense schedule was over the years, the selector and I had a multitude of wonderful and rarely not so wonderful experiences meeting artists and seeing their pieces in the spaces where they actually worked. With that in mind, three visits were most memorable and worth mentioning.

Russ Warren picked Marcia and me up at the Charlotte, North Carolina, airport to drive us to Davidson, North Carolina, a short distance away and where he was a university art professor. He was *so* excited having Marcia in his car and kept up a one-sided conversation nonstop as we were driving along on the interstate. Marcia and I had had a long day and were totally exhausted and wanted to rest. After what seemed an interminable amount of time, all of a sudden, Russ shouted out, "Oh no" as his van whizzed by a highway sign "Welcome to South Carolina." Oh no indeed! Seems he was so preoccupied with talking that he took the wrong turn and went south on the interstate when he should have been heading north. This meant that we had to retrace our mileage to Charlotte before we could begin our northward journey to our final destination. We both slept well that night.

The second memorable studio visit occurred in late 1994. When Dan Cameron, then independent curator based in New York, and I made our studio visits for the *1995 New Orleans Triennial*, we approached Atlanta-based artist Todd Murphy's studio in a cavernous empty warehouse next to deserted railroad tracks. As we entered the dark space, we heard the incredibly beautiful sounds of a large bell tolling with string orchestra; the beginning was pianissimo, which slowly, continually built into a loud crescendo. In this huge space and providing the only light were a number of crystal multibranched chandeliers hung from high above over a group of comfortable overstuffed old sofas. The haunting music continued as we stood and waited for someone to appear. Finally, Todd made an appearance and welcomed us. By the way, the seductive music we had been experiencing, I discovered later, was the enchanting music of the living Estonian composer Arvo Pärt, and the particular piece we heard was *Cantus in Memoriam Benjamin Britten.*

A third memorable studio visit occurred when Charlotta Kotik, guest curator of contemporary art at the Brooklyn Museum, and I went in the spring of 1998 to the space Tim Haley called his studio in New Orleans. After welcoming us, we noticed Haley had prepared a setup with a live television turned on. He reminded us that this Saturday afternoon was the running of the Kentucky Derby, and it would begin shortly. In preparation, he had assembled the necessary ingredients for

mint juleps for us all to enjoy while watching the annual Running of the Roses.

He instructed us that we would be placing our bets on which horses would win, place, and show. The juleps were made, and the race was on, with each of us cheering for our projected winners. Afterward, he presented us with trophies. They weren't roses. They were pieces of horse shit encased in round, poured-plastic amber molds.

I don't recall that we saw any art objects that day, but we knew we had been a part of and witness to a well-thought-out and totally original art performance. He had just gotten into the *1998 New Orleans Triennial*.[7]

In 2000, I was planning on retiring, and the question was who would be selected to curate next year's triennial, the exhibition everyone perennially loved to hate. Many friends told me I should do it myself, but I deferred. After a period of considering it, I came up with an idea I liked. Yes, I would do it with the participation of all the artists in Dan's and Charlotta's 1995 and 1998 exhibitions as cocurators.

This is how it worked. I was in such admiration of the artists Dan and Charlotta had selected in 1995 and 1998 respectively, I decided to ask them all to join me to cocurate the 2001 iteration. I asked each of them to nominate three artists whom they greatly admired. One stipulation was that none of their nominees could have been included in any previous exhibition of this series. Once I received their 111 nominations, I proceeded to ask each of the selected artists to submit their work for my consideration. From that, I made the final selections of who would be included in the *2001 New Orleans Triennial*.

I was extremely pleased with the results. Included in my exhibition were Radcliffe Bailey, Roy Ferdinand, Simon Gunning, Trenton Doyle Hancock, Aaron Parazette, and Gina Phillips, among others. Also included was the collaboration of artist Sharon Jacques and her art students at the New Orleans Center for the Creative Arts high school to work together on the joint project *The Wall Project: The Opening* in which they built a drywall and wood wall barrier, covering it on both sides with wallpaper, and then smashed a hole in the center to reveal the space beyond. The artist Luis Cruz Azaceta, who nominated them, expressed it best in his written statement in the catalog saying that the

project "us[ed] students to break open holes, hammering, pulling, tearing the wall-papered patterns and sheetrock construction—creating a passageway to consciousness to a new space. Free from psychological, physical, domestic, social and political enclosure."[8]

One final thought on that triennial and that performance by Sharon and her NOCCA students. I positioned their piece as the title wall at the entrance for the exhibition. As the students were in the process of hammering a hole in the wall, I asked if I could participate, to which they readily agreed. It was with *great* relish that I purposely destroyed a small portion of the title!

Pierre Joseph Landry: Patriot, Planter, Sculptor

My last exhibition of a self-taught artist at NOMA was the nineteenth-century Louisiana carver Pierre Joseph Landry in 2015, six months before my retirement of fifty years at that institution. It was an exhibition I had dreamed about for more than thirty years after the Kuntz family had given one of his sculptures to NOMA in 1982. When my friend Marc Tullos became director of the Louisiana State Museum, I called to congratulate him and to tell him my wish to do a serious exhibition of Landry. There are only ten known carved wood sculptures by him in the early nineteenth century, and the state museum owns six of them. Mark enthusiastically agreed that our two institutions would cohost the exhibition at NOMA with two of his curators as cocurators. Katherine Burlison, Richard Lewis, and I all contributed essays to the beautiful publication. At the opening, there was an outpouring of Landry families in attendance from around the state.

Building NOMA's African Art Collection

All the while I was involved in Fabergé eggs, a NASA moon rock, Salvador Dalí, a Mardi Gras Indian chief, the biennial/triennial series, and other projects outside my training and expertise, I was also focused on

my primary mission for being there: African art. When I arrived in 1966, there were several credible African pieces in the collection along with a bunch of spears and shields.[9]

My inaugural exhibition at the Delgado that fall was *Odyssey of an Art Collector*, which included a group of outstanding African pieces. It was only after its closing that Fred and Mimi Stafford agreed to leave on extended loan the African pieces, which gave me something of importance to work with. They served as a strong base for me to install a small permanent installation of African art in the galleries.

Two years after my arrival at the museum, the first exhibition of which I was the sole curator was *New Orleans Collects: African Art*. It was an uneven accumulation of locally owned objects, including the featured piece on the cover, which was later discovered to be a fake! It was most encouraging that Jim Byrnes allowed me to do the exhibition at a time when African art exhibitions in American art museums were rare.[10] Even though it brought an awareness to the elevation of this subject as artwork locally, the lasting effect was disappointing.

Also in 1968, my former fellow African art student at Indiana University, Peggy McDowell, was teaching at Tulane and wanted to put together an exhibition of African art in the Newcomb Art School's Carroll Gallery. She and I went to Houston to visit John and Dominique de Menil in November, as they had a tremendous collection. Mind you, these two young people with no real credentials and experience were graciously received by the de Menils. They couldn't have been any more welcoming and willing to give us their attention. When Peggy told them of her desire to put together an exhibition of African art and wondered if they would consider lending any pieces to it, they gestured around the room and said, "What do you want?" Peggy selected a number of pieces, and the deal was done. It was that simple. The de Menils rank high on my list of extraordinary people of significance.

In late 1969, Jim Byrnes and I became aware of an extremely important African sculpture by the well-known Yoruba master carver Olowe of Ise (circa 1875–1938), which had become available on the market. The asking price from New York African art dealer Everett Rassiga was $12,000, an extremely high price for an African piece at the time. It

was far beyond what the museum was capable of spending. After some negotiating and being cognizant of the uniqueness of this opportunity, in early 1970, the museum purchased the masterpiece for $9,500 with acquisition funds from the Ella West Freeman Matching Fund.

This beautifully carved polychromed wood sculpture of a mounted warrior with attendants was one of the three veranda posts in the palace of the Ogoga in the city of Ikerre in the Ekiti Region of Nigeria. There are less than forty known works by this recognized artist, and the museum's nearly five-foot sculpture is thought to have been created around 1910–1914, at the height of his career. Roslyn Adele Walker, the recognized authority on Olowe and his work, has written, "[Olowe is the] Yoruba court artist whom Western art historians and connoisseurs consider among the most imaginative and innovative African artists of the 20th century. The Yoruba themselves held him in high esteem; his _oriki_ or 'praise poem' asserts that he was 'outstanding among his peers.'"[11]

Fortunately for both the recently renamed New Orleans Museum of Art and me, with the arrival in 1973 of John Bullard as the new director, I had an ally who understood the importance of building the African collection. A number of significant traveling exhibitions were scheduled over John's thirty-seven-year tenure. Other African exhibitions I curated with publications were _Shapes of Power, Belief and Celebration: African Art from New Orleans Collections_ (1989); _The Art of Ghana From New Orleans Collections_ (1995); _Roots of American Jazz: African Musical Instruments from New Orleans Collections_ (1995); and _Ancestors of Congo Square: African Art in the New Orleans Museum of Art_ (2011).

Another defining moment in the development of the African collection was the unexpected bequest from New York collector Victor K. Kiam, which came in 1974 and was accessioned in 1977. Overnight, the complexion of the museum's holdings dramatically changed from meager to meaningful. The news of this wonderful benefaction quickly spread in the art world, and many of the most prominent African art historians, curators, dealers, and collectors beat a path to NOMA's door to get a look even before it was put on view.[12] Mr. Kiam is discussed in more length later in these pages, and dramatic details of the how, why, and what of the bequest are unfolded.

In 2004, the museum was making preliminary plans to double the size of the African galleries as the collection had outgrown its space. With this in mind, I casually asked my curator friend Frank Herreman at the Museum for African Art in New York if he would be interested in any loans while NOMA's entire African collection would be in storage during the construction of the new galleries. His response was immediate and most positive. Yes, he would! As a result, the exhibition *Resonance from the Past: African Sculpture from the New Orleans Museum of Art* was selected by Herreman and a handsome catalog published. The exhibition opened in New York and then subsequently traveled to seven other American cities.[13] Several significant facts resulted from this tour. It was the first African art exhibition ever in the State of Wyoming and while presented at Middlebury College in Vermont, every department on campus devoted their curriculum that semester to Africa and that exhibition!

The arrival of Hurricane Katrina and subsequent failure of the levees the next year unfortunately put an abrupt halt to any further discussions on an expansion of the African galleries, at least for a while.

When Susan Taylor came on board in 2011 as NOMA's next director, I was in the midst of writing and editing a large comprehensive volume: *Ancestors of Congo Square: African Art in the New Orleans Museum of Art*. I had invited fifty outstanding scholars from three continents, North America, Europe and Africa, to write about the museum's pieces, which were their special expertise. Susan's reaction was immediate: this book deserved to have an exhibition. Therefore, the first exhibition of her incumbency in the main galleries was the pieces featured in this new book.

I am proud of my accomplishments in regard to the mission I initially set out to achieve when I first came to New Orleans in 1966 to join the Delgado Museum. That mission was to build an outstanding African art collection in an art museum in a city whose majority population was African American. This was at a time when few American art museums recognized African art and displayed it permanently in their galleries. Fortunately, the city has benefited from four important factors essential to the development in this area: the presence of a world-class African art dealer, Kent and Charlie Davis, and a scholar/curator at the art museum,

both of whom sought to cultivate an interest in and educate the community in hopes to develop local collectors. Three universities in the city have had scholars/professors teaching African art history. All of these four facets—art dealer, museum curator, university professors, and art collectors—comprise a working relationship which has brought success to New Orleans. The museum has been the recipient through the generous giving of collectors beginning with Victor Kiam and ending with Françoise Richardson.

In 2015, my last African exhibition with illustrated brochure at NOMA was an emotional one for me. It was a selection of outstanding work from my dear friend's bequest, *African Art: A Bequest of the Françoise Billion Richardson Charitable Trust*. She is discussed in much more detail later in this volume.

When I decided to fully retire after fifty years of service to the museum, I wanted to take advantage of the two major museum endowments specifically dedicated to the purchase of African art, the Françoise Billion Richardson and the Robert Gordy Funds. I am pleased to report that the museum now owns, courtesy of those funds, an extremely rare and valuable seventeenth–eighteenth-century ivory figurative ceremonial staff from the Ijaw peoples of eastern Nigeria.

Looking back, it is frightening to realize that if my Italian Renaissance professor at the time had not been terminated by Indiana University for sexual misconduct in a public bathroom, Roy Sieber, most likely, may never have come to Indiana University and shaped my life to become an African art historian in New Orleans!

Two years after my retirement, the museum hired my successor, Ndibuisi Ezeluomba, a PhD scholar of African art who is an Igbo born and raised in Nigeria. I could not be more pleased. I feel his approach to the subject will be quite different from mine. In fact, we have discussed this. I believe the two methods will complement each other, and I am eager to see and learn from his experience.

Episode 6

Ladies of My Life

I can't explain the magic or chemistry, but with great friendships, you don't try to figure them out, you simply enjoy them, because they are so rare in life.[1]

Edith Rosenwald Stern

When all is said and done, it is my acquaintances and friendships with others that have made my life so rich. The adjectives "fascinating" and "special" don't adequately describe how marvelous they have been for me. Topping the list are the recognized triumvirate "grande dames" of New Orleans of their day—Muriel Bultman Francis, Sunny Norman, and Edith Rosenwald Stern—who, almost triple-handedly, so to speak, ran the New Orleans culture scene, including the art museum, symphony, opera, ballet, and theater in the 1960s, 1970s, and 1980s. I dare say a day never passed when these three women were not on the telephone talking to each other and any other parties involved addressing the latest "crisis" that one of these cultural organizations was currently faced with.[2] They worked tirelessly "behind the scenes" until the problem was alleviated. If they were on the problem, one could almost rest assured the matter would be worked out if at all possible. Many times, it was their checkbooks that came to the rescue.

I had the great distinction of escorting, in my role as a designated "walker," each of these three social activists and generous philanthropists to numerous black-tie galas, previews, dinners, performances, parties, and arm-wrestling and tiddlywink face offs. They were all to

become my good friends. Having newly arrived from Indiana, developing relationships with these highly influential women was for me an enlightening experience. Each one taught me valuable lessons on how I should shape and conduct my own life. One of the important lessons I learned from them was, just because you were not feeling well that evening, that was no excuse not to go out. I am convinced their genuinely interested involvement and dogged determination are what kept them going. In other words, I learned not to give up just because it would be the easy thing to do.

Edith was their leader simply because, let's face it, she had the most money and consequently the most power as a result of her being the heiress to the Sears & Roebuck fortune. She "ruled the roost" in New Orleans, not only with culture but with politics as well. She was the queen bee. She and her late husband, Edgar Sr., had a long-recognized record as civic activists and philanthropists.

Edith's siblings in other communities had strong reputations as supporters and collectors of art, particularly her brother, Lessing, who gave his superb print collection to the National Gallery of Art. Within the family, she was recognized as the only one not actively involved in art. Later, her daughter, Audrey, was to marry Thomas Hess, the longtime editor of *ARTNews* and the recognized authority and scholar of the work of Willem de Kooning and later curator of contemporary art at the Metropolitan Museum of Art in New York. Her son, Philip, was married to an artist, Leni, and together they lived in Washington, DC, and were active along with Walter Hopps in founding an institution devoted to contemporary art there. Consequently, Edith felt left out, and being Edith, she didn't like being the black sheep of the family. So, she went about changing that deficiency.

Her first venture into art was quite modest and had civic-minded implications. In the early 1960s, she purchased, through the Stern Family Fund, a collection of forty-four oil crayon paintings and more than a hundred dry-point etchings depicting historic New Orleans, particularly French Quarter architecture, by Newcomb College art professor William Woodward and presented them to the Delgado Museum. By advancing funds to enable the museum, with the assistance of her niece-in-law

Simonne Stern (a future pioneering dealer of contemporary art in New Orleans), to publish an illustrated pocket-size catalog of these views, Edith accomplished two objectives simultaneously. A handsome tourist guidebook was provided to the French Quarter, and a vehicle was furnished to launch a revenue-producing item for the sales shop at the museum. Having the collection of the actual Woodward artworks at the museum was lagniappe.

She decided it would be fun to buy art for the art museum and arranged a trip in 1963 to Europe with her Chicago artist friend and shoe heiress Lillian Florsheim. Before leaving, she consulted Jim Byrnes, the then director of the Delgado Museum, and he advised her to visit Joan Mitchell and Sam Francis, both American artists living in Paris at the time. Alas, she didn't take his suggestion. However, while in the French capitol, she met Denise René, who had one of the leading galleries of contemporary art. From that trip, the museum was to receive a number of significant gifts: a stone and bronze sculpture by Alicia Penalba, two shadow-box sculptures by Victor Vaserely, and a light-sculpture environment by Julio Le Parc. This was the beginning. From New York's Madison Avenue art dealer Madeleine Lejwa she acquired a large marble by Jean Arp for the Delgado and a major oil painting by Wassily Kandinsky for herself.

As the Stern family had been deeply involved in the founding of Dillard, an African American university in New Orleans and a strong supporter of the work of Martin Luther King Jr., I therefore concluded Edith would be an excellent ally in my quest to build an African art collection for the museum. After several attempts to educate her on the subject and show her some fine African artworks, she eventually and decisively let me know she had no interest and that I should cease my efforts on that subject. The message was received loud and clear, and I looked for other ways to establish a foothold in my mission.

Her involvement with the museum continued. She was instrumental in beginning the quest to acquire the *Portrait of Estelle* by Edgar Degas painted in New Orleans.[3] With the success of the Ella West Freeman Matching Fund campaign for acquisitions, the museum board and staff were deliberating over the museum's future direction, and Edith's

son-in-law, Tom Hess, was brought in for consultation for his New York art world perspective. When he arrived at the New Orleans airport, he was greeted by a large sign on the building announcing, "New Orleans: Gateway to the Americas." His suggestion was that the museum focus on developing a permanent collection around the Arts of the Americas. This made sense for a number of reasons: the city's relative geographic location and historic and economic ties to Central and South America; the comparatively low prices for works of art from the Americas coupled with the museum's meager budget for acquisitions; and last, no other major American museum had such a focus.

Tom's idea was accepted and adopted by the museum's trustees. Jim Byrnes suggested the museum first focus on building the collection by acquiring art from Central and South America. Edith soon became friends with New York pre-Columbian dealer Alphonse Jax and Washington, DC–based Ramon Osuna and Luis Lastra, who represented the first-rate collection of Cuzcanian Spanish colonial paintings owned by Celsor Pastor, the former Peruvian ambassador to the United States. Pastor had brought the works into the country by diplomatic pouch and was now offering them for sale. At an acquisitions committee meeting as impeccably dressed Luis, an extremely suave and debonair Hispanic, was making his eloquent pitch with a seductive Latin accent, Muriel Francis, who was sitting next to me, leaned over and whispered, "Boy, Edith sure knows how to pick 'em!"[4]

The museum board ultimately decided not to buy the collection, but Edith and her neighbor on Garden Lane and museum trustee Arthur Q. Davis did. They had the paintings and fragile gilded gesso frames beautifully restored. In 1974, a deal was reached in which the collection came to the museum as a gift/purchase. She also purchased the Merle Greene Robertson collection of rubbings of Maya relief sculpture for the Middle American Research Center at Tulane with the proviso that the museum had lifetime rights to display them.

With the Arts of the Americas program fully adopted by the museum and the City of New Orleans committed to building a large addition to the original Delgado building, Edith boldly proposed that the museum make the Americas emphasis not only its main focus but

also its exclusive collection! The question quickly arose: "What was to become of the museum's existing European, Asian, African and Oceanic collections?" All that could simply be sold, she suggested. Not only that, but she proposed the grand staircase in the Great Hall of the Delgado be torn out in order that visitors would have a direct line of access into the new city addition to be built in 1970 in back! Because of Edith's power and influence, these were not idle proposals that were dismissed readily. Fortunately, more rational sense prevailed, and her ideas to commandeer the entire museum were rejected.

Unfortunately, there was another incident with Edith that subsequently became a problem for me. With the museum buying pre-Columbian art for its Arts of the Americas permanent collection with monies from the Ella West Freeman Matching Fund, a major Maya stelé from El Caribé in Guatemala was brought before the acquisitions committee for consideration. Because it was a "registered" piece, meaning that it was known publicly and had been published in a scholarly journal and could not be exported from its site, I was not in favor of our acquiring it. However, Edith was, and so consequently was the director, and together they convinced the board to purchase it. Much later, when the American Association of Museums was holding its annual national meetings in New Orleans, and the museum held a welcoming reception for the convention delegates, scholars Clemency Coggins at Harvard and Ian Graham were in attendance, and I watched them as they fervently hunted for our "hot" stelé. They were unsuccessful as we foresaw the problem and had hidden it behind a temporary panel in the center niche on the landing of the grand staircase.

That was not the end of this sad tale. Still later, the Delgado director, Jim Byrnes, was fired at the insistence of his two patrons, Edith Stern and Arthur Q. Davis, and I was appointed interim director. Meanwhile, the Federal Bureau of Investigation came to pay a visit at the museum, no doubt at the suggestion of Coggins and Graham. They wanted to know why the museum had purchased a major pre-Columbian monument when it was known to have come out of Guatemala illegally. It's ironic that I, who had opposed its acquisition, was ultimately left holding the bag and on the hot seat. The new director, John Bullard, made a

suggestion that would satisfy everyone. The museum would acknowledge its mistake and offer to return the piece only when Guatemala would have a safe place to display it. In the meantime, the country would leave it at NOMA on permanent loan for the public to enjoy. Consequently, the FBI was happy, NOMA was happy, Guatemala was happy, and I was relieved!

More positively, Sears, Roebuck & Co. had initiated a national advertising campaign "Paint Great American Homes." They were painting the Illinois home of Abraham Lincoln and other American notables around the United States. While interim director, I convinced Edith to persuade Sears to paint the interior of the Delgado as it was the home of great art and in dire need . . . and they did.

With her association with Denise René in Paris, she had become enchanted with the current op-art movement and, in particular, the artist Victor Vasarely. Besides acquiring a number of his works, she commissioned him to design a sizable carpet for the room at Longue Vue, which she had converted into a gallery to display her growing art collection. When he came to New Orleans to visit in 1965, she showed him with great pride her own art creation: in her new parking lot behind the tennis courts, she had designed the pavement simply by having the cavities of upended grey cinderblocks filled with black concrete to make an attractive geometric op-art patterning.

Edith loved parties and entertained with frequent lovely dinners in her beautiful home, occasionally with celebrities in attendance. Being a single man, I was at times invited and have many fond memories of those glamorous evenings. While dinners took many forms from serving po-boys to Isaac Stern to an affair comparable to a "state dinner" for Adali Stevenson, there was a predictable pattern. I was privileged to have been invited each year to the family Christmas dinner but had to decline as I traveled to Indiana to be with my parents. Through these other dinners, I became friends with her son-in-law, Tom Hess,[5] and his wife, Audrey, and Clay Shaw, who had been ludicrously and wrongfully accused of being a conspirator in the JFK assassination.

The dinners were a successful collaboration of Edith with her devoted staff, secretary Vilma Schnexnayder, and Mrs. Ceola Bond Otto,

who deftly handled the social and etiquette details, and cook Johanna Martin who prepared lavish dinners and bountiful flower arrangements with aplomb. Minnie Otgen was another who was indispensable on the household staff along with the perfect gentleman chauffeur Isaac Delandro. Upon arriving at Longue Vue, one was ushered in for cocktails and hors d'oeuvres to the second-floor drawing room with a large glass window overlooking the extensive garden, the Spanish Court, with its water fountain creating a double-arched allée of cascading water in the distance. When dinner was announced, guests descended the grand circular staircase to the dining room off the main corridor. After dinner on special occasions, Edith would offer to make café brulot herself in front of the bay window looking out onto the Pan Garden. She made it with much flourish, adding the necessary spices and liquor to the large silver bowl and allowing the flaming brew to twist down the curly rind of an orange. Bravo! Later the guests were led into the blue sitting room with the Kandinsky over the mantelpiece for after-dinner conversation and digestifs.

One dinner stands out among the others. Edith's wicked sense of humor and devious ways were in full throttle. Earlier, she had told me of an experience she had while visiting France. A couple she knew had invited her to dinner, but she was shocked and felt highly insulted when she was taken out to a restaurant, as was the accepted custom there, following cocktails at their showplace residence instead of entertaining her at dinner in their home. Many months passed, and the couple came to visit in New Orleans, and Edith was eager to reciprocate. The dinner in *her* dining room was quite grand that evening, but she served a most unorthodox meal of bratwurst and sauerkraut. I am convinced she had not forgotten what she had perceived as a supposed slight to her months before.

In 1970, Edith's three children, Audrey, Edgar and Philip, commissioned Washington, DC, artist Rockne Krebs to design the first permanent installation of an outdoor laser sculpture on the front exterior facade of the Delgado in celebration of their mother's seventy-fifth birthday. Titled *Rite de Passage*, the single beam was refracted through a prism to create lavender, green, and blue lines that crisscrossed the

museum facade like a cats-cradle by being reflected in two large mirrored walls facing each other on the portico before bouncing off a series of small disc-shaped mirrors mounted on trees and poles in the park. Another beam bounced off the neighboring lagoon's water, while yet another single beam traveled horizontally down Lelong Avenue in front of the museum, over Beauregard Circle and drew a straight green line above the trees down Esplanade Avenue to the Mississippi River and beyond. In fact, the naval air force base at Belle Chase down river complained that the beam interfered with their jets' navigation. The piece was a glorious sight and drew crowds to the front of the museum every night it was on. Those partaking in various recreational drugs were particularly dazzled by the display. A foggy night with its suspended moving vapor created yet another enchanting, ethereal experience for viewers. Alas, the light show came to an end as the laser machine, installed in an unairconditioned attic, required frequent maintenance, and the small mirrors required constant adjusting from passing vibrating traffic. No funds were made available for these necessary repairs, so, reluctantly, the museum had to cease its operation. The light show was over but was wonderful while it lasted.

Late in her life, Edith proposed that Longue Vue should become the decorative arts facility for NOMA in a similar manner to the Henry Francis du Pont's Winterthur and Ima Hogg's Bayou Bend. The museum's board expressed an interest in her offer. In negotiating the deal and the details of how it would operate and be funded, she suggested that she and the museum could get "engaged" and "live in sin" during an experimental trial period, and, later, if things went well to all parties' satisfaction, they could "marry." Ultimately, they never tied the knot, and it's a good thing because the arrangement would have ended in divorce.

Muriel Bultman Francis

It's been more than thirty years since Muriel Francis died in 1986, and I still remember her telephone number. Over the years, she and Sunny became my confidants, and I was certain that anything I told them

would be safe. And I believe they felt the same way about me. It was a good feeling, and I benefited greatly as a result of their trust in me. There were rare occasions when I would do something that upset Muriel, and oh boy, did I hear about it! She would scold me and lambaste me with all her furor. And then it was over. She would become my friend again and my mistake would become history never to be mentioned again. That no nonsense, matter-of-fact personality was, I thought, a remarkable quality which I came to admire.

Muriel's philanthropic family has had a long history of being involved with the arts. Her father, A. Frederick Bultman Jr., had an association over the years with the Delgado Museum, and her brother, Fritz, became a noted artist in New York and was affiliated with the first generation of the abstract expressionists and the Irascibles. She lived in New York for three decades as a public-relations agent for several artistic enterprises. From the mid-1940s to the early 1960s, she had her own agency, Muriel Francis Associates. It focused on classical music performers with clients that included opera stars Rise Stevens, Lily Pons, Ezio Pinza, and Marguerite Piazza and violinist Yehudi Menuhin, most of whom were close friends and confidantes.

Another of Muriel's friends in New York was the acclaimed fashion designer Charles James, who dressed her for their active participation in the social scene there. Her somewhat gaunt, pencil-slim figure was a joy for other designer friends Christian Dior and Yves Saint Laurent, who designed frocks just for her. Upon the death of their father, she and her brother, Fritz, inherited the family's prominent New Orleans funeral home business and art collection, and with that nucleus, she continued to purchase important art.

As her professional career wound down, Muriel decided to sell her Stanford White–designed five-story town house at 116 East Sixty-Fifth between Park and Lexington Avenues on the Upper East Side in New York, where she had been commuting from New Orleans since the early 50s.[6] Located directly across the street from the headquarters of the Palestine Liberation Organization, with its twenty-four-hour-manned sentry station placed prominently outside its door, one had the feeling there was no safer (or, more likely, unsafe) spot in

Manhattan. NOMA offered to help her with the dismantling, pack-
ing, and shipping of her valuable art collection to New Orleans. And
what a collection it was: paintings by Odilon Redon, Claude Monet,
Stuart Davis, Juan Gris, William Baziotes, and John Graham; works by
surrealists Max Ernst, Joan Miró, Victor Brauner, René Magritte, Man
Ray, and Matta (born Roberto Sebastian Matta Echaurren); drawings,
watercolors, or collages by Jean-August-Dominique Ingres, Jacques-
Louis David, Eugene Delacroix, Edgar Degas, Pierre Bonnard, Edouard
Vuillard, Jean Leon Gerome, Henri-Joseph Harpignies, Puvis de Cha-
vannes, Pierre Renoir, Paul Cézanne, Paul Klee, Pablo Picasso, Georges
Braque, Henri Matisse, Amedeo Modigliani, Alberto Giacometti, Fer-
nand Leger; and sculptures by Kurt Schwitters, Giorgio de Chirico,
David Smith, David Hare, Seymour Lipton, Joseph Cornell, Tony
Smith, and Lynda Benglis. Some of these works were bought directly
from the artist, such as the commission of David Smith's painted steel
The Swan, which he personally installed in the town house in 1953.
Others, such as a watercolor by Hofmann and a construction by Cor-
nell, were thank-you gifts to her from the artists. This remarkable col-
lection, with the exception of two works chosen by her nephews, was
willed to NOMA and is one of the most significant benefactions in
the museum's history. One of her regrets and the museum's was the
Jackson Pollock paintings she sold.

As she prepared for the move, I assisted her in making arrange-
ments and facilitating the transfer. I was in residence for a month at the
old Hotel Barbizon, a few blocks away on Lexington Avenue. Before
the process began, I had a professional interior home photographer
document each room. A first-rate art packer and mover was hired, the
insurance brought up to date, and myriad others details put in place.
While the execution of this mammoth undertaking (no pun intended)
went relatively smoothly, there are a couple of things I would have done
differently. Why didn't I save the couturier clothes boxes and hat boxes,
particularly from Charles James and Fortuny, her favorite designers,
instead of setting them out curbside on East Sixty-Fifth Street for the
garbage collector? Someone smarter than me snatched them up before
the sanitation workers arrived.

However, my biggest regret was not taking copious notes, or any at all, from Muriel's detailed responses to my inquiries over nightly dinners about her and her brother's early days hanging out with many of the struggling young artists of their day whose works she bought in support: Jackson Pollock, Tony Smith, Robert Motherwell, Hans Hofmann, William Baziotes, and David Smith. In any case, I learned during my stay in New York that Muriel kept a detailed diary and faithfully wrote her activities and thoughts each day in detail. (I made the same dreadful mistake after spending the afternoon in the late 1960s with Jeanne Henderson quizzing her at her house on Second Street in the Garden District about her fond reminiscences of travels in Europe collecting art with her late husband, New Orleans collector Hunt Henderson.)

Muriel "ran" the New Orleans Philharmonic Orchestra. After returning to New Orleans, the orchestra needed help, and she stepped up to the plate. From her involvement with the music world in New York, she could lend her expertise. She became its first woman president. She also served in the same capacity at NOMA. At the time of the planning and building of the Mahalia Jackson Theater for the Performing Arts in Louis Armstrong Park, Muriel was heavily involved, making sure it would be a first-class facility with all the finest features to make it adaptable for multiple uses.

One incident left me extremely upset, and I'm sure, Muriel as well. At a black-tie evening for the symphony, I escorted Muriel as I often did to such events. We were sitting at a small round table with Philippe Entremont, the noted pianist and retiring conductor, and André Watts, the soloist that night. Philippe asked Muriel if she was having any success finding his replacement. She proudly replied that she had found Russian composer Dimitri Shostakovich's son, Maxim, to lead the symphony to which both pianists bitchily guffawed and said unflattering things about her choice. They thought Maxim was second rate at best and riding on his father's name and reputation. How mean! How rude! I wanted to punch both of these pompous asses for deflating Muriel at that moment of her proud announcement.

At another black-tie gala evening at the Brooklyn Museum, for the opening of an exhibition on ancient Nubia which NOMA was sched-

uled to take next, the dinner was delayed, and the cocktail hour went on interminably. As Muriel puffed away on her now favored French-made Gauloise cigarettes over her formerly preferred unfiltered Chesterfields, a distinguished man approached and greeted us. I could see that he wanted to talk to Muriel privately, so I wandered off, leaving them to chat for some time. Finally, dinner was announced, and I returned to fetch Muriel and escort her into the dining room. As we walked through the now-opened doors, Muriel leaned over and whispered, "Who was that man?" I bemusedly replied, "That was Philippe de Montebello," the director of the Metropolitan Museum of Art, to which she simply responded, "Oh!"

In 1967, when United States District Attorney Jim Garrison made the wildly inflammatory accusations of businessman and civic leader Clay Shaw's involvement in a conspiracy to assassinate President John F. Kennedy, Muriel and Edith Stern were shocked and outraged as were many others in New Orleans. These two women quietly bankrolled their good friend's defense in his nationally publicized trial, which resulted in his acquittal after only a thirty-minute deliberation by trial jury. That not-guilty verdict came two years to the day after his unseemly arrest. Regrettably, this witch hunt ultimately devastated Clay financially, and his morale and pride were destroyed by the facts of his private homosexual life being prominently exposed in the courtroom. He died a broken man five years later.

Tennessee Williams was one of Muriel and her brother's friends through her life in the New York theater world and their common New Orleans connection. One of his plays, *Garden District*, was adapted by Hollywood and retitled *Suddenly Last Summer*. The plant-filled conservatory of the Bultman house on Louisiana Avenue in New Orleans is widely thought to be the basis for the film's setting and Muriel as the Katherine Hepburn character.

As I have pointed out, Muriel was a no-nonsense, sometimes painfully frank, woman who also had a wicked sense of humor. On one occasion, when speaking about a prominent New Orleans neurosurgeon widely known for his ego and irascibility, she acidly quipped, "Don't tell me about that man. I bury his mistakes."

When Muriel died in 1986, her nephew, Johann, called me and said, "Bill, Muriel has died, and the family has decided that since you took her everywhere while she was alive, we thought you should take her to her grave as well. Would you be a pallbearer at the funeral?" I was honored to serve along with Mayor Moon Landrieu, Father James Carter, Drs. Siddharth Bhansali and Kurt Gitter, Morris Herman, Sandy Ingram, and Joe Mizelle. At that time, the *Times-Picayune* ran an editorial recounting her life and concluded, "Mrs. Francis' almost wraithlike appearance belied her intellectual strength and energy. She was long a graceful figure in the city's artistic and civic circles. The city was the richer for her presence."[7]

Sunny Norman

Everyone has their favorite Sunny Norman stories, and I am no exception. Even though this one does not involve me directly, it is indicative of the things that happened to/because of her. While she was serving on the symphony board, it was decided that each member would draw straws to take turns entertaining the visiting guest artists. Sunny drew Indian musician Ravi Shankar, who was appearing at one of the Pop Concerts. Perplexed, she asked her husband, Roussel, what they should do, and he suggested they give a party in his honor. She thought that was a marvelous idea as she loved entertaining, so she began making telephone calls to invite their friends. When she called Mary Dixon, Mary exclaimed, "Oh Sunny, how thoughtful of you and Roussel. Dave and I have always wanted to be invited to celebrate one of those Jewish holidays!"

Sunny, whose birth name was Mildred Gould, was born in Port Arthur, Texas, and later raised in Houston. She acquired her nickname in childhood for her bright disposition. She married lumber businessman Peter Roussel Norman from Morgan City, Louisiana, where they lived for twenty years before moving to New Orleans in the late 1950s. Both were strong advocates for the arts, and she became a prominent fixture on the New Orleans art scene, while her husband preferred to be the more "silent partner" to Sunny's hands-on activism. Her participa-

tion was certainly not limited to her adopted city as she was well known nationwide through her activities with the International Council of the Museum of Modern Art in New York, the Collectors Committee at the National Gallery of Art in Washington DC, and the Fellows at Harvard's Fogg Art Museum. Through these prestigious organizations, she was on a first-name basis with the nation's art elite, including David and Blanchette (Mrs. John D. III, the president of MOMA) Rockefeller and others.

Sunny's overriding interest was children's art education both at NOMA and the New Orleans Center for Creative Arts (NOCCA); she was an instrumental force in creating the latter along with Shirley Trusty Corey in NOMA's basement. At the museum, Sunny was known among the staff as "Mrs. Anonymous" for her saving the day when funds were needed on short notice or when there was an impasse in having a project move forward. The staff knew that when the chips were down and all avenues had been exhausted, they could turn to Mrs. Anonymous for last-resort help.

Sunny and Roussel were passionate in their support of new, young artists who needed a boast to launch their careers. Jeweler Mignon Faget; glass sculptor Maurice Alvarado; installation and video artist Dawn DeDeaux; painter, printmaker, and sculptor John Scott; and countless others who have remained anonymous benefited from the Normans' largesse. This is what truly gave the Normans pleasure.

After going to a spring graduate exhibition at UNO's fine arts gallery on its waterfront campus, Sunny was so distressed that only a few people would see this excellent exhibition, that she arranged for the entire exhibition after it closed to be transferred for installation at her house for the summer months. This necessitated taking down her own collection for this special display, where she believed more people would see it and have an opportunity to buy some pieces. It goes without saying that she made a few purchases herself.

Sunny often appeared at gallery and museum openings and fancy-dress parties wearing her vividly colored clothing and flamboyant jewelry, mostly David Webb originals. She was short in stature, so upon entering many New Orleans restaurants, the maître d' or hostess knew to fetch a telephone directory, open it halfway, place it on the chair, and

cover it with a napkin where Sunny would be sitting. If the staff of the restaurant, either in New Orleans, New York, or Paris, did not already know her, she would request the book, much to their puzzlement.

Sunny's longtime African American cook, housekeeper, and beloved pal, Anne Dangerfield, ran the house and was comfortable being regarded as one of the family. As I often did, one afternoon I took some out-of-town guests to Sunny's for a visit. This particular day, she was delayed and not at home when I arrived at the appointed time with my distinguished guests. Anne graciously received us, offered drinks and some of Sunny's famous and incomparable lump crabmeat, and then sat down with us in the living room in her stocking feet and proceeded to be the hostess in Sunny's absence. After all, that is what Sunny would have done, including the stocking feet.

Sunny's penchant for abandoning her shoes was not confined to her home; she was known to take them off almost anywhere, including when she and I attended the opening of Bob Rauschenberg's retrospective opening at the National Collection of Fine Arts in Washington, DC, and even at a black-tie dinner hosted by then Governor Edwin Edwards in the Hall of Mirrors at the Palais de Versailles!

When she was in Washington to help her friend Lee Kimche McGrath launch her new Art in Embassies program, Sunny attended the gala black-tie reception at the State Department and soon abandoned her shoes. As she was going through the receiving line, she looked up to be greeted by then President Ronald Reagan, to whom she quizzically responded with astonishment, "What are *you* doing here?!"

Once, Anne had been feeding a stray cat outside the kitchen door for months. Sunny did not approve and would not allow the cat to come inside. On several occasions, I was honored to be invited to Sunny's with her family for a Jewish Seder (Pesach) dinner. As we approached the part of the ritual service to let Elijah in, Sunny instructed her young grandson, Brian Friedman, to go open the front door. After a rather lengthy absence, he came back and announced, "He came in."

"What?" we questioned, and again Brian repeated the pronouncement. A few moments later, the cat leisurely strolled into the dining room, and I leaned over to Sunny and said, "I think he now has a name!"

Anne was enterprising. On one occasion, Sunny thought she had purchased a Larry Rivers painting from a prominent New York art dealer, when, in fact, the deal fell through since the artwork had been sold already to someone else. As a consolation, the dealer offered to send Rivers to New Orleans to paint her portrait. While a guest of the Normans, Rivers made many sketches and studies and, ultimately, discarded them in the waste basket. Realizing the potential value of these drawings, Anne, when cleaning, retrieved these abandoned artworks for her own collection!

While I was driving the visiting British freelance art historian and writer Edward Lucie-Smith and Sunny to a party out in New Orleans East at John Scott's sculpture studio, Edward was in the front seat and Sunny in the back. She had just met Edward and really didn't know who he was, so, leaning over the seat, she started asking questions. When he explained to her that he wrote books, she inquired how many he had written, and his response was eighty-four. Without asking anything further, she said, in a matter-of-fact manner, "Send me copies of your last six!"

Once, Sunny and Roussel invited me and artist Rockne Krebs, who was visiting from Washington DC, for a drink at their house on Vendome Place after we left work at the museum, where he was installing his exterior laser sculpture. It was 1970, and Rockne had long hair flowing down his back, and I had a beard. We were in our dirty work clothes of Levi's and T-shirts. After having been at the Normans' awhile, we saw a policeman approaching the front door. Anne answered the door, and the cop inquired if everything was alright. The Normans assured him it was and then asked why he was there. He revealed that their neighbors had seen two suspicious men get out of a van and go into their house. Little did we know that the house was surrounded by the NOPD! That's the third time I had been accused of being a thief. No, it's not all glamorous social gatherings.

When Robert "Mac" Doty, curator at the Whitney Museum of American Art in New York, was coming to New Orleans as the guest curator of the then *New Orleans Artist Biennial* at the museum, Sunny said she would take him to dinner. In making arrangements on the phone

to meet, he inquired how he would recognize her when she picked him up at his hotel. Her reply, "Just look for an old beat up bleached blonde."

Sunny and Roussel enjoyed visits to New York City several times a year, holding court in their beautiful suite of rooms at the Plaza, where they received their many friends. Of course, they offered Sunny's famous lump crabmeat, which she had shipped from her top-secret source in Morgan City, Louisiana, via Greyhound bus to New Orleans and then immediately flown to the Big Apple.

One time when they were at the Plaza, I was also in the city for the opening of the *Louisiana Folk Painting* exhibition that I had curated at the then-named Museum of American Folk Art. I suggested that Sunny and I attend the Robert Scull auction at Sotheby's one evening as I knew it was going to be an historic, memorable event. She was game, put on her shoes and most impressive fur coat, and off we went in a taxi. There was a beehive of activity on Madison Avenue in front of the auction house. When we squeezed into the crowded elevator, I whispered to Sunny that collector Joseph Hirschhorn was standing behind us, to which she blurted out her introduction to him, "Mr. Hirschhorn, I am Sunny Norman from New Orleans."

Kathleen L. Housley eloquently sets the scene and best describes that unforgettable evening in her biography of Emily Hall Tremaine.

The . . . newsworthy auction . . . of Robert Scull's collection of Pop art on October 18, 1973, [was] necessitated by the acrimonious divorce from his wife and cocollector, Ethel. The auctioneer was Sotheby's the prestigious London-based firm that was just beginning to expand into the field of contemporary art. It had purchased the Parke-Bernet auction house in the mid-1960s, and it was under that name (more acceptable to Americans, who were still chafing about the takeover) that the Scull auction was to be held. The day of the auction the weather was miserable, a cold rain mixed with sleet, but that did not deter a large crowd of spectators and journalists from showing up at what was sure to be a theatrical event. For an added bit of dramatic effect, several of the cabbies who worked for Scull marched outside of Sotheby's, waving placards that accused him of not paying them decent wages. The Tremaines made it through the crowd, as did Philip

Johnson, several celebrities, and many dealers. Even Rauschenberg, whose works were in the Scull collection and hence up for auction, was there, although he was visibly upset with the idea that his art was going to be sold as if it were a slab of prime rib. "All the intimacy of the work is gone," he complained. From a sheer economic point of view, the auction was good news: if Rauschenberg's work fetched a high price, all the art he was then producing would likewise increase in value, to his benefit. But that was not way he perceived it. Auctions were not psychologically healthy places for artists, because they were not about art but about money. Of course, the back rooms of galleries, where the re-sale of art was carried on routinely, were also about money, but the scenario was not as blatant and certainly as raucous. At this auction, money of a kind never before seen at such an event changed hands. Jasper John's Double White Maps was bought by Ben Heller for $240,000, setting a record for the highest amount ever paid for the work of a living American artist. White Fire by Barnett Newman fetched $155,000. Rauschenberg's works went for $85,000 and $90,000, leaving him fuming. The final tally was $2,242,000.[8]

Since Sunny and I had not decided to attend until the last minute, we were herded into a side room off the main gallery. As chairs were at a premium, Sunny agreed to sit on the floor in her full-length fur coat and stocking feet.

The next day, I had an appointment with dealer Leo Castelli at his gallery at 4 East Seventy-Seventh Street, around the corner from the auction house. Even in the late afternoon when I arrived there was much commotion among Leo and the staff. The auction the night before was the talk of the town, and many were upset by the high prices realized, especially Bob Rauschenberg, who was on the phone with Leo complaining about his work being sold at record prices and he would not profit from it.

In her later years, after Roussel had passed away, Sunny relinquished driving herself and in the spirit of *Driving Miss Daisy* engaged an older, heavy-set African American woman to take her where she needed to go. What was particularly unusual about these trips around town was that the driver always kept a loaded pistol sitting in her lap.

After Roussel's passing, Sunny wanted to create a lasting memorial to him at the museum. Her goal was to commission a nationally known artist to create a sculpture to place on the lawn just to the left of the entrance. Both she and Roussel were most interested in children's education at the museum. Therefore, one of her primary prerequisites was that children would be allowed to safely climb on the sculpture. It was only at the conclusion of a couple of years' research interviewing artists and visiting numerous studios and commercial galleries that she made her decision. Tony Smith was her choice. With the Normans' wishes known, Smith made a cardboard maquette taped together for her to examine. Passing her inspection, Smith proceeded to fabricate *Lipizzaner*, one of his last major sculptures and one of his rare white works. He titled it after the famous performing white stallions of the Spanish Riding School in Vienna.

Around this time in her life, Sunny and Françoise Richardson had dinner weekly, Dutch treat, usually at the local chain restaurant Houston's. After one of these get-togethers, Françoise discovered to her shock that she had been using Sunny's credit card for several weeks. And Sunny had been using hers!

When Sunny died at 94 in January 2006, I was quoted in her obituary in the *Times-Picayune*: "After the deaths of Edith Stern and Muriel Bultman Francis in the 1980s, Mrs. Norman became the sole survivor of what had been a triumvirate of wealthy, intelligent women who ruled the city's arts scene and cared deeply about it. There's nobody to replace those people. The gusto and the commitment and the drive! They had a vision. They knew what was best for this city, and they did it."[9]

To all who knew her, it is agreed there will never be anyone quite like Sunny.

Bernice Norman

Bernice Norman was Sunny's sister-in-law. (Bernice's husband, William a.k.a. Nip, and Roussel, Sunny's husband, were brothers.) Even though Nip was a physician, he shared the family's business interests with Rous-

sel. Bernice and Nip often visited Sun Valley and were neighbors of Mary and Ernest Hemingway. The two couples often dined together. Tragically, Nip was killed in 1975 in the crash of Eastern Airlines Flight 66 upon landing at LaGuardia from New Orleans along with members of the prominent Stream and Bright families. Like Sunny, Bernice was a colorful woman, and her acquaintances have a number of "Bernice stories" to share, including me.

The two traits for which she is legendary, are her unashamed hedonistic lifestyle and her boundless generosity to others. In other words, she had money, and she knew how to enjoy it for the benefit of everyone, including herself. After Nip's untimely death, she spent most of her life hopping from one ship to another on world cruises. It was an endless journey around the globe with ever so brief layovers in New Orleans. And she went in style! Since dinners at sea on the ships were always formal, Bernice would take a suite adjoining hers to house her wardrobe alone. As she would never wear the same gown twice on the same cruise, metal clothing racks were brought along and assembled in the empty luxury quarters. The suite also housed her extensive collection of Judith Leiber bejeweled handbags, possibly the largest assemblage of these unique creations in private hands. Sometimes she would bring along her secretary Eleanor or her good friend Joe Mizelle.

Bernice loved a good party, and she knew how to throw one. On every cruise, she would invite the ship's entire passenger manifest to a special evening at her expense. Every other December, before beginning another cycle of cruises, she would stage a large formal dinner dance with full orchestra in the Grand Ballroom of the Fairmont Hotel with the entire ceiling covered with hanging clusters of cut orchid blossoms. Around Labor Day, she would celebrate her birthday with a formal cocktail party in a penthouse suite at the Windsor Court before retiring to a beautiful private dining room for a sumptuous repast. These glamorous events were not limited to her New Orleans friends as many of her fellow cruising buddies and the executive staffs of the ships themselves flew in to be in attendance.

Through the influences Bernice had with various cruise lines, I had the good fortune to be invited to be a guest lecturer on portions of two

world cruises with her. One was in 1983 on the *Rotterdam*, and as a result of that single trip, I saw the Taj Mahal, the pyramids in Egypt, the Holy Land, the Parthenon, and ancient Pompeii, all in little more than three weeks. I was originally scheduled to lecture only from Bombay to Egypt as my speaking assignment was to talk about Tutankhamen. However, I approached the cruise director and explained I could talk on Alexander the Great as well, so I was allowed to stay on through Athens. Because the next port would be Naples, I convinced the director I would like the opportunity to talk on the ancient ruins of Pompeii. He agreed and then said that I could stay on the ship as long as I wanted. However, I agreed to leave at the port in Italy.

The other cruise was three years later, in 1986, on the *QE2*, and one of the highlights was flying to Rio on a charter Concorde from New York, arriving just in time for that year's Carnival. Our next stop was Cape Town, then on to Mombasa and short safari in Tsavo Parks East and West in Kenya, on to a visit on the Seychelles and Karachi, Pakistan, before disembarking in Bombay.

When the Concorde was obliged to make a refueling stop in Trinidad, we had landed in a tropical paradise of Port of Spain with Carnival in full swing in town. With the sounds of the Caribbean island music and drumming pulsating and in the air the sensuous smells of the native cuisine mingling with the smoke of the cooking fires, I was tempted to stay. The lure was enticing, but, of course, it was out of the question.

Once we boarded and took off, the pilot announced we would be circling back with the plane tilted over the airport for the best on-ground camera view to "show off," as he put it, for a photo op to accommodate the huge crowds who had turned out from town and were lining the fence along the road to see the Concorde on its maiden visit to the island nation. Lunch on board that day at Mach 2 at 60,000 feet consisted of cold lobster and smoked salmon, a rare filet, with squash, spinach, tomato, and turnips, followed by chocolate mousse, all washed down with an ample supply of wine and champagne. The meal concluded with cheese and port as I gazed out the window at the spectacular sunset over the Amazon jungle.

The evening ritual on ship never wavered. I would join Bernice and Marge Johnson, widow of Howard Johnson (the restaurant and hotel

guy) for drinks in the cocktail lounge. The two ladies held court for all passing visitors and staff. At the appointed hour, we proceeded into the dining room to have our usual premeal nibble of endive and caviar washed down with champagne. Following dinner, it was on to the theater or nightclub for the evening's scheduled entertainment. Bernice was always one of the last to leave for the night.

Bernice rarely left the ship unless it was to meet her driver at Port of Naples for a day-long trip for a boot fitting in Rome or traveling to Jerusalem from Haifa for a night at the King David Hotel. Her regular driver had arranged to meet her in each port. When in Bombay, she hosted an elegant dinner party for her local Indian friends at the hotel Oberoi Towers. Often upon arriving at an exciting port of call, Bernice, when asked if she was getting off the ship, would simply reply in the negative, "I don't need to. I've seen it before."

One of the pleasures of being in India was visiting a tailor and having clothes custom made at comparatively inexpensive costs. The outfitter in the Taj Mahal hotel, Burlington's of Bombay, was widely sought out for the high quality of its selection of fabrics and fine craftsmanship. Mindful of this, I spent time there having two raw silk suits, two raw silk shirts, and a sports jacket made to order and sent home. After this splurge, I met Bernice, and as we taxied to lunch with local friends at the toney Gymkhana Club, she quietly informed me I had just selected my birthday present! Yes, it was March 1, and it was my birthday.

Just when I thought I knew Bernice very well, she would amaze me with another side of her personality. She was a faithful volunteer at Touro Infirmary, where she did menial tasks. While she enjoyed the good life, she was not beneath helping someone in need. However, on one occasion, I saw the tables turned. For all Saints home games, Bernice had the unique privilege of having her uniformed chauffeur, Richard Osbey, drive her up the Superdome parking lot ramps to the level where her seats were located. There he waited until it was time to return home. She was an avid fan and could talk the talk about the team's players, their plays, and their strategies. I was her guest near the 50-yard line for all the home games.

After one night game, we left our seats to find Richard, but he and the car were not at our regular rendezvous location. After a lengthy wait

and before the era of mobile phones, we finally decided to walk down the ramps out onto the street. Still, there was no Richard, who was known for his dependability. What to do? Well, leave it to Bernice: she simply went out into the night traffic and stuck out her thumb, hoping to hitch a ride from one of the cars leaving the stadium. Finally, a Good Samaritan stopped, and we piled into an already-full car. After Bernice explained our plight, the driver agreed to take her back to her apartment on Saint Charles Avenue! I never found out what happened to Richard that fateful night.

On one of her cruises, Bernice became ill and was taken off the ship in Bangkok and diagnosed to have an advanced stage of cancer. Flown home and put into Touro Infirmary, she knew she didn't have long to live and readily admitted it. While I was visiting her there, Colette Newman, a dear friend of hers who was there also, jokingly blurted out in a forceful, commanding voice, "Bernice, you can't die now; oil is at sixty dollars a barrel!"

Perhaps my dear friend Bernice can best be summed up by quoting her favorite drinking toast: "May the rest of your life be the best of your life, and may all your pains be champagne." That was Bernice.

Françoise Billion Richardson

Fitting into the vanishing breed of New Orleans's grande dame philanthropists was Françoise Billion Richardson. Born in France to a New Orleans mother and French father, Françoise and her family fled Paris during the Nazi occupation. She dedicated her life and resources in New Orleans to the arts with a special love for NOMA and the symphony. To ensure a reason to come visit her buddies at NOMA after her tenure as president of the board expired, a special vice treasurer's title was created for her that required her to visit the museum weekly to sign checks. That way, she could keep up with the staff about all that was going on there and discuss the latest gossip.

She was a consummate volunteer, be it Charity Hospital or DePaul Hospital for the mentally ill. Françoise was among the first to volunteer her services at the outbreak of AIDS and was known to have scrubbed

floors on her hands and knees at Project Lazarus and developed loving friendships with residents there, often driving them to their medical appointments.

Her son introduced her to African art. After Robert began collecting, she became interested and started her own collection, acquiring superb works for herself and, when she saw a need and opportunity, for the museum as well. Not only did she give the museum important works in memory of members of her family, but she underwrote the naming of the expanded African galleries in 1993 in honor of her parents. She established a special purchase fund in her name to be used exclusively for the purchase of African art for the collection. Additionally, she provided the funds for underwriting the curatorship of African art at NOMA, a title I proudly held from its inception in 1997 until my full retirement in 2016.

Françoise enjoyed nothing better than being with her friends and family. With an insatiable appetite, curiosity, and spirit of adventure, she often traveled in her plane to remote places with her fellow Frenchman with Louisiana ties, Arnaud d'Hauterives. She was most content whether she was visiting John Bullard in Maine every summer or on national holidays throughout the year hosting a few dear friends at her house near Covington across the Lake Pontchartrain. Her exuberance for living could be summed up in one of her favorite expressions about a food she found to be particularly sublime, such as pâté Forestier or the Sunday Eugene ice cream dessert at Upperline restaurant: "It was so good I could rub it in my hair!"

After lingering failing health, she passed away on April 11, 2012, leaving her sizable and important African art collection to her beloved NOMA.

Catherine Tremaine

I have not known Catherine as long as many of these other wonderful women. I met her upon her return to her hometown after she had lived many years in the East, mainly in Connecticut and Florida. We quickly

became friends. Our first meeting was when the Arts Council of New Orleans invited me to chair a blue-ribbon panel about collecting art, and Catherine was one of the participants, along with Anne Milling and Arthur Roger. I knew her name from her well-known in-laws, Emily and Burton Tremaine, major collectors of modern and contemporary art later sold at auction. Her father, Dr. Edgar Burns, was one of the founders of the Ochsner Clinic.

Catherine meets all of the qualifications one would expect from a grande dame. She's Hollywood beautiful, elegant, charming, refined, and intelligent. She's also fun. She and I share a penchant for manual shift, convertible sports cars. She reminisces about her days tooling around in her classic Jaguar convertible XKE. She defies her age of mid-90s by looking and acting twenty years younger, courtesy of periodic "updates." She is always beautifully dressed and coiffed and laden with smashing jewels. She currently is taking French lessons, has a physical trainer, and can do the splits!

When going out (and she is not one to stay home), she carries her oversize leather satchel "Big Red." We love to share periodic dinners together at our favorite restaurant, Upperline, sit at our favorite table, visit with our favorite hostess and favorite waiter, and proceed to have long, extended petite dinners while we discuss, chat, gossip, reminisce, confide, giggle, and just have fun whiling away the evening slowly sipping our drinks.

From her early childhood here in New Orleans, Catherine had a fine voice and desired to pursue a career as a vocalist. With her parents' encouragement, she took voice lessons to fulfill her dream. With her continued training, it was evident her voice was not suited for grand opera. However, it was for light opera, and she performed often in New York in Gilbert and Sullivan productions. She was also quite in demand to sing at charitable events, both in New York and in Hartford, where she was living. Her first public concert at the Wadsworth Atheneum, "Short and Sweet," was with Bobby Short.

Catherine loves entertaining at home, giving smashing cocktail and dinner parties in her lovely, art-filled Garden District home. Her annual Thanksgiving dinner is on Wednesday the day before the holiday. This

allows her to give her beloved staff, including Regina Busch, her cook, and Harold Villerie, her butler, the day off to be at their homes to celebrate with their families.

Every other year, she invites ninety of her nearest and dearest to a grand springtime black-tie evening dinner party. And it is grand in every sense. Upon entering through the front gates, the guests arrive on a red carpet and are greeted with a bar, both tented, outside the door entering the house. At the doorway, our gracious, bejeweled hostess receives her many friends, who enter into an overflow crowd enjoying a lovely cocktail hour with clarinetist Dr. Michael White and his ensemble providing the music. At the appointed hour, Catherine's guests are led into her back garden, where her swimming pool has been covered over with a temporary floor, which is carpeted and tented. The "room" is lit with crystal chandeliers and candles, and an assortment of small round and square tables are festooned with beautiful individual floral arrangements. After being seated, a five-course dinner ensues, prepared personally by Chef John Folse and his staff. With all the amenities covered, including a gorgeous art-filled home, engraved invitations, valet parking, lovely music, sensational flowers, fabulous food, charming guests, and a beautiful hostess, each dinner is indeed an enchanted evening!

Doris Zemurray Stone

Another woman who became a very dear friend was Doris Stone, the daughter of the late Sam Zemurray, widely known as Sam the Banana Man and the philanthropist who built the United Fruit Company empire in Honduras and Costa Rica. This tall, elegant, well-mannered lady with a lean figure, close-cropped hair, minimal makeup, and conservative dress belied a rough and tough woman not afraid of tossing one back with the boys and getting her boots muddy. She and her husband, Ronnie, were avid fishermen ever seeking new exotic and remote areas to mountain fly or deep-sea fish. When not being chauffeured across the lake into New Orleans by her faithful gentleman driver, Stanley Smith, she drove her beloved vintage Citroën with its hydropneumatic self-leveling system.

Part of the chemistry that made my friendship with Doris so strong was our common interest in ethnographic art, particularly in her case, pre-Columbian art. With degrees from Radcliffe, she was recognized as one of the outstanding scholars of pre-Columbian Costa Rican art and, in fact, had served at one time as the director of the art museum in San Jose, where she lived on a coffee plantation with her husband, Roger Thayer Stone. Her highly technical books on Central American anthropology and archaeology were accepted references and pioneering additions to the literature. Once, I asked her when she had time to write such impressive volumes on the art and archaeology of Costa Rica, and her offhand response was, "On airplanes."

Among her many honors and recognitions for her advances in scholarship and philanthropy, the one that meant a great deal to her was the Harvard Medal. One thing I admired about her was her cease-lessly inquisitive mind, ever searching for answers. Consequently, there was hardly a place where she had not traveled, either to hunt and fish or to investigate a new archaeological discovery or theory. She would travel to the ends of the earth looking for answers or to investigate a new anthropological discourse. One pilgrimage late in her life took her to Outer Mongolia to observe new findings that the wheel had played in that ancient culture. Another favorite theory for contemplation was whether it was possible that there had been trans-Pacific contact in ancient times. She sought out Thor Heyerdahl looking for answers. She was not afraid to delve into controversial territory in her search for the truth.

For many years, John Bullard and I were invited to come for holi-day dinners at Doris and Ronnie's rambling one-story, u-shaped ranch house, strongly reminiscent of an informal hunting lodge, on the Tche-functe River across Lake Pontchartrain from New Orleans. To arrive at the unpretentious house located on a large wooded estate, one had to know where to turn off the main highway onto a paved country road until one spied a small discrete sign "D + R" with an arrow pointing to a gravel road. A short distance away began a mile-long, winding, unpaved road flanked by large azalea bushes, ablaze in an allée of fuchsia in the springtime, leading up to an automatic electrified gate.

The u-shaped building design was essentially one long continuous room eclectically furnished with alternating comfortable seating areas of well-worn, overstuffed furniture interrupted by an informal dining table and chairs handmade from Honduran mahogany. Adding a decided splash of color was a full-size, brightly painted Costa Rican cart with large spoke wheels that served as a fully equipped, well-used bar. A framed, oversize pre-Columbian hand-painted Peruvian textile greeted visitors upon entering the foyer, while in the living quarters, a vintage Tiffany floor lamp with multicolored glass shade and an old Chilkat wool blanket from the Indians of the Northwest Coast stood out. Just off the foyer, a flight of stairs led up to an enormous low-ceilinged room, which could not be termed a cozy conventional library even though the open unobstructed space was lined with stuffed bookshelves and countless tables stacked with even more books, professional journals, booklets, pamphlets, and papers as far as the eye could see. It was obviously a workspace used for research and writing. To one side of the rambling corridor was the baronial formal dining room with a large oil landscape by George Inness and an impressive oil by Frederick Remington on flanking walls, while a life size pre-Columbian volcanic stone head stared out like a trophy head from the side-wall credenza.

One never knew who would be invited to these festive occasions. Eagerly cohosting with his masters was their standard black poodle, Feli. The guest list varied, but the regulars included author Walker Percy and his wife, Bunk; Tulane archaeologists Vicki and Harvey Bricker; Monroe Edmonson and his wife, Barbara; Wyllys Andrews and his wife, Patty; anthropologist Bay Watts; Frank Bograns; Richard Greenleaf; and Tulane's president, Eamon Kelly, and his wife, Margaret. Sometimes Haydée and Judge Steve Ellis, the Andy Goodyears, the McGinnises, the Laboisses, the artist Shirley Rabe Masinter and her husband, David Bradley, were included. Another favorite was Doris's Covington doctor, George Riser, who prided himself as an amateur archaeologist specializing in the use of shrimp and crayfish in south Louisiana Native Americans' diet.

The holiday repasts were quite grand, utilizing the finest silver, china, crystal, and starched and ironed table linen table and napkins.

There was a genuine formality as houseman Stanley and the cooks served each guest the multicourse fare. Perrier-Jouët champagne was served with dessert. Doris would make a toast ("Bottoms up!"), which, when delivered in Spanish, inferred something other than the tipping of glasses. After a couple of rounds, invariably Monroe was encouraged (it didn't take much) to get out his guitar and lead the merry group sitting around the table to join him in singing old favorites mostly in Spanish. There was something incongruous about this table of mainly field archaeologists dining with such ceremony. The sing-a-long usually concluded with Doris's favorite melody in Spanish, "La Paloma" (The Dove). Upon leaving the table, the guests retired to another conversation area on the other side of the house, and Doris, always the gracious hostess, would inquire, with hands folded demurely in front of her, if anyone would like to use "the courtesy of the house."

On occasion, a few were invited to stay overnight at Christmastime. Each spacious bedroom had its own fireplace, and occasionally, Stanley would steal into the room to add another log to the fire. I felt highly honored when on several occasions I was the only nonfamily member joining her son, Sam Stone (nicknamed Pebble or Peb for Little Stone) and his wife, Haydée, and their children and grandchildren. On those solo outings with Doris, I cherished our solitary long walks on the well-worn paths in the woods around the fenced perimeter of the property.

In the late 1980s, the museum staff was tossing around ideas how we could commemorate the five hundredth anniversary of Columbus's discovery of the New World. It was a subject with controversial and political implications. Doris suggested putting together a wide-ranging exhibition exploring possible contacts and interrelationships of the native peoples living in 1492 in the region from the tip of Yucatan all through Central Mexico, through what would become the southern United States to Key West, Florida. This was a subject that had not been tackled in a meaningful, scholarly way at that point. Doris loved being a pioneer and stirring the pot. One of my favorite expressions of hers, which she said with mischievous glee, was, "Let's agitate!"

Through her connections, the museum selected Steve Williams, former director of Harvard's Peabody Museum, to cocurate the US aspect

of the project with Jeffrey Wilkerson handling the Mexican element. After several conferences together in New Orleans on this intriguing subject, the proposed exhibition was given the working title *Pathways before Columbus: Ancient Realms of the Gulf Coast*. Doris, Steve, John Bullard, and I traveled to Mexico to meet Jeffrey, who lived there, to further explore ideas for such an ambitious undertaking. However, the project never really got off the ground. One problem was that two planning grant applications were rejected by the National Endowment for the Humanities because scant material evidence had come to light that could have been included in a meaningful exhibition. Second, the two guest curators were not getting along. In the end, I know Doris was willing to accept the verdict, but I am sure that she felt that one day her idea not only would be proven worthy of consideration but also would become historically factual.

Following the phenomenal success of *Treasures of Tutankhamen* the year before, John Bullard and I accompanied Doris in March 1978 on an exploratory trip to Bogata, Columbia, to meet with officials regarding a loan exhibition called *The Search for Eldorado*, featuring the fabulous pre-Columbian gold of that country. We were the official guests of the Colombian government and its president. Treated royally, we were given a private tour of the national bank's underground pre-Columbian gold vault with its theatrical light show, chauffeured everywhere in a bullet-proof limousine, and had cocktails with President Alfonso López Michelsen in his presidential palace. At the conclusion of a grand visit, we were the guests of honor of President Michelsen at his beautiful hacienda in the glorious countryside outside the capitol.

Always the explorer, Doris joined a group of museum members I led for an overnight bus trip to a special exhibition on view in Memphis. At the end of one day, we had some extra time, and as an added bonus, I suggested we as a group visit Graceland. Many were most enthusiastic and agreed. I asked Doris if she would like to come along or go back to the Peabody Hotel where we were spending the night. When I explained that it was the house belonging to Elvis Presley, she looked puzzled and asked who that was. When I told her I thought she would enjoy seeing this historic house, she gamely agreed. Following our pilgrimage there,

I don't think anyone in the group was more pleased to have been to this American shrine of the King of rock 'n' roll. She was like an excited school girl, and I was pleased I was able to broaden her experience and introduce her to a piece of modern-day anthropology.

Doris died "with her boots on." Her inquisitiveness took her to Ethiopia with her dear friend Doug Schwartz, head of the School for American Research in Santa Fe, on one of her learning quests, where she consumed some tainted food, became ill, and sadly never recovered.

Lillian Feibleman

Lillian Feibleman was a grande dame in the old New Orleans tradition, a descendant, along with her equally elegant sister, Justine McCarthy, of the wealthy Louisiana Godchaux sugar family. At one of Lillian's lovely dinner parties in her gracious Uptown home, the conversation around the dinner table focused on the recently introduced Cuisinart machine. One guest praised it for slicing and chopping, another loved it for kneading dough, while still another was thrilled with the ease of making mayonnaise. Lillian listened intently to her guests' enthusiastic endorsements of this new kitchen marvel. Finally, she spoke with her deliberate, imperious voice, making the pronouncement, "I don't have a Cuisinart. I have a cook!"

Mickey Easterling

Mickey Easterling is difficult to quantify. On one hand an extremely private person, Mickey was also one of the most widely known and recognized personalities in New Orleans. She was a mystery and a paradox, and I feel she wanted it that way. One of her favorite sayings was, "Age is a number, and mine is unlisted." While I knew her to be a tough, shrewd businesswoman and beyond the bluster having a heart of gold, it is her "Texas" Guinanlike, larger-than-life personality that she reveled in and that I knew best. The license plate on her car was her initials "ME."

She always proudly wore a rhinestone-diamond broach proclaiming, "#1 Bitch." With a legendary wicked laugh, this dame would smoke like a chimney, swear like a sailor, and refer to her beverage of choice, Veuve Clicquot, as "my medicine."

Mickey, diminutive in stature at five feet, was known for driving while wearing her everpresent chapeau and loaded cigarette holder in her mouth as she stretched her head over the steering wheel of her black Lincoln town car. Her vehicle was equipped with a blue flashing light prominently mounted on the dashboard if, on occasion, she wanted to park illegally. On rare occasions, it was turned on when she was behind schedule. When learning that one of her friends was ill, she jumped in the car and hand delivered to the patient's doorstep several pre-frozen Ziploc bags containing her excellent homemade chicken soup. Just what the doctor ordered—Mickey's famous remedy. And her special medicine worked.

Her extensive wardrobe was mainly by the daring and flamboyant British designer Zandra Rhodes, who often came to New Orleans for trunk shows at Saks and to visit her favorite patron. Two hundred forty of Mickey's hats were auctioned in New Orleans to an eager, overflow crowd four months after her death.

Mickey's formal dinner parties were legendary. Beginning in the Moroccan-themed sitting room and after much alcohol was consumed, mostly champagne, accompanied by her homemade cognac-laced chicken mousse, dinner was formally announced by a hand chime struck by the butler, and the guests were led into the dining room, where the long, oversize dining table was overloaded with sumptuous floral centerpieces and tall, grand silver candelabras on a raised mirrored tray and surrounded by a sea of fine china and an abundance of stemware. After finding their names on the place cards, diners were seated, and the production proceeded. Most of the lavish multicourse menus had been precooked personally by Mickey and then given their finishing touches and served by her butler. She was an excellent chef. On special, grand occasions, an eight-by-ten-inch menu printed on heavy stock was distributed at each place setting. Adorned with a fancy gold metallic ribbon

and a string of gold stars tied in a festive bow, this document announced in a combination of French and English the culinary program for the evening. For example:

14 January 2005

Mickey Easterling
Honoring
Daniel Martin
et
Frederick Fieux
Friday Eight o'clock in the Evening

-Menu-
1990 Champagne Brou de Lauriere Brut & Cocktails
Pate de Fois Gras Daniel
1994 Clos St. Urban Rangen de Thain Pinot Gris Grand Cru
Domaine Zind Humbrecht
Chilean Sea Bass avec Grape Leaves Emballage
et Roasted Pecans Butter
1996 Pouligny-Montrechet Grand Cru
Domaine Louis Carillon
Cotelette Agneau de Roti et herbs de Provence
Avec Legume L'Enfant
Salade Verte avec Danish Blue Cheese & Pecans
1989 Chasse-Spleen Mouli en Medoc
Mis en Boutille au Chateau
Fresh Pear avec Marzipan en Goldwasseur
1990 Gratien & Meyer Fleur de Lys Vin Rouge Mousseux
Coffee
Champagne Veuve Cliquote Ponsardin en
Magnum

Assorted Cognac et Brandy

Afterwards, the satiated guests retired to the formal French-decorated living room, where they were plied with even more alcohol as they indulged in much gossiping late into a well-inebriated evening.

One Easter Sunday, Mickey assembled a group of her friends for an afternoon luncheon. After an extended cocktail hour, her half-inebriated guests were invited to go outside on a hunt to gather eggs, hand colored by her and hidden around the house with the assistance of her gardener. One person in their eager quest for these decorated oval treasures fell into the swimming pool. Not to worry, that was just part of the fun! However, unlike the Gatsbyesque sumptuous atmosphere and frivolity, lunch—fried chicken and all the fixin's—that day was prepared by Monsieur Popeye's and served buffet style on freshly polished silver platters.

Mickey and I often went out on the town to dinner parties, charity balls, and other festive occasions. One evening, after attending the annual Fellows black-tie dinner at NOMA, she suggested, as was often the case, we go for a nightcap at one of her favorite haunts, the Polo Lounge at the Windsor Court Hotel. After causing heads to turn as she entered this swank watering hole wearing ropes of pearls, a floor-dripping silver fox boa, and veiled chapeau, and having had a few glasses of champagne, I suggested we move on to one of *my* pubs for another cocktail. She was game. We were on our way to being pretty oiled by this time. Off we went to Vaughn's in the Bywater to learn we were too late—they had closed. No matter, we proceeded to another in the 'hood—the infamous Saturn Bar on Saint Claude Avenue. When we entered this dimly lit den, there were only a few left standing at the bar. I don't know who was in more shock at what was transpiring at the early hour of the morning, the bedecked Mickey or the questionable characters assembled across the room, as we slid into a booth for one final drink for the evening.

As a longtime patron of Galatoire's, she was incensed, along with many other regulars, when the restaurant made some changes including the cessation of serving hand-chipped ice in favor of ice cubes. That just wouldn't do! In protest, she had a full block of ice with ice picks delivered directly from the icehouse to her table.

When Galatoire's reopened after Katrina on New Year's Day 2006, Mickey and I arrived promptly at noon and, at a table for two, proceeded

to drink, eat, drink, visit with other encamped diners, and drink some more. I lost track of the number of bottles of Veuve Clicquot we emptied that day. While I was getting inebriated, Mickey was quietly sipping coffee and remaining relatively sober. Being an inveterate smoker, she lit up cigarettes all day in defiance of the no smoking rule in the restaurant. When a neighboring table would complain, she would extinguish her smoke with apologies only to relight another later on. This was repeated all day long. We finally staggered out of the restaurant at 8:30 that evening.

For more than thirty years, Mickey had taken a villa in Tangier, Morocco, first at York Castle, on a cliff overlooking the sea, and later at Dar Zero, located close by, after the castle tragically collapsed into the bay as a result of insufficient shoring during a reconstruction of the hill. She first met the owners of these luxurious residences—the late interior designer Yves Vidal, once president of Knoll International, and his lifelong partner, Charles Sevigny—when the worldwide children's charitable organization Le Bal des Petits Lits Blancs held its lavish jet-set benefit gala in New Orleans in May 1976. Among the international celebrities who came to the Big Easy for this grand event was Valéry Giscard d'Estaing, the sitting president of France.

I was privileged to have been invited twice, in the summers of 2005 and 2009, as her guest at Dar Zero located next door to the Kasbah and literally around the corner from Barbara Hutton's large digs. Surrounded by a lovely, quiet interior courtyard with an ancient, twisted olive tree, Dar Zero was a multilevel hillside manse with multiple bedrooms and open terraces with panoramic views of the bay below. Far in the distance, the tip of Spain could be detected, somewhat similar to Sarah Palin being able to see Russia from her doorstep. A staff of seven kept the house running smoothly: Abdullah (majorduomo), Said (chef, chauffeur), his younger brother Rashid (houseman), Anwar (houseman), Hemo (sous chef and housekeeper), Kaltoum (maid), and Ammed (watchman and gardener). This most amicable group, all Muslim, was fiercely loyal to Charles and Mickey (the only person Charles would allow to rent to), and the young men were commonly referred to as "the Boys." It was obvious they were highly amused by Mickey's uncon-

ventional ways, and she maintained a close rapport with them. While each had his position and responsibilities, which they took seriously, they became more like members of the family, much like characters in *Upstairs, Downstairs* or *Downton Abbey*, sharing the news in the 'hood and humorous anecdotes concerning Charles and Mickey's neighbors and guests.

And what a lively, colorful cast of characters they were! First, there was Carla Dodge-Amtrins, an older French woman formerly the host of York Castle who thought that her past rank gave her license to be manipulative and deceitful with others. However, many found her transparent motives most disagreeable, and she definitely wore out her welcome. Then there was a Peck's Bad Boy and Carla detractor, Daniel Martin, a gay Frenchman who has had for many years a much older partner living outside of Toulouse. Known for his small glazed ceramic models of buildings for the rich and famous, Daniel was the head steward for British Airlines international flights. He claimed to have been the lover of both Malcolm Forbes and Kuwaiti princess Fatima Al Sabah. Not to be outdone in mischievousness was handsome Vincent Poppée, another young gay man in his forties who was born and raised in Kinshasa, the Democratic Republic of Congo, and now lives in a spacious, beautiful modern house with a large blue-tiled pool, a pool house, and guest cottages spread among the large manicured lawns and gardens. When Daniel and Vincent got together, it was most likely they were up to no good, whipping up some devilish trouble or possibly some devious plot against Carla.

Adding to the mix was Jean-Louis Riccardi, a Parisian decorator for Christian La Croix boutiques, who had a beautiful large house and gardens located above the ocean shore next door to neighbors Pierre Bergé and Yves Saint-Laurent. Located nearby was the tastefully decorated house of genial Chilean painter Francisco Corcuera, whose art is represented by Marlborough Galleries in New York. He always dressed with the flair of colorful jacket, tie, and pocket square. Another man, Bruno, had a grown daughter with children and a handsome Parisian boyfriend who was then in Tangier as a contractor remodeling a local hotel. Rounding out this bevy of gay men was the most affable James Lee, an older American living in Palm Springs, formerly in the diplomatic corps.

The men were not alone in their distaste for Carla. Certainly, one of my favorite women in this Tangier social mix was Madame Claude Guarangaud, the former wife of the former French minister of cultural affairs and ambassador to Japan. She was the quintessence of elegance and style and reminded me of Jennifer Jones in her heyday. Her beautiful home with an elevator was located at the Kasbah Gate and was for sale, at the time, for $2 million. Equally impressive was the cute, petite Lady Gay Baird, in her late eighties, the former lady-in-waiting to the Queen Mum. She drove herself everywhere from country to country (I wonder who would rent her a car at her age). She was outranked in age by Tangier resident Dougie Harback, in her early nineties, from Oklahoma, who went on to international fame in the 1930s and 40s as a Christian Dior model. French countess Elizabeth DeBret was another sweet, older grandmotherly type who was beloved by all. Yet another standout was Brenda Young, a French Canadian who had an extremely popular nightclub/disco/restaurant/swimming pool complex on the beach downtown. A highlight of the very active social whirl was her annual party for three hundred in her house in the hills outside the city. Very well liked by all was Anna, wife of Ahmed, who when she had too much to drink at Jonathon Dawson's Follies one evening was taken home from the party up the long, steep hill in a wheelbarrow.

An invitation to one of Mickey's functions at Dar Zero was always a prized ticket by all. On one particular occasion, in honor of her American houseguests Barbara Fransheim of Houston and *moi*, she had invited forty of her nearest and dearest for cocktails from seven to nine. Later, eighteen of those chosen ones stayed on for a formal candlelight seated dinner à la Mickey on the lower terrace. The prescribed limits and the confines on table space were dictated by Charles.

My only response to her regarding any requests I may have had during my visit was that I would like to meet Claudio Bravo, the international well-known Chilean artist living in Tangier. For Mickey, my request was her command. Claudio was well known for not participating in dinners of more than five, so when he accepted her invitation for both cocktails and dinner, it was a surprise to everyone. He said he would not arrive until eight o'clock as he worked a nine-hour day until seven.

Besides the fabulous multicourse dinner prepared by Said, the talk of the evening by the assembled who's who in Tangier was that Claudio had agreed to come at all. Mickey had done the impossible. Not only did he come bearing an enormous bouquet of blue and pink hydrangeas in both arms, but at the end of the evening said he had a marvelous time, and it showed.

Mickey had seated Claudio to her right and me to his right. He and I enjoyed chatting about art in general and the current art news and gossip as none of the other dinner guests was conversant in that area. I was surprised to discover that he was a friend of Bob Barron, a New Orleans physician and collector of fine Chinese porcelain, and he was saddened to learn Barron had died. I asked him which living artists he most admired. Even though he was not living, he immediately said Picasso. He also talked about Gerhard Richter as one of his favorites. When I mentioned Anslem Keifer, he responded, "Too Wagnerian!" Others I suggested were Morandi ("loved him") and William Bailey ("liked his work").

As he was leaving, I asked if I could come to his studio, and he agreed and told me he was starting work on a large triptych. When I inquired if it was a commission, he responded with defiance, "I don't do commissions anymore!" Regrettably, the visit never materialized as I suspect he was led to believe I wanted something from him, but, alas, that was not the case.

Dining at Dar Zero was always a special treat. Lovely quiet breakfasts set up in the garden courtyard were a time to leisurely review the events of the night before and to plan the schedule for that day. Tangier was a very social city, and we dashed off here and there almost every day to a luncheon or dinner at a host's home or a restaurant. On those rare occasions when we dined alone at home, Said created a wonderful menu or cooked Mickey's or her guests' special requests. I had two favorite dishes, which I specifically asked for. One was a lamb tagine liberally sprinkled with whole toasted almonds. The other was a dish, tricky to successfully execute, called *brique*. It consisted of tricornered phyllo dough folded to create a closed pocket containing a mixture of cheese, herbs, and uncooked egg. After this sealed packet was deep fried to soft cook the egg and melt the cheese, the crisp pastry shell was

cut open to reveal the contents slowly flowing out to make a sublime dining experience.

Jonathon Dawson, an Australian, had a penthouse apartment with roof garden in an old five-story building in downtown Tangier. The elevator didn't work; therefore, we had a long schlep up the winding stairs. Once we reached the summit, we were greeted by wide-open doors leading into an entrance hall and small-roomed apartment filled to the gills with marvelous, wonderful things. Every nook and cranny was populated with delicious furniture, paintings, sculptures, rugs, objets d'art, bibelots, trinkets, gee-jaws, and an eleven-year-old pet rooster sans wings aptly named Birdie, who greeted you at the door with a loud cock-a-doodle-do. Then there appeared his manservant, a small Arab man with handsome sharp features wearing a royal blue caftan and a dark red tasseled fez. He ushered us out to the terrace garden where cocktails were being served. The garden was filled with more of the same plus a caged green parrot sans wings and a small crimson Malaysian parrot. When lunch was announced, and as I passed the red bird's cage, I noticed the cage door was ajar and the bird missing, only to discover he had been transported to the round dining table and positioned in the midst of the centerpiece, a beautiful tight bouquet of coral roses. There he politely and assuredly held court all during the multicoursed luncheon served by the costumed manservant with Birdie roaming under foot looking for dropped crumbs and me with the former lover of Francis Bacon to my left, who was a costume designer for the cinema, with such films as *Lawrence of Arabia* to his credit. Once again: Toto, we're not in Kansas anymore!

After several years of failing health, Mickey died peacefully on April 14, 2014, at her beloved home at 1744 Lakeshore Drive. Her daughter, Nanci, called me at five o'clock that morning to tell me the news: "The grande dame has passed, and I didn't want you to hear it from someone else. Go back to sleep, and I'll be in touch with you later."

When she called me later that morning, she said her mother's wish had been that her funeral should be at NOMA as she considered herself one of its leading patrons. One of Nanci's weddings had been at the museum years before and was one of the most opulent and memorable

events in the institution's history. Her mother's desires were quite specific. She wished to attend her own funeral dressed in her best finery and wearing one of her signature chapeaus, seated upright in her coffin with arms outstretched, holding her cigarette holder in one hand and a champagne glass in the other!

I told Nanci I would consult with others at the museum concerning the feasibility of this unorthodox request. After director Susan Taylor and I discussed this at length, I told Nanci that the museum would be honored to have a memorial service for Mickey in the museum's auditorium or sculpture garden, but we would not agree to a funeral service with a body. I told Nanci possibly her mother's plans could best be honored instead by staging the event at the Saenger Theatre as Mickey was one of the owners.

Over one week after her passing, an event was staged in the lobby of the Saenger with Mickey's body propped up on a wrought-iron bench, eyes closed, and dressed as she had requested, including wearing her trademark rhinestone brooch proclaiming "#1 BITCH." Many of her friends gathered in a macabre cocktail atmosphere, sipping champagne and munching on hors d'oeuvres. I did not attend as I had a previous engagement in Baton Rouge where artist Wayne Amedee was receiving a prestigious arts award. *The New Orleans Advocate* newspaper published on the front page an oversized color photograph of Mickey seated on the bench with the large headline "Outside the box: Socialite throws one last party—for her own memorial."[10] This outrageous display went viral on the internet for days. In August, guests visiting New Orleans Auction Galleries were feted with shrimp and grits, quiche Lorraine, and flutes of champagne as they bid on Mickey's 240 chapeaus along with a selection of handbags, fur wraps, and a leopard coat.

Shortly before Mickey died, I had a most unusual experience. Elizabeth Shannon and I went to the reopening of the Saenger Theatre to see the musical *The Book of Mormon*. Our seats on the main floor were on the aisle, last row. After the performance began, a group of half a dozen entered through closed doors next to me and were having trouble finding their seats in the dark. They were holding champagne glasses and noisily talking, disrupting the performance on stage. I tapped one of the women

on her back and asked that they be quiet. After about five minutes and several polite requests, all of which were ignored, they finally found their seats. The next thing I knew, a policeman came through the door and asked me to step outside. In the lobby, he informed me I had a choice: either leave now or be arrested. My offense: touching someone! I asked to see the manager and was told he was not available. I figured either way I would not see the rest of the production, so I chose to go home. The policeman would not allow me to tell Elizabeth I was leaving; he said he would tell her (which he didn't). Shaken, I left and decided I was not going to complain and just blow the whole thing off as a bad experience.

Two days later, I remembered Mickey's connection with the Saenger, so I called her and told her what had happened. "What!! God dammit, your first mistake was not calling me for tickets! Whenever you want them, you just call me." She said she would call the manager to reprimand him for such behavior. After some more discussion, she figured out what had happened. There is a lounge in the theater where VIPs can go before the performance. Evidently, they were having such a good time they didn't realize the performance was to begin shortly, therefore rushing to their seats and causing me to miss the musical. In the end, it really didn't matter as I was offended by the cliché, caricature portrayals of African tribal peoples in Africa.

Leah Chase

Leah Chase, known as the Queen of Creole Cuisine, was legendary in the American culinary world. Leah and her husband's restaurant, Dooky Chase's, was the place where in the 1960s Black leaders often met covertly in a second-floor dining room to discuss strategy during the civil rights movement while eating her gumbo and fried chicken. Among the who's who organizers during that time were the Reverend Doctor Martin Luther King Jr. and his father, "Big Daddy"; James Farmer; Julian Bond; Thurgood Marshall; and New Orleanians Revs. A. L. Davis and Avery Alexander; Oretha Castle Haley; Israel Augustine; Rudy Lombard; Sam Cook; future judge Revius Ortigue; Dave Dennis; Kalamu ya

Salam; Nathanial Bird; Ernest Wright; and future mayor Dutch Morial. The single Caucasian participant was the mayor at the time Chep Morrison. There existed two widely differing camps: those who aspired to follow a program of nonviolent civil disobedience inspired by Mahatma Gandhi and the more extreme militant protestors. The meeting ground for much of this ongoing debate and planning centered around Dooky and Leah's small room on the second floor of the restaurant.[11]

Over the years, she had cooked for many famous figures in the art, entertainment, and political worlds, including several American presidents. When Barack Obama asked for some Tabasco sauce for his gumbo, she politely but firmly informed him, "Mr. President, you don't need any Tabasco for *my* gumbo."

Leah's love for art was most evident in the display on the restaurant's walls of her impressive collection of African American contemporary art. She was a vigorous patron of the arts and had been over many years an active supporter and board member of NOMA. Her late friend Celestine Cook had encouraged Leah to become involved with the museum at a time when Blacks rarely came to the museum and were virtually nonexistent on the board. Her quiet generosity was manifested for many years by supplying bountiful buffet luncheons without charge for the Women's Volunteer Committee meetings or any other needed occasion. She was unwavering in her support of my efforts to build an African art collection at NOMA. On another occasion, I arranged for her and food writer Jessica Harris to give a program in the museum's auditorium conversing about creole cooking.

Leah and I both sat on the board of Prospect New Orleans, the organization that presents the series of international contemporary art exhibitions in New Orleans called Prospect. After the opening ceremonies of each iteration of this three-year series of exhibitions, Leah provides without charge a buffet luncheon of her famous cuisine to any and all attending. After the opening of Prospect.1, I invited Leah to lunch at a restaurant of her choice. We had a lovely time at La Peniche in the Faubourg Marigny neighborhood, and she giddily rode with me in my small sports car down to the Lower Ninth Ward to see the biennial installed there and visited with photographers Chandra McCormick and Keith

Calhoun at their L9 Gallery. Their excitement at having Leah come visit their gallery was touching.

Leah's voice on cultural, social, and political issues was insightful, straightforward, and respected. Her position on any number of topics reflected her often strong convictions and the depth of her wisdom and experience. While she rarely came out into the dining room to greet and discuss issues with her guests as she often did in earlier days, she held court most every lunch in her active kitchen, sitting at a small table receiving her friends and admirers while peeling potatoes or chopping up vegetables.

Following my buffet lunch in the dining room, I would look forward to what had become a monthly visit with her in the kitchen to discuss recent local events and problems, talk about plans for action, and share opinions and gossip. During a "kitchen chat" a couple of years ago, she told me that the mayor had brought the editor of *Essence* magazine to the restaurant on the first day of the annual Essence Festival in the Superdome. Leah said she had suggested to the woman editor, "Stop publishing all those pretty people in your magazine, and instead tell mothers that they should mind their children."

On another recent visit to the restaurant, I had lunch in the dining room and afterwards went into the kitchen to see Leah for a prescheduled meeting. When I arrived, she was lying in wait for me, and she most definitely was not pleased! When I asked her what was the matter, she said to me in a most disapproving tone, "You put your fingers in the salad bowl in the buffet line!" I was unaware that I committed that transgression and apologized. She said, "You're just like Sunny Norman. She put her fingers in everything!" Leah and Sunny were close friends, and their admiration and support for each other was legendary. All during my dressing down, Cleo Robinson, Leah's niece and the fry cook, and other kitchen staff were standing around in the background having a good laugh about what was going on. After more discussion on the subject, Leah repeated her reference to Sunny to which I responded, "Well, you know Leah, I take that as a compliment."

Several days later, I felt bad about upsetting my friend, so I took her some roses. Little did I know that at that moment it had just been

announced that after weeks of the *Times-Picayune* newspaper coverage of who made the best fried chicken, Leah had been declared the winner of this highly sought-after title. She was elated and was standing in the kitchen wearing a handmade paper crown with the handwritten title CHICKEN QUEEN. I took her picture proudly wearing her symbol of excellence. I explained I was not bringing the flowers because of her new accolade, but to apologize for my misbehavior earlier in the week. She said, "Oh, you mean the Sunny thing," to which I responded in the affirmative.

Leah died at ninety-six, at her son's home Saturday June 1, 2019, after a brief illness. Her passing was the primary story reported on the television news and dominated the front page of both local newspapers and the *New York Times* with a color picture of her with President Obama with a mouthful of her gumbo with the cutline referring to her chastising him for requesting hot sauce. The *Times* article observed, "Mrs. Chase possessed a mix of intellectual curiosity, deep religious conviction and a will always to lift others up, which would make her a central cultural figure in both politics of New Orleans and the national struggle for civil rights."[12]

Among the numerous tributes was her quote included in *The New Orleans Advocate* editorial, "'Food builds big bridges,' Chase said in an interview last year. 'If you can eat with someone, you can learn from them, and when you learn from someone, you can make big changes. We changed the course of America in this restaurant over bowls of gumbo. We can talk to each other and relate to each other when we eat together.'"[13]

Ian McNulty best encapsulated her essence with his simple newspaper statement, "Her determination, her kindness and her courage to chart unconventional paths left a lasting mark on the worlds of New Orleans food, culture, art and politics."[14]

Elizabeth Catlett

In the 1980s, John Bullard suggested the museum give Elizabeth Catlett, the internationally known artist, a retrospective exhibition. As the first meeting with her in John's office to discuss and plan the exhibition was

concluding, I asked her if she had time for me to give her a tour of the galleries. She enthusiastically accepted, and as we were walking up the steps from the basement offices, she told me, "You know, I am so pleased by your offer to give me a personal tour of the museum. In the 1940s, I was planning to bring my students (she was the head of the art department at Dillard University) here but was not allowed to enter City Park because of our race. Therefore, it is very meaningful to me for you, the curator, to personally make this offer to me." I told her, "It is very meaningful for me as well."

She and I remained friends and got together whenever she came to town.

Mignon Faget

Mignon is a living legend in New Orleans. She is an artist whose jewelry is *de rigeur* for fashionable New Orleanians. Heavily based on the natural flora and fauna of Louisiana and culture of the beloved city of her birth, her name and wearable sculpture are synonymous with good taste and design. Wearing a piece of her jewelry is a badge of elegance and discrimination.

I first became aware of her in 1969 through an at-the-time trailblazing magazine spread featuring her new clothing line worn by chic feminine models posing among tough, masculine bikers and astride their "hogs" under the Spanish-moss-draped live oaks in Audubon Park. How incongruous! How outrageous! How cool!

Through our mutual passionate beliefs and abiding interest in the transformative character of art and its rich history, the wonders and beauty of the natural world as well as the essential need for the preservation of earth's bounty and manmade achievements, we became fast friends and have shared over the years many wonderful experiences.

We first kept running into each other in the early 1970s on our mutually independent forays to the Cajun country to enjoy the music and landscape, fraternizing with the locals and experiencing the culture there. Dancing, eating, having a good time—that's what life was all about

then. Cajuns worked hard, and they played hard, and we wanted to be a part of it.

For a number of years, Mignon rented a simple cabin with a couple of bedrooms and a magnificently extensive screened-in porch looking out over marsh land on Bayou Paquet on the North Shore. I was a frequent guest of hers, and this getaway afforded us the opportunity on extended weekends to let our hair down, cook, gossip, swim, read, "laugh and scratch," and explore the vicinity by foot through the woods or by canoe through the marshes. The enchanting chorus of frogs serenaded us during the summer months in the evening and throughout the night. A similar scenario was carried out many times in another of her rentals at a large old house named Witchwood with a wide wrap-around screened porch in a pine woods at water's edge on Perdido Bay in Florida.

In late spring 1990, Mignon and I took an archaeological trip to Mexico, beginning in Villahermosa, to visit the major Olmec site at La Venta. Then we moved on to the enchanting and splendid Maya site Palenque, set in a tropical forest on the edge of the mountains where we would spend several days in an adjacent and rather primitive country "resort" with individual cabins and communal dining room along a river bank. While sitting on the open porch of my cabin overlooking the river in the dense forest in the late afternoon, the winds would blow up, and dark clouds would form before heavy downpours lasted all night long, only tapering off gradually.

At the ruins, there was a sound unique to this site and not heard at our hotel only a couple of miles away. In the trees surrounding the archaeological grounds were insects emitting the most eerie, long mournful call in a pronounced dissonant, minor key. They definitely created a mood of this destroyed and abandoned ancient civilization, which had so many unanswered questions.

When climbing up the steep mountain slope, behind the Temple of the Inscriptions with its rough, rocky trails mudding from the previous night's rain, Mignon and I heard what sounded like a large animal roar up ahead. Thinking it was a Howler monkey, we decided to forage ahead and attempt to find it in spite of its fearful sound. As we approached, the sound grew louder and louder. When we located the tall cieba tree

that he was in, we could not see him through the dense vegetation, even through our binoculars. His roar was quite long and loud and truly frightening. We heard another one off in the far distance. After we waited awhile, he suddenly stopped, leaving only the other sounds of the forest, the many birds and insects.

Hazel Guggenheim McKinley

Hazel had a slight British accent, the result of having lived in England for more than forty years. Her life in New Orleans, the city of her late last husband's birth, was indeed modest and low key, certainly much less glamorous and grand than her past. Born in New York into the fabled wealthy Guggenheim family, her life was colorful and, it seems, a series of tragedies. Her father perished in the sinking of the Titanic, she survived numerous unsuccessful marriages, and her two infant sons fell to their deaths from a New York skyscraper. It was rumored she pushed them, but it was never proven to be true. Rebelling, she and her sister, Peggy, fled to Europe in the 1920s, where they associated with the avant-garde. Hazel painted and executed watercolors in a manner related to Utrillo and Dufy. In 1943, Peggy once showed her sister's work at her famous influential gallery, Art of this Century, in New York. Three years after Hazel's death in 1995, one of her paintings was shown at the Palazzo Vernier dei Leoni, the Venetian home of the Peggy Guggenheim Collection.

Hazel and her sister were estranged, and while living in New Orleans, she would never talk about what created the schism. She lived a simple life and went mostly unnoticed, except when she would arrive at a party or restaurant carrying her ever-present inflated rubber tube housed in a cloth bag to sit upon. She continued studying art at Newcomb College into her eighties, making whimsical scenes in colored pencil even while bedridden. She was welcomed into the New Orleans art community and was affable and unassuming but reluctant to talk about her once glamorous life associating with the European artists who had become famous and were now recognized for shaping the art of the early twentieth century.

John Hohnsbeen (a.k.a. "The Third Mrs. Johnson")

I rather doubt that John Hohnsbeen ever met Hazel on his frequent sojourns in New Orleans to visit with our mutual good friends Shirley and Leclare Ratterree. John was for many years the unpaid "man Friday" for Peggy at her Palazzo in Venice and acted as her private secretary, confidant, and art curator. John was cynical, and his caustic wit was legendary. Oh, the stories he told!

His life was noteworthy in itself. While John was the gallery assistant for Curt Valentin at his legendary Buchholz Gallery in New York, architect Philip Johnson, gallery hopping with Blanchette Rockefeller, didn't buy any art that day but picked up the good looking twenty-four-year-old John at the gallery instead, resulting in the breakup of Philip's relationship with writer Christopher Isherwood. This new liaison lasted a decade and resulted in John being referred to as "the Third Mrs. Johnson." John's penchant for living a life in luxury and a strong desire for being in the company of the glamorous was certainly fulfilled with his prolonged relationships with Philip and Peggy.

When Peggy Guggenheim died in 1979, John was vacationing away from Venice and immediately called Tom Messer, then director of the Guggenheim Museum in New York. According to John, he was told not to bother returning to Venice as he suggested. This abrupt dismissal created a controversial tempest in the press. John's friend, historian, and writer John Richardson wrote, "It was . . . Peggy who told me that she wanted John Hohnsbeen to carry on as her curator [after her death.] For some years he had helped her run the place on a shoestring for no pay, and he knew better than anyone how she liked things done. Hohnsbeen would have carried out Peggy's wishes more scrupulously than the present incumbents."[15] A heavy smoker for many years, John died of emphysema in 2007 in Santa Fe.

Thelma Toole

Thelma, a retired New Orleans school teacher, was in many ways a grande dame. Through her untiring devotion and persistence, she got

A Confederacy of Dunces, her late son's Pulitzer Prize-winning novel, published. This acknowledged masterpiece became a nationwide sensation and long-running bestseller.

As a result of all the notoriety and publicity generated by its instant success, this indomitable mother became a colorful personality in her own right. Opinionated and possessing a sharp wit, she was fun to be with. She flourished being in the limelight by appearing on nationwide television talk shows and giving numerous interviews. With a tasteful silver coiffure and wearing bright red lipstick, too much rouge, and ropes of pearls around her neck and draping over her chest, her overall demeanor and careful elocution could command attention. Once when asked where she lived, she grandly replied she resided on Elysian Fields enunciating the street's name with an affected flair. What she failed to indicate was that her modest shotgun house was located across from Schwegmann's, the ubiquitous discount grocery store chain.

Jan Aronson Bronfman

I first met artist Jan Aronson when she was hired by NOMA to teach the museum's summer art classes in the early 70s. She was the daughter of Meryl Aronson, whose family interests were Shoe Town stores in the New Orleans area. Meryl was a friend of NOMA. Artist Chester Kasnowski was working in the museum's education department as well, and Jan and Chester soon became an item and later married and moved into an A-frame house in Vermont, where they lived for several years before they divorced, and she moved to New York.

While still in New Orleans, Jan and Chester were good friends with me and my partner at the time, Ernie Mickler. One September, as we were all young and struggling with our finances, the four of us shared a room with two double beds in an inexpensive motel in back-of-town Morgan City, Louisiana, to attend the weekend annual regional celebration with the incongruous title of the Shrimp and Petroleum Festival.

Leaving Vermont, to advance her career as a painter, Jan eventually moved to New York City, where she met Edgar Bronfman Sr., the chairman and CEO of Seagram, Ltd., president of the World Jewish Con-

gress and Presidential Medal of Freedom recipient. After an extended courtship, she agreed to marry him in 1994. While she was younger, he encouraged her to pursue her career as an artist and go on arduous trekking trips to remote areas of the world, including Patagonia and the Himalayas of Nepal. They were a lovely couple and shared and supported their separate special interests. Those passions were blended well when they collaborated in publishing a Haggadah, a book that Jews read on the first night of Passover at the Seder table, with his writing the text and her drawing the illustrations.

My friendship with Jan has lasted over the years, with me often visiting her studio in Queens and having lunch with her either in New York or New Orleans. In November 2012 my New York friend, artist Aris Logothetis, offered to cook a dinner in my honor at his loft in South Bronx, Mott Haven, while I was visiting in the city. When he called Jan, whom he knew through a mutual artist friend, to invite her and Edgar, she said that they would be at their Westport, Connecticut, home that weekend. Later, she called back and suggested that she and Edgar cohost the dinner with Aris at their home there. After consulting the other invitees—art dealer Damon Brandt and his son, Clayton; photographer Phyllis Galembo; and filmmaker David Shapiro—we enjoyed a wonderful quiet evening in their baronial, informal lodge in the woods of Connecticut. Edgar died in his New York home on Fifth Avenue one year later.

Yashodhara Raje Scindia

New Orleans's only royalty rules at Mardi Gras and in the gay bars in the French Quarter. That was the case until Yasho moved to town with her new husband, cardiologist Siddharth Bhansali. Her family's princely state, Gwalior, was one of only five of the more than three hundred autonomous princely states to be accorded (before India abolished royal titles at the time of its independence in 1947) a twenty-one-gun salute from the British to the reigning maharajah. However, Yasho was raised in the family's more than nine hundred-room Italianate Jai Vilas Palace,

built by her grandfather, the maharajah. He commissioned and installed in the enormous Darbar Hall the largest known chandeliers in the world, each weighing two tons. As a test, the maharajah offered to first have his favorite elephant hoisted up in their place. The trial was a success, and the installation proceeded with a new assuredness. As he was a railroad buff, he had fabricated a miniature motorized train of solid silver that rolled on its tracks and stopped in front of each guest at the banquet table to serve liqueurs, cigars, and candy.

Yasho and Sid met through their love of horses and riding. Before they even had been formally introduced, she told him, "There's no point in talking if you don't want to marry me." Her family strongly opposed her marriage to a commoner, but she was resolute. Their wedding day was the day Prime Minister Indira Gandhi lost the election, which made Yasho's mother, the *rajmata*, extremely happy. Earlier, Gandhi had sent her, a political leader of the opposition National People's Party, along with the *rajmata* of Jaipur, to prison for countering her during the 1975–77 state of emergency.

Left alone to run and defend the palace, a totally inexperienced twenty-year-old Yasho quickly learned how to write a check and fend off government agencies opposed to the abolished monarchy. Compounding the situation, the *rajmata*'s son, Yasho's brother, joined the ruling Congress Party and was a member of Parliament across the aisle from his mother. The Scindia family feuds over politics, money, and property were quite public, with newspapers reports of the ongoing rift.

Yasho and Sid quickly became socially acquainted with New Orleanians. They made friends with the art crowd, particularly Sunny Norman and Muriel Francis. This handsome couple gave large cocktail buffet dinner parties featuring delectable north Indian cuisine in their bungalow house on fashionable Audubon Boulevard filled with art, particularly Indian and eighteenth-century sporting paintings.

I became acquainted with them through our interest in art and Yasho's involvement with the New Orleans Museum of Art. She appeared to relish living a commoner's life. This vivacious, smart, beautiful woman was most accessible and became an active member of the community. As a young mother, when once interviewed by the media, she was asked

how she resolved the difference of having the public bow to her, kissing the hem of her skirt in her native India and then being an everyday housewife shopping at the supermarket. She quickly answered, "You know, it's easy. Once a princess, always a princess."

This distinction became clearer to me when in early 1984 I led a group of museum patrons on a trip to India. During one of our stops, we were the overnight guests of Yasho and her mother in one of the many adjacent buildings of the main Jai Vilas Palace in Gwalior. Upon our arrival, Yasho did not come personally to greet us. Instead, I was sent a formal note from her giving me detailed instructions of how to bathe without running water. That evening, we were the guests of the *rajmata* and Yasho for a lovely buffet dinner in the living quarters of the main house. (The silver train was not needed that evening in the private dining room.) The next day, our group's day coach followed Yasho to the neighboring town of Shivpuri, where we visited the lavish Scindia royal family tombs and gardens. It was during this stay that I first fully realized my fun-loving friend from New Orleans was indeed royalty and performed her duties with grace and restraint when in India.

Corinne "Lindy" Boggs

Being a "walker" definitely has its advantages, and spending one-on-one time with Lindy was a case in point. Lindy was the widow of US House Majority Leader Hale Boggs and succeeded him herself, serving nine terms in Congress. After her retirement, President Bill Clinton appointed her the US ambassador to the Holy See at the Vatican.

Our outings together were often routine: it was agreed I would pick her up in my Porsche sports car at her lovely house embedded in the heart of the rowdy bars, bawdy nightclubs, and strip clubs along Bourbon Street in the French Quarter. I would pull up and illegally park (under the watchful eye of the New Orleans policeman on street duty) on Toulouse Street at the corner of Bourbon and walk half a block to meet her at her house. The two of us then would wind our way through the crowds on the street with the employees of her neighborhood empo-

riums forming an unofficial protective security guard clearing the way along the street while offering her an admiring, friendly greeting, "Good evening Miss Lindy." "Have a nice evening, Miss Lindy." She was definitely in good hands, and they were not going to let anything happen to their friend.

She was widely beloved for her infectious smile and quiet, gracious manner, and I would stand back in public appearances to give space to her many friends and admirers. She loved being with them. Her gentle, soothing voice gave one an assuring sense of calm. Spending down time with her in the car was a pleasure and made me more aware of her wonderful giggle and sense of humor. I cherished my opportunity to talk politics and discuss current events and issues as we were pretty much on the same page.

On one occasion, she left her gold and pearl clip-on earrings in my car. I never remembered to return them. Several years later, in 2013, I took them to her funeral at Saint Louis Cathedral, and when I expressed my condolences to her daughter, journalist Cokie Roberts, I handed the earrings to her and explained how I happened to have them. She smiled warmly, thanked me, and said, "I'll give them to her grand-daughter. She will love having them."

Stephanie Smither

One autumn in the 1980s, I was invited by Lillie Lamas from Atlanta to give an illustrated art talk to a ladies-who-lunch group in Houston, Texas. She would provide a handsome honorarium, round-trip airfare, and expenses for my services. She required I sign, which I willingly did, an elaborate legal document guaranteeing I would not renege on my commitment. On the appointed day for my presentation, Lillie was unable to make the trip from Atlanta, but all went well until it was time for me to return to the airport for my return flight to New Orleans later that evening. Feeling abandoned, I was at a loss. Finally, a nice, attractive woman volunteered to take me around to the museums and galleries in Houston before my return flight. We hopped into her Jaguar and became instant

friends during my afternoon tour. Her name was Stephanie Smither. The irony of this situation was that Mrs. Lamas was the one who reneged on me for the reimbursement of my expenses and honorarium after making me sign a binding contract for the very same thing.

Approximately a month later, I received a telephone call from a lawyer in Houston who identified himself as John Smither. He explained that I had informed his wife of a trip I was coplanning with the Museum for African Art in New York for a group to travel to West Africa, and he wanted to give her this trip secretly as a Christmas present. The trip was arranged for her and several other art collector friends I had convinced to go, including Houstonian Balene McCormick and New Yorker Bert Hemphill. The upshot was all the New Orleans people who had begged me to set this trip up backed out, and I could not colead the group. My three friends, not knowing each other beforehand, all bonded on the trip, while this matchmaker sat at home. Their new friendships lasted long after their return home as did mine with each of them.

Stephanie and I, along with John until his untimely death, shared a passionate interest in the work of self-taught artists following the lead of Bert, who was our mentor and leader. I visited my new best friends often, in Houston and New Orleans and at their lake house in Huntsville, Texas. Many a wee hour was spent discussing artists, dealers, collectors, and curators who contributed to this new field of folk art. There was no subject off limits during these marathon conversations.

Twice I was invited to be a judge at the Art Car parade and weekend sponsored by the Orange Show in Houston. This wonderful, elaborate site by the late mail carrier Jeff McKissack pays tribute to his favorite fruit. The site is now called the Orange Center for Visionary Art and includes the Beer House and nearly completed Smither Park.

Stephanie had undertaken this mammoth project of building a folk-art green space dedicated to her late husband. This outrageous, fanciful, functional play land features a covered stage, meditation garden, four-hundred-foot memory wall, pavilion, bench swings, and tower for rolling marbles. This whole environment was designed by Huntsville-based visionary artist and builder Dan Phillips. Most of the surfaces of the various structures are decorated with a plethora of reused and

repurposed materials, such as broken ceramics, bottle caps, tiles, and seashells. I am proud that a portion of the memory wall has a small section I designed and executed.

Stephanie was the founder of what has become the Smither Family of commercial enterprises. With her daughters, Ashley Langley and Paige Johnson, Stephanie's original secret recipe for her homemade Texas-style salsa and dillapeño dip are now made and marketed nationally under the Smither Family Kitchen brand, while her son John Kerr operates the Smither Family Bed and Breakfast in downtown Huntsville.

The year 2013 was momentous for Stephanie. She started off by coming to New Orleans for my fabulous seventy-fifth birthday party at the Marigny Opera House on March 1. In July, she had a hip replacement. By early fall, she required an immediate double lung transplant. As her condition was rapidly deteriorating, it seemed her chances of finding a suitable donor were becoming futile.

I drove to Houston in early September to be with her and to discuss with her and the family the future of her massive, important, self-taught art collection. We all agreed that the ideal solution would be for it to remain in Houston at one of its great art museums. The Menil Collection was selected, and it was agreed to organize an exhibition of the donated pieces and publish a catalog. Miraculously, at the last possible moment, on October 1, a donor was located, and her double transplant was a success! Plans continued with the Menil for the exhibition as she made a marvelous recovery. She recuperated enough to attend the Outsider Art Fair in New York in early May 2014. We had fun and had dinner at Morimoto on the Lower West Side in the Meatpacking District. She continued to be active and worked diligently raising money and overseeing the construction of Smither Park dedicated to her beloved late husband John.

The Menil had scheduled the opening of *As Essential as Dreams: Self-Taught Art from the Collection of Stephanie and John Smither* on Friday, June 10, 2016. I arrived on Tuesday, June 7, a day before I was expected. Stephanie's condition had deteriorated considerably. It was quickly decided Paige, she, and I would have an impromptu quiet evening at home visiting and eating takeout.

The next night was the gala dinner for ninety people at the Menil, and I was privileged to sit next to Stephanie. She was radiant in her bright red dress, sitting in a wheel chair with an oxygen tank. The evening proved to be too much for her, and it was highly questionable she would be able to return the next evening for the public opening. But she was determined, and when asked if she felt like going, her response was, "Well, I could die here or I could die there. We're going." And she bravely did. After a spectacular opening, she returned to her bed at home surrounded by the family, while a prearranged post-opening after-party she refused to cancel was in full swing downstairs. My beloved friend died without waking up thirty-six hours later. She had a wonderful life and tenaciously lived to see her dream come true.

Sharon Litwin

Sharon was a leading force in the culture of New Orleans for the last quarter of the twentieth century. Her untiring work through the years led to achievements that have enriched the city immeasurably.

The first time I met Sharon was in the studios of WYES-TV, during the public television station's annual week-long art auction televised live. We were both dressed in formal attire as was the custom for this widely watched event in those days. Before going on air, Sharon, as a producer at the station, approached me as a presenter, to introduce herself to ask who I was and how I would like to be introduced. I explained I was a new staff member at the Delgado Museum and served as the curator of collections. Fine. As the auction was broadcast in October, I told Sharon I would also like to mention that the Odyssey Ball was approaching early the next month and remind the viewers to buy tickets and attend the museum's annual fundraiser. Not fine. Under no circumstances did she want me competing with the nonprofit station for support. Oh well. The time approached, and Sharon gave me a lovely introduction. As I was getting ready to begin presenting the art items coming up, I said, "Oh Sharon, by the way, I would like to mention that the museum's Odyssey Ball is fast approaching, and I invite the viewers listening to attend." Sharon was not pleased.

Thank God that did not nip our new friendship in the bud as Sharon became one of my closest, dearest friends. It's ironic that even though she opposed me promoting the museum while at WYES-TV, she later was my close colleague at NOMA for more than a decade as head of development and fund raising. As a journalist, she wrote for many years at the *Times-Picayune* and as the editor of the Zagat New Orleans Restaurant Survey. We had much fun trying out the new restaurants in the city and beyond. Several years ago, she colaunched with her journalist friend Renee Peck *NolaVie*, a pioneering website dedicated to covering and promoting the full breadth of the city's unique culture. That was in between her resignation at NOMA and becoming the administrative head of the Louisiana Philharmonic Orchestra for a number of years before retiring.

After a lengthy illness, through which she carried on valiantly, my dear friend died on June 24, 2016, thirteen days after Stephanie Smither. I so miss both of them.

Emily Cyr Bridges

In the early 1970s, I was the only curator at the Isaac Delgado Museum of Art and fielded daily telephone calls from the public seeking information about art or a particular artist, how an artist could have a show at the museum, if the museum would be interested in the loan and displaying something (hopefully art) ,or an appraisal. The list went on and on. I developed a theory that after the soap operas on TV were over for the day, women would look up on the wall and wonder what that painting hanging there was and what it was worth. Why not call the art museum? Most of these calls never amounted to anything significant as far as the museum was concerned.

However, one of those calls stood out from the rest. Calling from Jeanerette, Louisiana, in bayou country southwest of New Orleans, a woman with a shaky, gravelly voice explained she lived alone on the Bayou Teche in a large, old plantation house that, along with its extensive grounds, needed constant repair and upkeep, all of which kept her in the poor house. The latest "emergency" was the house desperately

needed to be shored up, and that was going to cost much more than she had or could round up. She dearly loved the house and knew it was her responsibility to do all she could to keep it from falling apart. Her plight struck a chord with me. So why was she calling me?

Like the women who finished watching the afternoon soap operas, she called to inform me she owned a painting that had been attributed to the Spanish master Françisco Goya, and she needed someone to take a look at it. She was willing to sell it to raise money for the shoring of her house. Now she had my interest. She went on to explain the house was named Albania and was once owned by the sugar broker Isaac Delgado, founder of the art museum in New Orleans. Now she really had my attention. Would I be willing to look at the painting and tell her what it might be worth and how she could sell it? Normally, I would refer her to qualified scholars of Goya's work and appraisers who might be of some assistance to her. Nor do I usually make "house calls" two hours away. But I was intrigued by the situation and the personalities. Goya. Isaac Delgado. Yes, I agreed to drive down to Albania. Little did I know at that moment how this fateful visit would affect my life for years to come.

Emily Cyr Bridges had acquired Albania at public auction in 1957 from the City of New Orleans, who in turn had received it in a bequest from Delgado. Emily's father, Paul Cyr, had served as lieutenant governor during Governor Huey P. Long's administration in the late 1920s and early 30s. When Long became a US senator, Cyr had himself sworn in as governor, which prompted the former governor to call out the National Guard and the Louisiana State Police to bar Cyr from the governor's mansion. Emily, I was soon to discover, turned out to be quite the colorful character herself. As a pioneer aviatrix and member of the Civil Air Patrol, she flew patrol missions over the Louisiana coast during World War II.

As promised, I drove to Albania and met this charming if somewhat secretive woman in her mysterious, old house. The main building was huge, three stories high, and falling apart, with a wonderful freestanding circular staircase in the central hallway. The only section Emily lived in was a large parlor converted into a bedroom off the first-floor hall and the huge old-fashioned kitchen in the back with windows looking out on

the grounds and the Teche where she sat during the day with her TV and devoted cook and housekeeper. "Clementine, get me this." "Clementine, do that." Near the staircase in the central hallway was a small card table with postcards illustrating Albania and a guest book. Occasionally, the large cast-iron bell on a tall post in the front of the house (actually the back as the front of the house faced the gently moving Teche) would ring, announcing tourists who had come for a visit. Clementine would respond and proceed to give a small tour of the first floor only. "Miss Emily does this." "Miss Emily did that." Meanwhile, Emily sat quietly in the kitchen and never made an appearance to her unknown guests.

Unfortunately, I had to tell her that her painting was not a Goya, not even close. Besides the painting, she had large collections of antique dolls and baskets by Chitamacha Native Americans, whose reservation was close by. She had accumulated over the years an example of each type of basket they made, and when their basket-making tradition was dying out, the Chitamachas borrowed hers to relearn the techniques.

I was rather captivated by Emily, and we had a good visit that afternoon. Over time, we became friends, and I would visit her over weekends with Ernie Mickler, and we would stay in one of the outbuildings, formerly referred to as slave quarters but now called dependencies, she had acquired over the years and had transferred to her property. It was another manifestation of her being a pack rat with the house full of furniture and antiques.

Emily liked to drink. She started in the morning promptly after breakfast. She had rather eccentric beliefs too. She claimed Albania had a female ghost, a friendly one, who was more of an annoyance than threatening. She described the woman to her best friend and handyman, Lucius, who documented her likeness with a drawing of this invisible personage with her frilled bonnet. This rendering had a prominent place above the card table in the hallway and was a major subject of Clementine's history of the house. One night after drinking entirely too much at a friend's house in neighboring Franklin, she insisted we had to immediately return to Albania as it was getting late, and the flying saucers would be landing, as they had done previously, on the lawn between her front door and the Teche. Saying our good-byes, I drove

her boat-sized Cadillac at breakneck speeds back to Albania, but alas, the visitors failed to show that night. Neither did her neo-Nazi friend, Norman Lincoln Rockwell, with whom she corresponded regularly, ever come to visit from Virginia.

Without a doubt the most bizarre experience I ever had with Emily was when she called and invited me to visit one Saturday. She was having some people from Hollywood come to scout her house as a setting for a proposed television series about Cajuns and their life. It was to star, of all people, Bette Davis as a Cajun! While the tempestuous star would not be in attendance, I thought that spending the day with Emily and her guests could be fun, so I accepted and drove to Albania. What a morning and afternoon that turned out to be! Shortly after my arrival and introductions to all the guests gathered in the commodious kitchen cum sitting room, Emily suggested we have cocktails before lunch. Swell! One of the guests eagerly volunteered to make the martinis at the counter. I was sitting close by and thought he was taking an inordinate amount of time preparing the drinks. He kept working diligently, but I failed to see what was taking so long. Finally, they were served, and the party was underway. Soon I was feeling the effects of the alcohol and thought to myself I must slow down my consumption. By the time lunch was served, I was drunk, and I could tell others were feeling no pain as well. I reasoned that the lunch would sober me up, but I continued to be soused.

By late afternoon, I told Emily I had to leave as I had to be back in New Orleans that evening for a previous commitment. Emily asked me not to go, but I insisted I had to return. When I walked out on the gallery to go, Emily clung to me and pleaded for me not to leave her. "Bill, please don't leave me with those people!" Reluctantly, I did just that against her protestations. I was still inebriated and should not have been driving on those country roads. As I drove home, I felt weird and was puzzled by how quickly I had gotten drunk that morning and how long it had lasted.

Early the following week I called Emily to find out what had happened with her guests after I left. She answered the phone and reported in a weak voice, "Oh Bill, I have just gotten out of the hospital today."

"Emily, why were you there?"

"I was drugged! Those people drugged me. I had to go to the hospital shortly after you left on Saturday. They had to pump out my stomach."

How bizarre, but that helped explain my odd behavior as well. Unfortunately, I never did find out who those people really were and why they would want to drug Emily and me. But it did happen, and it kind of goes with the territory of what can happen when you visit Emily Cyr Bridges at Albania.

After Emily's death, the house was offered for sale, and, lo and behold, it was purchased by another friend, artist Hunt Slonem. This was the beginning of another chapter of my relation to that house on the Teche.

Hunt has spent a great deal of time and resources renovating Albania and furnishing it with period furniture, decorative arts, and his own paintings. Not satisfied with one old plantation house in Louisiana, Hunt acquired another a few years later in Bachelor near New Roads in the False River area. Lakeview is even larger, but it has been given the same loving restoration and furnishing. As of this writing, Hunt has just purchased from my friends Millie and Keith Marshall his third plantation house, Madewood, located on the Bayou Teche near Napoleonville, Louisiana. It is presently being fully restored.

Luba Glade

When I arrived in New Orleans in the mid-1960s, there were few art galleries demonstrating any serious commitment to contemporary works. All were located in the heart of the French Quarter. Naomi Marshall's Downtown Gallery and Lucille and Marc Antony's 331 Gallery, both on Chartres Street, were joined by the trailblazing Orleans Gallery on Royal, a cooperative run by a dedicated group of the most prominent local artists.

Joining the gallery ranks was Luba Glade, who possessed a deep passion for art. She opened her Glade Gallery on Toulouse Street and was able to lure two rapidly emerging artists, Robert Gordy and Ida Kohlmeyer, to join her burgeoning stable. Because of her serious com-

mitment and determination, she was able to advance their careers immeasurably. Her gallery quickly became recognized for its professionalism and her success. In 1967, her gallery was shut down temporarily by the vice squad for showing what was considered obscene art. Later, both Gordy and Kohlmeyer were lured around the corner on Royal Street again, this time by the newly opened Galerie Simonne Stern, which was established by the French-born wife of Walter Stern. On the last day Luba's gallery would be open, I took her a bottle of chilled champagne, and she and I sat in the gallery's window seat that Saturday morning drinking as the people passed on the street outside.

Luba quickly transferred her enthusiasm and knowledge for art into a career as an art writer and critic. This proved to be an appropriate vehicle for her outspoken views. I was highly flattered and amused when in her year-end summary of the New Orleans art world for 1972 in the *Vieux Carré Courier*, she named me "Art Hero of the Year." In the closing of her generous tribute to me, she wrote, "Which all goes to prove that behind that very personal giggle lies a real sense of humor and behind that affable exterior lies the tenacity of a tiger."[16] It's true; it was an eventful year: Jim Byrnes suddenly "resigned," I was appointed acting director, both my parents died within six months of each other, and I organized two exhibitions (one on Fabergé with a published catalog, and one on Dalí's jewels for the museum's annual Odyssey Ball).

In 1976, a couple of Luba's art stories in the *Times-Picayune* caused strong reactions. Her keen observations of the famous Tannen/Lalande party in the Marigny provoked her to write about the need for an art institution in New Orleans devoted exclusively to contemporary art. It is safe to say she could be considered the mother who originally conceived the birth of the Contemporary Arts Center with the help of a group of dedicated midwives and midhusbands.

On a less admirable move, that same year, John Bullard informed Luba in confidence that the *Treasures of Tutankhamen* would be coming to NOMA the next year. This is a common time-honored practice in journalism to give the press advance warning of a major impending story. She agreed that she would not prematurely publish the news since sensitive negotiations for the exhibition were still in progress. The

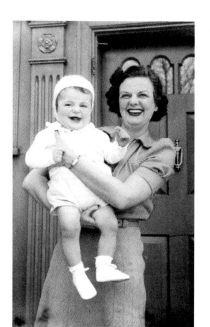

My mother and me at six months old.

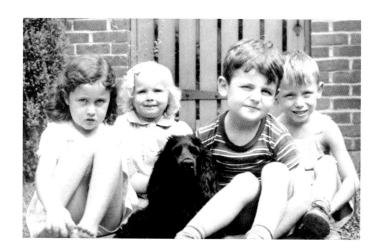

Suzanne McCandless, Elinor Sedam, my dog Cricket, me, and Larry Zernach.

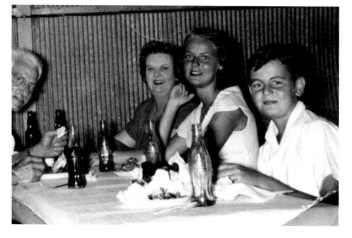

My father, mother, sister, and me at a Sunday church chicken-dinner social, Lawrenceburg, Indiana, 1950.

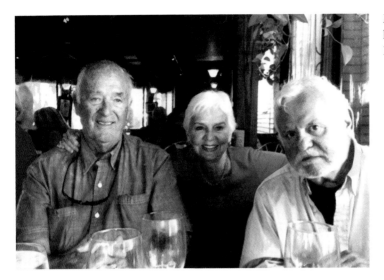

My sister, Pat, with her husband, Phil Potts, and me.

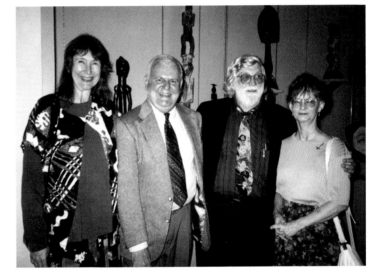

Sarah Hollis, me, Dr. Roy Sieber, and Peggy Pulliam McDowell.

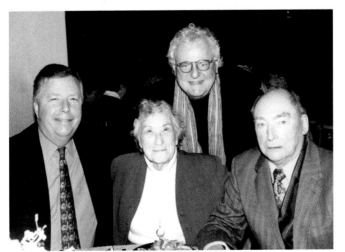

John Bullard and Jim Byrnes, my first two bosses as directors at the New Orleans Museum of Art, with Jim's wife, Barbara. I am standing behind them.

The Consul General of France Pierre Lebovics, John Bullard, Francoise Richardson, me, Jackie Sullivan, and Arnaud d'Hauterives at the induction ceremony for Jackie and me as Chevalier dans l'order des Arts et des Lettres at the council general's residence in New Orleans.

Barbara and Wayne Amedee.

The "Fagaly Gang" holding the bamboo poles with attached balloons to document for the photographer the upper and lower limits of what the expressway would look like if built. From the top: me, Bill Borah, Lynne Farwell, and Nell Nolan.

Susann Craig, honoree Phyllis Kind, me, and Stephanie Smither at Intuit: The Center for Intuitive and Outsider Art's gala in Chicago.

Jazz funeral procession given for the installation of Sister Gertrude Morgan's bronze cemetery marker on the anniversary of her birthday, April 7, at the Providence Park Cemetery in Kenner, Louisiana. From left to right: Preservation Hall Jazz band with Ben Jaffe on tuba; John Bullard in dark suit and red tie; Reverend Michael Stark, who officiated; author and collector Betty-Carol Sellen; Jonn Hankins; and me with hands folded.

David Butler and his neighbor children and me in David's sculpture garden.

Keith Sonnier center in black embracing Mickey Easterling with left to right Bombay Club founder Mark Turk, London fashion designer Zandra Rhodes, New Orleans Saints linebacker Steve Stonebreaker, and me.

Blaine Kern's Mardi Gras Napoleon figure being delivered to the New Orleans Museum of Art for Lynda Benglis (standing in the doorway of the museum) and Ida Kohlmeyer's (standing on the flatbed truck) collaborative installation "Louisiana Prop Piece" for the *Five from Louisiana* exhibition. A delivery man stands on the flatbed with Ida, and I am standing behind Ida on the ground. Ultimately, the large figure had to be eliminated from use in their piece because it would not fit through any museum doorway.

Artist Joseph Kosuth, my friend Charlcye Hawk, participating artist Tina Girouard, journalist Liza Baer, and me at the special preview of my exhibition *Five from Louisiana.*

Muriel Bultman Francis, Andy Warhol, and Sunny Norman at a party in his honor during his stay in New Orleans for the opening of his exhibition "Raid the Icebox" at the Delgado Museum in 1970.

Sunny Norman, Muriel Francis, and me.

Bernice Norman and me.

Catherine Tremaine.

Doris Stone and me.

Mickey hosting one of her memorable dinner parties.

Leah Chase and me.

Artist Jacqueline Humphries and her mother, Mignon Faget, and me.

Sharon Litwin, Ida Kohlmeyer, and me.

Luba Glade, Fred Weisman, Arthur Roger, Sunny Norman, John Bullard, and Jim Richard at the grand opening of Arthur's gallery in New York's SoHo art district.

Marcia Tucker.

Fred Feinsilber in his Paris apartment.

Anand Sarabhai on the Greek island of Kastellorizo.

Honoree Lynda Benglis and me at a Hirschhorn Museum gala in New York.

Dawn DeDeaux and Diego Cortez.

Elizabeth Shannon.

Me, Roger Ogden, Fredericka Hunter, and George Dureau.

Aristides Logothetis and me lunching in Como, Italy.

Dan Cameron and me on Mardi Gras Day.

Charlie and Kent Davis and me.

Marc Felix and me in Paris.

Ernie Mickler.

Bill Tobiasson.

Bill Tobiasson on horseback with resident caretaker and me on the Peruvian mountain top at the Inca ruins site Huchey Qosqo.

Marie.

next day, we were shocked to see that the banner headline on the front page of the *Times-Picayune* trumpeted the news with a byline by food critic Gene Bourg! While Luba technically honored the request, she got around that obstacle by giving the byline to someone who had no knowledge of the event to take place until Luba told him. How deceptive!

Ida Kohlmeyer and Millie Wohl

Shortly after arriving at the Delgado in 1966, I met Ida and her sibling, rival painter Millie Wohl. Not together however. Having demonstrated an interest in contemporary art, director Jim Byrnes assigned me the task of overseeing the long-running series of annual juried exhibitions of contemporary art. My first exhibition at the museum was organizing the simultaneous one-person exhibition *The 1967 Winners of the Artists of the Southeast and Texas Annual*, which included work by each of the two sisters. I quickly learned of the schism between the two women and how I would have to deal with that in my installation within the limited gallery space in the original Delgado square box of a building. Once these strong women learned they would be working with this young guy newly arrived at the museum from Indiana, each one demanded to see how her work was being presented. First came Millie, who suffered from ulcers that required her to frequently drink milk from the carton. "Where is Ida's work?" As Millie was in the corner gallery, I pointed across the Great Hall to the gallery on the opposite corner. "May I go see it?" "Sure," I responded. After contemplating the work with her nervous eye twitch, she made a derogatory comment and left. Next came Ida, who was suffering from a skin reaction to turpentine on her hands. She was slathering her hands in some kind of cream. After approving her installation, Ida asked, "Where is Millie's work?" "Way over there," I replied. "May I see it?" After inspecting it, she made some curt comment and left. This was my initial experience as a novice curator dealing with living artists. After that memorable introduction, I would go on to become friends with both.

Millie and her husband, Bernie, lived in the only dwelling atop a high-rise concrete parking garage off Saint Charles Avenue. It was

a physical jolt to drive in, park your car on one of the multi ramps, and enter a small passenger elevator to have the doors open on a sun-drenched, stylish penthouse with spacious open courtyards providing panoramic views of the city skyline. I felt like I was somewhere on the Mediterranean, and the cares of the world seemed to evaporate there.

Millie and Bernie were known for their glamorous parties with chic attendees and beautiful art. Once I made an appointment to visit Millie concerning some museum business. At her suggestion, I arrived early in the afternoon, and when I stepped off the elevator, no one was in sight. After a short wait, an apparition in diaphanous fuchsia ostrich feathers and thin veils appeared at the other end of the long hallway. It was Millie in her flowing dressing gown just beginning her day.

Ida and her husband, Hugh, lived in a neo-Georgian brick home in an upscale neighborhood of Old Metairie. One of Ida's passions was maintaining an extensive rose garden in the rear yard of the house. The wide palette of color provided by the flowers obviously reflected the color palette of her paintings and sculptures. She always wore a fragrance that smelled like a rose. Like her sister, Ida and Hugh loved giving large fancy garden parties when the rose blossoms were at their peak of blooming in the spring. The who's-who of the art world mingled with the Jewish swells.

After a time, Ida's career accelerated, and she became a driven woman making art. She outgrew her studio, and it was necessary for her to sacrifice a portion of her beloved garden to build an enormous studio for her burgeoning art career. NOMA presented several exhibitions over the years, including hosting a major retrospective and an exhibition of models of her winning submission to the Riverfront Aquarium competition. Two of her large, colorful outdoor sculptures are installed in the museum's Besthoff Sculpture Garden and building courtyard. I curated several exhibitions, including the first and only one of her work at the then named Newcomb Art Gallery, which surveyed her achievements as a sculptor. At her request, I wrote several essays on her work for a gallery show in Santa Fe and the art museum in Beaumont, Texas. Ida and I were tight and had a warm relationship.

Her two daughters, JoAnne and Jane, her husband, Hughie, and her cocker spaniel were the loves of her life, along with her insatiable

appetite for collecting art, especially ethnographic art. The downstairs living quarters were chockablock with fine examples of African, pre-Columbian, Native American, and Oceanic sculpture crowding every surface. Ida and I became fast friends as a result of our mutual passions. She enjoyed acquiring new art during her frequent travels. She would excitedly call and invite me upon her return home to come see her new treasures. I visited often at cocktail hour either in the living room filled with African and pre-Columbian art or her own art-laden studio. I was invited on occasion to have very informal lunches at the kitchen table with her and her staff, artists Andrew Bascle and Jade Jewett and daughter Jane, where the conversation was guaranteed to always be lively and spirited. I was family.

Being a dutiful, curator, I let Ida know I was interested in eventually acquiring objects from her collection for NOMA. She heard me and along with Hugh made occasional gifts of African and Native American art to the museum. I was rather persistent over the years about my wishes for the final disposition of portions of the collection after her daughters were satisfactorily accommodated. Finally, Ida said to me one day, "Bill, don't worry, you are my third child" (meaning NOMA, not me personally). With that assurance, I relaxed and felt NOMA would be remembered. However, after her death, the family chose to put the massive collection in a series of auctions in New York and New Orleans. I was fortunate to be a successful bidder on several wonderful objects belonging to Ida, and I made a very old, superb Kom helmet crest a promised gift to NOMA at the time of its centennial celebration exhibition.

Madeleine Chalette Lejwa

Among the many interesting people whom I met through an introduction by Sunny Norman was Madeleine Lejwa, a diminutive New York Jewish woman living in a Stanford White mansion immediately adjacent to the Guggenheim Museum at 9 East Eighty-Eighth Street. On a desperately cold, blizzard night in New York Sunny had arranged for me to escort Madeleine and another woman to a gala black-tie event at

the Metropolitan Museum of Art six blocks down Fifth Avenue from Madeleine's house. When we readied to leave the museum, she invited us both back to her house for a drink. Madeleine was a former prominent art dealer on Fifty-Seventh Street and herself a collector, and so her house was filled with work by important twentieth-century European masters, including Jean Arp, whom she once represented, as well as Max Weber, Picasso, Braque, Burgoyne Diller, Chagall, Julio Gonzalez, and Max Bill. Of particular interest to me was her most impressive collection of ethnographic art, mainly African.

After a lively visit chatting and imbibing, the other lady said she must go home, and I offered to walk her through the deepening snow to her Park Avenue apartment a couple of blocks away. Madeleine encouraged me to return afterward for further conversation and offered to show me her collection. I readily agreed even though it was getting late. When I returned, Madeleine and I continued having a grand time talking and talking. She was a lively conversationist. After a while, I looked at my watch and it was after 3:00 a.m.! I told her I had overstayed my visit and must be going, to which, she immediately quipped, "Why, am I boring you?"

That was the first of many fun visits with Madeleine at her treasure-filled house on East Eighty-Eighth. Of course, being a good museum curator, I solicited her for a possible donation to NOMA in honor of her good friend Sunny Norman, to which she told me that was not possible as her entire collection was promised to the Israel Museum in Jerusalem upon her death. Madeleine died in June 1996.

Marcia Tucker and the Panda Club

I first met Jack Boulton, then director of the Contemporary Art Center in Cincinnati, in the mid-1970s, when he was invited to give a talk at Nicholls State University in Thibodaux, Louisiana. As fellow Hoosiers turned art historians and museum curators, we hit it off immediately, and that led to my meeting his friend Marcia Tucker, curator at the Whitney Museum of American Art in New York, at the annual meeting of the American Association of Museums, which was being held in

Washington, DC, that year. As young curators, we dutifully attended the scheduled sessions but immediately found little of interest to us. Along with Marcia's young curator friend at the Albright Knox in Buffalo, Linda Cathcart, the four of us fled the meetings and went to the National Zoo to see the newly arrived pandas from China. Little did we know that fateful afternoon how we would all bond so well, and we soon christened ourselves the Panda Club. We were the four musketeers of contemporary art.

That alliance lasted through the years while Jack went on to head with Guggenheim director Tom Messer the government agency that determined which art exhibitions would represent the United States at worldwide biennials. Later, he was hired as the sole curator of the Chase Manhattan Bank art collection for David Rockefeller. Through his brilliant mind and discerning taste, Jack quickly assembled a magnificent collection for the bank. Tragically, Jack was one of the early victims I knew to be stricken with AIDS. Unable to cope with his deteriorating health from this mysterious disease, he committed suicide in 1987 at age forty-three by jumping out of the window of his apartment in Chelsea.

Linda became the director of the Contemporary Art Museum in Houston and led that institution successfully for a number of years before leaving to open a short-lived commercial art gallery in Santa Monica. Another brilliant mind who chose to leave the contemporary art world at the height of her career, she lived in Santa Barbara, where she established a museum, Casa Dolores, a center for the study of the popular folk arts of Mexico, until she passed away in 2017.

Marcia was fired in 1977 by director Tom Armstrong at the Whitney as a result of her avant-garde and then-unorthodox exhibitions and radical behavior and beliefs. Marcia was passionate and forthright concerning her battle for the feminist movement. One of her trailblazing innovations was to mount intimate exhibitions in the small, underutilized space immediately to the left of the main floor elevators in the Marcel Breuer building on Madison Avenue. It became known informally as Marcia's Gallery.

When she left the Whitney, she decided there was a need in New York for an institution to be free to show, recognize, and provide a plat-

form for marginal artists and for nonconformist and alternative ideas. Her passion for art was matched by her deep social consciousness. She was aware that I was a friend of African art historian and curator Susan Vogel, who had recently left the Metropolitan to found a brand-new art institution dedicated solely to that art, the Center for African Art.

Marcia asked me to put her in touch with Susan—another curator who left a major New York art museum—to find out how she was able to inaugurate such a pioneering project in New York. The outcome was the founding of the New Museum, whose first home was Artists Space at 105 Hudson Street in Tribeca. I was the first overnight guest inside this fledgling museum there. With the museum's rapid success, it soon moved to the first floor of the building owned by the New School on Fifth Avenue at Fourteenth Street, then to Broadway in Soho. While there, Marcia hired another friend, Dan Cameron, as guest curator for the controversial exhibition *Extended Sensibilities: Homosexual Presence in Contemporary Art* in 1982. In 1995, she hired Dan as senior curator. Today, the New Museum is in its own building on Bowery Street, directly across the street from Lynda Benglis's studio.

Marcia was a leading scholar of contemporary art. Her trailblazing exhibitions are legendary, such as *Bad Painting* at the New Museum, and as United States Commissioner for the 1984 Venice Biennale, she worked with her curators on the unorthodox exhibition *Paradise Lost/ Paradise Regained: American Visions of the New Decade*. She served as series editor of *Documentary Sources in Contemporary Art*, five anthologies of history and criticism.

In 1980, when Marcia was the guest curator for the *1980 New Orleans Triennial*, she had just met a young man considerably younger than her, an artist, who had swept her off her feet. His name was Dean McNeil, and she and I discussed her unexpected, sudden romance while we were making our studio visits around the South. Three years later, they were married, and their daughter, Ruby, was born in 1984.

Marcia was deeply devoted to the Art Mob, a contemporary a cappella choral group she founded in 1979. Always light-hearted but ardent in their mission, their self-described characterization has been over the years, "The dozen or so nonprofessional singers and punsters of the Art

Mob have been entertaining friends, family and first offenders for nearly twenty years with outdated and unfashionable songs from a variety of ever-to-be-forgotten sources."[17]

Marcia remained my friend until her death in 2006.

Antoinette K-Doe

It was the Sunday before Mardi Gras in 2009, and I took Cynthia Becker and my house guest, Hank Drewal, both African art historians at Boston University and University of Wisconsin, respectively, to visit Ronald Lewis at his House of Dance and Feathers on Tupelo Street in the Lower Ninth Ward. While Ronald was showing Cynthia and Hank around his private museum, which was dedicated to Mardi Gras Indians, I happened to notice a poster on the wall that had the birth and death dates of the emperor of the universe, New Orleans's rhythm-and-blues legend Ernie K-Doe. He was born on February 22—that was today! After our visit, I took my guests directly to the Mother-in-Law Lounge on North Claiborne Avenue to pay our respects and help Ernie's widow, Antoinette Dorsey K-Doe, celebrate the emperor's natal day. Antoinette was so pleased we had remembered his special day. She had made a pot of red beans, which I had enjoyed on earlier visits. She made great beans!

The Lounge had become a shrine to the late performer and his only number 1 hit, "Mother-In-Law," written by fellow New Orleanian writer and producer Allen Toussaint. The small, undistinguished building was filled with memorabilia, including his continuing presence in the form of a mannequin standing in a corner that she called "Ernie," fully clothed in her late husband's glittering performance garments. She often took "Ernie" when she made appearances around town. A classic *Offbeat* magazine 2006 cover illustrated her dining with "Ernie" at Galatoire's. When I told Antoinette, as we were leaving, I would be back two days later on Tuesday, Mardi Gras Day, she said she would be there holding court with her annual open house at the Lounge.

At 8:00 a.m. on Mardi Gras morning, Dan Cameron and I were standing in our costumes in front of the Backstreet Museum on Saint

Claude Avenue (since renamed Henriette Delille Street) waiting for the Skeletons to come out and start their walk around the neighborhood. They were late as usual. That's when we heard the unbelievable news passing through the crowd—Antoinette K-Doe had died of a heart attack lying on the sofa in the Lounge at three o'clock that morning!

After following the Skeletons around and checking out whether Darryl Montana, big chief of the Yellow Pocahontas, had come out of his father's house on North Villere (he hadn't, nor had Victor Harris, big chief of Fi-Yi-Yi, around the corner), Dan and I made our way over to the Lounge, where a large crowd stood in shock from the news. Her well-kept garden alongside the Lounge looked particularly beautiful that Mardi Gras Day.

Episode 7

Experiences with Great Art Collectors

> It's a fascinating thing to understand people who live with art. If you
> have art in your life, it is a powerful force, a force that can be too much
> for some people.[1]

I had on different occasions come in contact with two of the great Los
Angeles art collectors and business moguls—Dr. Armand Hammer
and Frederick R. Weisman—both of whom coincidently had gotten
their start at the beginning of their careers on New Orleans's West
Bank. Dr. Hammer bought a failing distillery in Gretna and made his
first fortune from it, while Fred, as the CEO for a food company, had
bought the Wesson Oil Company for his bother-in-law, Norton Simon,
who owned what was to become Hunt Wesson Foods. Dr. Hammer, a
medical doctor who never practiced his profession, became the CEO
of Occidental Petroleum.

Dr. Armand Hammer

A number of years after his acquisition of a failed distillery in Gretna, a
large exhibition of Dr. Hammer's collection of European and American
paintings was first shown in 1970 at the National Museum of Natural
History in Washington, DC. It had been severely criticized in the Wash-
ington press for the quality and authenticity of many of the artworks. He
was outraged and felt insulted, and he did not want the same experience
at the exhibition's second venue later that year, which happened to be
the Delgado Museum in New Orleans.

When this all came up rather suddenly, the Delgado director, Jim Byrnes, was already in Europe for the summer, so it fell to me to work closely with Dr. Hammer. He had decided he wanted to host a lavish dinner at the Royal Orleans hotel following the opening. It quickly became apparent to me that expense was no object as he was determined to make the New Orleans opening an unqualified success and celebration after the disaster he endured in Washington.

Since Dr. Hammer knew virtually no one in New Orleans, he asked me to put together the guest list and make all the arrangements with the hotel, including selecting the menu, seating arrangements, table settings, flowers, and music. I myself was relatively new to the city and not that familiar with the "who's who" and certainly not that familiar with local fine cuisine. It was indeed a quick learn for me on both scores. The day before the big event, I told Dr. Hammer during one of our many phone conversations that I was having trouble getting through to the hotel's caterer as it had been announced at the last minute President Nixon would be coming to town on the same day as Dr. Hammer's dinner, and the president would be staying at the Royal Orleans!

This had put the hotel in a beehive of frantic activity preparing for the president of the United States. When I told Dr. Hammer of this unexpected complication, he immediately asked me, "Well, is the president coming to the dinner?" When I responded that I hadn't thought of inviting him, he immediately ended our call and called the White House to extend an invitation—without an acceptance I might add. I am pleased to report Dr. Hammer's dinner party was a huge hit both with the guests and the host, and I was very relieved and surprised that I was able to pull the whole thing off in such a short amount of time.

Several years later, our paths crossed once again. In 1972, Matilda and Harold Stream gave a private dinner the night before the premiere of the exhibition of the Matilda Geddings Gray Fabergé collection at the museum for which I was the organizing curator. Again, as the curator of African art, I was thrown into a subject I had no expertise in. It fell upon me to write the description of each piece and the text for the published catalog. Dr. Hammer had originally brought the jewels out of the Soviet Union with Lenin's personal permission. Many of the pieces

were eventually sold to Matilda Gray during the 1933 Chicago Exposition by Dr. Hammer's brother, Victor.

Attending the Streams' dinner that evening, Dr. Hammer told me his painting collection would be opening at the Pushkin Museum in Moscow the next month. He strongly encouraged me "to beg, borrow, or steal" to come along for the opening in December. After thinking about it over the weekend, I called him the following Monday morning and reminded him what he had said to me about attending. With a bit of chutzpah, I inquired if I could go on his plane and got an instant negative. It was filled with members of Congress and others. However, he told me to come, and I did! And so did Matilda and Harold Stream and their daughter, Sandra.

The Soviet Union and Madame Furtseva

The Cold War was at its height. President Nixon had made an unprecedented visit to Moscow earlier that year. It was rare for Americans to be there, and here I was not only going but was a part of the special entourage of Dr. Armand Hammer, who was treated as a celebrity by the communist government and its people. Everyone in Moscow knew who Dr. Hammer was, and being in his party opened doors.

Upon my arrival at the Moscow airport on a bleak day in early December, I was stopped while going through customs by several surly and intimidating Soviet soldiers. In the spirit of friendship to my museum colleagues in this communist state, I carried a number of heavy art exhibition catalogs and books to present as gifts to those I anticipated visiting while there. The soldiers gruffly rifled through the satchels and inspected the contents of books with their colorful illustrations of beautiful artworks, while grunting their apparent displeasure. I was interrogated at length concerning the books and why I was carrying so many. With questions answered, and at the end of what seemed an interminable period of inspection, I was told curtly to go. As I was preparing to leave, one soldier leaned forward and quietly whispered in my ear in English, "They are beautiful."

On a cold winter's night in a downtown Moscow hotel, Dr. Hammer threw another huge and lavish dinner reminiscent of the one in New Orleans. Vodka flowed with limitless fresh caviar and much sturgeon *en gelée*. On that historic evening Madame Furtseva, the Soviet minister of culture and member of the Politburo, announced that as a "thank you" for Dr. Hammer allowing his collection to travel to the Soviet Union and for his generous gift of a Goya painting to Leningrad's Hermitage, she was allowing a group of the Hermitage's finest French impressionist and cubist paintings to travel to the New York Knoedler art gallery owned by Dr. Hammer. This proclamation was unprecedented and would be a real breakthrough for cultural cooperation between these two super powers during the height of the Cold War. And I was there to hear this earthshaking art world news. Being the only American museum official in attendance, I rushed up afterward to the speakers' table and inquired, after introducing myself to Madame Furtseva, if it would be possible for my museum in New Orleans to have the exhibition after Knoedler. She acknowledged it was a possibility. I then hurriedly approached Jacob Bean, the United States ambassador to the Soviet Union, who was sitting a few places down from the Soviet minister, and asked him if he would assist me in my quest. He agreed. I floated out of the hall that night feeling I just might have pulled off a real coup for our museum.

When news of the Soviets' great gesture to Knoedler became known in the United States, President Nixon interceded and requested that the exhibition go to the National Gallery of Art in Washington, DC. And it did. Attending the opening in Washington, Madame Furtseva held a press conference and announced that she wanted to visit two American cities while she was in the United States: Palm Beach, where Dr. Hammer had a house and deep-sea fishing boat as she loved fishing, and New Orleans! I knew she wasn't coming here to fish in the traditional sense. Oh my gawd, she was coming to New Orleans! What were we to do?

At the time, I was only the acting director of the museum. Suddenly I was getting all kinds of calls from the State Department, the FBI and the Secret Service. I hastily called museum trustee Shirley Kaufmann, who had been to the Soviet Union recently, and asked her to help me entertain the minister and her delegation. Shirley generously offered to

have a dinner party for them in her house in Metairie. The night of the dinner, nine Soviets met with Shirley and her husband, Richard, and me at their gracious contemporary home on Iona Avenue. The exterior of the house was surrounded by sinister security men from Washington ducking in and out of bushes. We told our Soviet guests they could relax and have a good time privately after all their official functions in Washington. Cocktails were pleasant enough, and then we sat down to a grand dinner. Shirley had outdone herself.

After a while, I couldn't stand it anymore and blurted out, "Madame Furtseva, I understand that you announced in Washington that you are considering allowing the Hermitage pictures to possibly travel to other American cities. Is that true?'

"Da" was the response.

"Which cities?" I timidly asked. She acknowledged that this had not yet been determined. Her next question spoke volumes. "Who are your Senators?" I told her Russell Long, chairman of the Appropriations Committee, and Bennett Johnston, head of the Arms Committee. I pointed out that much of the grain that was being sent to the Soviet Union left America through New Orleans's port. Obviously, she was impressed with the clout of our legislators as her next question was, "May I come to see your museum early in the morning?" Of course. I hastily called the night janitor, Bernard Maniscalco, the only person in the building in those days at night. I informed him I was coming with some important people at 7:30 in the morning, and I wanted all the gallery lights on and everything looking its best.

The next morning, Shirley and I drove them to the museum, showed them the galleries for temporary exhibitions, and then, after seeing all they wanted to see, they were gone. We were left with armloads of vodka that they mysteriously had tucked into the linings of their overcoats. As a follow-up, I attempted to get members of our board and civic leaders interested in the possibility of such an extraordinary loan to New Orleans. Unfortunately, this was before the age of "blockbuster" art exhibitions in America, and the New Orleans city fathers did not realize what a positive effect such events could have on the local economy. I was unable to interest anyone to work with me. Consequently, the

exhibition went to the Kimbell Museum in Fort Worth and the Los Angeles County Museum of Art, where money talks, and communities knew that. Oh well, I gave it my best shot but it was not to be. Still, I have fond memories of those heady times and that special trip.

Visiting the USSR

My rude airport reception into this communist country was just a preview of how I would be treated during my stay in this unwelcoming and unsettling country. The Soviets' behavior was rather schizophrenic, and I never knew what to expect, which, I suspect, was just the reaction they were aiming for. Keeping visitors off balance was the plan. On one hand, I experienced less than friendly and accommodating Muscovites, and, on the other, suddenly, without warning, plans could instantly change, and all obstacles would vanish.

For example, while in Moscow and Leningrad, I took full advantage of going every night to either the opera, the ballet, or the circus. To obtain a ticket, it was necessary to go to the Intourist office on the day of each performance and make a request for that evening. The predictable daily response was that all tickets were sold out and that I had to return later. Each day, the scenario was the same. After several knowingly futile visits, just before curtain time, a ticket would miraculously become available for one of the best seats in the house. I got the feeling it was just a plan to frustrate foreigners from the United States.

During those days in Leningrad, the buzz was that there was a young, new ballet dancer who was causing quite a positive stir each night at the Kirov. I went to see him several nights. This handsome blonde's dancing had a brilliance and athleticism that was truly breathtaking. It was a thrill to be a witness to the emergence of a new star of Russian ballet. This young man, Mikhail Baryshnikov, defected to the West two years later, in 1974.

Another unsettling incident occurred in the Moscow National Hotel's spacious second-floor dining room with its large windows overlooking Red Square and Lenin's Tomb. One day, I had a late lunch there

in midafternoon in an almost deserted room. After placing my order, a gentleman entered and was seated next to me. How curious, I thought. After politely conversing for some time about nothing in particular, he began to speak in disparaging terms and complaining about the Soviet government. I was immediately suspicious of his motives and refused to fall into what could have been a trap by agreeing with him.

On another occasion, I met a young Australian man in the hotel bar who wanted to go out on the town that night and party. He was loud and slightly inebriated and saying unkind things about the Russians and their government. I told him that he should be careful what he said and that I didn't want to join him that night. Early the next morning, I ran into him in the lobby, and his mood had decidedly changed. He was frantic and yelling, "They're after me! They're after me! Help me!" I told him there was nothing I could do for him. Again, was this all a setup, or was I just letting my paranoia get the better of me?

As I was known to be in Dr. Hammer's official traveling party, I was extended special privileges. However, when I met the director of the Russian State Museum, I asked to see their collection of constructivist paintings not on view in the galleries. When he told me they were in storage and not available, I then aggressively inquired if my museum in New Orleans could mount a special exhibition of these hidden treasures since they had no plans of showing them. "That would not be possible," was the icy response.

I also met the director of the Hermitage, and he, in turn, introduced me to his curator of Western art, Albert Kostenevich. Albert and I were both in our midthirties, and we instantly became friends. For such a young man, he had scores of other curators under his supervision. He rarely if ever had an opportunity to meet and visit at length with a curator colleague from the West. Therefore, my visit was a special treat for both of us. He offered to meet with me a portion of every day I was in Leningrad. He was starved for news concerning art from the Western world since American or European art journal and periodicals were not available to him.

Albert and I enjoyed our daily visits. We had lengthy conversations about art and mutual museum concerns. Each day, he would ask me

what I wanted to see on my visit the following day. He showed me their dazzling treasure room of Scythian gold and the gallery devoted to the work of the American communist Rockwell Kent, both rooms not open to the general public. However, he drew the line when I requested to see the Hermitage's vast art storage. That would not be possible.

As I was wandering through the galleries of the Hermitage, I came across Dr. Hammer's photographer who was shooting color transparencies of the paintings to be loaned to Knoedler. While watching the works being unhung and rehung as they were photographed, I was invited to step in and assist in the rehanging of a fabulous Cezanne still life. What a thrill for me to actually hang a work of art at the Hermitage!

Traveling in the Soviet Union in December was grim. It was cold and continually overcast, with low-hovering gray clouds. I never saw the sun the entire time I was there. It would only become light around ten o'clock in the morning and be dark again by four in the afternoon. The barren landscape and cities were colorless. The people, all wearing dark, colorless clothing, walked about the city like robots without much animation. After leaving the country and upon deplaning at Heathrow in London, I genuinely felt like I was entering a Technicolor fairyland.

One last note. When Madame Furtseva was taking Dr. Hammer and his party through the Kremlin, Dr. Hammer asked where the Soviet Union's Fabergé collection was. She looked him directly in the eye and exclaimed, "Dr. Hammer, you know very well where our Fabergé is!"

Frederick R. Weisman

My friendship with the other Los Angeles business mogul/art collector, Fred Weisman, began in 1988. As a member of the Republican Party's exclusive high-roller contributors' club, the Eagles, he wanted to present a major exhibition of his collection at NOMA when the party's national convention was in town, and the museum agreed to his wishes. He had a reputation of often traveling to a new town, becoming infatuated, and expressing a desire to buy a house there. And New Orleans was no different. After being told by my colleagues that he would never fol-

low through, he persisted in his wish. It was assumed by many that, if indeed he would acquire a house here, he would want to live Uptown in the Garden District. (After all, his house in Los Angeles was in the fashionable Holmby Hills with Bert Reynolds on the left side and Barbra Streisand on the right!) No, he was only interested in living in the French Quarter, where all the action was.

At a lovely dinner party Sunny Norman threw for him and his companion Billie Milam, I introduced him to Dorian Bennett, who owned one of the major real estate companies in town. His agency specialized in Vieux Carré properties in particular. After much searching, Fred settled on a large town house with carriageway, courtyard, and dependency on Saint Philip Street, two blocks down from my house! It was located around the corner from Café Sbisa, a restaurant he liked and directly across the street from a rowdy gay bar and a voodoo shop. He was in the thick of it and loved it. Fred and Billie came to love New Orleans so much they eventually secretly were married here at city hall by the mayor!

During their many trips to the Big Easy in his Lockheed Jetstar painted by two of Los Angeles's most prominent artists, Joe Goode (he painted on the plane's interior ceiling a partly cloudy blue sky) and Ed Ruscha (he painted on the plane's exterior body a midnight-blue starry night), and moving a houseful of art into their new digs on Saint Philip, the two transplants became totally immersed in the Louisiana art world. Fred was like the voracious collector Joe Hirschhorn in that he had an insatiable appetite for looking and buying. It seemed he could not let a day go by without acquiring a new piece for his collection.

They were the new hot couple in town, and everyone wanted to snag them for an evening at dinner. One night in particular I was sitting across from Fred at a dinner party and saw that he was bored. I leaned across the table and whispered, "Fred, would you like to go see some art tomorrow morning?" His eyes immediately lit up, and he eagerly accepted my invitation. It was a running joke that he, who owned the mid-Atlantic distributorship for Toyota and Lexus, had to go in my inexpensive Hyundai. And we had fun. I figured that in six-months, he had bought enough art to save the art galleries and artists from a tough economic period. And he loved the attention.

One day, we came across a large mural-size painting with figures. Fred took a shine to it, but both Billie and I thought it wasn't very good, and it certainly was not for Fred. It was so big, where would he put it? No matter what Billie and I said to try to dissuade him, he was adamant. Then I said to Billie, "Doesn't that main figure in the picture remind you of Norton?" She exclaimed, "You're right; it does!" Fred immediately lost all interest and decided the painting was not for him. The business arrangement between Fred and his former brother-in-law, Norton Simon, had not ended amicably.

The museum had a policy of showcasing New Orleans sculptors' works in the circular pond in front of the main entrance. Fred had been interested in acquiring a kinetic work by Lin Emery. We placed a piece of hers in the pond at the time of his exhibition at NOMA in 1988. When the exhibition closed, we sat down to discuss where all of the works were to be sent. Finally, I asked him where we should send the Emery. He said he liked it where it was and thought it would be a shame to move it as he didn't know where to send it. I then asked if he would consider buying it for the museum. That way, it would not have to move, and he would save shipping expenses. Fred agreed, and it did not move from the front pond until Hurricane Katrina in 2005 ripped it off its plinth and hurled it across Lelong Avenue, where it landed near the lagoon and under a fallen tree.

Today, it is mounted in the reflecting pool in the museum's Sydney and Walda Besthoff Sculpture Garden.

Victor K. Kiam

When John Bullard was appointed the fourth director of the museum in 1972, Alonzo Lansford, Sue Thurman, and Jim Byrnes preceding him, one of the first letters he received was handwritten on small powder-blue stationery in a blue envelope, inviting John for a visit next time he was in New York. It was signed by Victor K. Kiam. Not knowing who this was, John asked me, and I admitted I was unfamiliar with the name. After he asked a few others, the name remained an enigma until John accepted

the invitation and made an appointment to visit the mysterious Mr. Kiam in his Park Avenue duplex. Upon his return to New Orleans, he reported finding an extraordinary collection of modernist painting and sculpture, interspersed with ethnographic art, mostly African and Oceanic.

A Houstonian by birth, Kiam was reared and educated in New Orleans, where he had received his bachelor's and law degrees at Tulane. After setting up and practicing in a law office on Baronne Street for a few years, he eventually moved to New York, where he lived for nearly a half century and achieved financial success in the stock market.

John encouraged me to visit Mr. Kiam to see the African and Oceanic work, and so I did on my next trip to New York. I punctually arrived and was received most graciously and humbly by Ms. Chang, Mr. Kiam's companion. As I stepped into the foyer, I was overwhelmed by the strong scent of Jungle Gardenia eau de cologne! I was ushered into a small sitting room filled with African masks hanging on the walls and was told Mr. Kiam would see me shortly.

After a brief time, a diminutive, elderly gentleman entered the room wearing eye glasses with Coke-bottle-thick lenses. After polite introductions, he inquired about my background. Upon telling him I had studied with the pre-eminent African scholar in the field, Roy Sieber, which I thought would impress him, he exclaimed, "Terrible man!" and went on to denounce my professor. After several other questions, all of which I provided the seemingly wrong answers, I concluded things were definitely not going well, and I should make a polite escape before making my host any more annoyed.

He hesitated a moment and then directed my attention to the masks on the wall. Pointing to one, he asked me what I knew and thought about it. I told him that it was from the Senufo peoples from the Côte d'Ivoire and how it was worn and used by them. I told him what distinguished it from others of its type and other details. Humph! And a pause. Next mask, same questions. After going around the room discussing each and every piece, he stopped and said, "Would you like to see some more?" With that, he slowly opened a pair of French doors to reveal a large room filled with Picassos, Mirós, Braques, Legers, and Giacomettis interspersed with more African and Oceanic masks and figures. On a

pedestal in front of the windows at the far end of the large room was an extremely rare male wood figure from Hawaii. I was overwhelmed. The sight took my breath away. Now I had a feeling how Howard Carter must have felt when he exclaimed, "I see wonderful things!" upon first peering into the newly opened tomb of King Tut. For the next couple of hours, Mr. Kiam and I systematically went around the room discussing each ethnographic piece, including the modernist paintings. We ended the evening in his upstairs library, where he showed me his rare artist-produced books, scrapbooks, and other memorabilia, including photos of al fresco lunches he'd had with Picasso and Miró. What an evening! I guess I passed the test.

Shortly thereafter, John decided he should reciprocate Mr. Kiam's hospitality. With the cooperation of NOMA trustee Muriel Bultman Francis, he invited him and Ms. Chang to come to her five-story town house on East Sixty-Fifth Street between Park and Lexington to view her extraordinary collection before taking them out to dinner. When their arrival time came and went, John and Muriel wondered if Kiam had forgotten or scheduled to come another day. Finally, they called his house and told the housekeeper they were awaiting Mr. Kiam's arrival. They were informed he would not be coming. He had dropped dead on the street that afternoon!

Later, the museum learned it would be the recipient of half of his art collection, sharing it with another beneficiary, the Museum of Modern Art. As it turned out, chairman of the Department of Painting and Sculpture William Rubin at MOMA knew about Mr. Kiam's collection and was eager to have the nine important Mirós in particular. MOMA's holdings of Miró are impressive and comprehensive, but there was a noticeable gap. One period of the artist's career was not adequately represented, and Bill Rubin interceded and went directly to Miró to ask for his assistance in persuading Mr. Kiam to leave a certain painting to satisfy that vacancy at MOMA. When Mr. Kiam learned Rubin had deceptively gone behind his back, he was enraged and made a codicil to his will: the New Orleans Museum of Art would receive his entire collection, leaving MOMA out altogether! The moral of this story: don't be a greedy curator.

What Mr. Kiam obviously did not know was that he would die when the stock market was down and the majority of his estate was his art collection. Under New York state law, if an estate's principal is left to a nonprofit organization, the heirs may contest, and they did. Mr. Kiam's son, Victor Jr., was left out of the will entirely, but his children were given the residual trusts. After much maneuvering by the lawyers for several years, the dispute was settled amicably out of court with the family receiving one million dollars of appraised art of the museum's choosing. Five of the lesser Mirós were conceded by NOMA, and the museum kept four of the most important that gave a solid cross-section of the master's oeuvre. Victor Jr. proceeded to sell his share to acquire the Remington razor company and told us frequently in his incessant television commercials "I liked the razor so much I bought the company." Later, he became the owner of the NFL's New England Patriots as well. As time passed and his wealth increased, Victor Jr. became a friend of the museum.

During this time of negotiating, there was an offer from "a Parisian dealer" to purchase "the less valuable African and Oceanic art and take it off the museum's hands." I told John to tell them where to go—we were not interested indeed!

Fred Feinsilber

The day after 9/11, I flew from Naples to Paris. Sitting in the front of the plane, I noticed that the door to the pilot's deck was standing wide open all during the flight. I thought to myself, hadn't the airlines learned anything from yesterday's tragedy? That evening I was, yet again, the guest of honor at another beautiful dinner party at the exquisite home of Fred Feinsilber and Carol Allen. I had become friends of this charming couple who had been living in France for more than two decades. Originally hailing from Eunice, Louisiana, Carol had met Fred in New Orleans when her daughter, a concierge at a local hotel where Fred was staying, was offered a nice fee for finding a guide to the city. Later, when she reported to him, she had been unsuccessful, he asked her to continue

trying. Finally, she was able to report happily she had found someone who could show him the city. In desperation, Carol's daughter had called her, and to help her daughter out, she reluctantly agreed.

Their luxurious apartment, filled with important art, including African, is in the building just off the Seine on rue Bonaparte in the fashionable Saint-Germain-des-Prés, where Eduard Manet was born and Yves Saint Laurant and Pierre Bergé lived on the first two floors. Carol and Fred could look down on the fashion designer and his partner's lovely gardens below. The other half dozen guests that evening were all American ex-pats. My dinner partner at the table was Diane Johnson, author of the popular novel *Le Divorce*, among her other books about Americans abroad. She and I shared a bond as former Midwesterners. Everyone at the table was still in shock from the previous day's horror, and the mood was subdued and somber. Carol, who is an excellent cook, had prepared a gorgeous dinner, but she confided she had cried all day in the kitchen.

After making my rounds in Paris for a few days, I took the TGV to Orange in the south of France to be met at the station by Fred, who was already there. We drove to the village of Roaix, where I was the guest of Carol and Fred in their glorious hilltop chateau overlooking the idyllic Provence countryside. During my stay, Fred and I had wonderful conversations about the philosophy of art, one of his favorite subjects and one he planned to write about. Having visited New Orleans several times with Carol, Fred inquired about the people he had met there. In particular, he asked about a certain New Orleanian, and after I described this individual in more depth, Fred exclaimed, "You know, that is the only person I know who has a bigger ego than me!"

In recent years, I have been Fred's guest four times, staying in the beautifully furnished and decorated garret apartment two floors above his own, twice during the time of the Parcours des Monde, the important large annual tribal art fair in his neighborhood. Each time we have the opportunity to spend time together, we visit dealers and discuss his favored subjects: aesthetics and the philosophy of art, particularly their relation to ethnographic art. He continues his writing in earnest. On one of my visits, he generously informed me I could have the use of the apartment anytime it was available.

On a recent third stay in early Fall 2019 in "my" apartment, my visit with Fred and his new dear friend, Dominique, our conversations continued regarding his interest philosophic writing. A philosophy professor visits him weekly to discuss Fred's writings of that week which have become more serious and intense. This has led to him reading Hegel and Kant and other noted scholars as research for his own writings.

Fred is a master of numerous interests. Originally a scientist and chemist who retired and turned his attention to the arts, he collected and later sold at auction an extraordinary collection of rare books and manuscripts. He created at Roiax a cabinet of curiosities and a magnificent hilly several-acre strolling garden with a philosophical theme. He delved into the collection of the finest African art sculptures and, having accomplished that, now has turned his attention with the same fervor to Oceanic art.

Anand Sarabhai

Anand was a molecular biologist and entrepreneur involved with research and healthcare. He participated in the Human Genome Project, and he was an inventor and art collector. As the founder of Ecological Applications of Technology for International Trade (EATIT) World, Anand became concerned for the loss of natural eco-systems and habitats, which inspired him to champion products made from sustainable resources such as cane, bamboo, and leaves. Two of his most successful ecologically sustainable, aesthetically delightful products were papadini pasta made from legumes and a bicycle fabricated entirely of cane.

The Sarabhais in the state of Gujarat are one of the leading families of India. I refer to them as the du Ponts of India. Their diverse manufacturing businesses, named Calico, delve into medical instruments, pharmaceuticals, plastics, and textiles. Once, flying with Anand from his home in Ahmedabad to Bombay, he periodically looked out of the plane's window and exclaimed, "Look there's one of our plants down there." The family had a distinguished career and reputation in India supporting the arts, particularly dance. Anand's grandfather was

an early supporter of Gandhi and helped him relocate to Ahmedabad after his return from South Africa. A Gandhi quote in the Ashram in Ahmedabad says, "I have nothing new to teach the world. Truth and nonviolence are as old as the hills."

When Nehru invited Le Corbusier to India in the early 1950s to build the new capital for the recently partitioned state of Punjab, the Sarabhai family invited Corbu to design several buildings in Ahmedabad. Today, the Sarabhai family lives in a home and compound, named Shahibag, meaning Royal Garden, designed by the great French architect. All local materials were used: black stone for the floors, rough terracotta tiles for the parallel series of barrel vaults for the roof, and Indian teak and white cedar for the doors, storage units, and tables. In an interview, Anand talked about the house: "The roof garden was conceived and installed when the house was built and we have always taken our informal meals there. It is built on about 2 feet of earth and keeps the house very cool in the summer and insulted in winter. The [water]slide [for the swimming pool] was an idea of my brother Suhrid and myself. We wanted it because we like sleeping outside on the roof garden and it was exciting to slide into the pool before going to school. The grounds are purposely unruly and surround the house with a forest. There are wonderful textures of different varieties of trees and vast population of exotic wild birds."[2]

An outgrowth of the house commission by Corbu was the family's expanded patronage of the arts, especially under the leadership of Anand's mother, Manorama, affectionately known by all as Mani. The family established a residency program for leading contemporary American artists and designers; the agreement between the family and the invited artist was informal but with certain mutual understandings and rules. It would be the artist's responsibility to get to Ahmedabad. Once there, the Sarabhais would provide housing and meals, studio space, and any necessary work assistants. There was no limit to the time of the residency, and if the artist did not care to produce any work, that was acceptable. A driver was made available for the artist to explore the area for possible inspiration or simply to enjoy the environment and Indian culture. At the conclusion of the residency, the artist was under

no obligation to leave any of the completed works with the family. However, over the years, the Sarabhais amassed an impressive collection of American art of the last half of the twentieth century.

Alexander Calder was the first artist to be invited in 1954, and his large mobile is installed outside over the swimming pool. Some of the other artists who have spent time working at the Sarabhai compound in Ahmedabad are Peter Alexander, Alan Shields, Ivan Cheymeroff, Kim McConnall, Robert Kushner, Charles Eames, Richard Smith, Leo Leonni, John Cage, Robert Rauschenberg, Frank Stella, Isamu Noguchi, Robert Morris, Keith Sonnier, Eric Fischl, and April Gornik.

Of course, the artist whose first visit in 1979 has had the most lasting relationship is Lynda Benglis. Anand and Lynda were life-long partners until his death in 2013. She continues to travel often to India to stay with her family, and they come to visit her in the States.

Early on, Le Corbusier had objected to the installation of ceiling fans in his barrel-vaulted ceiling, but Mani insisted and prevailed. Today, those fans, at the suggestion of Anand, have been painted by visiting artists Sonnier, Chaymeroff, Benglis, and Shields.

For many years, it has been a dream of mine to put together an exhibition of the works made by those visiting American artists. Over the years, these residencies have had a profound effect on the work of many of the attending artists. With a working title *Made in India*, the exhibition would include Robert Rauschenberg's Jammer series (1975) which was inspired by the Sarabhais' Calico textile mills; Roy Lichtenstein's large cloth landscapes (1977); Frank Stella's metal Bird series; Keith Sonnier's Bamboo series; and Robert Morris' large leather pieces, which were dried in the sun on the second-floor roof gardens.

While visiting Anand in early 1983, I pointed out to him that I, at that time, had been the only American museum curator to have visited Ahmedabad and asked if he thought the notion of an exhibition of work made here had any merit for him. He was most receptive to my idea, but we agreed I should wait a few years until more artists had visited and made work. Today, I still feel that it is worth considering, and I would hope someday an art historian/curator would pursue the subject for an exhibition. It is clear that the Sarabhai family has had, at the very least,

an influence on contemporary American art during the last half of the twentieth century.

During that stay, Anand and I also discussed his dream to one day build a museum to house his art collection of finished works by visiting artists. Included could be all the beautiful photographic documentation of each artist's tenure and other working plans and sketches. He wanted to commission a leading world architect and at that time was considering Arthur Erickson. In later years, he approached Frank Gehry, who expressed a serious interest in such an undertaking. We also talked about the possibility of me working with the architect and being the director of the finished museum. Again, at that time I was not ready to leave NOMA and New Orleans, and Anand wanted to wait a few more years before undertaking such a project. In 2013, Lynda Benglis and Anand called me from Ahmedabad and asked me to come there to work on the family archives with all the visiting artists who had residencies there over the years. Unfortunately, it was not possible at that time for me to go, and Anand died two months later.

Episode 8

I'm an Artists' Groupie

The gifted artists are the great benefactors of the world. Life flows from their souls, from their heart, from their fingers. They invite us to celebrate life and to meditate on the mystery of the world, on the mystery of God. Artists constantly open new horizons and challenge our way of looking at things. They bring us back to the essentials.[1]

As I pride myself an unabashed "artists' groupie," I have been blessed to have had my fifteen minutes with many talented, entertaining, fascinating personalities—including Andy Warhol, who coined the famous phrase about fleeting fame. Those moments I cherish and want to share a few memorable incidents; brushes with the legendary is always a thrill.

As I wrote in 2003 in my Contemporary Arts Center exhibition brochure, "I have found artists to be most stimulating, and they are my heroes. Besides artist friends with whom I associate regularly, I have sought out those who have never had any formal art training and whose artwork fascinates me. Being welcomed into their private milieu—usually disconnected from the traditional art world—and developing relationships, sharing ideas and experiences, has been particularly enriching and fulfilling. It has provided yet another insight into humankind's inscrutable compulsion to create."[2]

Lynda Benglis

Little did I know that my visit in the mid-1970s to Lynda Benglis's studio on Baxter Street in Lower East Side Manhattan would develop into a

lifelong friendship. I was seriously considering her for my *Five from Louisiana* exhibition, and we hit it off immediately. She was eager to show me her new work—lozenge-shaped sculptures of multilayered, multicolored melted wax in painterly strokes of color coupled with complex peaks and valleys of rainbow-layered wax. In a way, they reminded me of ancient surfboards. After a most enjoyable studio visit, Lynda suggested we go to some gallery openings that evening where she eagerly introduced me to many in the art world including Klaus Kertess, Robert Smithson (shortly before his tragic death), John Chamberlain, Dorethea Rockburne and Jennifer Bartlett. "I want you to meet my new friend who is a curator at the museum in New Orleans!" Her exuberance and enthusiasm were not what I anticipated from one of the new shining art stars in what I conceived of as the uptight, snobby New York art world.

Lynda relishes in helping others, particularly young people who are just beginning their careers in the art world. When a nice, young woman approached her concerning employment, Lynda had nothing available at the moment and suggested she ask Lynda's at-the-time boyfriend, Klaus Kertess, who co-owned the popular Uptown art gallery, Bykert Gallery, if he had anything available. He hired her on the spot to be a gallery assistant. She worked very well. In fact, Klaus began complaining to Lynda she was doing too well. "She's taking over the gallery!" Her name was Mary Boone.

Lynda collects properties. Her inventory includes a huge contemporary house/studio that she built deep in the woods of East Hampton, an old stone house on the tiny island of Kastellorizo in Greece that she inherited from her grandmother, and an old adobe house that she renovated on the fashionable Acequia Madre street in Santa Fe. She recently bought yet another house in Santa Fe known as the Gillette Mansion built and formerly owned by the razor-blade family. Outside of Santa Fe, she built two large studios in the desert near the Cerrillos Hills. She also maintains apartments in the Bowery and on Prince Street in Soho. If all that isn't confusing enough, she often goes to Ahmedabad, India, where she shared a home with her longtime partner, Anand Sarabhai. More recently, she acquired a large Victorian house near the foundry she

works with in Walla Walla, Washington. Lynda has long had the desire to own a house in New Orleans. She's often asking me to recommend a place for her.

Lynda and I bonded early on, and we have been like siblings—we both care for each other a great deal but have our moments. For me, one of the tests of any friendship is how well the parties travel together. I have been her guest several times at her house on Kastellorizo, Greece.[3] On another occasion, Lynda, Anand, and Los Angeles painter Peter Alexander, and I traveled to India and visited the Ajanta cave paintings and Ellora temple carved from living stone.

One of the maddening things about Lynda is her penchant for talking on the phone about some particular person or place or occurrence and relating the story starting with chapter 2 and not explaining the preceding part. What is she talking about? Who are these people? How did this happen? It's like hearing an audible puzzle, and your job is to figure out the sequence and fill in the missing pieces.

Once on a trip to Minnesota to do a gig at a university or museum, she impetuously bought a dachshund puppy and brought it back to New Orleans. This dog, Oscar, became the cherished pet of both Anand and Lynda and traveled with her everywhere before he finally ended up living in Ahmedabad to sire litters of puppies. Her dogs have traveled the world with her as emotional support animals and have stayed in many fine hotels and been accepted at many restaurants (that don't allow dogs!). One of Oscar's progeny was her much-beloved, lively female Pi who recently went to doggie heaven. She has been replaced with a new puppy, Cleo.

Lynda has been most generous, not only through her continuing love and friendship, but also with sharing her art through gifts. The most recent piece came most unexpectedly. The board of Prospect New Orleans held an event celebrating its own 10th anniversary and honoring me as its first board member. Before Chris Alfieri, Prospect's President, introduced me at the party, he unveiled a sculpture sitting on a pedestal. It was a blue/purple translucent acrylic sculpture which Lynda made in 1982 as the first maquette for her first fountain sculpture made for the Louisiana World Exposition in 1984. I was totally speechless! As it

turned out, at the close of the World's Fair, the fountain was acquired by an individual and ultimately lost for many years much to the Lynda's distress. I was instrumental in finally locating it and having its rightful ownership determined with Chris's legal help, Lynda was so grateful for what I had done. This gift of the first maquette is extremely meaningful to both of us.

Kitty Carlyle Hart

Actress Kitty Carlyle Hart was born and raised in New Orleans. She had an affection for her home town and occasionally came back to visit with friends, among them Justine Godchaux McCarthy. One year, Kitty agreed to host the annual fund drive for the local PBS station, WYES-TV, which auctioned donated artworks on air. As I had done for many years before, I was an auctioneer the same evening Kitty hosted. After our shifts were finished, I noticed she had apparently been abandoned by the station and its volunteer workers, who had made no plans for the rest of the evening. I asked her if she would like to go to dinner. "I would love to!" she enthusiastically responded.

So off we went in my small Porsche 914 with the top down. It was a Sunday evening, and that meant *tout* New Orleans was dining at the popular Caribbean Room in the Pontchartrain Hotel on Saint Charles Avenue. When the maître d' ushered us through the crowded dining room, heavily bejeweled Kitty in her billowing marine blue taffeta evening gown and me in my spiffy tuxedo, there was a hush, and all eyes followed us to our table on the other side of the room from the entrance. She was a consummate show person and knew how to make an entrance! Oh my, was the room buzzing.

Kitty and I had a delightful dinner together. I was a huge fan of her husband, Moss Hart, and had just read his memoirs, *Act One*. We had a wonderful time talking about him. After dinner, I took her back to her hotel, the Roosevelt. As we parted, she said something I will long remember: "Now the next time you come to New York, give me a call. You know, there's always some place to go!" Regrettably, I never did.

Georgia O'Keeffe

One of the most memorable meetings I've ever had was on June 28, 1974, one relaxing summer morning visiting with Georgia O'Keeffe in her studio at Ghost Ranch in New Mexico a few years before her death. Even though I had made an appointment through her New York agent, Doris Bry, she was not expecting me, and when I pulled my car up in her driveway, resident artist Juan Hamilton approached the car and inquired if he could help me. After he retreated into the house and returned, Ernie Mickler (my partner at the time, more about him later) and I were invited in, despite her plan to spend the morning working in her studio. As Ernie described, "It was an adobe house with logs for beams and the wooden slats between to keep the dirt from coming in and brickish kind of floors, tile floors and nothing to it. Just the commonest. I mean there weren't three sticks of furniture in any room. She lived very basically, no frills."[4]

We sat in her large-windowed studio with the northern light flooding the room, she in a rocking chair and Ernie and me seated opposite her. Several finished paintings were sitting around the room, and one of her white cloud works hung over the fireplace mantel that was casually strewn with natural forms such as stones, seashells, seedpods. The low windowsills also displayed bleached antlers and other special forms she admired and collected. She explained that the cloud paintings had been inspired by her fascination of looking out of airplane windows when traveling.

We spent a delightful couple of hours casually chatting with her. When I told her I was from New Orleans, she declared, "New Orleans— I haven't been there since 1917!" She then reminisced about the city, recalling that there seemed to be a lot of laundry hanging out on clothes lines between the buildings. (She must have been there on a Monday.) When she expressed a desire to return to Louisiana as she was eager to go into the swamps, I told her I could arrange for her to do that. Then her eyes brightened, and she said, "You must get a lot of good dope down there!" Taken aback by this candid remark from such a regal old woman, I meekly said we did and then tried to change the subject. But

she wanted to know more. It was then that I realized, why shouldn't she—she's chosen to live in the middle of a peyote field all these years!

Even at her advanced age, she was *au courant* with what was going on in the art world and loved to gossip. She spoke about her painter friends Marsden Hartley and John Marin and photographer Paul Strand who all were shown by her husband Alfred Stieglitz in his gallery An American Place. She had a special affection for Arthur Dove and his work and felt he had never received the recognition he deserved. I told her how impressed I was that Stieglitz was such a pioneer in exhibiting African art in his Gallery 291 in 1907. I told her photography was becoming more widely sought after by museums and collectors and that NOMA was just beginning to develop a collection of the history of photography. She expressed surprise that Stieglitz's photographs were commanding such high prices and said she would have to dig out the ones she had stored in her house in Abiquiu. Another artist she particularly admired was Ellsworth Kelly.

As we passed a good time in her studio chatting, her two Chow Chow dogs went to the door and started pawing it. She looked at me and said, "Excuse me," and got up and let them out. When she got back to her rocking chair, she said, "You know why they wanted to go out, don't you?" When I said that I didn't, she said in an understanding way, "So they could come back in again."

Ernie was looking forward to acquiring Native American turquoise jewelry when we arrived in New Mexico, and I said I had no interest in that for myself. A few days later, when we went to visit Georgia, my arms, fingers, and waist were laden with my recent purchases. You couldn't miss it. I told her that when I had arrived in Santa Fe, I had vowed that I was not going to give in to buying any jewelry, and now look at me. When Georgia began fingering my bejeweled accessories in admiration, I sheepishly admitted my guilt at having been seduced so quickly by the silver and turquoise. She responded in a most sympathetic and understanding voice, "I know, it happens to all of us."

She asked if we would like to see the kiln and ceramics studio she built for Juan behind the house. Of course we would. There were many ceramics cluttering the building, and she pointed to certain ones and

asked what we thought of them. When we gave her a positive response, she seemed genuinely pleased. What we didn't know at the time was that Juan had been teaching her to do ceramics, and most of the ones we admired were made by her own hands.

Strolling outside, I exclaimed with surprise, "My God, it really *is* your backyard!" referring to NOMA's O'Keeffe painting titled *My Backyard*, which we had purchased from Doris Bry. Later, in a distinctly reverential voice, she pointed out the flat-topped mesa in the Jémez range called the Pedernal and told us she felt a special communal feeling and "ownership" with that particular landscape. She once said, "It's my private mountain, it belongs to me. God told me if I painted it enough, I could have it."[5]

When we were preparing to leave, we walked by some natural objects she had lovingly collected and left sitting on benches around the house. She gave Ernie one of her cherished sun-bleached antlers he had picked up and admired. I have since been informed by the curator of the Georgia O'Keeffe Museum in Santa Fe that she normally did not like for visitors to touch or rearrange her collection of natural forms lying about, so for her to offer one as a gift after being picked up meant she liked us and was enjoying our visit.

When she died in 1986, Juan scattered her ashes on the Pedernal.

Imogen Cunningham

During the same trip west in 1974, Ernie and I had the good fortune to visit the renowned photographer and equally senior Imogen Cunningham at her home in San Francisco. It all happened thanks to Sunny Norman, a fellow graduate of Mills College, who had visited her earlier with her husband, Roussel, and he had charmed her. That charm resulted in Imogen allowing them to purchase a number of her early platinum prints. As it turned out, one of them was unsigned, so Sunny gave it to me to get signed and arranged the visit.

What a pistol Imogen was! Her acerbic tongue and feisty manner were quite a contrast to the laid-back velvet-toned Ms. O'Keeffe. When

we arrived, she was feuding with her neighbors over the fence about a recently cut down tree. At the same time, she was deliberating the development of a Chinese-style ink chop to add to the verso of her original prints to certify that they were genuine, a kind of stamp of authenticity. As a museum curator, I was sought out for my thoughts and advice of such a device. In Chinese calligraphy, she wanted the wording to be rather cryptic or nonsensical. Later during our conversation, this diminutive lady curtly announced she had just made a television commercial. "If Ansel [Adams] can do it, so can I." Her nemesis had earlier made one for Toyota. When I inquired who she made the commercial for, she snippily retorted, "The mortuary service!"

Ernie listened intently to our lively conversation. Suddenly, she turned to him and abruptly inquired, "And what to *you* do?" In reference to an on-going heated garbage men's strike in the city at that time, she quipped, "I hope it's not trash!" Ernie responded that indeed it was as he was thinking of writing a cookbook on white-trash cooking. At another point in our visit with this legendary character, the telephone rang, and she answered it in the other room. Soon we overheard her yelling to the caller, "Why do I want to look at your photographs!" This went on for some time, and finally she agreed, saying, "Oh well, bring them over. The curator from the New Orleans Museum of Art is here. Maybe he'll look at them for you!"

Andy Warhol

My most extensive visit with Andy Warhol was in early 1970 when he came to New Orleans for the opening of *Raid the Icebox I*, an exhibition which he had curated. The Isaac Delgado Museum of Art mounted the exhibition after its premiere at the Art Barn at Rice University in Houston. I first met Andy after the Rice opening in 1969 at a dinner Dominique and John de Menil gave at their Philip Johnson-designed house on San Felipe in River Oaks. Accompanying him to the New Orleans opening was his entourage, including his film director, Paul Morrissey, his cute, young interior decorator boyfriend Jed Johnson, and his glam-

orous new Superstar Jane Forth with her raven hair pulled back tightly in a bun, highly plucked eyebrows, and ruby red lips. For several days I was their chauffeur, social secretary, confidant, and tour guide.

His visit to New Orleans was one the few times he had made a public appearance after Valerie Solanas had shot him in June 1968. While he was recuperating from that incident, he would send a surrogate impersonating him to other scheduled events. We were not sure if he really would show up or we would get a stand-in, but I guess the lure of our charming, decadent city was too much for him not to come.

After picking them up at the airport, I was driving Andy and his posse around New Orleans, and I casually pointed out a Dempscy Dumpster where the day before a dead vagrant's body had been discovered. Andy's comment, which became a frequent utterance during the visit, was a drawn-out whisper, "Oohh Wwoooww!" This excited Paul and Andy, who explained that they had just wrapped up shooting their next movie the night before, a film to be called *Trash*.

Raid the Icebox was the brainchild of John and Dominique de Menil. It was planned to be the first of several exhibitions where well-known artists would be invited to serve as guest curators to select an exhibition from the storage area in various American art museums. This first one paired Warhol with the art museum at the Rhode Island School of Design.[6] Andy's was most unorthodox as one can easily imagine. Chain-link racks, like those found in many museum storage areas to store paintings, were built in tightly packed rows in the Delgado galleries and works hung on them. Other groups of paintings were stacked on the floor "cheek to jowl" and secured by sandbags holding them in place. As intended, all of this made it impossible to adequately view the paintings. Works by Degas, Prendergast, and Dutch masters were interspersed among other artworks by obscure and unknown academics and amateurs. Other parts conformed to his common notion of repetition: storage cupboards filled with rows and rows of racks filled with fashionable women's shoes throughout the ages. Early in his career, Warhol had made illustrations of ladies' slippers for newspaper ads in the *New York Times*. Stored above the viewer in the gallery were long rows of antique wooden chairs on pegs and hundreds of bumbershoots.

In keeping with the nature of the exhibition, we planned the museum preview to be just as unconventional. At ten o'clock at night, the basement loading-dock doors at the rear of the museum were opened to admit all those who had been waiting and had paid ten dollars to come meet the pop master and his entourage. After being escorted through the museum's basement storage area with corridors of painting racks, the crowds were ushered upstairs to the exhibition, where they were received by the artist himself. In the spirit of the evening, we installed a glittering, rotating mirror ball and an old-fashioned bubble jukebox in the Great Hall and offered Lucky Dogs served from those iconic French Quarter carts in the shape of a gigantic hot dog. Dominique de Menil was in attendance and loved our opening, particularly guests entering through the basement loading dock and through art storage.

What an evening! Hundreds and hundreds of excited patrons were having a ball . . . all except the special guest who everyone had come to rub shoulders with. Word got back to me that Andy wanted to leave. He wanted to go back to the hotel and watch old movies on TV! Reluctantly, we accommodated his wishes, and I took him to his hotel, the Royal Sonesta. The party, however, went on into the wee hours of the morning, and Andy was hardly missed. The next day, Alan Katz of the *New Orleans States-Item* covered the glamorous soirée on page one. " . . . The result was a delightful blending of a Mardi Gras ball and a hippie happening. . . . There were togas and tuxedos, super mini-skirts and evening dresses, buckskin jackets and Edwardian suits, top hats and felt hats from the 1930s, long hair and short hair, high heels and bare feet." Katz concluded, "For last night at least, the young and the old celebrated a truce for the purpose of aiding the Delgado Museum. If Andy Warhol intended his exhibit as a gentle laugh at ourselves, the New Orleanians in attendance last night joined in his merriment and had a fine time doing it."[7]

The next night, I threw them a party along with friends Tommy Long and Leclare and Shirley Ratterree at the couple's large house on Peniston Street. An invitation that night was the hottest, most sought-after ticket in town!

During his two or three day stay, invitations were fast and furious. As his driver, I was always expected to fill Andy in on our hosts. By the time we arrived at our destination, he had been fully briefed on who and what to expect. When we would leave, he would say, "Who was that crazy lady?" or "Tell me about so and so" Of course, I would fill him in on all the unabridged, uncensored details. Well, what had totally slipped my mind at the time was that he had a small tape recorder operating every waking hour, and all of my gossipy information had been recorded! Not only that, but he intended to *publish* transcriptions of the tapes in a book titled *B* as a follow up to one already published from earlier tapes titled *A*. Well, I thought my goose was cooked, and I nervously told Sunny Norman I would be run out of town if he followed through and published. Sunny responded, "Bill, don't worry, we'll all have to leave town!" Thank God, he never did get around to publishing that second volume, but maybe someday someone will![8]

While I was in college, I had bought a first-edition serigraph of Andy's *Liz* from the first exhibition at Leo Castelli Gallery. While Andy and his party and I were walking in the Quarter, we stopped at my apartment on Governor Nicholls, where I showed him the print. "Oh wow, that's one of the GOOD ones!" he drawled in his melodic voice. Even though it had previously been signed by him, I asked if he would sign it again. He pointed out it was already signed, but I wanted a dedication. Not wanting to alter the front, he obliged and inscribed the back "To Bill F. F. F. F. F. Andy Warhol"

Andy was so impressed with the city, he and Paul Morrissey, his film collaborator, were already discussing coming back to make a movie about Walt Whitman as a male nurse during the Civil War. Andy and Paul were in the final development of the film with a finished script.[9] He asked if I would like a part in it as I had the requisite beard. Sure, why not. That never happened either.

Andy came back to New Orleans a few years later in conjunction with an exhibition of his work at the Freeman-Annacker Gallery owned by his friend Tina Freeman. Tina threw a lavish dinner party in his honor in the Rex Room at Antoine's Restaurant to which I was invited. During cocktail hour, I noticed he became infatuated with all the photographs

of celebrities papering the cavernous walls of this legendary restaurant. Foreign kings and queens, Hollywood movie stars, US presidents, world leaders, and other notables who had dined there were now immortalized along with distinguished members of Mardi Gras royalty of years past. He was enchanted. I volunteered to explain the mystique of the intricacies and importance of this later event, including the fact that his hostess was a past queen of Carnival.

He was mesmerized when I showed him a particularly small, unnoticeable photograph documenting an unforgettable event that occurred in the city. The legendary story goes that word was received in New Orleans that the Duke and Duchess of Windsor were planning to come to Mardi Gras in 1950 and had expressed a desire to go to Rex's ball that evening. The Rex Organization was aflutter . . . what to do? How can they be properly received, and more importantly, how will the duke and duchess act when formally presented to his majesty Rex. For days tensions mounted, and finally the moment came and was dully captured for posterity in the photograph of the duke and duchess curtsying and bowing deeply to the enthroned Rex and his consort. A huge sigh of relief was felt throughout Uptown, and life could go on. Andy ate it up.

Robert Rauschenberg

I first met Bob Rauschenberg in Amsterdam in 1962 while on my first three-month-long grand tour of Europe to celebrate my graduation from college with my good friend graphic designer and sculptor Jack Nichelson. While visiting the Stedelijk Museum, I encountered a crazy, wacky sculpture that enchanted me. It moved in a most erratic, silly, jerky Rube Goldberg nonsensical way. It made me laugh. Who *was* this artist? The label identified the artist Jean Tinguely. I went to the museum shop and inquired if they had something published on the piece, possibly a postcard. Unfortunately, they didn't but informed me that the artist was in the building and asked if I would like to meet him. "Sure," I eagerly replied.

He was eating lunch in the museum café, and I was escorted in and introduced to him and his fellow diners—Niki de Saint-Phalle, Martial Raysse, Daniel Spoerri, Per Olof Ultvelt, and Robert Rauschenberg. They

had all been invited by the museum to work on an upcoming collaborative exhibition which was called *Dynlaby* (Dynamic Laboratory). It was to open in a few weeks. However, at that point, things were not going well among the invited artists. Bob was pushing for what the museum had brought them all there to do, to collaborate. This concept was to remain one of his major tenants throughout his career. The others, primarily Tinguely, were reluctant to cooperate, and Bob became irritated and felt Tinguely was giving orders and generally bossing the others around. With this ongoing friction, it was decided each would do their own separate piece in their own assigned space.

All the artists were busy assembling their site-specific pieces in the assigned galleries. Bob had elected to go out on a "scavenger hunt" around the city retrieving found, discarded objects from which to build his piece. Bob and I struck up a friendship (he grew up in Lafayette, Louisiana), and over the next several days he eagerly showed me the new "treasures" he had found that day. When I told him I had just visited the Venice Biennale a couple of weeks before, he was eager to hear all the details as he, at that point, wanted to win the Biennale prize. This became a reality two years later. Regrettably, I did not stay in Amsterdam for the opening of the exhibition and never saw the finished pieces that each artist had created. My friendship with Bob continued through the years. My *Five from Louisiana* exhibition, discussed earlier here, was the one time we were able to work on a project together.

In the late 1970s, Leo Castelli had installed in his gallery on West Broadway his first exhibition of drawings by a renowned group of contemporary architects, much to the chagrin of his visual artists. In a conversation one day on the phone, Bob described the opening night, "Bill, you think art openings bring out weird people! Well, when the elevator doors opened that night at Leo's, you would have thought it was the bar from *Star Wars* entering the gallery!"

Dawn DeDeaux

I came to know artist Dawn DeDeaux when she was hired by John Bullard in 1975 to produce a new publication for the museum, *Arts Quarterly*.

Dawn was a visionary who gave birth to this publication to keep the members informed about what was going on and coming up at NOMA. Her journalistic instincts and style gave the periodical a substance that sometimes went afield from simple reportage and announcement of museum functions and events. The subjects and authors of contributing articles were intellectually thought provoking and a definite contribution to print journalism. The *Quarterly* soon became a literary journal of note, often commissioning from noted writers insightful articles with little association to the museum. While appreciating the attention the paper was getting, John felt the *Quarterly* was drifting off base from its intended mission to inform readers of the museum's past and future activities and requested the paper should be directed back to its original intent.

Dawn loved to entertain and threw lavish dinners at her beloved single shotgun facing the racetrack across Gentilly Avenue. Several times, she and her neighbor Leon "Smokey" Brier, in his midnineties, treated their guests to a feast of Oysters Rockefeller.[10] Starting with a full sack, as fast as Smokey could shuck 'em in the backyard, Dawn would cook 'em in the kitchen. It was a heavenly occasion. In honor of those marvelous epicurean evenings, I christened the house the Oyster Shack.

Like Lynda Benglis, Dawn likes to collect properties. In addition to the Oyster Shack, she bought a second studio/home a block and a half away on North Gayoso Street, both featured in a beautiful article in the *New York Times*.[11] After Katrina, she escaped to yet another residence/studio in Point Clear, Alabama. Six months later, a storage shed for her artwork and art supplies around the corner from her houses burned to the ground and destroyed everything! Since then she has disposed of the two properties on Gayoso and acquired four other adjacent properties nearby in Gentilly where she relocated. She renovated these properties and dubbed them Camp Abundance, a new setting for new dinner parties and group get-togethers.

The Wilde Ball and the Feast of Panthers

Dawn certainly outdid herself with an extravaganza in City Park one summer's night in late June. Dawn was, after all, an artist, and she put

together an event which turned out of be such an incredible evening for all who participated.

On June 30, 1982, the *Arts Quarterly* sponsored *The Wilde Ball and Feast of Panthers*, a free, one-time art performance in the Peristyle in City Park not far from NOMA. This special occasion celebrated the one hundredth anniversary of Oscar Wilde's visit to New Orleans. A formally set table, decorated with Wilde's symbolic sunflowers, ran the length of this Greek-inspired, lozenge-shaped and colonnaded open-air pavilion. With a harpist and flutist playing softly, the catered multi-course dinner for the evening was served, featuring chilled cucumber soup, watercress salad, chilled redfish with green sauce and asparagus, curry of lamb with baked banana, and cherries jubilee, all accompanied by champagne!

On the afternoon of this grand gathering, a violent thunderstorm came rushing through the city, scattering the beautifully set table and handsomely designed souvenir programs throughout the park. The entire setting had to be hurriedly reconstructed in time for the invited guests' arrival at sunset!

With long lengths of diaphanous white gauze suspended between the architectural columns and flowing in the gentle evening breezes, Oscar Wilde, in his inimitable fashion, made his grand torch-lit landing by barge from the adjacent lagoon by the Peristyle. Appropriately dressed, Blair Zigler, who had an uncanny physical resemblance to Wilde, acted the part with flair and acumen. Other luminaries attending that night were General P. G. T. Beauregard (George Schmidt); George Washington Cable (Kenneth Holditch); Sarah Bernhardt (Elizabeth Shannon), who brought along an alligator, one of Oscar's fascinations; Henri de Toulouse-Lautrec (George Dureau); Salomé (Lois Simbach); Julia Ward Howe (Tina Freeman), who was criticized for entertaining Wilde in her Boston home; Ernest Bellocq (Wayne Amedee), accompanied by one of the Storyville ladies of the evening in her underwear and bloomers (Barbara Muniot); and nineteenth-century Louisiana sawmill owner F. Sam LaBlanc (great grandson Kim Amedee). Queen Victoria in all her regalia was there twice: Sunny Norman and red-bearded Reverend Mike Stark.

The re-enactment of Wilde witnessing Saint John's Night, a covert torch-lit ritual along the banks of the bayou bearing the saint's name

on June 24, 1882, also involved voodoo. I was Baron Samedi with my scantily clad assistant and Dureau model Jude-Paul St. Martin. James Abbott McNeil Whistler, the sometimes target of trenchant Wilde barbs, was a no-show—he was summering in Maine at John Bullard's house on Deer Isle. Luba Glade came as herself. JoAnn Clevenger and Luis Hansa made special costumes and attended as well. The *Times-Picayune* social columnist Nell Nolan reported that "Wilde Ball coordinator Dawn Dedeaux zeroed in on Xariffa, the *nom de guerre* of Mary Ashley Townsend, the poet laureate of the Crescent City in the 1880s and 90s who is also known to have penned poesy for Rex."[12] Others who made for an unforgettable, joyous evening were Leah Chase, Robbie Robertson, Thelma Toole, Steve Sweet, Emery Clark, A. J. Loria, Lee Kimche, Dorn McGrath, Guy Lesser, Mea Townsend, and period-costumed US House of Representatives member Lindy Boggs of Louisiana.

Dawn's artistic career has been on a skyrocketing path in recent years. In 1994–95, curator Thelma Golden included Dawn's standout work in her trailblazing exhibition *Black Male: Representations of Masculinity in Contemporary Art* at New York's Whitney Museum of American Art. In a highly unusual performance piece, she entered the high-testosterone Monster Jam demolition derby in the Superdome and won, defeating all her macho fellow participants. Following her extremely popular installation, *The Goddess Fortuna and her Dunces in an Effort to Make Sense of It All* (based on John Kennedy Toole's masterpiece *A Confederacy of Dunces*) for Prospect.2 in 2014 in the famous Brulatour Mansion and Courtyard of the Historic New Orleans Collection, she was selected for a Rauschenberg residency at his compound and studio in Captiva, Florida. This residency had a momentous effect on her artistic thinking and creation process, which resulted in her being selected by curator Denise Markonish for a solo exhibition, which opened in 2017 at Mass MOCA titled *Thumbs Up for the Mothership* based on Stephen Hawking's dire premise that the planet Earth will not outlast this century), which opened in 2017 at Mass MOCA. Following her participation in Dan Cameron's *Open Spaces* performance festival in Kansas City in 2018, she will have a major retrospective exhibition at her former employer, NOMA, in 2020.

Elizabeth Shannon

Elizabeth is one of my most enduring and endearing friends. We first came to know each other in the late 1960s when she ran the Downtown Gallery on Chartres Street for Naomi Marshall. Hailing from Morgan City, where her prominent family has had the hardware store for many years, Elizabeth has had a successful career as an artist in New Orleans since the 1970s.

Her art has manifested itself in many forms over that time: sculptural, conceptual, installation, performance, photography, and avant-garde fashion, all with a pervasive ecological theme. Her concern for environmental issues is demonstrated not only through her art but as a community activist whether it be coastal erosion and the loss of the wetlands or the threatening urbanization and gentrification in her beloved Bywater neighborhood. She has been an active participant in Delaney Martin's *The Music Box* project from the outset. Her talents as a set designer have been demonstrated in numerous photo shoots for music videos and commercials or for the Big Shot VIP lounges at Jazz Fest. I would be remiss if I failed to mention her skills in the culinary arts, in particular her gumbo *z'herbes* which ranks with Leah Chase's legendary recipe.

While Elizabeth has had several addresses over the years, The Last Resort on Esplanade Avenue is the most memorable. Renting a large antebellum mansion from architect Ronnie Katz, she, as the manager, and a group of friends including at various times Ray Diamont, Jim Rivers, Mary Jane and Ron Todd, Rebecca Venable, Don Marshall, and Calvin Harlan lived in what amounted to an urban hippie commune. It became a popular gathering place for their friends Vaughn Glasgow, Mercedes Whitecloud, Nora Marsh, Tobiatha Rossiter, Peter Dean, Frank Lincoln Viner, Bob Tannen, Jeanne Nathan, Herman Mhire, Alex Traube, John Geldersma, and me.

Functions at this address included dinner parties; yoga, theater and dance classes; guest instructors and speakers lecturing on a variety of subjects; dance and musical performances; readings; workshops on crochet and fiber arts; spinning, weaving, and dying yarn activities;

and in-depth studies on Louisiana's cherished brown cotton. Photographer Alex Traube made a suite of images featuring Elizabeth, titled *Slow Dance at the Last Resort*. An annual highlight was the traditional May Pole celebration, with participants holding multicolored ribbons while dancing around the tall rod firmly planted in the side yard. Guests brought boxed lunches and then were asked to exchange them among themselves. Through the enormous good will and blind faith of the dependable Mr. Porter at the French Quarter branch of the Whitney Bank, this whole operation was financed through loans and a communal checking account in the name "The Last Resort."

It can be argued that Elizabeth's artistic career could be defined by the recurrent theme of her popular alligator sculptures, in the same vein as Robert Indiana's LOVE sculptures. In the late 1970s, she became acquainted with Dovie Naquin, an endearing, elderly Cajun whose first language was French. He lived in Point au Chenes in South Louisiana. For a number of years, she visited Dovie during the September alligator-trapping season and stayed in one of his complexes of houses in the swamps. She actively participated in trapping these green behemoths that would become her "art supplies" after taking her catch to the taxidermist. When I took Frederick Weisman to visit her studio, he wanted to buy her sculpture of a stuffed alligator climbing a ladder to put in his outdoor courtyard on Saint Philip Street. However, that was impractical as it would not survive the weather. He was disappointed but determined. To solve the problem, he commissioned her first alligator cast in bronze. He later gave it to NOMA in my honor.

For many years, she has been an active participant in a "girl's night out" poker club with a notable but widely varied group of player members: Tina Freeman, Kent Davis, Patricia Chandler, Josephine Sacabo, Nancy Monroe, Betty Cole, Ginny Hardy, Betsy Mulliner, Marigny Moses, and Tina Shannon. While they take their card playing seriously even though the pot is a pittance, these monthly gatherings are an opportunity for this multicultural group of women from varying backgrounds and vocations, mainly artists and media professionals, to

socialize and discuss issues, express opinions, celebrate a special occasion such as a birthday, and just enjoy each other's company.

Before "cultural tourism" became a catch phrase in Louisiana, Elizabeth invented the concept of Obscure Tours to promote South Louisiana. Taking no more than four clients at a time, she would lead them on outings tailored to their specific requests, which often included a swamp tour. One of her more memorable and unorthodox junkets was with the photographer William Eggleston.

Elizabeth and I both enjoyed hearing music on weekends at music clubs around the city for many years. Frequently, we would run into our friends Barbara Muniot and Wayne Amedee. The pattern was always the same: one of us would call the other early in the morning, and we'd inform each other who was playing where that evening and then decide our itinerary for the night. We were very early followers of a new young local group called the Neville Brothers and went to hear them any chance we got. As years passed and we grew older, our enthusiastic calls in the a.m. would be followed up by another call in the late afternoon about our plans with "I don't know, I'm kinda settled in right now. Let's plan for another time." Later, we didn't even bother calling, and it became clear to us our late-night pilgrimages out on the town had come to an end.

Perhaps Elizabeth's most remarkable and least credited artwork is the performance art piece she created and produced on September 24, 1983.[13] She, along with most of New Orleans's residents, were saddened in the spring by the news that their beloved Pontchartrain Beach amusement park would close on Labor Day weekend. She decided something should commemorate this moment in the history of the city. She conceived of producing and staging a final event for New Orleanians to come experience and celebrate the park one final time. It would be called The Last Ride.

She approached the Batt family, who owned the amusement park and had leased the ground along the lakeshore from the New Orleans Levee Board for all those years. With the family's enthusiastic approval of her idea, she was put in touch with Stephen Kaplow, a real estate

developer who obtained the new lease of the site. With permission granted, she approached her good friend Don Marshall, director of the Contemporary Arts Center, for support, to make this day a fund-raising opportunity for the institution. Her next stop was with businessman Sydney Besthoff for his cogent advice and assistance in obtaining necessary permissions and participations.

Elizabeth was off and running! For the next three months that summer, she and her assistant, Claire, diligently raised money, obtained the necessary insurance, secured Ogden Foods as vendor, rehired Beach employees (ride operators, concession workers, security force) for the day, made numerous promotions on the radio, and issued a call to artists to participate in working with the rides and other art-related events. Sharon Litwin created a VIP lounge. Elizabeth enlisted her dear friend Dawn DeDeaux of DeDeaux Publishing to design and produce a beautiful poster promoting the event.

Twelve thousand people came and had a glorious time at their beloved park that late September day. Musical performances occurred throughout the day, and Arthur Roger produced a sand-castle contest on the beach with artists and architectural groups. Steve Sweet made a fifty-foot banner featuring local icon Tony Campo on the Wild Mouse ride; Steve Rucker built a tall wood fire tower which was lit at sundown; Luis Colmenares made foam-rubber sculptures for high-ticket holders; Steve Kline made a sculptural piece in the lake; and an acrobat daredevil performed over the swimming pool, surrounded by open flames of fire. Dickie Landry's music played overhead on the midway, while humorous mannequins, created by Elizabeth, rode the ski-lift ride. Besides arranging this three-ring-circus atmosphere for the day, Elizabeth had time to mount an exhibition from the Pontchartrain Beach archives. The evening concluded with a live concert by Fats Domino. A jazz funeral led the festival goers out of the park as the Blue Angels did a flyover. Now that's Performance Art!

While the event resulted with nominal monetary benefits for the CAC, it generated much good will and outreach for the relatively new institution. Elizabeth was subsequently invited to New York by their own Coney Island to assist them with the planning of the one hundredth anniversary of their fabled roller coaster.

Clarence John Laughlin

One of the first artists I met upon arriving in the Crescent City in 1966 was Clarence John Laughlin, thanks to an introduction by Henry Holmes Smith, my former IU photography professor. Oh yes, I was soon initiated into the weekly Friday-night salons with Clarence holding court in the book-filled garret in his Upper Pontalba apartment on Decatur Street. Those evening rituals hardly ever deviated much. The assembled dutifully gathered round as Clarence carefully set up his straight-back chair, positioning a rickety iron floor lamp behind with its spotlight directed downward toward the chair's broken cane seat. The stage was set for the evening's monologue performance. Clarence had his eager, captive audience waiting to hear the master expound on his own work. The lamp cast a harsh light on his heavy jowls and bushy eyebrows, lending an unscripted macabre atmosphere in this dimly lit, low-ceilinged room. Preselected photographs were taken one by one and held tightly against his chest with the image concealed from the viewers while Clarence expounded endlessly upon what image they were going to eventually see. After what seemed entirely too long, he would turn the photograph around and place it on the makeshift chair/easel . . . purposely *upside down*. He would proceed to explain how viewing the image in this position presented all new possibilities of seeing. Strangely enough, this surrealist/romantic outlook all began to make sense. While this planned ceremony was maddening and often irritating, Clarence's thesis was not something one could dismiss. Finally, after what seemed an eternity, his audience was allowed to see the image in its upright position. He had made his point, and everyone was satisfied and anxious to move on to see the next photograph he already had programmed for his obsequious flock.

I was enchanted by this unique character. Wherever he was, he always wore short pants that exposed pasty white legs, knobby knees, and stubby, fat calves. From my initial introduction to Clarence, I knew that I wasn't in Indiana any more. New Orleans was to be my Oz. One of his favorite topics was to complain how he was not properly recognized and appreciated for his genius, particularly in his own hometown. In a sense, he was right.

So I had the bright idea to organize a major retrospective of his work with a catalog at the Isaac Delgado Museum of Art. After its premiere in New Orleans, the show could travel nationally. One would rightly think that would have pleased him to know that the curator at his local museum wanted to give him this overdue notable acknowledgment. Oh no, that wouldn't work even though I offered to give him much latitude in the exhibition's organization. We could use the lengthy captions he had written to accompany the photographs as he strongly felt the writing was more important than the image. What I didn't realize at the time was I was just a cub curator at a small regional museum, not John Szarkowski at the Museum of Modern Art in New York City. He had bigger fish to fry than me. Also, it would invalidate his contention that he was not being given his proper due. Oh well, so much for that idea!

Besides antiquing through the Quarter, one of the things that Andy Warhol most wanted to do while in New Orleans was to meet Clarence. That was not a problem. One morning, I called Clarence and told him Andy was in New Orleans and expressed an interest in meeting him. Would it be possible for us to come over? "Well, I have some errands to do, I have to wash the dishes, I'm working on some captions for my photos," with myriad other minor chores that could not wait. This was typical Clarence, thinking only of himself and not knowing or wanting to be gracious. After all, Andy Warhol was one of the most heralded artists of his time, and he wanted to meet him! But no, Clarence had other things to do.

I suggested we continue our excursions visiting antique shops in the Quarter, and I would call him again in the late afternoon to see if he could make time to see Andy. Fine. As scheduled, I called again in the late afternoon, and Clarence had more lame excuses. I told him we were near his door, and we were coming over *now*. He reluctantly agreed, and we climbed the mountain of steps to his attic apartment in the Pontalba. When Andy admired and sat down on a round ottoman upholstered in a period art deco print, one of its legs collapsed, and Andy went thundering onto the floor with legs flying. Embarrassing!

As usual, Clarence started in on his theme that he was not properly given the recognition he deserved and could not find anyone who would publish his important written work that was essential to his pho-

tographs and his thesis. Andy was listening intently and eagerly suggested he had connections in New York with Harry Abrams and others, and he was convinced he could help Clarence get his work published. Did Clarence hear that or most probably want to hear that? No, Andy's enthusiasm and offers went on deaf ears. It was an awkward but memorable meeting between these two twentieth-century icons. Later on, I took another visiting photographer, Duane Michaels, to meet Clarence, and that meeting went a lot smoother.

In spite of his quirks, I did enjoy Clarence's company (in short doses). His library was filled with fascinating material on unusual and diverse subjects. He loved showing me rare books on subjects that were of mutual interest: the occult, architecture, surrealism. And I have to admit, I did feel sorry for him at times. Like his many other sycophants, I occasionally would give him a hand with something that needed to be done. One of his most urgent and perplexing needs was getting rides as he had no car. One of the most amazing aspects of his career was that he never had a darkroom of his own. To help him, Edgar Stern allowed Clarence to use the darkroom in the basement of his estate, Longue Vue, out on Bamboo Road. After working all night down there, he would have to carry his trays of new prints in their liquid baths on the public bus from the Sterns' to his attic apartment on Jackson Square. To alleviate this awkward predicament, I gave him transportation in my car, for which he later rewarded me with a beautiful photograph, one of his favorites that he selected for me entitled *The Goddess of the Butterflies*.

Clarence liked to talk on the phone, and we often would talk on Saturday mornings. One day, we had been chatting for nearly an hour when he suddenly stopped and said in an annoyed voice, "I am very busy, now what is it you wanted?" I gently reminded him that he had called me on that day, I didn't call him. "Oh, all right!" he replied and hung up.

George Valentine Dureau

In several ways there were many similarities between Clarence and George Dureau, another New Orleans artist. While Clarence strongly

believed he was not given the proper local and national recognition he felt he deserved, George and his art never received much attention outside of his own hometown and state during his lifetime. Yes, he did have a couple of exhibitions at the Robert Samuels Gallery in New York, and Arthur Roger showed his work during his gallery's brief stay there too. And yes, noted national photographer Bruce Weber did a major publication profiling George.

In the first decades of his chosen vocation, George was mainly known as an accomplished figure painter. Sometime during this successful career, he began photographing his models to better facilitate the work on his paintings. The photos initially were to be considered merely a research device and preliminary "sketches" for the works in oil. Like Clarence who believed his extended written captions were primary to the secondary photographs they accompanied, George's preparatory photographic images were of less importance than the paintings.

In spite of both artists' firm contentions, popular sentiment of their work ultimately proved not to be in general agreement with their audience's assessments. Just as Clarence's writings were thought to be poorly composed and superfluous, George's paintings lacked the social impact and striking statement of his photographic images. Were the artists off base in their own evaluation of their work? The debate continues, and only history can adequately answer this question.

While growing up on Bayou Saint John, and upon his return from college, George gravitated to the French Quarter, where he became a fixture and well-known personality. New Orleans was his spiritual habitat. A bon vivant and talented raconteur, George's various apartments took on a distinct theatrical flair and ambiance. Paintings were mindfully positioned on easels, and photographs were pinned to the walls and lying around in apparent haphazard heaps. Restrained still life arrangements of dried flowers and other cherished objects on tables and the floor completed his carefully orchestrated setting meant to appear otherwise. Past press clippings, magazine articles, books all featuring George were strewn tastefully in random piles throughout the house, all with the pages turned to the mention of him. It was thoughtfully designed chaos. A perfect host and never at a loss for words, dashing about and dramati-

cally flinging his arms with a flourish, sometimes referring to himself in the third person, George with his melodious basso profundo voice was the star and center of attention on his own stage.

However, George's arena was not limited to the confines of where he lived. He loved to hang out in French Quarter restaurants. Two of his favorites—Marti's on North Rampart, then Café Sbisa on Decatur—were where he would make appearances nightly and hold court. George didn't limit his scene of action indoors; he was spotted frequently cruising the Quarter and adjacent neighborhoods in his open-air Jeep or his bicycle.

George was a very good cook and could throw something special together out of whatever happened to be around the kitchen. I always was eager to have an impromptu dinner with him whether it be in his first two apartments on Esplanade Avenue or a third on Rampart Street overlooking the Tremé (now Armstrong Park). Later, he had a huge loft with a wraparound gallery on the corner of Dauphine and Barracks. His living quarters were always on the second floor with an outdoor balcony or gallery, never the ground floor. I believe this vantage point above the street allowed him a better view to spot potential models for his artwork. His last place was on Bienville in the French Quarter. He loved to entertain and did it with dramatic flourish.

George was constantly cultivating his image and persona, creating his own myth. His beloved New Orleans, which he rarely strayed from, turned out to be the only setting for his enormous character and artistry. By neglecting his potentially national art-world audience, his career on a wider stage never materialized as it could have. However, since his death in 2014, his career is being reexamined and evaluated by recognized art critics and historians.

His favored models were mostly young, nude, African American males, particularly those with physical handicaps such as amputations or dwarfism. He gave them dignity and respect not unlike that of earlier New Orleans photographer Ernest Bellocq, with his portraits of Storyville prostitutes. Among George's favorites, some of whom I got to know, were Troy Brown, Clarence Williams, Lawrence Patterson, Glen Thompson, Wayne Ducros, Ernest Beasley, Sonny Singleton, John Slate, Brian Reeves, Wilbert Hines, B. J. Robinson, Wally Sherwood,

Stanley Hurd, former NFL player David Kopay, fellow artist and break dancer Jeffrey Cook, Raymond Maxwell Hall, and amputee Wingy. Over the years, many were devoted to George and hung out doing menial chores around his domicile and studio. I once inquired how he found his models, and he explained he simply wandered the city and would spy a person on the street and instantly know their potential by the way they walked.

The subject of George's art, for the most part, could be identified by its prevalent homoerotic focus that occasionally employed classical or mythological themes. In an era of general nonacceptance of homosexuality, his blatant depictions did little to deter his acceptance and admiration by proper Uptown society. In fact, they may have served as an impetus for their approval. Arthur Roger, his longtime dealer, summed it up succinctly, "George was the only artist I know that managed to make it acceptable to hang photographic nudes of African-American men in the grand mansions of the Garden District and Old Metairie."[14] He was the darling of doyennes at their Uptown *soignées soirées* (one of his favorite phrases), and it was not unusual to see a picture of him on the newspaper's society page. To them, he was not eccentric but admired.

Robert Mapplethorpe once came to visit collectors Michael Myers and Russell Albright and stayed in the dependency apartment of their magnificent "Haunted House" in the Quarter. They introduced Robert to George, and the two became fast friends. It has been a point of discussion and debate over the years of which artist has had an influence over the other's work. Having observed this relationship as it occurred, I feel that both were working simultaneously in similar veins, and after they met and became aware of what each was doing, their mutual predilections of subject matter probably fed upon each other.[15]

In 1989, I was invited to be guest curator of the *Forty-First Corcoran Biennial of American Painting* in Washington, DC. The assigned focus that year would be works by artists living in the American South. At that point, I was faced with the dilemma of what to do with two of New Orleans's most acclaimed contenders for this exhibition, Ida Kohlmeyer and George Dureau. They were both dear friends, and I admired their work. However, I didn't feel they would fit into what I was hoping to

capture for this particular show. What to do? First, I approached Ida at cocktail hour at her house and explained what I was doing and that I had made a decision not to include her work in the exhibition. I explained that I felt both she and George had reached such a high plateau in their careers that their work was beyond the boundaries I had set. She graciously accepted my explanation and thanked me for informing her.

When I met with George to tell him the same thing, I was riding in his Jeep as he drove along Bayou Saint John. He erupted in a rage when told the news. Adding fuel to the fire, I further explained I was an admirer of his painting but felt what he was doing with his photographic work was of more interest. He was so angry I thought he was going to physically push me out of his Jeep into the bayou. It was only a few years later that our friendship was restored. In retrospect, I sincerely don't feel my inclusion of his paintings in the Corcoran show would have had much appreciable effect, if any, on his exposure to a larger art-world arena.

George's death made the front page of both of New Orleans's daily newspapers. It was Eric Bookhardt who had aptly summed up George in his review in *Gambit Weekly* the year before, "It was Dureau's singular genius to be able to meld Charles Baudelaire's poetic otherworldliness with Walt Whitman's utopian American egalitarianism in singularly striking images that reflect something of the soul of his city."[16]

Marti Schambra

Marti's Restaurant on North Rampart Street, directly across from the Mahalia Jackson Theater of the Performing Arts, was the New Orleans equivalent to Sardi's in the Broadway Theater District of New York. This fashionable restaurant flourished in the 1970s, 80s, and 90s and was patronized by the art crowd. It was a place for excellent food and a place to be seen. Located around the corner from my house in the French Quarter, I frequented this chic watering hole often as it was a favorite of my friends in the arts.

Marti Shambra was a handsome gay guy who had posed for pornography magazines and films and was a practicing abstract artist. One

Sunday afternoon at a pre-Mardi Gras party, I was chatting with my good friend Shirley Ratteree, and Marti approached. Shirley said, "Bill, you know Marti?" Without thinking, I responded, looking Marti straight in the eyes, "Yes, we've met many times before; however, you never remember who I am." A moment later I blurted out impulsively, "and I really don't care!" Whoops! Well, he never forgot me after that; in fact, we became good friends.

Peter Halley

I first became acquainted with Peter Halley while he was studying painting with Jim Richard at the University of New Orleans.[17] After receiving his MFA, he returned to New York City to begin his career as an artist. During one early visit with him there in 1980, he took me to see an exhibition he had put together at P.S. 122 in Lower Manhattan. It was difficult for me to assimilate what it was that I was being confronted with. One of the most perplexing pieces for me in the show was stacked double-decker vacuum cleaners encased in fluorescent-lit, clear Plexiglas enclosures. What in the world? Peter informed me the piece was by his friend Jeff Koons, a member of a group of young artists who were referred to as the Neo Geo. Peter and Jeff, along with Hiam Steinbeck, Ashley Binkerton, Philip Taaffe, and Meyer Vaisman were the core group of Neo Geo and showed at the gallery International with Monument on Tenth Street near First Avenue on the Lower East Side.

Neo Geo became the hot new group overnight, and Peter in particular was on the cover of every respectable art magazine and journal in America. His then unorthodox paintings of electric fluorescent neon color paint on Celotex ceiling material were very much in demand. At the height of this intense interest in his work, I was chatting one day with him on the phone, and I commented about the phenomenal attention he was experiencing in the New York art world. He replied, "Yes it's amazing, but I want you to know something, Bill. You were the first person to ever take my art seriously." To which I responded, "I know Peter, . . . and don't you *ever* forget it."

In 1988, at the height of Peter's whirlwind success in the art world, Arthur Roger gave him an exhibition in New Orleans. Peter brought along with him Tricia Collins and Richard Milazzo, the independent art dealers who represented him at the time. They in turn invited Dan Cameron, their friend and Peter's, who they thought would like the city. (More about him in the next chapter.)

Aristides Logothetis

Jim Richard was the UNO painting professor of another artist, Aris Logothetis, who would become one of my dear friends. Aris had come to New Orleans with a fellowship in pursuit of an MFA. We met at a party given in honor of Judy Chicago in New Orleans in 2001. I had just returned from spending the summer as the house guest of artist Lynda Benglis in the small island of Kastellorizo, Greece, and Aris and I hit it off right away, chatting about the country where he was born and raised and about art. Since that initial meeting nearly twenty years ago, he has had numerous exhibitions in New York, including one at his neighbor, the Bronx Museum.

One little known fact about Aris is his early commitment to art during his college days in Boston where he had moved. Dropping out of college after one semester, he became immersed in a journey of self-knowledge through punk-rock culture and art. When he was twenty years old, he curated his first art exhibition, *Boston 1989*, in his apartment, then called Gallery Schmallery. Over time, the gallery and its subsequent exhibitions expanded to a large loft and then quickly became the hot, hip alternative exhibition space in Boston and garnered much favorable press attention. Eventually, he enrolled as an art student at Boston's School of the Museum of Fine Arts (SMFA). Aris continued to curate exhibitions, including the little-known but significant and prescient *New Talent Exhibition* in 1993 at the Institute of Progressive Art, which included work by unknowns SMFA student Ellen Gallagher and RISD student Kara Walker.

His latest venture is worth a special mention. During his studies at Tufts University and SMFA, Aris spent a semester abroad, at

College Years in Athens (CYA). It was then that Aris and his friends noted, discussed, and developed the need for Athens to host an artist residency program. Many years later, while on a six-month artist residency in Northern Italy in 2016, I visited him and took a two-week trip to various cities in that part of the country. As we had ample time to talk while driving, he revealed to me a twenty-year dream: starting an artists' residency program in the city where he was born and raised—Athens! I was dumbfounded with this incredible news, and so we spent many hours while experiencing the beautiful landscape of the Piamonte area of Italy discussing this bold decision. While I gave him encouragement to pursue his dream, I played my customary role of being the devil's advocate to further develop a plan. Near the end of our journey in the beautiful city of Como, after enjoying Milan, Parma, Rapallo, Genoa, Barolo, Alba, Asti and Turin, and after numerous deliberations and assurances that he could find the means to activate this ambitious undertaking, we concluded that the risk was worth it, and he should go for it.

Upon returning home, he quit his job of fifteen years as the principal waiter at the highly acclaimed Greek seafood restaurant Avra in mid-Manhattan to begin this new journey establishing ARCAthens (Artist Residency Center Athens), a nonprofit organization in the United States, writing by-laws, employment and certificate agreements, a proposal for the selection of artists, hiring a staff, establishing a board and an advisory board, securing properties in Athens, raising money, and more! One of those fellow student dreamers back during his CYA semester was Iris Plaitakis who is our assistant director!

The pilot program commenced with artist Cullen Washington Jr. and curator Larry Ossei-Menash having been awarded six-week residencies in Athens beginning in February 2019. A second pilot program is scheduled for the fall 2019, with artist Tomashi Jackson and curator Miranda Lash as the residents. After these two initial test programs had been concluded and evaluated, the full three-month residency programs will commence. After two decades of dreaming and thought, Aris has successfully accomplished this monumental task only two and half years from its conception in Northern Italy!

Tobias Schneebaum

Tobias Schneebaum first came to the public's attention in 1969 with the publication of his memoirs *Keep the River on Your Right*, which tells his outrageous tale, as a gay artist on a Fulbright fellowship to study art, hitchhiking from his home in New York to Peru and ending up living for several months in the remote Amazon rainforest among the Arakmbut, an indigenous cannibalistic people. This shocking story reveals that he had a tribal male lover and, as a participant in a triumphant warring raid, once ritually ate one bite of human flesh of the vanquished. That single experience haunted him the remainder of his life. After returning home and receiving a master's in cultural anthropology, he lived for years with the Asmat peoples of Irian Jaya, Indonesia, another tribe of headhunters. Years later, filmmaker David Shapiro took Tobias back to Peru and Irian Jaya to make a full-length documentary of Tobias' story, *Keep the River on Your Right: A Modern Cannibal Tale*, and capture his reunion with his former lovers and tribesmen.

Holly Solomon introduced me to Toby one day in her gallery on Houston Street in Soho. While I knew of him by reputation, I had no idea we would become friends when I casually mentioned to him it would be nice for him to come visit in New Orleans. His response was "invite me."

Several years passed, and I had introduced him to my friend Aris Logothetis who later arranged for us to have dinner at Toby's Greenwich Village apartment. Toby loved having visitors, and his partner was a good cook (well, not that good). In any case, Aris and I went there several times for food and friendship. Finally, I did invite Tobias to New Orleans again to speak to NOMA's active affinity group Friends of Ethnographic Art. Our members were enchanted to meet this quiet, gentle man. Later, at one of Toby's dinners, he offered to give his collection of Asmat decorated skulls to NOMA. At that time there was a moral prohibition in museum circles against displaying human remains. I explained this to him and reluctantly declined his generous offer, and he understood. I now regret my refusal as I have changed my views and gladly have on view in NOMA's Oceanic galleries a half dozen outstanding decorated skulls on long-term loan from Dr. Abba Kastin.

Episode 9

Experiences with Curators, Dealers, Musicians, and a Playwright

Dan Cameron

One of the things I marvel about Dan is his encyclopedic knowledge of contemporary art worldwide, or more precisely, as Robert Goldwater's often quipped when asked about his student Marcia Tucker, "Oh Marcia, she's only interested in the last five minutes of art history." That comment is certainly applicable to Dan, but in his case, Dan's scope is wider and encompasses the art history of the world. For me, what is even more astounding is his equal genius in the realm of twentieth-century music.

Peter Halley's 1987 opening at the Arthur Roger Gallery coincided with the annual New Orleans Jazz and Heritage Festival. Peter suggested Dan might enjoy going, and he did and was hooked. "It was love at first soft-shell crab po-boy. I got my first soft-shell po-boy just as the Nevilles were going on. I looked around. There were all these people enjoying the scene and music. It was the most amazing combination of sensations I had ever felt. And it was fleeting. But afterward I kept asking myself, 'Did that really happen?' I kept coming back and it wasn't just me. It kept happening. This is the way life should be lived. You can't explain it. You just have to get people to come down here and experience it."[1] Since 1987, Dan has returned to New Orleans every year to be at the Jazz Fest gates when they open at eleven in the morning and until the music stops at the end of the day. Staying at my house during the Fest has also become a tradition for many years.

Since he was the senior curator at the New Museum in New York, he was not always able to attend both Jazz Fest weekends. I encouraged him to stay over for both, and one year, he agreed he would. However, when he arrived, he informed me there had been a slight change of plans and that he would have to go away for a few days in between weekends to Gwangzhou, South Korea! So, Monday morning he was off, only to return when the gates opened that Thursday morning. Amazing!

When Dan was the curator for the Istanbul Biennial in 2003, Aris Logothetis and I were there for two weeks to celebrate the occasion with him. The international press conference for the event was scheduled for the Thursday before the opening weekend. One week before, Dan received word that his father, whom he had not seen for some time, had died in Illinois. Without hesitation, he flew to Chicago, had someone drive him to central Illinois for the funeral, and then drove back to Chicago, where he returned to Istanbul in time for the press conference.

In 2000, I organized a trip for NOMA's Friends of Contemporary Art group to attend the opening of the Havana Biennial. As I am not a scholar of contemporary art, I hired Dan to accompany our group to give us a personal tour each day through the exhibition located throughout the Cuban capital. Each morning at breakfast, the group was told where Dan would be taking us that day. Regrettably, each day everyone had his own agenda and chose not to follow Dan. As a consequence, I was his lone taker and received a learned education for the experience.

Dan's most recent venture was to produce a performance festival in Kansas City, Open Spaces, which ran from in late August 2018 to October 2018. With his vast knowledge of both contemporary art performance and music, it was a magnificent event, melding these two mediums.

Diego Cortez

Dan Cameron eloquently wrote, "Curator Diego Cortez, who in 1981 would organize the epochal *New York/New Wave* exhibition at P.S. 1 Contemporary Art Center (in Queens, New York), was at the of sea

change [of punk rock music], immersing himself in the music scene while continuing to observe its impact on the many visual artists who began to gravitate to the Bowery and beyond in search of signs of a broader cultural transformation."[2]

Diego (né James Curtis, adopted art pseudonym in 1973) cofounded the Mudd Club, in Tribeca at 77 White Street, which became a mecca for underground music and counterculture events. As the *New York Times* described it, "The Mudd Club was the scene of the crime. It was a dance hall, drug den, bar and pickup joint. And within that, an incredible incubator for talent."[3] This wildly successful music club lasted from 1978 through 1983. Meeting young, hip yet unknown artists Keith Haring and Jean-Michel Basquiat there, Diego recognized their talents and became their friend and art agent.[4] It was this foresightedness that enabled him to guide their fledgling careers and put them onto successful paths in the New York art world. At that time, he also was a founding member of the trailblazing artists group Colab (Collaborative Projects).

I'm not certain how or when I met Diego in New Orleans (or was it in New York?) in the 1990s. Possibly, it was during a visit to New Orleans with his artist friend Philip Taaffe, who both stayed at my house. Maybe it was through Tina Girouard, a mutual friend of ours. I don't think it was during the time I was associated with Fashion Moda of the South, whose founders, Joe Lewis and Stephen Eins, were members along with Diego, of Colab. In any case, we became instant friends with many common interests, especially art and food. Like anyone with intelligence, he was seduced by the charms of our city and came back often.

At the time I semiretired from NOMA in late August 2001, Diego invited me to visit him on the island of Capri at the villa La Solitaria along the fashionable high panoramic promenade Belvedere of Tragara. Diego rented the top floor apartment for three months, located atop a rocky cliff overlooking the famous jagged tall Faraglioni outcroppings, in the sea a few yards from the coastline. After a week-long rigorous regime of reading, sunning, swimming, strolling, napping, visiting, and dining, we took the hydrofoil to Naples for a meeting with the director of all the Neapolitan museums, Nicola Spinosa, at the Capodimonte.

Diego was in negotiations with him about the purchase of an enormous four-part drawing by former Neapolitan Francesco Clemente.

After a leisurely lunch in the old quarter of Naples at a small, modest restaurant—favored over the years by artists including the late Joseph Beuys—we taxied to another museum; at around 3:00 p.m., Diego received a phone call from a friend living in Puerto Rico. Agitated, he reported to Diego that something terrible had just happened at the World Trade Center in New York which was nine o'clock in the morning there. Details were sketchy at that time. We then proceeded to the lobby of the Neapolitan Hotel, where we were to rendezvous with the contemporary curator of the Capodimonte for an appointment with a "collector of African art" set up earlier that day by Spinoza. By that time, 4:00 p.m. local time, we saw the first television reports of the magnitude of what had just occurred in lower Manhattan. Stunned by what we saw, questions raced through my head—How could it have happened? What about all the super sophisticated US intelligence and security we have come to believe existed? Unbelievable!

Badly shaken and with great reluctance, I agreed to keep my appointment to visit the collector Spinosa had so kindly arranged for me. As I suspected, the "African art" was not genuine, and my mind was only in New York.

That evening, a friend of Diego, Maurizio, had prearranged a large dinner party in our honor in his sumptuous Neapolitan apartment. With stacks of dinner plates on the table, the elegant party went on as planned. Despite it being lovely, the food delicious, and the jet-set-style guests looking like they all just stepped off a fashion-show runway, I was in no mood to party, and, besides, I didn't understand anything anyone was saying as they gaily chattered away in Italian. My mind was in New York.

In 2007, John Bullard appointed Diego curator of photographs at NOMA. During his few years there, Diego organized thought-provoking and sometimes offbeat special exhibitions and arranged several large substantial donations from major out-of-town collectors, not to mention his own benefaction of hundreds of important photographs. Following an exhibition of his friend artist/singer/poet Patti Smith's

Polaroid photographs and her performance/talk at NOMA, she donated all the unique exhibition images to the museum.

Arthur Roger

Arthur has been a longtime friend and is mentioned throughout these pages. However, there is one incident worth confessing. While he was working as a framer at Floyd McLamb's 927 Gallery on Royal Street in the French Quarter, we would see each other often working out at the Brent House gym at Ochsner Hospital. In the 2017 NOMA catalog *Pride of Place: The Making of Contemporary Art in New Orleans* that celebrated his magnanimous gift of his private art collection to the museum, I wrote, "One day, Arthur eagerly approached me and announced with a wide smile, 'Bill, guess what? I'm opening an art gallery!' When I inquired where, he proudly responded, 'On Magazine Street.' After this astonishing announcement, my first thought was, 'Oh brother, this kid has no idea what he is getting into! It will never last.' Well, so much for my dire prediction! Arthur opened the gallery in April 1978 in a narrow storefront space on Magazine Street, and next year the gallery will celebrate its fortieth anniversary in a huge, beautiful space in the Warehouse District, where it moved in 1988. Despite my initial incredulity, Arthur's gallery has grown into one of the oldest and most renowned in New Orleans."[5]

His gallery became so successful Fred Weisman offered to help by giving him needed backing for opening a branch in the heart of the popular Soho arts district in New York City. Arthur's gallery grand opening on Prince Street was overwhelming, with an exhibition of Jim Richard's paintings. I led a group from NOMA's Friends of Contemporary Art support organization to New York for that festive occasion. Arthur was welcomed by the New York art world, particularly Lisa Phillips, at that time a curator at the Whitney Museum of American Art and Phyllis Kind whose major gallery was around the corner on Greene Street.

Then Fred Weisman, his major backer, became ill with a life-threatening illness and, despite Arthur's gallery being received and doing quite

well in New York, Fred's attorney and money manager suddenly closed down all of Fred's interests on the East Coast, including two horse-racing tracks in Maryland and Arthur's gallery. Arthur was forced to close and return to his two flourishing gallery locations in New Orleans. Sadly, that New York chapter of Arthur's gallery venture was over.

The AIDS medical crisis loomed up in the early 1980s, and Arthur was at the forefront in helping to fight this mysterious fatal illness, mainly among gays. President Reagan would not acknowledge this impending national disaster or provide needed medical assistance to solve this dilemma. To that end, Arthur began what has become an annual fundraising event titled Art Against AIDS at his gallery. I suggested an idea to him I learned about from Phyllis Kind. At Christmastime, she annually invited all the artists in her gallery stable to make Christmas ornaments to be sold in her gallery. Borrowing her idea, I thought we could invite New Orleans area artists to make ornaments that could be sold first to those attending the event and later to the public visiting his gallery during the holiday season. As expected, New Orleans artists outdid themselves with imaginative, beautiful, clever, and humorous ornaments to be sold. Among my many favorites are Judy Cooper's "Famous Santa" photograph of that patron buying the ornament wearing a Santa Claus hat and white beard; Brian Borello's small hard-bound book bolted tightly shut titled *Happiness: How to Find It*; and my most favorite, Bob Tannen's tin Band Aid container with the first "d" eliminated. That annual Art Against AIDS event became so successful it was later transferred to the Contemporary Arts Center then Champion Square. It flourishes today.

One final comment about Arthur. Later in the 1980s, Arthur and I where participants in a white-water rafting and camping week-long experience on the protected Middle Fork of the Salmon River in Idaho with Roger Ogden, Ken Barnes, Tom Collam, and a few other out of town friends. The company furnishing the trip provided nightly setup and morning breakdown of tents and luxury dining on the sandy shores of the river. On the last days of the trip, there was a raging forest fire on both sides of the river, and we slept on the beach, where embers were still burning around us.

Our group of gays provided the few others on the trip with myriad cutup adventures such as hiding our rafts for unexpected "invasions" of the "enemy" rafts with water fights. At night, there was the usual short sheeting of beds and other pranks. We were having a blast. With some secret advance warning, I knew Arthur would be collapsing the tent I was sleeping in. Sure enough, it happened, and I was ready. Working my way from under the crumpled canvas, I gave the culprit a phony voracious tongue lashing, outraged by his behavior. The art curator versus the art dealer! How dare he! He fell for my trick tirade. I won! The next morning, I confessed my misdeed, but I'm not sure he believed me.

Kent and Charlie Davis

The Davises' history would make a fascinating Hollywood movie. How they became universally recognized by scholars, curators, collectors, critics, and dealers as the foremost dealers in African art is a tale of adventure, romance, and happenstance.

Hailing from Wilmington, North Carolina, and after attending Wake Forest University, Charlie received a bachelor's degree at the University of North Carolina in European history with a minor in art history. After working on windjammer cruises, he entered the US Navy and was stationed in Panama City, Florida, on a minesweeper vessel. When the ship was brought to Avondale Shipyards for repair, he met Kent Gerard, a recent graduate of Louisiana State University with a bachelor's in Spanish, in New Orleans, where she was teaching English. After dating and corresponding for more than a year, they were married in her hometown of Lake Charles, Louisiana, and moved to his hometown where he worked at the municipal zoo.

Leaving the States, they embarked on an adventure of a lifetime. They purchased a Land Rover in England and made their way through France and Spain, where they crossed the Straits of Gibraltar into Morocco. For more than a year, these adventurous souls worked their way from the northern tip of Africa across the Sahara Desert and through the jungles of Central Africa to the southern tip of South Africa.

Upon returning home, Charlie worked with famed animal handler Jim Fowler at a zoo in Virginia. After becoming disenchanted with the work in the zoo business, he gathered his life's savings and made his first trip to Africa to collect tribal art and become a dealer. While originally intending to establish an art gallery in Houston, he and Kent, after retrieving his African art acquisitions at the customs house in New Orleans, chose to remain in the Crescent City and established their gallery on Magazine Street in 1974.

Leading New Orleans artists were among their early clients, including Ida Kohlmeyer, Robert Gordy and Wayne Amedee. In a short time, the gallery became successful, and Charlie and Kent over the years became well known for the superb quality of art their offerings.

What set their gallery apart from others in the United States and Europe was the widely held belief that the African continent had been depleted of good original African art and the only place to find quality material was in the Western world. Not following this popular opinion, Charlie returned to Africa every three months for more than thirty years to collect African art. He scouted out information, pursued leads, and waited, often for years, for a particular piece to become available. His persistence and patience paid off handsomely. Works offered by the Davises have been acquired by many major American art museums, including the Metropolitan Museum of Art in New York and the National Museum of African Art at the Smithsonian Institution in Washington, DC.

John Bullard and I were privileged to be the first to view the latest pieces Charlie acquired from his latest visit to the continent. It was just as exciting as when Jim Byrnes and I were years the first to see the pre-Columbian material coming out of Mexico and Central America years before. From time to time, US Customs would withhold pieces Charlie was bringing into the country, mostly because they included parts such as feathers, shells, or fur of endangered animals.

Charlie divulged to me that he was particularly upset because an important Boki Janus-Headed Head Crest from the Nigeria/Cameroon border was impounded as it contained two endangered monkey skulls. I later called the US Fish and Wildlife Service and inquired whether they had that piece to which they answered in the affirmative. When asked

what their plans were for it, they indicated they had none. As it was sitting on a shelf in their storage warehouse, I asked if they would give it to NOMA, so that the public could enjoy this important artwork. They responded they thought that was possible. Today on view in the African galleries that powerful Boki Head Crest's label reads, "Gift of the United States Fish and Wildlife Service."

The New Orleans Museum of Art's collection has greatly benefited from the Davis Gallery's presence in the city. Through the years, they have nurtured many New Orleans collectors who have subsequently given some fine additions to the permanent collection, the most notable from Robert Gordy, Wayne and Barbara Amedee, Nancy Stern, and Françoise Richardson. The museum has purchased fine objects from them, and the collection has been enhanced from their own important gifts, the most notable an extraordinary early twentieth-century facade comprising of seven exterior (each over twelve feet high) and one interior (nine feet high) palace house posts from Big-Babanki Palace in the Cameroon Grasslands, and a glorious large snake from the Baga peoples of Sierra Leone. I am greatly honored that both these generous gifts were given in honor of my first (2001) and second (2015) retirements! In short, the New Orleans Museum of Art's African collection would not be nearly as great without the presence of the Davises in New Orleans.

Marc Leo Felix

Marc is one of the leading African art dealers in Europe, specializing only in the art of the Congo. Like Charlie Davis, Marc has acquired many of his inventory by going directly to the source in the Democratic Republic of Congo. Recognized as one of the leading scholars of this particular area, he is equally perceived as a one-of-a-kind character with his flamboyant attire and unconventional behavior. Wearing pea-green ostrich-skin roach-killer boots, worn green leather pants, a khaki safari jacket, a long flowing scarf around his neck, and a wide-brimmed slouch hat adorned with a plastic image of "Felix La Chat," he is unmistakable in a crowd. With the demeanor of a macho Indiana Jones, he is gregarious, passionate, a marvelous host,

and always a gentleman. At his house in a wooded, upscale area of Brussels, he raises pigeons just outside his breakfast-room window.[6] He owns more than a half dozen 1954 Mercedes Benz two-door coupes.

I came to know Marc in the 1980s, when he would stop in New Orleans during his semiannual tours around the United States hawking his extraordinarily high-quality wares. The routine never varied. Prior to his arrival, a postcard would be sent announcing his appearance on particular days. He would be staying at an upscale hotel, in New Orleans it was the Hotel Intercontinental, and he would receive collectors, curators, other dealers, whoever, and show his pieces. As the African art curator, I was usually the first to see him upon arrival. After catching up gossiping and exchanging news, he would set up his traveling spotlight positioned over the display area and proceed to open the first of several large metal trunks containing his carefully wrapped treasures. One by one the sculptures were revealed with great ceremony and a discussion of the piece would follow. At the conclusion, we would then leave all the pieces sitting on every available surface of the room to go eat.

Marc's tours took him to numerous cities throughout America. They were arduous, unpacking and packing his valuable cargo over and over again. One night, after a particularly long evening, he arrived at his hotel totally exhausted. When he opened the door to his room, there were his sculptures all staring him in the face. "Oh no, that won't do," he thought. Turning around, he went back to the street, where he had noticed a young girl in fetching attire lingering near the hotel entrance. "Excuse me miss, would you like to come up to my room and do a little work?"

"Certainly," she replied, and off they went. Upon opening the door to his room, he said, "Please pack this."

In October 1995, I took members of NOMA's Friends of Ethnographic Art to Europe to see two spectacular African art exhibitions: *Hidden Treasures of the Tervuren* in Brussels and *Africa: Art of the Continent* at the Royal Academy of Art in London. Both were rare, breathtaking events not to be missed. While in each city, we visited African art galleries, museums and private collections. In London, we visited the legendary Josef Herman collection and had dinner at Lance Entwistle's gallery. In Brussels, we had the rare treat of visiting the Willie Mestach

collection and dinner at Marc Felix's house, specially planned Congolese dinner with ingredients directly from Africa. He and his cook personally prepared the impressive feast.

Marc was a gourmand, and we enjoyed going to fine restaurants to take pleasure in fine food. However, a requisite stop each visit to New Orleans was Popeye's Fried Chicken! On one occasion, I told him we would be going to Upperline Restaurant, and he was in for a special treat. It was August, when the owner JoAnn Clevenger offered her annual all garlic menu. My surprise for him turned out to be a surprise for me instead. Upon scanning the menu, Marc turned pale with a worried look on his face. "Bill, I'm allergic to garlic!" After a hurried consultation with JoAnn, Marc enjoyed a special meal sans garlic.

Speaking of dining out, Marc, who always enjoyed the company of women, was complaining that whenever he was in New York, he didn't know any ladies to take to dinner for a pleasant evening. I gave him contact information for Jacqueline Humphries, who had accompanied me for two weeks in Senegal and Mali in 1987. She was an artist, most personable and fun, and especially loved Africa. When he arrived in New York, they made arrangements to meet at the beautiful bar in the Equitable Life Building in mid-Manhattan. Its interior showcased a continuous mural by Sandro Chia, a famed Italian painter.

After drinks, they decided to go downtown for dinner. Stepping outside on a blustery, cold night to hail a cab, they soon discovered taxis were hard to come by. Finally, one did pull over, and as Marc approached it, a man in a trench coat and briefcase darted in front of him to open the door. Being a gentleman, Marc politely said with his strong French accent, "Excuse me, sir. I believe that is our cab," to which the man sneered, "No, buddy, this is New York." With that, Marc grabbed his coat at the neck and pulled him close to his face and said, "I'm not from New York!"

Professor Longhair

In the early 1970s, Eddie Haslam, a young Tulane student, approached me for a booking. At the museum, I was in charge of arranging Sunday

afternoon lectures and concerts in the newly built Stern Auditorium. Eddie was the rep for Professor Longhair. "Fess" had been a rhythm-and-blues 'n' boogie singer and pianist of the 1940s and 50s whose career was on the skids in the 60s and had resorted to being a janitor for a records store where his recordings were sold. When it was announced in 1971 that Henry Roeland Byrd (a.k.a. Professor Longhair) would be performing at the second Jazz and Heritage Festival in Beauregard Square (later changed to Congo Square), very few knew who he was. When Haslam asked if his client could perform a couple of solo concerts at NOMA, I agreed. I had previously presented concerts featuring modern jazz saxophonist Earl Turbinton and his brother, Willie Tee, a keyboardist and vocalist who is noted today as one the early originators of New Orleans renowned funk and soul sound. Regrettably, those two Professor Longhair concerts on December 2 and 16, 1973, were poorly attended.[7]

"By 1977, Professor Longhair was a beloved local icon and Jazz Fest favorite. 'No festival could be complete without Professor Longhair, whose exotic rock 'n' roll piano technique brought the day's excitement to its climax at sunset.' gushed the [*Times-*] *Picayune*, only six years after questioning his alleged greatness."[8]

James Booker

When in 1975 NOMA presented a major African exhibition of masterpieces from Zaire, the museum gave a lavish dinner to celebrate the opening at Commander's Palace in a private dining room. James Booker, a New Orleans musician, who was secretly gay and had a history of being troubled by mental health issues and heavy drug addiction, was invited that evening and was seated at my table. He had recently returned to New Orleans from a lengthy stay performing in Europe and did not know anyone at the dinner. Wearing his star-decorated eye patch, he and I hit it off. He was very appreciative of being included at that distinguished museum event. As a result, he always remembered me whenever our paths crossed. While I am a huge fan of many New Orleans musicians, James today remains at the top of the list.

Billy F. Gibbons

A couple of months after publishing several of the museum's new acquisitions in *African Arts* magazine, I got a curious telephone call informing me that Billy F. Gibbons of the legendary rock group ZZ Top wanted to purchase one of the works illustrated: an unusual face mask made by an unidentified Sukuma artist of Tanzania. Its straightforward physiognomy conveyed an image of fear, threat, and confrontation with its prominent saw-tooth, open-mouth grimace, evil eyes, and applied animal-fur eyebrows and beard. Taken aback by this determined pronouncement, I politely informed the caller the museum was not in the habit of selling its acquisitions. Not to be deterred, the caller persisted. When I learned Mr. Gibbons would be in New Orleans for an upcoming concert, I said I would be happy to show him the mask if he would like to come for lunch. Accepting the invitation, arrangements for a visit were made.

On the appointed day, I greeted him in the Great Hall of the museum. Wearing his well-worn woven Cameroonian hat covered with short tubular twists, he eagerly came rushing up to me, proudly showing me a small silver pendant hanging around his neck. It was only then I realized that it was a miniature replica of NOMA's mask! I showed Billy the mask on display in the African galleries, and it was only then, over lunch, that he explained his desire to own the mask in question. For ZZ Top's upcoming world tour, a blowup, several stories high, of this threatening visage would hover behind the performers. The mask was the main set decoration as well as the logo for the tour. I learned that Billy had collected African art after he had toured that continent years earlier. Sharing this common interest, Kent, Charlie Davis and I would later visit him in Houston, where he lived. Whenever he performed in New Orleans, we were sent complimentary VIP tickets.

Tennessee Williams

I became acquainted with Tennessee in the French Quarter and the Marigny, most notably those infamous parties hosted by Bob Hines

and Jack Fricks, our mutual friends. Through my friendship with Muriel Francis, I asked Tennessee to write a piece on Lynda Benglis for a catalog I was doing in conjunction with the 1977 exhibition *Five from Louisiana*. Later, as a thank you for agreeing to write about something he had no knowledge of and for being so cooperative, I invited Tennessee and John Bullard to a Sunday brunch at Marti's, an extremely popular restaurant for the art crowd at the time and one of his favorite hangouts. Tennessee's house at 1014 Dumaine Street in the French Quarter was just across the street. When John and I went to pick him up, he obviously had had a few cocktails and was cooking lunch for a group of friends. He had completely forgotten our own brunch date. He invited us to join them, but we declined. He felt bad about his failed memory and said he would join us at the restaurant, but by the time he arrived later, he was totally inebriated!

Later that day, I had cocktails with entertainer Bobby Short, again at Marti's, and to top off the day, later that evening I was invited to a small dinner party at Restaurant Jonathan's, a beautiful restaurant with an art deco theme, down the street from Marti's. We sat in the Erté Room, with the artist honoring him on his nintieth birthday. Rock Hudson and I were seated at the same table. What a day that was—January 23, 1977—five days before the opening of my *Five from Louisiana* exhibition!

Long after Tennessee had submitted his written piece on Lynda for my catalog, I realized I had not paid his honorarium. I called him in New York and apologized for my oversight and asked where he would like me to send the money. His response caught me off guard; he told me to send it to a friend of his, Oliver Evans, who was living in a nursing home across the river in Algiers. "He needs the money more than me," he responded. He never even asked how much the honorarium was!

Episode 10

Fun with Chefs

Julia Child

Besides priding myself as an artists' groupie, I also like to think of myself as a "foodie." Meeting the great chef and cookbook writer Julia Child at a function in her honor at JoAnn Clevenger's Upperline Restaurant was just such an occasion. I was in such awe of Julia (and JoAnne) when introduced to Julia, I didn't know what to say. I nervously told her how grateful I was to her as she had taught me how to cook with her programs on public television for many years. Sensing my discomfort, she replied, looking down at me with hunched shoulders and in her inimitable husky voice, "It's fun, isn't it?"

Dinners at Emeril's

Shortly after Emeril Lagasse opened his restaurant on Tchoupitoulas, I stopped in one evening for a quick dinner. At that point, reservations were not necessary. In the back of the dining room, there was a curved "bar" with diners seated on stools overlooking a cooking station where Emeril personally cooked "to order." He loved nothing better than being told to cook whatever fancied him at the moment. That evening, I was one of only two recipients of his enthusiastic performance.

Sometime later, when I suggested restaurants to visiting New York art dealer Steve Schleisinger for dinner that evening, he hesitated and then said he was a vegetarian. Not a problem. I called Emeril's and asked if I could come in to have a vegetarian meal. They said, "Come on in.

We can take care of you." After being seated in the packed dining room, Emeril appeared wearing his tall toque and approached our table. Emeril suggested some vegetarian dishes, and we told him just to surprise us with what he felt like doing. He happily returned to the kitchen and later returned with dish after dish. With the waiters hovering about the table, Emeril described in detail what he had prepared. This routine was repeated course after course until finally we thanked him and surrendered as we had had enough. When the check arrived (which was considerable), the waiter said to us, "Everyone here wants to know who the hell you are!"

Episode 11

Two Influential Dudes: My Partners

Ernest Matthew Mickler

Little did I know how eventful that Saturday morning, March 23, 1974, would be for me. I was returning home proudly carrying my batch of fresh spinach I snatched up at the French Market down the street. Walking down Governor Nicholls Street, a young man stopped and admired the glorious bouquet of green. I admitted I didn't know what I was going to do with it and said that I was not an improvisational cook. He started telling me the different ways it could be prepared. Since he seemed to know so much about cooking (and he was attractive), I invited him to my house a short distance away to help me cook my prized purchase.

I discovered his name was Ernie Mickler, and he had an interesting past. Born in the "swamp cabbage patch" of Palm Valley, Florida, located between Jacksonville and Saint Augustine, he showed an early talent for entertaining on stage. Teaming with a young lesbian friend to form the singing duo Ernie and Petie, they eventually toured from time to time throughout the South at live concerts with members of the Grand Ole Opry like Roy Orbison, Connie Francis, Buck Owens, June Carter, and Skeeter Davis. Ernie and Petie's most popular tunes were their own songs "Our Love" and "You Don't Even Know."

Ernie graduated with a master's degree from Mills College in California, where he had shown up at the ceremony wearing the traditional cap and gown flamboyantly augmented by a giant pair of hand-made multicolored butterfly wings flapping on his back. His cleverly outrageous display made the San Francisco newspapers. While living in San Francisco, he had a lucrative career as a glorified junk dealer, a product

of his assiduous prowl of thrift stores, auctions, and the streets of the Bay Area. In many ways, he was always ahead of the curve regarding what would become fashionable and sought after. He had an impeccable eye for spotting a hidden treasure and a disarming charm to sell almost anything.

I met him shortly after his arrival in New Orleans. Through his experienced eye, he found what are now some of my most treasured objects—the three crudely fashioned wood benches reportedly from a Black church in LaPlace and a few superb art deco objects. There was a short period when we collected anything with a pink flamingo subject or theme. When that enthusiasm faded, I gave my considerable number of these ceramic trinkets to artist Robert Tannen to stack and glue in his inimitable manner into a sculptural pink tower of curving s-shaped necks and stick legs.

While we were together, Ernie often spoke of his desire to make it in the music industry performing his own songs. Singing and playing the guitar, he would adopt the stage name Willie Starbuck. Once while I was visiting Macon, Georgia, on art business, I was invited to Phil Walden's home for dinner as he was anxious for me to see his art collection. This now legendary figure in the mid-twentieth-century music world operated Capricorn Records, and among his most famous clients were Otis Redding and the Allman Brothers. When he asked me to sign his guest book, I was happy to oblige. Since the last signature had been "Cher"—she was currently an item with Greg Allman—in that spirit I simply signed "Bill." That evening, he agreed to listen to a test recording of my friend Willie Starbuck. Upon returning home, Ernie made the recording, and it was sent off to Macon. We never received a response.

Graduating with a master's from Mills, Ernie/Willie was a visual artist and executed one-time site-specific performances. Barbara Muniot, Wayne Amedee, and I accompanied the artist in a hired black limousine on a trip to the campus of Nicholls State University in Thibodaux for one of Ernie's unique presentations. With the three of us and a few assembled students as spectators, the Black Widow slowly emerged from the black stretch vehicle onto an open field. The Widow was costumed in a multilayered long dress and large-brimmed, draped black hat, all

handmade of black-dyed cheesecloth. Gauze veils flowed in swirls as the totally obscured figure performed on the field before reentering the car with us and mysteriously being driven off down the road.

Perhaps his most memorable performance was his Christmas gift to me of the glorious setting of the sun on the 1975 winter solstice overlooking Lake Maurepas at Pass Manchac. I had never been given a sunset before and thought this one, titled *Laid Back Louisiana Sunset*, was a most original present from someone who had little funds to spend. At the appointed time, we went to Pass Manchac to witness an indeed beautiful setting of the sun over the lake.

I had a little Porsche 914 midengine sportscar, and we made many memorable trips in it. On several occasions, we went to Jacksonville to visit Ernie's friends and family. We stayed with an eccentric and fascinating woman, Dorothea Harris, who was known as Mother Goose. Her house was filled with an odd assortment of art, collectibles, bric-a-brac, and just appealing junk. She and Ernie had many mutual interests along these lines. Each time we visited, he would ask if he could borrow the Porsche to go down to Palm Valley to see his kin. I agreed, but I was never invited to accompany him. He wanted some private time with his brothers and cousins, and that was okay with me.

However, during another visit in Jacksonville, he asked if I would like to come along to Palm Valley. I realized at that moment things had changed. He was now willing to share with me his earlier life and vice-versa, allowing his family and friends to meet his male partner. Mind you, this was the early 1970s, when things and attitudes were much different. I nervously accepted, and off we went. We arrived at a cousin's house trailer located along the Saint Johns River bank with a large trampoline erected alongside other assorted yard objects. Inside, Ernie's cousin, Merline, had recently had a bad seizure and was laid up in a large bed with a swollen face, black eyes, and other bandaged areas of her body. Speaking with difficulty, she greeted me and invited me to sit on the edge of her bed. Female relatives crowded into the small space and were encouraged to do the same. We had brought some beer with us. After a few tense moments and after drinking a few rounds, everyone began to relax. With Ernie, me, and this group of young women all piled

in bed together, we laughed and joked, generally all having a good time. Everyone seemed to be enjoying the party.

A while later, we ran out of beer, and Ernie asked if he could borrow the car and go get more brew at the store. Left alone with this gaggle of relative strangers, things got more serious when they began to interrogate me about my relationship with their cousin. I answered as frankly as I felt necessary, but they kept persisting with personal questions I thought inappropriate. I politely indicated my reservations about responding to this embarrassing inquisition, and they backed off the attack.

Fortunately, Ernie returned well stocked for more rounds of heavy boozing. The party continued until the wee hours of the next morning. During the festivities, another cousin, Bill, a burly, bearded man-mountain-dean kind of guy showed up in his pick-up truck with a large horse *standing* on the vehicle's bed. After an introduction to me, he joined the party. The laid-up cousin's small children had the TV blaring in the next room while running the noisy electric vacuum cleaner over the floors for no apparent reason. Simultaneously, others were popping corn on the stove and jumping on the trampoline outside. It was a loud three-ring circus breaking the stillness of the night at the end of a country dirt road. The horse never moved from his station in the back of the truck.

All was going well until the husband of the bedridden cousin returned home after a long night playing guitar in a rock 'n' roll band at a motel lounge just outside Jacksonville. It became quite obvious the motel management allowed drinking while working. When he saw me sitting on his bed with his wife, he was not pleased to say the least. "Who are you? What are you doing here? You're not one of us. Get out!" When Ernie and my fellow partiers tried to explain what was going on, he would have none of it. "Johnny, go away, we're having a good time," they told him.

"God damn it! I told you to get the fuck out of here. You're not one of us!" he shouted. He finally left, and the party continued until he returned with a shotgun in hand and repeated his demands to me. Everyone quickly sobered up a bit, and the tension was palpable. Even though he eventually backed off and left, the party was effectively over. After all, it

was halfway through the night. Ernie and I returned to Mother Goose's with memories of an unforgettable night in Palm Valley.

Around the same time, Ernie and I made one of our frequent outings to Cajun country to visit Dickie Landry and Tina Girouard. For this particular evening, we planned to visit Russell Dupré, a professor of landscape architecture at the University of Southwestern Louisiana in Lafayette, whose house he designed and constructed mainly of recycled materials in a tall, thick forest of bamboo in the middle of nowhere. Whole walls were made of different colored bottles stacked up on their sides, giving the interior a warm glow. Joining us that evening for cocktails was one of Russell's lovely students, Josephine, who came beautifully attired in a baby-blue, strapless gown with crinolines.

When we were going to hear Clifton Chenier play at the Dippsy Doddle (a.k.a. the Double D Club), a country roadside dance hall, we invited the young lady to join us. This was a Blacks-only club, and when we walked into the large, crowded building, Clifton was already playing with his band on stage. The place was jumping, but upon seeing us white folk coming in, many stopped their partying. When Dickie was spotted among our group, things resumed, and we were pointedly told by the doorman, "We hope you have a good time here. If you have any problems, you come see me."

We bought some beers and stood around in a group watching the crowded room having a good time dancing and drinking. Dickie went up to the bandstand to greet his friend Clifton, who invited him to sit in with them, which he did. Then a young African American girl asked Ernie to dance. He accepted, and I was then asked to dance as well by another. What little racial tension there was that night seemed to be easing up as time passed.

Finally, a Black man asked our blue-gowned mademoiselle to dance. Looking like a debutante as she stepped onto the floor, she was thrilled to be invited to dance. However, Russell was not as pleased with the way things were going. He then informed us that Josephine, his student, was really named Joe, and he was a guy in drag! If the people in that room knew the truth, I don't know what would have happened.

We stayed on and left only when Dickie finished playing with the band. I sure felt relieved when we were safely on the road back to Dickie and Tina's that night.

One year in the 70s while meeting with the H & R Block people, I asked if I could declare my roommate as a dependent. The person attending me stood up and shouted to his female supervisor in the rear of the crowded room to which she stood up and defiantly shouted back, "Not if it's a *woman*" to which I shouted back, "It's *not!*"

The Blue Room at the Fairmont Hotel (now the Roosevelt) was a fancy supper club with named acts performing nightly with a full house band. While the Pointer Sisters (a hot act at the time) were the headliner there, Ernie and I decided, being big fans, to give a party for them at the apartment I rented from Milton Melton and Steve Scalia on Governor Nicholls in the French Quarter.

After a simple telephone call informing Bonnie Pointer of our intentions, they thought it was a grand idea and enthusiastically agreed. On a Sunday evening, May 18, 1974, when the Blue Room was traditionally dark, the girls were picked up by horse and buggy and delivered to Governor Nicholls. It was a great party and lasted late in the evening. Much loud music, drinking, smoking, snorting, nude swimming—everyone was having a blast. Allen Toussaint was invited and came. It was fun until the next day, when I was told I was being evicted. Seems I didn't realize the mother of one of the property owners had died, and he returned home during the height of the blowout.

What a bummer and what to do?! I began searching the city for something I could afford to buy. My sister, Pat, and brother-in-law, Phil, told me they would go in with me on the purchase of a property as they enjoyed visiting New Orleans and thought owning a house in the city would be a good long-term investment. Among the many properties I looked at in this historic city were the modest houses of Jelly Roll Morton in the Seventh Ward, Henry ("Dr. Livingston, I presume") Stanley in the Lower Garden District, and the large antebellum mansion on Esplanade Avenue where the French impressionist Edgar Degas had lived and painted while visiting his relatives for four months from 1872

to 1873. While owning the Degas house was extremely tempting, I finally decided against it as it needed a lot of work to renovate, and I just wasn't into taking on that time and expense.

Time was running out for me to move out of Governor Nicholls, and I had not found anything to my satisfaction. Running into a friend and neighbor, Patricia Chandler, at the grocery one Saturday evening, she commented, "Bill, you look depressed. What's wrong?" When I explained my plight, she told me of a lovely house available on Saint Philip. "Oh, I can't afford anything in the French Quarter. I haven't even bothered looking there." Further describing the house, I suddenly knew which house she was referring to—the one NOMA board member Jimmy Coleman Jr. and I had visited five years before when the owner, Dr. Ralph Fabacher, was selling many of his nineteenth-century Louisiana landscape paintings (Richard Clagues, William Bucks, etc.). When Jimmy and I first entered that little house, we both looked at each other and said, "Wow." It was a gem, and so was the art. The museum subsequently bought the collection.

Upon realizing the house in question, I hightailed it over to 915 Saint Philip, reintroducing myself to Dr. Fabacher and his sister, Ceil, who co-owned the house with him. This was the house for me. It already had strong art karma. Quickly reporting my find to Pat and Phil and negotiating with the real estate agent, we settled on a deal that same weekend. After the act of sale, the house was quickly transformed: we pulled down the sumptuous thick drapes and valences and pulled up the expensive custom-designed carpet in this elegant high empire décor. Adding to the art karma was the fact that a brother and sister sold to another brother and sister.

Ernie had lived in San Francisco before moving to New Orleans. We decided to take a road trip back to California to visit his friends in Los Angeles and the Bay Area. We made a number of stops along the way. The first was just outside Amarillo, Texas, to meet and visit with Stanley Marsh 3 (he explained that the Roman numeral "III" was just too pretentious for his name), an eccentric millionaire with whom I had been in correspondence previously. Being a big man with big ideas in a big state, his "letters" to me were supersized on large, heavy poster sheets with

enlarged typewriter copy and giant envelopes. He had commissioned a number of site-specific artworks for his Texas-sized sculpture garden out on the lone prairie. The most notable were Robert Smithson's *Amarillo Ramp* and Ant Farm's *Cadillac Ranch*, a row of partially buried, upturned at a forty-five-degree angle, fancy cars with tail fins piercing the skyline. Our visit with him did not disappoint my expectations. He was just as nutty and flamboyant as I expected. However, tragedy followed him too. Smithson was killed in a plane crash while inspecting a possible site for his Earthwork on Marsh's property.[1]

After a stay in Santa Fe and our visit with Georgia O'Keeffe at Ghost Ranch, we were on to Los Angeles. One evening, we went to the Roxy Theater on Sunset Boulevard to see a new, live, outrageous rock musical that was the talk of the town starring Tim Curry and Meatloaf. It was the American premiere on July 5, 1974, of the London-originated *The Rocky Horror Picture Show*.

Finally, in mid-July, we arrived in San Francisco. Ernie and I had been spatting occasionally throughout the trip, and Ernie blurted out one evening, "You know what you should do is take EST!" Ernie had taken EST while living in San Francisco, and when he outlined what it was, I defiantly agreed, "I will!"

Erhard Seminars Training, or EST, was an encounter group similar to the Esalan extremely popular in the Bay Area at the time an. EST incorporated some elements of numerous philosophies and religious beliefs and enjoyed national attention. A cross between Zen Buddhism and Dale Carnegie, it was founded by Werner Erhard, who has been equated in more recent times with L. Ron Hubbard and even Jim Jones. Does Erhard deserve this comparison to these other religious cult leaders? I don't think so.

This pop psychological movement had a serious, demanding structure from which there was little or no deviation. After registration, two hundred fellow participants were corralled into a secure, closed-door hotel grand ballroom early on a Saturday morning and held for eighteen hours with one bathroom/dinner break late in the afternoon. A trainer went through a highly structured lecture/performance, stopping at intervals for individuals to "share" their reactions and their own

experiences with the group. Sometimes, the trainer took on the characteristics of a tough Marine drill sergeant, other times that of a comforting father confessor. At times, the dialogue became quite heated and confrontational. Speaking voluntarily, some participants came forth to share deep, dark secrets from their past. For others, deep-seated feelings, past denials and conflicts surfaced. Crying was not uncommon. These public confessionals were highly emotional and disturbing for others to hear. There were occasional elements of the program that were physically participatory, such as standing at attention and motionless on a platform in front of the audience while the group leader approached you face to face and very close up for what amounted to a staring contest. It sounds easy, but it wasn't.

One of the most effective and memorable exercises involved the whole group "getting into your space," which consisted of lying stretched out on the floor and following a series of relaxation instructions as a kind of self-hypnosis. The planned outcome of this intense two-weekend exercise was one's personal epiphany of "getting it." For me, EST was an encounter group, but the only one I encountered was myself. The aim of "getting it" was the realization that there was nothing to get. I "got it" and "graduated" in the wee hours of the Monday morning of the second weekend.

My successful completion of this rigorous exercise made me no longer a victim. I alone had to take responsibility for my actions, *all* my actions. I could not blame others for the circumstances of my life good or bad. It is a tough realization and one that I had to fully accept and abide by at all times. At that point, I, like everyone else, was on an extreme high as if we had taken potent hallucinogenic drugs. It was an exhilaration that lasted for days, months, even years. Strange as it may sound, I firmly believe it changed my life as I confronted myself and got to know who I really was and am.

Digressing from my trip, a year later, I contracted a bad case of hepatitis, and I retreated to Weyanoke, an idyllic, unrestored plantation house owned by Nora Marsh in West Feliciana Parish between St. Francisville and the Angola Penitentiary. A columned expansive front gallery faced an allée of live oaks surrounded by rolling pastures with

grazing cows, a wide central hallway, peeling plaster walls, rotting lace curtains, naked light bulbs hanging in the center of each room from ornate plaster medallions, half and full tester antique beds, claw-footed bathtubs, country kitchen . . . I couldn't have asked for a more tranquil setting for my recovery. My every need was dutifully attended to by my housemate and friend Rebecca Venable, who was a superb cook.

Fresh from my EST experience, I decided to put my new awareness to the test in conquering my illness. The results were amazing. My doctor was dumbfounded by my unbelievably rapid recovery from a serious case. I developed a daily, late-afternoon ritual of immersing myself in a bathtub of body-temperature water and "getting into my space." With limbs extended, I concentrated on relaxing my body, beginning with my toes and working my way up, part by part, to the top of my head. Once there, I mentally visualized the size of my illness. It filled a basketball-sized receptacle. With an imaginary dipper, I gradually emptied the container until it was bare. I visualized the affliction again and found it was now the size of a tennis ball. I repeated the emptying sequence, and when completed, envisioned the virus which was now ping pong sized. This mental procedure went on until there was no sickness to imagine. Strange as it may be, I attribute the daily repetition of this unorthodox ceremony to my speedy recuperation.

Regarding EST, after an honest examination and reflection I have come to know better who I am. I am comfortable with what I have learned about myself and will not let others dictate their perceptions of who I should be. Having accomplished this, I am a more independent and satisfied person, content with my being, my persona, and my goals. I am no longer obliged to attempt to conform to others' beliefs of who I should be. I am my own person.

While in San Francisco, Ernie and I visited Imogen Cunningham. At the time, there was a garbage man's strike in San Francisco, which was causing quite a commotion in the community because of their union's outrageous demands. During our visit, Imogen suddenly turned to Ernie and inquired, "And what do *you* do? I hope it's trash!" He acknowledged that indeed it was in a sense. He was in the midst of writing what would become the classic *White Trash Cooking.*

An equal passion of Ernie's was to write a cookbook. Again, I kept encouraging him to just go ahead and do it. But he never did, at least not while we were together. After we parted, he *did* write that book *White Trash Cooking* published by my friend Jonathon Williams of the Jargon Society. It became an overnight national bestseller and a cult favorite that sold more than 350,000 copies. One of my recipes appeared in the book as Aunt Alma's Almond Omelet.

Among the wide publicity promoting his tome, he appeared on *Late Night with David Letterman*. He showed David how to cook chicken feet! Ernie had become a national celebrity as a noted humorist. Two years later, he published a second cookbook, *Sinkin Spells, Hot Flashes, Fits and Cravins*, which sold extremely well too. "The publisher calls the new book a celebration of the most sacred and secular ceremonies of country people."[2] Among the whimsical chapter titles are "Foot Wash-ins, Prayer Meetings, Creek Baptisms, and All Day Sings"; "Funerals, Wakes, and Cemetery Cleanins"; and "Hog Killins."[3] When Ernie died of AIDS in 1988, the *New York Times* gave him a major obituary that included his picture: "Ernest Matthew Mickler, 48, Dies; Author of Best-Selling Cookbook."[4]

Recently, Dan Cameron accepted a residency at the Hermitage Foundation in Florida. He became friendly with a fellow attendee there, Michael Adno, a journalist. One day Michael mentioned to Dan he had just published an extended article on a fascinating man who authored the cookbook *White Trash Cooking*, to which Dan immedi-ately responded, "Do you know Bill Fagaly?" Michael replied, "No, I don't know him, but I have written about him in my piece."[5] Dan explained that he was a friend of mine and offered to put the two of us in touch. Michael ultimately came to New Orleans, and in honor of his visit, I hosted the Ernie Mickler Memorial White Trash Dinner in early Febru-ary 2018, featuring a menu of dishes from the cookbook and cooked by guests Dawn DeDeaux, Elizabeth Shannon, and me. The *carte du jour* for the evening included two hors d'oeuvres—Yellow-Eyed Deviled Eggs and Minna Dean's Mock Oyster Dip—followed by Tutti's Fruited Por-kettes, Edna Rae's Smothered Potatoes with a Combination Salad, and concluded with Florence's Lemon Ice-Box Pie with Florence's Pie Crust

and Quick Fruit Cobbler. We all agreed all the dishes were surprisingly good. As an added lagniappe, Mike, not to be out done, brought his death-defying Dirt Cake presented in a clay pot.

Ernie had a profound influence on my life and who I am today. Admittedly, he was quite a horse of a different color from Julia and Emeril. Looking back, I'm glad I didn't know how to cook spinach.

William Leroy Tobiasson

After Ernie, Bill Tobiasson lived with me for four years while studying at Tulane University. He was approximately fifteen years my junior and was studying architecture and art history. Bill opened for me new worlds and a younger lifestyle, while I introduced him to the art world and its players. We both benefited from learning as each of us had an insatiable curiosity and willingness to try new things. Bill was exceedingly intelligent but slightly mad in a good way, impetuous and unpredictable, and full of energy. He was masculine and wild, and I never knew what to expect from him next, except that it would not be something I had to deny or worry about.

We had much in common and were a good pair. Between his fast-paced studies at Tulane and my equally demanding role as curator at NOMA, we lived an active life together. Consequently, those evenings when we were both available, our dining room, so to speak, was the soul-food restaurant Buster Holmes at Burgundy and Orleans around the corner from our house. This was our shared time to catch up over ribs, fried chicken, greens, and red beans and rice.

Bill had a motorcycle and parked it in the dining room of our house. One year, he shocked his fellow students when he showed up at the architecture school's annual Beaux Arts Ball at the Royal Sonesta Hotel dressed outrageously as Divine from John Waters' *Pink Flamingos*. He loved to cook his native Peruvian dishes, particularly his favorite *anticuchos de corazon*—marinated beef hearts cut in bite-sized pieces and grilled on kabobs—or boiled or fried yucca. Another favorite was his lethal Pisco Sour cocktail made with the national Peruvian brandy.

We each had our own groups of friends, and we loved sharing them with each other. One weekend, a friend of Bill's, Billy Wilkins, who lived Uptown and was a part of the "A" social group of gay men whose pedigrees contained Uptown straight society names and backgrounds, invited Bill and me to one of his proper formal dinners as only gay men can put on. Even though I knew and liked Billy and some of the people who would be there that evening, I did not particularly want to go. It just wasn't my kind of thing. Bill pleaded with me to go. Billy Wilkins was widely known for the practical jokes he constantly played on people. Knowing my reluctance to accepting the invitation, Tobiasson suddenly suggested, "Let's go in drag!"

"No, that's out of the question." I protested. "I've never done that and have no intention of starting now."

Bill insisted, "It would be so much fun getting back at Billy on all the jokes he pulls on everyone else." He had a point.

At the last minute, Bill and I raided one of our friend's closets in the neighborhood, selected all the necessary garments, accessories and makeup, jumped into my convertible and headed Uptown, both with our own full dark beards. Driving through Central City, a primarily African American section of town, with the top down on this summer Sunday evening, Bill waved and called out to everyone standing on the street. With a sheepish grin, I half-heartedly waved too. Purposely arriving late so that all his guests were all having cocktails when Billy opened his door and saw us standing on his porch, for a moment I believe he seriously considered closing the door in our face. But he didn't. Introducing us around the room, everyone was in shock, and all were buzzing among themselves. How scandalous!

The dinner party proceeded with cocktails and dinner. The joke was over, and we had made our point. However, I was now having so much fun I didn't want to get out of character and continued my charade throughout the evening. After dinner, a few known gossips made excuses for an early exit. I knew full well they retreated to get on the phone at home and start calling all their friends, "You won't believe what happened tonight and who I saw in drag!" I am convinced the phones Uptown that night were full of chitter chat, chitter chat. As much as I

thoroughly enjoyed the experience, I have never since ventured into this make-believe world and have no desire to do so again. I credit Tobiasson for having had the imagination and humor to push me to do something that was so not my lifestyle. Good for Bill.

Peru

A year after meeting Bill, he wanted to show me the country where he was born and raised. His mother was Peruvian and his father an American who was the manager for the Exxon refinery in northern Peru. Gathering supplies for the trip and borrowing his mother's Volkswagen Beetle, Bill drove from his parents' house in the affluent Miraflores section of Lima to Cuzco, where I flew in to meet him. As I deplaned, Bill walked out on the tarmac, handed me a package containing an assortment of the country's favorite recreational stimulants, and said with a broad smile, "Welcome to Peru!"

In his greeting upon my arrival, Bill also proudly announced he had bought a horse.

"What! Why?" I nervously inquired.

"Well, there's this guy in Pisac, and he needed some money, so I bought his horse to help him out."

Bill didn't have a ready answer when I inquired what we were going to do with our new steed, which was being kept in the tiny village in the Urubamba Valley across a mountain range from Cuzco. Impetuous indeed!

Our first base of operations was a Spartan hostel overlooking the Plaza de Armas. From there, we took daily side trips into the Urubamba Valley to visit archaeological sites and deal with Bill's horse. One day, we took an all-day train excursion to the famous Machu Picchu Inca site. Armed with supplies of sugar cane, tangerines, bread, coconut, chirimoya, and bananas, we picnicked while sitting on our hard, wooden seats during the rattling, jostling ride through the majestic snow-capped Andes to one of the great wonders of the world. As the train approached the site, it ran along tracks that slightly declined while following the

Vilcanota River. The vegetation became lusher and more tropical with the increasing presence of orchids, bromeliads, papaya trees, and ginger plants. Finally arriving at the great Machu Picchu did not disappoint. As a Peruvian, who had studied this ancient architecture, Bill gave fantastic lectures on the ruins throughout our wonderful six-week stay.

We were extremely fortunate to be in Cuzco for the annual one-day Corpus Christi festival centered around the plaza, faced on two sides by magnificent ancient Spanish Baroque churches. For this all-day event, beginning at sunup and lingering into the late hours of the night, Indian women had come into town from the neighboring mountain villages to set up operations on the street curbs around the plaza. They cooked their specialty dishes in large kettles and sold their fresh fruits and vegetables. Some of the delicacies being offered were *ceviche* (mountain trout pickled in lemon, onions, and hot peppers), *rocoto relleno* (stuffed hot peppers) *papa rellena* (stuffed, fried mashed potatoes), *picarones* (fried doughnuts) *huevera* (fried fish roe), and Bill's aforementioned favorite, *anticucho de Corazon*. Among the many fruits offered were two I was not familiar with. In describing them, Bill had his own definitions for the *chiramoya*, which he referred to as "the milk shake fruit," and the *granadilla* he indelicately called the "snot fruit."

There was another prized treat which I was highly encouraged to try: *cuy*. Described as "grilled white domesticated rat," this rare local delicacy, I was told, was a must. It was grilled whole on a spit with protruding yellow teeth, beady eyes, and curled up clawed feet and a few singed hairs. I gamely but gingerly took a bite of cooked meat that had been carved for me from the rump of the animal. "Mmm, not bad," I thought. I just ate some grilled rat and *liked* it! Days later, I realized there was a bit of a translation problem: it was really guinea pig, not a rat as I know it.

Another much-anticipated spectacle was the procession of oversized and heavy carved and painted wood figures of Christian saints, such as Santiago on Horseback, Saint Sebastian, Saint Peter, Saint Barbara, Saint Mark, and the Virgin Mary. These top-heavy loads were carried on litters by inebriated men, weaving their way out of the church, around the plaza, to return to their home base in the sanctuary of the

church. There were heart-stopping moments when the combination of the men's intoxication and the overload they were carrying made the statues wave back and forth precariously in the air. Meanwhile, other drunken groups of men performed all day and all night in a kind of battle of the bands in various corners of the town square pounding bass drums and blasting coronets and trumpets and repeating over and over the same nonmusical tune only stopping to urinate and defecate in a discreet corner. While most people disbanded during the waning hours of the evening, the music continued late into the night.

Shining Path

Bill and I visited Peru at the beginning of the Shining Path, a rebel activity of the dangerous Maoist faction of the Communist Party of Peru wreaking havoc throughout the country. There were nightly curfews with Peruvian military troops and tanks patrolling the streets of Cuzco and other cities. Occasional gunfire was heard outside our hotel in the plaza. The roads and highways were littered with burning tires and mountain boulders from student and peasant protestors, while frequent military checkpoints were stationed along the way, impairing travel. At one point, people were rioting, protesting the 50 percent overnight price increase of gasoline. Impromptu strikes hampered normal activity. There were rumors that the annual ancient Inca Inti Raymi (Festival of the Sun) might be canceled because of the unrest. Armored vehicles, police with machine guns, and guards on rooftops made for an uneasy atmosphere. It certainly was an uncertain time in Peru, and tensions were high.

Camping out in the Andes

After spending time exploring the area around Cuzco and finally unloading and selling the horse, Bill and I were to begin another exciting adventure into relatively unknown territory, at least in modern

times. We obtained permission from the Peruvian minister of culture to visit an undocumented Inca site high above the village of Calca in the Urubamba Valley variously named Huchey Qosqo, translated Little Cuzco, or Qaqyaqhawana, meaning "where the lightning can be seen." The principal purpose of this expedition was to fulfill an assignment given by Bill's Peruvian architecture professor at Tulane to make an official survey of this site for the first time.

After acquiring the necessary surveying tools and some camping supplies in Cuzco, we moved to the Urubamba Valley and set up a base camp for several nights in the pitch black of night along the banks of the mountain rapids of the Vilcanota River under a grove of fragrant eucalyptus trees and a canopy of thousands of stars. On the second night there, I waited for Bill's return from Calca, where he was buying more foodstuffs and other supplies. Stretched out on the ground and gazing at the blanket of stars twinkling above me in the heavens, I became aware of an unknown animal rustling the leaves around my legs. It appeared in the darkness to be small, black and white, and was not deterred from my attempts to scare it off. Its identity suddenly became apparent when I realized I had been sprayed by a skunk!

Bill used his Peruvian American heritage to his advantage. The large private haciendas of the wealthy Peruvian ranchers had been commandeered by the Shining Path, transforming them into cooperatives. The rebels were in full control and not known for their warm hospitality. When we needed foodstuffs, we would drive into the cooperative farmyard, and Bill, as a Peruvian, would negotiate with the rebels while I, as an enemy American gringo, hid in the car. On the other hand, when we had to pass through numerous road checkpoints, Bill became an innocent American touring the country. He knew how to work it both ways, and his Dr. Jekyll and Mr. Hyde cleverness got us through many a sticky situation.

Having an animal to carry our camping gear and surveying equipment up the mountain to our destination was essential. Renting horses on a daily basis was expensive (where was that horse Bill had purchased and successfully sold when we needed him?), so a single burro was the beast of burden of choice for our supplies. After Bill negotiated a deal renting a fine-looking animal who appeared totally disinterested in his

fate, the three of us were off as the sun came up the next morning. For budgetary reasons and availability, Bill and I walked while leading our new friend and compatriot on our mountain-bound trek. In deference to him, we named the burro William not to confuse further the issue of names. However, maybe William knew more than we did as he was most reluctant to go up the mountain. As we finally set out that sunny morning, Bill and I took turns pushing him from the rear to move him forward, which, we soon discovered, was further complicated by the fact that William had diarrhea! Oh, the unexpected travails of travel.

Dehydrated, heat exhausted, and suffering from altitude sickness, we decided that evening to make camp midway on our trek. The all-day exposure to the unrelenting rays of the sun had taken its toll. Devouring three oranges for nourishment and with no real campsite on the edge of the steep incline, we reluctantly slept on a narrow cliff, hoping not to roll off.

Somewhat refreshed and continuing onward the next morning, we found we frequently were getting out of breath with the considerably thinner air at the 11,800-foot altitude. Around mid-day, we arrived at our destination at the summit and soon found a small mountain spring, which was a lifesaver. Water! However, for access to drink this precious liquid, we had to share it with a pack of wild boars. We were desperate and thought little of our having to engage with these smelly rude beasts in pushing matches for access to the cold, clear, refreshing mountain water.

We felt we were at the top of the world with the stunning panoramic views of the Andes over the Sacred Valley of the Incas. Besides boars and pumas, we were in the company of howling wolves, large darting hummingbirds, and swallows that flew like torpedoes and made nests by digging caves in mud brick walls of the ruins.

For the next few days, we mapped, surveyed, photographed, and made drawings of the ruins, terrain, and artifacts. Breaking the silence only punctuated by the mountain breezes, in the evenings, we heard William braying next to the spring where he had been tied up and was standing, waiting. Later it occurred to us he must have been in fear of being attacked by the pumas that we also heard occasionally roaring in the distance. Those are not the only sounds we heard. The annual Raising of the Cross Festival far below in Calca had not been canceled in

spite of the Shining Path—imposed curfews and bombs and student pro-
tests. Smoke emanated from neighboring mountains indicating other
prevalent dissent. However, we felt somewhat safe on our high perch
where we could observe all this unrest through our binoculars.

A word concerning our meals. We ate well, cooking every day at
our campsite. Food always seems to taste better al fresco. The breakfast
menu, when not consisting of leftovers from dinners the night before,
often was a choice of oatmeal, fried eggs, onion omelet, toasted bread
rolls, and maté tea. Lunch and dinner could be spaghetti with meat
sauce, oxtail soup, or stewed chicken with rice.

A word about the tea brewed each day using fresh cocoa leaves: it
provided a nice caffeinelike pick-me-up. However, if a small amount of
an unknown black, greasy substance is added as a catalyst, a mild high
is achieved.

Having successfully accomplished our mission at Huchey Qosqo,
our adventure pushed forward as we returned to Machu Picchu for a
longer visit. We stayed in the small peasant village Aguas Calientes at
the base of the mountain where the ancient site is situated. The "hotel"
building also served as the community's only restaurant, post office,
police station, jail and whore house. It was tantamount to an entire
shopping mall in a single building. One stop shopping indeed! For the
equivalent of fifty US cents I slept on a wire spring cot in the hallway of
this multi-purpose establishment. It was the only time I considered I
got ripped off by a hotel. Early the next morning, we visited the village's
namesake natural thermal baths up the hill above the town. There we
encountered a man, extremely agitated as he had just witnessed a fly-
ing saucer hovering overhead. He described it in detail. It seems there
have been numerous sightings of UFOs in the vicinity of this famous
archaeological site. We missed it.

Having successfully met our goal on the mountain, we continued on
to our next destinations. After driving one frigidly cold and uncomfort-
able night over the lengthy *altiplano*, or high plateau, a very desolate,
arid flat land with rocky and dusty "washboard" roads, we arrived next
morning in Puno on Lake Titicaca. Then it was on to the archaeological
site of Tiahuanaco across the border in Bolivia before we arrived in the

capital La Paz surrounded on all sides by majestic white-capped peaks. We returned to Lima in our trusty little Volkswagen driving more than the 20,000-foot-high Andes to Arequipa, a city largely built using whitish tuff from a nearby extinct volcano.

Certainly, one of the most thrilling experiences I have had during my lifetime (and that is saying something, I realize) is hiring a small Cessna airplane and flying over the Nazca Lines in Peru. Arriving at an isolated ramshackle bamboo shelter on an open field, the permanent sign instructed us to wait on the wooden bench next to an exterior wall for others to just show up to fulfill the six-passenger capacity of the Skywagon 207 sitting nearby on an open filed. Four additional individuals appeared after a while, and we were off in the rattling plane.

What was almost totally invisible on the ground became a glorious spectacle from the air. In an area of 190 square miles on the flat plains of the Peruvian desert near the Pacific coastline the Nazca Indians from 200 through 700 AD created a "site-specific installation." The ancient people drew with amazing accuracy a web of hundreds and hundreds of laserlike lines over the terrain, many parallel, others forming extended trapezoidal shapes. Some lines extend 50 miles in length. Interspersed among this linear maze were numerous stylized figures, enormous in scale, illustrated with precision on the flat terrain. Outstanding among these zoomorphic depictions were a hummingbird, a condor, a spider, a monkey, a fish, a shark, a llama, a lizard, and a dog, among others. The rendition of a human figure called "The Giant" was on a hillside. With a depth of mere inches, the lines incorporated in this entire spectacle were created simply by making shallow trenches on the ground to remove the reddish surface pebbles to expose the grayish earth beneath. The constant dry and windless climate has allowed this artwork to remain intact for nearly two thousand years. Its longevity has been credited to the dew that naturally forms each night and the burning daylight sun, which act together as a kind of glue to hold this fragile environment in place. Over the years, I have highly encouraged anyone who is traveling in Peru not to miss this unique treasure. Recently, I was informed by my Peruvian friend César Infante that this was no longer such a good idea—the same dilapidated Cessna I rode on in 1977 has never been replaced![6]

Episode 12

My Beloved Roommates: My Cats

Dogs have masters; cats have staff.

Some of my best and closest friends weren't even people—they were my cat roommates. To paraphrase Will Rogers's famous quote, I've never met a cat I didn't like. All were rescued from the SPCA shelter, picked up off the streets, or adopted from a previous owner and had their own personalities. Some of their more unusual individual traits are worth sharing. For instance, my two cats Black Kitty, a domestic short-haired, and Gray Kitty, a Persian, while eating side by side would simultaneously stop and look at each other from their individual bowls and then switch bowls and continue to eat. Before being adopted by me, Gray Kitty would have his own whiskey sour every evening at cocktail hour with his former owner. He went on the wagon at the Fagaly household.

Predictably, Yellow Kitty, a Maine Coon, used her sandbox each time I used mine. It became family activity together. Some of my cats, after success with the sandbox and apparently feeling much better, would celebrate by racing back and forth from one end of the house to the other. On the other hand, Marie, a domestic long-haired, almost always washed her front paws in her drinking bowl after using the sandbox.

Four days after the death of Black Kitty, while I was still in mourning, a gray-and-white cat was sitting across the street in front of the museum as John Bullard and I were leaving for the day. It's as if the cat was waiting for someone. After I proceeded to get acquainted with him, John's comment was, "It must be fate!" We decided this lonely kitty should come home with me. I later found out from museum staff the

cat had been living around the museum in the park for about a year, and now Louie, a domestic short-haired, had found a home.

Louie became strongly attached to me, and whenever I would go away on a trip for a few days, he would climb the tall banana trees in my courtyard, jump onto my roof, and then jump over to the neighbor's roof, down their sweet olive tree, across their courtyard, through a hole in their fence, across another courtyard, and over a brick wall into a third courtyard of the apartment complex nearby. Upon my return, neighbors would tell me where he was, and I would call him from my upstairs window. He would answer with a mournful and pitiful meow. However, he didn't know how to retrace his steps, and I would have to go rescue him. That pattern repeated itself a number of times. On another occasion, he was taken in by a neighbor in the second courtyard. He allowed Louie out on his front stoop, where he would sit all day apparently waiting for me. To put a stop to his escapes from my courtyard, which only occurred when I left town, I took a cue from the Royal Sonesta Hotel on Bourbon Street with the annual Greasing of the Poles at Mardi Gras time. I applied a generous ring of Vaseline around the upper trucks of the banana trees. That technique worked and kept Louie at home from then on. Licking sticky paws takes forever!

After Louis Quartorze had settled in his new home, I went shopping at the SPCA for a suitable companion for him. After interviewing numerous seductive, beguiling females, I chose Marie, whose coat was black on the surface but pure white underneath. She was beautiful, and I knew Louie would be pleased with my choice. Or so I thought. After a few days of adjustment growling and hissing, they finally called a truce and made up and slowly became friends.

Marie Antoinette would become impatient about my slow response to dispensing the latest dinner course and would take matters in her own paws so to speak. She would reach under the bottom of the closet door where the food was kept, open the door and then pull the bag of food out of the closet onto the floor in front of me. She would then tuck her head underneath her body and do a somersault to get my attention. "Is that enough of a hint, Bill?"

I left the bathroom window facing the neighbor's courtyard open during the day while I was away at work, and Gray Kitty and Black Kitty would invite the neighbor kitties in for rowdy afternoon parties. When I returned after work, there would be a definite vibe of "Party's over! Bill's home! Let's get the hell out of here!" Everyone raced for the window at top speed, leaving clear incriminating evidence with all the rugs throughout the house scattered and crumpled in balls. Good times were evidently had by all!

Marie wanted her breakfast at the first sign of daylight in the morning. She would jump onto the bed and, with a gentle tap of her paw on my cheek, attempt to tell me it was time. If I played possum and feigned sleep, she would go across the room and then jump onto the bed at top speed, pouncing on me with a clear message.

My cats took great pleasure in adjusting electronics in the house. They turned the TV on and off and changed channels by walking across the remote, turned off the table lamp by batting the tasseled pull on the light chain, and walked across the computer keyboard, creating their own secret kitty messages.

Shortly after both Louie and Marie went to kitty heaven, I met a leopard tabby on the street, and we struck up a conversation. She agreed it would be great to come home with me. Being a street urchin, I decided an appropriate name would be Eliza, and I took her off to be spayed at the SPCA. When I returned to pick her up after surgery, the vet politely told me Eliza was a boy! How embarrassing! I didn't even know the difference! The vet reassured me that was a common mistake. That's how Eliza became Oliver.

I soon discovered Oliver required a playmate as all he wanted to do was play, play, play. I returned to the SPCA to audition candidates, ideally a young, pretty female who had a similar penchant for having a good time playing. In the interview room, I found the ideal companion for Mr. Fun. She was a tiger tabby, so beautiful and a former street cat from Chalmette. She was quickly named Eliza and came home to meet Oliver. They were inseparable and played, sparred, chased, groomed, slept, and ate together. The height of togetherness was when, more than once, I found them using the sandbox together!

One of Eliza's and my favorite things to do together was to watch on television the annual Westminster Dog Show at Madison Square Gardens in New York. Each year, she would sit by my side on the arm of my chair as the dogs were presented and pranced around the ring being judged. She was fascinated and watched intently for most of the show. Other television programming had little or no interest for her.

Recently, Eliza passed away in her bed, and it was only then I realized how much she had entertained Oliver through the years. Once again, he turned to his human pal to play, play, play.

Episode 13

A Special Friend in Denver

Speaking of animal friends, fifteen years ago, I met someone while visiting the Denver Zoo. I always have had a special place in my heart for gorillas. That day, as I passed a thick wall of glass of an outdoor enclosure, I encountered a seated adult gorilla leaning against the wall. We noticed each other, and I let it be known that I acknowledged its presence. The gorilla reciprocated. For nearly a full hour, the two of us had a most remarkable time silently communicating with each other. One of us would make a special gesture to which the other would mimic it with mutual glee. We were having so much fun having a "conversational visit" together. Our party only broke up when my family, who had been looking for me, were ready to leave, and reluctantly I said goodbye to my new best friend.

Episode 14

Enjoying the World and Its Wonders

What a Wonderful World![1]

I have been fortunate in my life, traveling to many wonderful places, but the most rewarding were those trips that put me in a natural environment detached from modern civilization. The most memorable adventures include spending six weeks in the Andes of southern Peru and northern Bolivia with Bill Tobiasson; camping out with Paul Tarver and his girlfriend for a week in Chaco Canyon in northern New Mexico; the white-water rapids trip mentioned earlier; and spending one week on the Polynesian island of Rapa Nui a.k.a. Easter Island in the South Pacific. Here we were fortunate to be under the daily tutelage of UCLA archaeologist Jo Anne Van Tiburg, director of the Easter Island Statue Project.

Perhaps the most exhilarating experience was spending two months in the bush in West Africa, where I had the rare opportunity to assimilate myself to the culture and environment.[2] I was able to cool out and abandon the daily pressures back home. Being out in nature and isolated from civilization was special. I totally share my friend and art critic Holland Cotter's thoughts he so eloquently wrote in the *New York Times*:

> When the sun sets in rural Africa, the world changes. Temperatures drop. New scents rise as street dust settles and cooking fires start. Markets empty, voices quiet down. Bodies and eyes that struggled all day with heat and glare relax and move toward sleep.
>
> The most dramatic difference, though, is visual.

It comes when the stars appear; first a twilight sprinkling of them, then a tidal wave washing across the sky, covering and soaking it. At such a sight jangled daytime thoughts tend to give way to admiration, inquiry, meditation.[3]

I know exactly what he was describing for I had experienced these identical sentiments and sensations. He was right on in his description in his inimitable, beautiful prose. While in West Africa, I spent some time in urban environments. It was my visits with artist Jacqueline Humphries with the tribal people of Mali and Senegal and later by myself to Côte d'Ivoire, Burkina Faso, and finally meeting Charlie Davis in Cameroon that were the most rewarding. One of the highlights of this marvelous adventure was visiting the Dogon people who live on sheer cliffs of the Bandigiara Escarpment in Mali not far from the legendary Timbuktu on the southern edge of the Sahara Desert.

My journal from that heady time is a testament to my experiences (see addendum 1).

Episode 15

Experiencing Cuba and
Its Havana Biennale

Traveling to Communist Cuba in 2001 was a fascinating experience, and several incidents stand out. When the US government became aware of NOMA's impending group trip to the Havana Biennale, I received a number of calls from the State Department in Washington questioning the trip's purpose. After these rather intimidating calls, I was informed the American attaché, Vicky Hudelston, was inviting our group to her house for a reception in honor of Cuban American artists living in the United States. Little did we know that Mrs. Hudelston lived in the grand mansion of the former US ambassador. Her enormous party was ostensibly lavish with food and liquor. Beyond the wide French doors at the end of the entrance hallway and leading into a beautiful garden was a huge black sculpture of a bald eagle with wings dramatically outstretched.

Among the scheduled members of my group to make the trip to Cuba was internationally known Cuban-born artist Luis Cruz Azaceta, and it was a thrill for me to be the one to take him back to his homeland. However, the Cuban government would not approve his visa. Finally, the night before we were to depart New Orleans, late word came their government would allow him to come back to Cuba after many years in exile. However, it was with great sadness Luis was forced to make the wise, last-minute decision not go after all as he had reason to believe he would be arrested upon arrival at the José Marti airport in Havana.

On the first night in Cuba, our group met exiled Cuban Al Nodal, who was currently living in Los Angeles and was responsible for putting our trip together. We had dinner at El Aljibe in the suburbs of Havana.

I was seated next to Al, and his cell phone rang. Answering it, he got up and walked away to talk in private. When he returned to the table, he had a grave expression on his face and reported, "That was the minister of culture, and he wants to see me in his office tomorrow morning at 9 o'clock." When I inquired, he said he did not know the reason but suspected it had something to do with the *Memoria* book Al was publishing, a comprehensive history of twentieth-century Cuban artists, including those who had fled the regime of Fidel Castro.

A private launch party of the book was scheduled that Saturday night. The minister wanted to know who was coming and why. I asked Al if it was unusual for the minister of culture to call him at a late hour in the evening. "Very!" he replied. Late the next afternoon, I inquired how his meeting went. "Very well," he reported. "The minister just wanted to chat!" Just a bit of old-fashioned intimidation was my thought. Evidently, Al thought it was going so well that he blurted out, pointing to the minister, "I want your job someday!"

Several days after Al's meeting with the minister, he informed me the government was very upset with the beautiful color brochure announcing the *Memoria* publication, which the Castro regime thought was anti-Cuban government. The book included Cuban American artists, such as Luis Cruz Azaceta, who had made anti-Castro sentiments. That Saturday, Dan Cameron and I attended the press conference with the four coauthors seated in front of a bank of microphones at a table in the courtyard of the Museo National. Al was fidgety and looked pale and worried. Afterward, Christina Vives, one of the Cuban authors, said when I congratulated her, "You don't know how much your support means to me." Al's response to my felicitations was, "At least I didn't get arrested!"

Episode 16

Reinventing Myself

On my fiftieth birthday, in 1998, my *Time* magazine arrived in the mail emblazoned with the headline splashed across the cover, "He's 50!" No, not me. It was Superman's anniversary they were honoring.[1]

The beginning of a new millennium in 2001 was a time for personal renewal. To shake up my life, change direction and focus, I reinvented myself. I formally retired after thirty-five years of service at NOMA; had surgery on my upper and lower eyelids and neck; went on a Sugar Busters diet and lost forty pounds; joined the New Orleans Athletic Club and hired trainer Lonnie Arroyo; and started my own business named FUN, which is an acronym for **Fagaly Un**limited. (It is unlimited because I am a whore and will do anything for a price.) My business's motto is "If it's fun, let's talk." As it turned out, my business is fun both literally and figuratively but not financially.

During my initial interview with Dr. Michael Moses in preparation for the facial work, he asked me as we were concluding our conversation if I planned to tell anyone about my upcoming surgery. I thought about it a moment and replied that I didn't know. I hadn't thought about it. When meeting with him several weeks later, on the day before our date in the operating room, he asked, "Well, did you tell anybody?" I proudly replied, "Oh yes, I told *everyone*, so Michael your ass is on the line!"

Episode 17

August 2005

There were more than one and a half million people living in metropolitan New Orleans in 2005, and after the fateful storm and federal floods on August 29, there were many stories to be told. And mine is no exception.

It was mid-August, and I had just returned from a two-and-a-half-week stay in Morocco, the first part spent visiting and partying nonstop with Mickey Easterling at her lavish, beautiful rented villa in Tangier and the second with a driver I hired to take me around the countryside visiting Fes, Meknès, Volubilis, Marrakesh, Essaouira, Casablanca, and Rabat.

Shortly after my return, I was scheduled to visit Houston art collector Stephanie Smither at her lake house in Huntsville, Texas, with fellow collector Susann Craig from Chicago to do a taped oral history of the career and remembrances of the legendary art dealer Phyllis Kind. This was an outgrowth of many nights returning to Phyllis's pad on Greene Street in New York's Soho, which was virtually around the corner from the Puck Building where the Outsider Art Fair was held. Stephanie, Susann, and I annually bunked at Phyllis's house and stayed up until the wee hours in our jammies gossiping and reminiscing, which required frequent trips to refresh our drinks at the bar. These semidrunken sleepovers made us realize what an important story Phyllis had to tell about the beginnings of what I call the modern folk-art movement that began mid-1960s and took traction with the Corcoran exhibition in 1982. She was an integral part of that movement, and her participation should be documented for posterity.

On my way to Huntsville, I stopped overnight at Kent and Charlie Davis's lovely, large raised cottage/fishing camp with its wraparound

screened-in porch facing Big Lake south of Lake Charles. Dawn DeDeaux was there too. At sunset on that late summer evening, we gathered with a couple of neighbors before dinner and had cocktails and hors d'oeuvres seated in the charming covered gazebo at the end of our hosts' long pier. Claiborne, the Davises' daughter's golden retriever, slumbered contentedly at our feet. It was an idyllic setting over the lake as we imbibed and watched that magnificent large deep-orange ball slowly disappearing on the water's horizon. Unknown to this relaxed, convivial gathering was that in a few short days, this lovely setting would be violently attacked and destroyed.

Driving on from Big Lake to another lake house in Huntsville, Stephanie, Susann, and I interviewed Phyllis all the next day, prying out valuable facts and stories with a tape recorder whirling away. Taking a break to watch the evening news, it was announced a potentially big storm was forming in the Gulf threatening the Coast. Uh oh, I thought. This could be bad. As the news worsened, I was in contact with my kitty sitter back in New Orleans. "Bill, there's a mandatory evacuation of the city, and I can't take Marie. I don't have room." "That's o.k. Just leave her lots of food and water, and you will be back in a couple of days."

After Katrina slammed into New Orleans, and the levees failed, I was forced to extend my stay with Stephanie back in Houston. The internet quickly became the most reliable source for communication as cell phone transmission was intermittent due to downed transmission towers. It was the resource for news developments in spite of the excellent and relentless reportage on television. Through satellite imagery, I was able to locate my house on Saint Philip Street to see if it had been flooded or had roof damage. At that point, all the national news channels were reporting flooding in various parts of the city's neighborhoods—Lakeview, Gentilly, the CBD, Lower Ninth Ward, Mid-City, and elsewhere. I found myself yelling at the TV, "But what about the French Quarter?!" They didn't hear me. Finally, I realized the reason there was no report of flooding in the Vieux Carré was because there wasn't any. It was the highest ground in the city and had been spared. The internet was also a useful way for me to register with all the animal shelters nationwide that were actively setting up operations outside the city to rescue stranded pets.

I had been in communication with John Bullard at his summer house on Deer Isle in Maine and Jackie Sullivan, NOMA's deputy director, in Gonzales, Louisiana, where she had evacuated to Saint Theresa's Convent. I decided I would meet Jackie at the convent, accept the nun's invitation to be their guest, and do what I could to help Jackie with whatever needed to be done at the museum.

I arrived in Gonzales eight days after the storm and flood, and the next day, armed with papers from the Louisiana State Police to pass through numerous National Guard checkpoints surrounding the city, Jackie and I drove to Elmwood Shopping Center in Harahan outside of New Orleans to meet the retired New York City policemen who the museum's insurance company, AXA, had hired to assist in securing the museum. Flying in the police helicopter over the city, all one could see in any direction was a dotted pattern of houses and buildings in an endless sea of water. In the far distance, the skyline and Superdome appeared to defiantly rise out of this vast flooded terrain.

Each day, as we drove from Gonzales to New Orleans, we passed endless convoys of military vehicles of all sorts and columns of utility trucks, many with cherry-picker buckets, streaming into the city day and night from all regions of the country. As the floodwaters slowly receded, it was finally possible to drive, dodging obstacles in the road, to the museum. However, the route was circuitous: from Elmwood Shopping Center down Clearview to the Huey P. Long bridge junction at Jefferson Highway to a side street near Ochsner Hospital to River Road to Saint Charles Avenue, weaving from one side of the neutral ground to the other drive to Canal Street to North Peters Street through the French Quarter on Decatur to Esplanade Avenue for another zigzag drive to Beauregard Circle to Lelong Avenue in front of the museum. Even though we passed through the French Quarter, I was not allowed to stop at my house to get my cat. During those early days, I repeatedly called out aloud to the wind, "Hang in there Marie!"

Deserted streets, no traffic lights, no traffic, no birds, the ever-prevalent stench of rot, the smell of mold and mildew and death, everything the same gray-brown color, downed trees, broken branches and limbs strewn everywhere, standing trees stripped bare, roofs in the middle of

the street, a brick church steeple toppled, pets waiting alone at the top of the stairs on their family's porch, other frightened cats and dogs lost, confused and running, a bloated dead body of a man lying on a street curb, National Guard troops in their camouflage fatigues and drawn firearms, and possibly the most disturbing of all, the ominous stillness and eerie silence in this sea of destruction.

This was not a Hollywood disaster movie; this was really New Orleans or what was left of it. Every morning those first few weeks I would awake and realize it was not a dream, it was a real live nightmare I was experiencing. I was in shock like everyone else. These images are indelibly etched in my mind, and they make me shudder to even write about them now years later. My first reaction upon hearing of the deaths of my friends art dealer Bill Peltier and museum curator Vaughn Glasgow, who both died a few days before the storm was "they were the lucky ones." For the city known as the Big Easy, it had now become for me the Not So Big, Not So Easy.

A few weeks later, when more and more first responders were entering the city to face the destruction and begin the arduous task of cleaning up, the complexion of the city changed again. From the look of an abandoned metropolis in a war zone, it began to look like a citywide dump populated with worker ants. The little construction-equipment workhorses, the Bobcat skid-steer loader, scooted around like friendly R2D2s busy as a swarm of bees rearranging trash. Almost all houses on all residential streets had a least one smelly scrapped refrigerator—many with wry, witty labels and signs such as "Free 7 month old Gumbo Inside," "Levee Board Victim," "Mr. Stinky"—deposited curbside, along with one-story high mounds of discarded debris nearby obscuring the scared and gutted homes facing the street. Still later, thousands and thousands of abandoned filthy, mud-covered flooded automobiles were lined up for miles in their not-so-temporary storage beneath the elevated highways. Eventually, a structure, four or five stories tall, one block wide, and extending nearly a mile long was created on Pontchartrain Expressway just to accommodate the waste, while a more permanent solution was decided upon. What an awesome, terrifying sight that behemoth was!

Meanwhile, at the museum, we had our own cleanup to tackle. The first few days were committed to sweeping out, by emergency light only, the standing water in the art storage and office area on the ground floor filled with stagnant air. After securing the services of a remediation service from Lafayette to take over and finish the job professionally, Jackie and I turned to the next most immediate need: cleaning out the bank of upright commercial freezers in the Courtyard Café. Without electricity, the stench of hundreds of rotting thawed chickens, eggs, and other foodstuffs stockpiled by chef Mariz Longoria was beginning to fill the art galleries throughout the museum. Of all the things we did at this time, this chore of filling dozens and dozens of large black garbage bags with putrid, decaying flesh ranks high on my list of "I never want to do that again!" During a break one afternoon during this laborious ordeal, we were sitting on the outdoor courtyard steps when out of nowhere a car pulled up with Charlie Davis and New Orleans–born best-selling author Michael Lewis, who stopped to chat and compare war stories. How they got to City Park from their locations in Uptown New Orleans seemed miraculous.

During this most challenging time, my friend Marcia Vetrouq, editor in chief of the national magazine *Art in America*, was able to get in contact with me and ask if I would write a report in the November 2005 issue on what transpired at NOMA during and after Katrina. In "Letters from New Orleans: Beleagured [*sic*] City," I outlined in detail the elaborate preparations and procedures NOMA normally takes in preparation for any impending storm when it enters the Gulf of Mexico. Then I described what transpired at the museum when "The Big One" hit the city. The magazine wrote a Postscript to my article, direly proclaiming, "In early October, layoffs of city personnel reduced NOMA's staff of 100 to 17."[1]

AXA, the museum's insurance agency, had policies with some of the city's other prominent art businesses (M. S. Rau Antiques), institutions (the Contemporary Arts Center), and collectors. At the request of AXA, Jackie and I toured the city as best we could to inspect in person the status of their buildings and homes along with those of a few of NOMA's trustees—Françoise Richardson, Sydney and Walda Besthoff, Catherine

and David Edwards, Russell Albright—and our friends—Sharon Litwin, Mary Elise Merriam—and Jackie's relatives.

The most memorable of those investigations was at the Gitters compound on Bamboo Road. Before we could even arrive, Jackie, with her indomitable influence, had the National Guard clear Bamboo Road of many fallen trees—no small feat itself. With cell phone in hand and communicating with Kurt from his Fifth Avenue residence in New York, we were walked through the location of the hidden keys to the main house and to the adjacent Japanese Study Center building. Both had been flooded. The pair of French doors in the living room leading to a garden courtyard had blown open during the storm. Several Japanese scroll paintings had been hanging on the walls from a single nail ended up in the floodwaters on the floor. I reported this to Kurt.

"Which ones are they?" he anxiously asked.

"I don't know. They have become indistinguishable and are literally glued to the slate floor," I responded. Reaching the Study Center, Kurt then gave me the combination to his walk-in *kura*, the Japanese name for vault, where the great majority of his extremely valuable collection of Japanese, mainly Edo period, screen and scroll paintings were stored. Using a flashlight and opening the heavy door, I peered into the dark interior, definitely feeling like a reincarnation of Howard Carter, and reported, "Kurt, everything is dry and safe!" I heard an audible sigh of relief and then "Thank God!"

Later, after Alice and Kurt had returned to New Orleans, I helped him clear out his flooded garage, where another of their sizable collections of contemporary American self-taught art was stored. The destruction was major. One by one, we pulled out paintings and sculptures by well-known artists, accessing the degree of damage of each. We began making several piles, one for total losses in spite of the value, another for salvageable pieces that could be sent to the restorer, and yet a third for the few pieces that were not affected by high water.

During this period of long recovery, I had been in communication with Sabrina and Darryl Montana. Their home in New Orleans East had been badly flooded, and his stored Mardi Gras Indian suits had been ruined except for the few that he had suspended from the ceilings or laid

on their bed, which, curiously, had floated. They desperately needed to find a large open space to lay the salvageable suits to dry out. I contacted my friend Diego Cortez, who kept a spacious second-story loft in the Bywater, and asked if he would be willing to store Darryl's suits on his floors. He readily agreed as he was a big admirer of Darryl and the other Indians. With a pickup truck, Darryl and I found our way through back roads in a most labyrinthine route from the east to the Bywater. Darryl was most appreciative of Diego's cooperation and generosity.

Our lives had changed overnight. For instance, my successful efforts to keep my weight down were thrown out the window as food sources were limited. Calorie-laden fast food, such as chips, pretzels, candy bars, Hostess cupcakes, and soft drinks were readily available and satisfied those of us on the run as comfort food. Those legendary MRE's (meals ready to eat) were supplied to us by the National Guard at the museum and were certainly a novelty at first.

The nuns, Jackie, and I often sat around the kitchen breakfast table around midnight catching up on the events of the day. One night, one of the nuns mentioned that the Lamar-Dixon Expo Center on the outskirts of town was taking in evacuees. That name immediately rang a bell for me. It is one of the facilities where the Humane Society had set a temporary headquarters in the area after the storm to assist with lost animals. While still in Houston, I recognized them online as one of the agencies assisting in that effort. (For my accounts of what happened to Marie, read addendum 2. That email went viral on the internet; for months, strangers I would meet would exclaim, "Oh, you are the one who found Marie!")

Saving the day for me was my stay with my old friend Nadine Russell in her splendid and spacious house in the gated Country Club Estates in Baton Rouge. Nadine graciously took Marie and me in, along with several other evacuees, after the nuns would not allow Marie to stay at the convent with me after I had found her at the Lamar-Dixon Expo Center in Gonzales. Nadine suddenly was operating a B&B for a posse of "refugees." However, she offered more than a lavish self-serve breakfast. For the upcoming week, she would create a daily dinner menu with several optional choices as preferences that we would check off. The

items getting the most votes would become the menu for that day. If one anticipated they would not be returning in time for the appointed dinner hour, that was checked off too. In essence, Nadine became the chef of a small restaurant in her own house. She took on this task with gusto and delight. And the meals were wonderful and nourishing. Exhausted and returning each evening from an arduous and stress-filled day in the disaster zone to the comfort of Bistro Nadine was certainly one of the few positive and enjoyable moments of my entire Katrina experience.

I have a couple of concluding notes about fulfilling dietary needs during that period. With more and more residents and out-of-town volunteers coming into the city to put Humpty Dumpty back together again, most restaurants and grocery stores were out of business. To feed these workers, many New Orleans chefs—some of the famous and revered—set up free "soup kitchens" on the streets. Weeks later, a few of the fine restaurants emerged like a phoenix rising out of debris, but with a slight difference. Among the first to reopen were Cuvée and Bacco, two restaurants that presented an abbreviated menu, with offerings served on paper plates, wine in Styrofoam cups, and paper napkins. It was good to be dining again in the Not-So-Big, Not-So-Easy.

Another benefit of this tragedy, was meeting and getting to know artist Paul Chan. He called me on the recommendation of Jacqueline Humphries, saying he was coming to New Orleans to be the artistic director of Samuel Becket's masterpiece *Waiting for Godot* presented by Creative Time and produced by the Classical Theatre of Harlem, both based in New York. New Orleanian actor Wendell Pierce was cast as Vladimir. President and Creative Time artistic director Anne Pasternak wrote in the program brochure, "More than a play, the project has evolved into a collaboration between local residents, artists and community leaders on the subject of waiting. Set in an intersection of the Lower Ninth Ward and a front yard in Gentilly, this production allows Becket's play to contextualize the unfolding story of New Orleans as a controversial and renewing city."[2]

Dan Cameron and I saw the performance at the Lower Ninth Ward location and were deeply moved by the devastating, desolate setting, the darkness, and the silence except for the voices of the actors. This eerie

location was appropriate for the opening stage directions as Becket out-
lined them, "A Country Road, A Tree, Evening," which constituted the
only words on the black-and-white signs Paul had tacked to telephone
poles throughout the destroyed city.

New York art critic Holland Cotter came to see Paul's poignant pro-
duction and got in touch with me as he wanted to visit Sister Gertrude
Morgan's destroyed house in the Lower Ninth. When he arrived there,
he insisted upon entering the Prayer Room of the heavily damaged Ever-
lasting Gospel Mission. He was truly moved by the experience.

One year after Katrina, through the kind efforts of Françoise Rich-
ardson and Arnaud d'Hauterives, the Secrétaire perpétuel de l'Académie
des Beaux-Arts in Paris, the French government awarded Jackie Sullivan
and me the Chevalier dans l'ordre des Arts et Lettres at a special cere-
mony at the French Consulate on Prytania Street in the Garden District.

Episode 18

The Conception and Birth of Prospect.1

Four months after the federal levees failed and the floods subsided, leaving the city in shambles, on Friday evening, January 27, 2006, Arthur Roger put together a panel at his gallery on Julia Street to assess Katrina's effect on the New Orleans art world. The blue-ribbon panel consisted of Richard Powell, art historian and chairman of the art department at Duke University; Douglas Brinkley, presidential historian and professor at the University of New Orleans; and Dan Cameron, art historian and curator at the New Museum of Contemporary Art in New York. How do you go about repairing the damage to our livelihood? Where do we go from here? Let's count our blessings and begin to rebuild. For a standing-room-only crowd, the panel's thoughts and ideas were encouraging and enlightening. However, during the discussions, Doug suggested that by rebuilding the city, tourists then would return to help revive the art community. This did not sit well with Dan. He thought Doug had gotten it backwards. It was the art community that could help bring back the tourists and revive the local economy. Dan said, "I took issue with something Doug Brinkley said—that the recovery of the art world depends on the vitality of the tourist economy, that tourists buy art. I was thinking out loud, but I said, 'Tourists don't buy art, collectors buy art. If you want to help the art community, bring in collectors' I said, 'You could have a big international art show and bring them here.'"[1]

Following the panel discussion, the panelists, Arthur, and several others had dinner at nearby Rio Mar Restaurant and the dialogue continued, particularly on the issue of tourist- and art-sales recovery. The

following morning, my two house guests, Dan and New York artist Aris Logothetis, and I continued the conversation at a prolonged breakfast in the courtyard of my house. The three of us continued our talks later that day at lunch at Crabby Jack's out on Jefferson Highway. Dan just thought the art community could become the catalyst. From his past experience as the guest artistic director of two international art biennials, Poetic Justice in Istanbul in 2003 and Dirty Yoga in Taipei in 2006, he knew the art community worldwide would turn out to see a serious survey of contemporary art wherever it was. The potential for the host city's economy being substantially augmented was enormous. Of the many countries around the world hosting biennials, there was none being undertaken in the United States.[2] Why not change that and have one in New Orleans?

Dan's participation as the guest curator for the 1995 New Orleans Triennial helped crystalize this idea of a biennial. For him, this series, begun by the Artists' Association of New Orleans in 1887 as an annual and taken over by the Delgado Museum after its opening in 1911, served as an early model for his concept. Over the years, it had had a local, regional, national, and international focus, and Dan knew the nearly 120-year-old series had come to an end at NOMA in 2005. He felt that a new biennial could be considered the next iteration of this long tradition in the city, hosting the longest continuing, contemporary art exhibition series in the United States. When its reach was international, Claude Monet had entered the competition in 1905 and 1909 but failed to win a prize! A member of the 1909 jury, William Woodward, who was art professor at the Newcomb Art Gallery at the corner of Sixth and Camp Streets where the exhibition was on display, awarded himself the silver medal, while another local artist, Alexander J. Drysdale, received the cherished gold medal.

For the few days that my houseguests remained in New Orleans, we shared this cockamamie idea with Arthur Roger. Of course, a thousand questions were addressed all at once. We even took a tour of potential location sites, including the derelict building on the riverfront in the Bywater owned by Sean Cummings that would subsequently be restored into the present-day Rice Mill condominiums.

Dan had been visiting New Orleans on a regular basis, particularly going to Jazz Fest every year, since the early 1980s. He knew the city and loved it. Now it was essential he got to know other aspects of our town's makeup, particularly financial. From his first utterance of a biennial, my question was, "Where are you going to get the money?" This undertaking was going to be costly, and no one denied it.

It was time for me to offer Dan some personal advice on the city, and I suggested numerous local people who I thought would be sympathetic to an international contemporary biennial in the city and could be effective board members. He declared, "A board? Yeah, I guess you're right. I will need one. Would you be on my board?"

"Sure, if you think I could do it. Count me in." However, when it came time to choose artists to participate in this venture, I never interjected myself into Dan's selection process. He rarely, if ever, solicited my advice or comment concerning artists.

One issue that Dan and I disagreed about was whether the exhibitions should be every two or three years. I argued that a triennial format would be better for several reasons. First, it gave us an extra year to raise large amounts of money to stage these huge undertakings and allow the board more time to get that job done. Second, I strongly felt, having organized a number of periodic series of contemporary art exhibitions at NOMA, to have an exhibition every three years would make each of those presentations more eagerly anticipated. I feel the same principle holds true for the Whitney Biennial in New York today—they occur too frequently, and within a two-year period, contemporary art does not significantly change, whereas over a three-year period, each iteration of the series becomes more of a statement about the current condition of art. Dan did not agree and insisted on a two-year format.[3]

Having lived here for more than four decades, I felt I had some insight on the city. One of the first personal observations I shared with Dan was that Mardi Gras was not a 1-day event; it was a 365-day event. In other words, this city's existence revolved around Carnival socially, economically, culturally, and spiritually all year. Also, this city could not be the wonderful place that it is without the significant contributions and existence of a major African American population. Their cultural

influence on the city's unique character was indelible whether it was food, music, architecture, or simply lifestyle. Third, the city was contradictory in that while being conservative and uptight, it is at the same time liberal and permissive, which again I attribute to Mardi Gras.

Dan would set up a 501c (3) nonprofit organization called US Biennial, Inc., and reached out to New Orleanians and New Yorkers explaining his concept and asking if they would be interested in serving on a board. His friend in New York, Toby Devan Lewis, was the angel he needed to pledge a substantial amount of money to launch his dream, not only for the first of the series but an equal amount for each of four succeeding iterations in the future. In a short time, he had remarkable success in assembling a blue-ribbon board.

On November 1, 2008, Prospect.1, the first in a proposed series of New Orleans biennials, was launched with great fanfare throughout the beleaguered city, and as Dan predicted, the art world flocked to the city to see what he had put together. In his acknowledgments in the catalog, Dan wrote,

> The people who have been part of *Prospect.1 New Orleans* since the beginning deserve very special acknowledgment, as they have offered the longest span of constructive advice and suggestions, and frequently have made it possible for me to figure out how to accomplish things with the least delay possible. The first was Arthur Roger, who called me in the early days of September 2005, while still displaced in Baton Rouge, to ask if I wanted to be a part of a dialogue about the cultural rebuilding of the city. That call and the subsequent invitation to be a part of a panel discussion at his gallery in January 2006, were the stimuli for everything that followed. By the time I knew that I wanted to develop a biennial for New Orleans, Bill Fagaly was the person whose counsel I most relied on, and his judgment has been an enormous help at every step of the way.[4]

Episode 19

The Power of Music in My Life

Music is and has been an integral part of my life. Looking back, I now realize its many manifestations have had, over my formative years, a profound influence on me, and it has continued to be a strong part of who I am throughout my adult years. My grade-school music teacher, Robert Marple, introduced his young students to classical music by playing records in class and teaching us how to listen and appreciate. Among my earliest memories was Richard Strauss's tone poem *Till Eulenspiegel's Merry Pranks* and Paul Dukas's *The Sorcerer's Apprentice* hearing the disobedient apprentice frantically call out when the water was quickly rising around him, "Mass-terr, Mass-terr, Come an' help me! Come an' help me!"

This new world of music had opened up new vistas for me. While I was still in grade school, my parents took me to Music Hall in Cincinnati for an historic performance of Hollywood star pianist Oscar Levant soloing with the legendary conductor Paul Whiteman and the Cincinnati Symphony, playing George Gershwin's immortal *Concerto in F*. In spite of Levant's widely known erratic temper, my parents took me backstage to meet this ornery curmudgeon in his dressing room. Everyone backstage had warned my parents that he would not see me. However, they were all astonished that he not only agreed to meet me but was also very kind, and he even autographed my program, something that he was famous for never doing!

While I was still in grade school, my parents also encouraged me to take piano lessons, first from Mr. Marple, and later from my sister's friend Charles Green. I got through all the interminable Czerny exercises and graduated to playing real pieces. Also, my parents encour-

aged me to learn another instrument, the saxophone. They associated it with being "modern." Starting in the lower grades and continuing through high school, this instrument led me through a variety of usual experiences that shaped my youth, which included performing in the championship state marching high school band and winning first place in the state solo saxophone contest for several years running. While I practiced very hard, I was petrified to perform in front of an audience, let alone a music judge.

However, one musical experience was not so commonplace. In the early 1950s, I played lead saxophone in a high school dance orchestra the Hi-Liters. We played a lot of Glenn Miller arrangements, including "In the Mood" and got a lot of gigs not only in Lawrenceburg but also in the neighboring towns of Rising Sun, Sunman, and Dillsboro. We were hot!

Our dance band's mentor was Art Baldwin, the local high school band instructor, formerly a member of Charlie Spivak's Big Band. On Friday and Saturday nights, Mr. Baldwin played in a popular honky-tonk nightclub, Riverview, on the edge of the Little Miami River on a country road in rural southern Ohio outside Cincinnati. It was a rowdy place, and drunken fights would break out almost nightly. To keep things civil, these altercations were not allowed inside the club, only in the parking lot. There it was permitted. Art would sometimes invite members of our high school orchestra to sit in with his roadhouse orchestra until the wee hours of the morning. What a thrill that was! My fellow students and I felt like we were pretty hot stuff playing music and drinking beer in this notorious dive. I still marvel that my parents allowed me to participate in such a questionable activity at such a young age. I'm sure they worried a lot, but they never openly showed their concern. I believe it's because they wanted to demonstrate to me that they had enough confidence in me to do the right thing, which, in turn, put me on notice to *do* the right thing.

We members of the Hi-Liters were so committed to our orchestra that Art decided we needed to make up our own arrangements. He offered classes for us to learn music theory and music composition. This was in a small-town high school in rural Indiana. Each one of us would make our own original arrangements of standard tunes, writing

out the parts for each instrument. We then would distribute our newly created sheet music to hear how our own arrangements sounded when performed. It was challenging, and my most successful arrangement was for "I've Got Rhythm."

I firmly believe one of the greatest blessings of my life was experiencing the birth of rock 'n' roll as a teenager and growing up during the era of this new American-based music. This was a major music revolution, and I was experiencing each new development as it occurred. To my mind, it all began with the soundtrack music from the 1955 movie *Blackboard Jungle* with Bill Haley and the Comets' "Shake, Rattle, and Roll" and "Rock around the Clock," which would change American music forever. I was there in 1956 when Elvis Presley burst upon the scene with multiple hits ("Heartbreak Hotel," "Hound Dog," "Don't Be Cruel," "Tutti Frutti," "Blue Suede Shoes," "Love Me Tender") followed in 1964 by the explosion onto the scene of the Beatles and the Rolling Stones. One night in 1979 when I heard the complete just-released solo album of Michael Jackson, *Off the Wall* on the radio, I knew, at that very moment, I was experiencing another musical revolution and that he was destined to become a major star. It was just that phenomenal.

My music appreciation was not just limited to rock 'n' roll. Indiana University has one of the most respected music schools in the country if not the best. For several years, I was a member of the highly acclaimed Singing Hoosiers.

Every Saturday night, the school presented a full-scale opera, and I took full advantage of it. In addition, each year on Palm Sunday, the music school would mount an annual lavish production of Wagner's *Parsifal*, performing the first act in the afternoon before a dinner break to return for concluding acts in the evening. For a couple of summers, the school took over IU's football stadium and mounted lavish productions on a stage positioned in front of the horseshoe curve of the seating area. Across this vast stage, they performed a spectacular *Aida* one year and *Turandot* the next.

In those days, at the conclusion of their season in New York, the Metropolitan Opera Company would take a couple of their productions on the road to a limited number of cities in the United States. Among

their stops was Bloomington, certainly not a major city. General manager Rudolf Bing brought his company to IU for performances because of the music school. One of the highlights of their stay was their annual presentation *After Opera Antics* performed by the lead singers, such as Elizabeth Schwartzkoff, Richard Tucker, and Eleanor Steber, in the dining hall of the Men's Quadrangle dormitories. Always funny and often off color, these late-night musical skits were enormous fun for all.

Among the most memorable performances was hearing Rise Stevens compete with the roaring lions during her appearances as the lead in *Carmen* at the Cincinnati Zoo. I was fortunate to see a bountiful *Aida* at the Bath of Caracalla in Rome, a sublime *Der Rosenkavalier* at the Vienna Opera House, a perfect *Eugene Onegin* at the Bolshoi in Moscow, *Die Zauberflöte* at La Scala in Milan, and a tempestuous Birgit Nielsen as *Salomé* at the old Met. Other thrilling moments were the world premiere of Philip Glass's *Einstein on the Beach* at the Met and American debut of his *Akhnaten* at the Houston Grand Opera.

Then there are those unexpected, unique moments. On the evening of March 25, 1964, there was advance buzz that a young unknown singer was about to become a new star in a new musical at the Winter Garden Theatre in New York. Obtaining the last available seat, in a box, for the last preview before opening night, I saw then twenty-two-year old Barbra Streisand perform *Funny Girl*. The rest is history.

The Warehouse in New Orleans is legendary. It was our city's equivalent to Filmore East and West. It is gone now, and so are Bill Johnston, who was the force behind its origination and its wildly successful operation. (Bill was briefly married to Dawn DeDeaux before they amicably went their separate ways.) While in its heyday I had the privilege of attending, often with my Osage Native American buddy and neighbor Pierre Blaine, many memorable nights in that stiflingly hot, unairconditioned, fully carpeted (used), abandoned brick depot along the river on Tchoupitoulas to hear many of the iconic performers of the day: Chicago, Sly and the Family Stone, the Allman Brothers, Leon Russell, Emerson Lake and Palmer, Pink Floyd (twice), Procol Harem, J. Geils Band, and Fleetwood Mac.

Another extremely popular music club opening in the late 70s upriver on Tchoupitoulas was the now legendary Tipitina's (affectionately referred to as "Tip's"), which I frequented often with friends. Named after a standard tune of Professor Longhair, this large club with a capacity of one thousand partiers was the last base for that legendary piano musician. Here on any weekend night music lovers crowded into the smokey, sweaty club to hear and dance to local favorites such as the Neville Brothers, Dr. John, Radiators, Wild Tchoupitoulas, Galactic, or Cowboy Mouth or national groups such as Nine Inch Nails, Patti Smith, Phish, or Willie Nelson.

Episode 20

Closing Thoughts

My story would be lacking if I didn't mention other friends whom I dearly love and respect and who have made my life richer and more complete. How can I not recognize the last ten years of working with Susan Brennan and Chris Alfieri to make Dan Cameron's dream for Prospect become a lasting reality? Or my totally unexpected wonderful close familial bond with Miranda Lash and Russell Lord, both fellow curators at NOMA? Or my introduction of my former college girlfriend Charlcye Smith Hawk to her future husband and my friend Jim Hawk, who was born on the same day, same month, and same year as me? I cherish them all.

It has been some time since my first venture harvesting and selling nightcrawlers. I have moved on and have been truly blessed with a full, rich life. As it approaches its conclusion, I can look back and ponder the achievements that give me the most satisfaction. Perhaps the accomplishment that provides the greatest fulfillment is to have brought an awareness of traditional sub-Saharan African art to a city whose majority population is African American and to have been instrumental in building a quality permanent collection for the New Orleans Museum of Art. It pleases me that I have made a contribution to the understanding and knowledge in the field of twentieth-century American self-taught art, particularly recognizing and adding to the dialogue the unique talents of Louisianans David Butler, Roy Ferdinand, Sister Gertrude Morgan, Charles Hutson, "Tootie" Montana, and Pierre Joseph Landry. Also important to me were my efforts to promote and support contemporary art in general in New Orleans through my keeping alive the continuation of the oldest continuing contemporary art survey at an American

institution and as a cofounder of both the Contemporary Arts Center and Prospect New Orleans and most recently ARCAthens.

Another fact that gives me enormous pride is having curated three art exhibitions with publications in three different fields—contemporary, self-taught, African—in New York three consecutive years. They are *Aristides Logothetis* at the Cue Art Foundation (2003); *Tools of Her Ministry: The Art of Sister Gertrude Morgan* at the American Folk Art Museum (2004); and *Resonances from the Past: African Sculpture from the New Orleans Museum of Art* presented at the Museum for African Art (2005).

In closing, one thing I'm known for is my distinctive laugh. People often say to me, "Oh the other night at that party, I didn't see you, but I knew you were there. I heard your laugh." You know, if I'm going to be known for something, I'm glad mine is a laugh!

LAGNIAPPE

Addendum 1

In Africa: A Personal Journal from Dakar to Bamenda

Local Guides

When anyone arrives in any new town or village, an unknown young man immediately "acquires" that person to act as guide, confidant, friend, and protector all during the stay. I realize early on there is no choice in the matter. So I realize just to accept this graciously and put myself willingly in his trusting care. I come to accept that this unknown young man will know what is best for me and will go to great lengths to accommodate my needs. It is a curious relationship. On the one hand, I realize that "he sees me cornin'" and that my trust at first must be measured. On the other hand, these guides are, by and large, good people who are genuinely interested in foreigners, particularly Americans whom they rarely see. They are proud and eager to show us their community. Since they want the work, and I desperately need the service they can provide, it's an arrangement that usually works out just fine.

For example, in Ziguinchor, Senegal Goddard "found" me even before I had a chance to get off the bus. He had "taken over" without my even being aware of it. Goddard helped me find a hotel when all were full; took me to the local favorite restaurants; bought stamps for me at the post office; showed me the market, the docks, the fruit and animal farm in the country; arranged reservations for me in a bush taxi driving straight through to Dakar (quite an achievement); and had the driver

pick me up at my hotel instead of the hassle of having to go to the "bus station." All these hidden amenities that Goddard was able to provide were most gratefully received.

At the conclusion of my two months of travels throughout West Africa, I still have fond memories of all the new young friends who made my visits such a success and so personally rewarding.

February 19, 1987

Traveling by Bush Taxi

How do I describe traveling by that best-established institution in all of Africa—the *taxi-brousse* or bush taxi? It's an experience that is difficult to put into words in order to convey adequately all the color, drama, excitement, fear, anxiety, fatigue, boredom, anger, confusion, exhilaration, humor, and discomfort that always accompany such a journey. The trip described here is from Dakar to Ziguinchor in Senegal traversing the Gambia, a long, narrow country penetrating into Senegal along the wide Gambia River.

To get to the taxi-brousse, you first must take a local city taxi to the "bus station," an endless parking lot filled with busses of all shapes and sizes. There are always throngs of people milling about—some shouting, others sleeping, unconscious of the music blaring on the ever-present radios. Everywhere, there are vendors selling anything you might need, might want. There are sunglasses, watches, flashlights, apples, oranges, bananas, knives, cigarettes, sugar, nuts, colored water in clear plastic bags knotted at one end, cookies, breads, crackers, soft drinks, and more, and more. There is always much confusion and always strong odors—smoke and urine, grilled shish kabob meats and urine, gasoline fumes and urine, and all mixed with the acrid smell of carbon monoxide. The buses, small vans, and taxis are marked with signs beside them to show their destinations in Senegal. They are exotic names—M'Bour and Tivaouane, Thies, Diourkel, Foundiougre, St. Louis.

Upon getting out of the city taxi, swarms of young men cluster about to grab your bags, running off with them to the bus of your stated destination. At the bus, negotiations are begun with the driver or his agent, while myriad vendors sell their wares, grabbing at you, pulling your sleeve, making you aware of their specialty and its cheap, good price. After settling with the agent on an agreed tariff—one for you and one for your baggage—the bags are either squeezed and shoved into the back end of the bus or thrown on top with piles of other satchels, gunny sacks of produce, stacks of brightly colored plastic dishpans and buckets, furniture, duffel bags, bags of plastic toy soccer balls. After taking a seat (you're lucky if you get one with a cushioned seat and metal back because otherwise it's a small hard wooden bench placed in the aisles between the regular seats) you get the distinct feeling you're a sardine wedged tightly into a can. Not to be deterred, the vendors persist, tapping on the windows, reaching into the bus, waving their wares under your nose.

Finally, after enough people have showed up to fill—and I mean fill—the vehicle, all deals are concluded. All cargo is securely strapped down under the roped netting, and the voyage begins. Each person "finds his or her space," limited as it is, and settles in for the long, monotonous ride, bumpy and dusty and hot. Also begins "the entertainment": a loud radio blaring from the rear speakers. This is not pleasant African music, but men shouting incessantly in their local tongues. There is no relief. You may try to ignore it, you may try to tune it out of your consciousness, but nothing works. The shouting continues.

After a couple of hours, numbness takes over and you try to nod off. But just when you're succeeding, the bus brakes abruptly to avoid an errant goat or cow which has strayed onto the road. Then when it seems the journey has resumed smoothly and at full speed, it's time to stop at one of the many small villages to reshuffle things again. Passengers get off. Passengers get on. Ditto the cargo on top of the bus. Things are handed up. They are handed down. Of course, the moment we arrive, the omnipresent vendors with their selection of wares descend upon the bus and surround it like a swarm of locusts, each vying for our attention

and money. Old Muslim men hold out their hands, asking for alms for the poor. It is expected that everyone give something, sometime.

While riding along the road, to pass the time and ease the boredom of endless sitting, we watch the passing show, the scenery. The landscape varies from desolate fields of scrub brush and tall baobab trees with their colossal, gnarled trunks and disproportionately short, thin branches to lush forests of very tall palms, mango trees, and vines. Occasionally, we pass a single farm or a cluster of houses, mostly mud brick or cinderblock with circular, conical thatched roofs, often with vines and calabashes on them, or the ubiquitous corrugated tin. The buildings have fenced-in yards without a single living thing growing in it. Fences come in a variety of styles and materials: woven canning, corrugated tin, roughhewn flat wooden planks, round poles. Goats, chickens, pigs, donkeys, and cows populate the farmyard in various combinations.

Clearly standing out from this predominantly brown and tan environment are the very brightly colored and patterned cloths of the "boubous" that women wear with a flair, those ground length wrap-around skirts with loose shawl tops and accompanying matching chignon wraps on the head. People sit alone or in small clusters on the ground. Some have set up fruit stands along the road. At midday, they disappear, and the farms and villages take on the character of ghost towns. It is the siesta and easy to understand why—*IT IS HOT!*

As we approach the Gambia frontier, the bus stops at several security checkpoints. Passports and identity cards are shown, and tickets for the ferry are issued, at extra cost, of course. We then proceed to travel on the road until we get to "The Line." Oh, the line—cars, trucks, donkey carts, buses, vans waiting endlessly to get on the ferry. Everyone evacuates the bus to sit and wait, sit and wait, eat that orange I bought back at the station, buy a cold drink, purchase whatever there is in the numerous shanty stalls that line the road on both sides. The midday sun beats down. There is no escape.

Fortunately, buses and cars are allowed to bump the line in front of the large trucks. After hours of waiting in the heat (sometimes I am told the wait is so long it is necessary to spend the night at river's edge), our bus is allowed, finally, to get on the ferry. Observing the process,

there is, it seems, an established ratio of small and large vehicles to balance things out for safety's sake. With just inches to spare, the ferry is loaded to overcapacity, while the ferrymen shout and gesture directions to the drivers. The huge, heavy trucks, mostly loaded with sacks of millet and peanuts piled high and deep, make the ferry tip and groan frighteningly when they drive on. With the small engine chugging away and belching clouds of dense black smoke, the ferry slowly departs with its overloaded cargo and passengers (including confused baying goats) reminding me of images from *The African Queen*.

The ride across the wide river takes about twenty minutes. As soon as the steel ramp noisily bangs onto the poured concrete slab of the shore, a sea of humanity hurries off and runs up the ramp and crowded road. I walk off with the others, watching carefully for our bus to disembark and drive away. I don't want to be left behind. When the bus has an opportunity to stop, everyone is allowed to pile on once again to continue our journey overland.

February 23, 1987

And Then There Is Michel

Out-of-the-way places and remote parts of the world seem to attract a curious assortment of foreign personages. (Should I include myself in this group of extraordinaires, I wonder, or am I among those "normal people" unlike the rest?) They include what seem to be general misfits, hippies, beatniks, druggies, ne'er-do-wells, shady characters, adventurers, and Frenchmen. In the main, they are a scruffy lot, some even repulsive and disgusting. Wearing dirty T-shirts, or faded patterned shirts, worn old swimming trunks and flip-flops or leather sandals, they travel in packs, haunting the cheap local bars where, I suspect, they gather to lounge around and compare stories of their travels and complain about the European and American establishment governments.

But then there is Michel. There can't be many Michels in this world—in fact, there probably aren't any other. He is unique, definitely not one of those nine-to-five coat-and-tie workers with attaché cases.

I first notice Michel when I am checking into the Grand Hotel in Bamako. He is all over the place—talking to the receptionist, chatting with the lobby art dealers, consulting with the taxi drivers. He is a good-looking, affable Frenchman (from Grenoble, I learned later) with wavy, jet-black hair combed back, deep dark tan, small wiry body, yellow-patterned shirt, and blue jeans. He appears high strung, with a high metabolism.

Animated and never still, he speaks with dramatic gestures and facial expressions as if he were participating in a game of charades. Varoom! Varoom! Later, when I meet him (he knows everybody around the hotel), his story is revealed. He buys, ten to twelve at a time, large eighteen-wheeler trucks in France and he and his crew drive them in a convoy over the Sahara Desert through Algeria to Mali, where he sells them for three to four times the price he paid. Needless to say, he's a little bit crazy. Still, he says, he makes good money at this "business." He should. Who else would try something so outrageous? He claims this is by far the most inexpensive way of getting the trucks to inland West Africa. The exorbitant taxes and fees for shipping them by sea to Dakar or Abidjan make that method highly impractical economically. Michel's way is not cheap either because much money is lost passing through Algeria. Their currency is worthless, and one is required to change large amounts when entering the country. The Algerians also insist upon the purchase of their insurance (which is also worthless) even though one already has enough. Still, he says, Algeria is the way to go.

Starting out in France, the trucks are driven to Genoa, Italy, where they are shipped to Tunis. Crossing the desert takes three weeks. Michel's stories about these trips are exotic and colorful. He tells me of trucks getting stuck in the shifting sands and having to take days to dig them out. However, he leads his convoy over the firmer, compacted sand, which is identifiable by its color. Sometimes the sand storms become so fierce, he says, one cannot see anything, and it is necessary to wrap the body and head completely for protection. The storms ruin the motors and the paint on the trucks. Once, Michel says, one of his crew prepared a lamb dish for a meal, and it tasted terrible. It turned out he didn't have any cooking oil. So he had used motor oil instead.

Perhaps Michel's best story was the one about a group of punks with red and blue mohawk haircuts. It seems they just appeared in the desert one day, racing their way across in regular automobiles. Michel told them they would never make it, but they wouldn't listen to him and sped off. Later, he says, he came across one of the cars overturned. After helping the driver and passengers right it, they continued. Eventually, one by one, all their cars were overturned, and their "joy ride" was over. And so is this little story.

February 25, 1987

A Memorable Trek into Dogon Country

I arrive in Bamako with the intention of making arrangements for a trip to Segou in the Bamana country, the ancient city of Djenné (where the archaeological terracottas are being discovered), Mopti and Sangha in the Dogon country. But it is Saturday, and everything is closed until Monday, so it's time to cool my heels and wait. In the meantime, I explore the city, visit the market and the art museum. I plan my strategy: it will be best to fly to Timbuktu and then to Mopti. working my way down to Bamako by bush taxi.

On Monday morning, I pay a call on my friend Claude Ardouin, the director of the Musée Nationale du Mali. He writes a letter of introduction for me to the travel organization, Dogon Voyages, and asks the museum driver to take me there. At their office, I meet Madame Montadre, who informs me there are no Air Mali flights to Mopti and Timbuktu (now I understand why it's called Air Maybe). She says it is because this is the end of the tourist season as it is the beginning of the hot season (I have no trouble understanding *that*) and that there aren't enough people to make the trip. So much for my well-laid plans made over the weekend!

Madame Montadre tells me the only way to go now is with one of her four-wheel-drive vehicles and driver. Her trips are normally for six people, so if I am the only one to go, it is going to cost me a bundle, and

I know it. On the other hand, here I am. I came all this way, and I know this is going to be the highlight of the trip. So what am I going to say—No? No, I will do it. Just then Madame Montadre receives a telephone call informing her that two French girls want to do the same itinerary. Would I accept them? Of course! It will cut the costs by two-thirds. I feel I have arranged as good a deal as possible under the circumstances, and the next morning I will go to visit the Dogon, the people who make some of the most extraordinary sculpture in Africa while living in an exceedingly remote place in the world.

The next day, I discover the two girls will not join me, but I decide to go anyway. The driver picks me up at the hotel. His name is Mohammed Coulibaly, but he is called Coulou. There's a lot of the laid-back New Orleanian in him with his relaxed, cool, and confident manner. Nothing, I suspect, could ruffle his feathers. No question, Coulou is cool.

On the outskirts of Bamako, we buy, for ninety dollars, our first fill-up of gasoline in our Toyota Land Cruiser as well as in the auxiliary tanks on the roof, and then we are off at midmorning. Coulou puts Ivoirian reggae musician Alpha Blondy's latest album *Apartheid Is Nazism*, currently the rage throughout Africa, on the truck's tape deck, and the warm country breeze feels good as we cruise along. Coulou is cool.

The landscape is desolate, but the roads are good. Occasionally, we pass through small Bamana towns and villages consisting mainly of modest adobe buildings. After lunch in Segou at the L' Auberge, we stop in the late afternoon in the town of San to see the beautiful walled-in mud mosque. The many tall conical minarets terminating with rounded tops have wooden sticks and poles projecting out from them, giving the effect of thorns on a cactus. These wooden stakes are not structural but are used as a kind of scaffolding for the workers to stand on and use as ladders when repairing the surface, which must be done annually after every rainy season. The tallest minarets are adorned with one or two cream-colored ostrich eggs pierced with rods pointing skyward. They are reminiscent of lightning rods. The eggs purportedly bring good luck.

It's time to leave, and we drive on as dusk approaches. The African sunset with its fiery red-orange ball suspended in the steel-blue-gray sky over the sparse scrub of brick red, mauve, dark rose and ochre is a

marvel. The colors and light change each minute, a tranquil, serene feast for the eye. Then, as darkness descends on the land, millions of stars come out in the panoramic sky.

When I arrive in Mopti, there is no room at the hotel. After hanging around for an hour, the manager releases a room of a "no show." Tired, hot, dirty, and hungry, I quickly take care of all my immediate needs and fall into bed.

The Relais Kanaga Hotel has a distinct feeling of the architecture and atmosphere of Santa Fe, New Mexico, a modern translation of the old adobe buildings with informal contemporary furnishings. In fact, if all the Dogon and Bamana masks and figures that decorate the walls were removed, you would be hard put to know you were in Mopti, Mali, and not in the desert Southwest. This reaction is again reinforced upon seeing the large painting of a Dogon Kanaga dancer in the dining room. How similar the mask and costume are to those of the Hopi!

The next morning is surprisingly cool as I meet my guide for the day, Ibrahima Tapo. First, we go for an all-morning trip by pirogue on the Niger River to the Bozo fishing village Cacolodaga and the Tuareg-Mela nomadic fishing village Daga. The pirogues are constructed of long, flat planks of wood, imported from the Côte d'lvoire. They are painted black and are elegant with their pencil-slim silhouette low in the water, each end terminating in slender points. On the sides in the front and back are geometric paintings of signs, checkerboards, and numerals in predominately red, black, white, yellow, and blue, highly reminiscent of the paintings of American artist Alfred Jensen. With the comfort of rattan woven mats on the floor, I sit on a simple board seat as Ibrahima poles the boat while standing up at the rear. When the water becomes too deep for the pole to reach bottom, he paddles. For various reasons, Mopti has been referred to as "the Venice of Africa." While acknowledging the obvious analogies between these two unique cities, I find the comparison inappropriate and unfair to both. Venice is Venice, and Africa is Africa.

Cacolodaga is an adobe community with narrow, winding streets and little open squares where workers clean and smoke the fish, women pound the millet in large wooden mortar and pestles, and men weave long strips of cloth. Centrally located is the mud mosque on a small cliff

overlooking the Bani River. During the season of annual flooding, the slightly elevated village ground is completely surrounded by water. At water's edge, clusters of men slowly pull in the two ends of a gigantic fish net that reaches far out into the wide river. It's a procedure that is repeated twice a day.

The morning quickly heats up, and by the time we reach Daga, the sun is pounding down unrelentingly. Daga is only a temporary seasonal settlement with all the buildings made of straw. When the annual floods come, this whole area will be under water.

The next morning, Coulou and I leave early to drive to Sangha to spend the day visiting the Dogon. It is a three-hour drive, with the road degenerating and becoming more difficult the further we go. The landscape becomes more rocky, arid, and barren but dramatically changes temporarily as we approach a small stream, its banks lined with emerald-green onion fields and some patches of tobacco. When we reach Sangha, I am told that the guided hikes are over for the day. It is too hot. After taking stock of the situation, I decide to stay overnight at the very basic (a simple cot with mosquito netting—for the flies, as there are no mosquitoes in Sangha—it's too dry) Campement de Sangha and take the four-hour hike beginning at six in the morning.

Even though it is midday, and all sensible people are taking their siesta, I cannot resist going out and wandering about, exploring the two nearby villages, Ogol-Leye and Ogol-Da. Two young boys approach in the usual pestering manner. I tell them I don't want to buy anything from them, and I don't want a guide. They persist, informing me that I cannot enter the villages without a guide because there are sacred altars and shrines that cannot be violated or photographed. Sensing the truth of the situation, I agree, and off we go, first to the small fenced-in fields to admire their healthy crops of onions and tobacco. The boys' names are Anagalou Dolo, who is fourteen years old, and Amatégué No. 2 Dolo, who is twenty-three. He is called No. 2 because he is the second son. When I realize they share the same last name, Dolo, I ask if they are brothers. They claim they are, but I cannot determine whether they mean blood or tribal brothers. Later, I learn that the Africans have no concept of cousins, whom they refer to as brothers.

My younger friend has been studying English in school and wants to know if I would like to see his "copy book" which, of course, I would. He hightails it home and before long is back, proudly displaying his hard work. I indeed am impressed with the sophisticated precision script and the accuracy and thoroughness of his grammar. "I go to the house; you go to the house; he goes to the house." Page after page of perfect English. He hands me a small piece of paper with his prewritten name and address with his school class (as do many other small children during my stay in Sangha) in hopes of finding pen pals from foreign countries.

We enter the villages, winding our way through the narrow walkways between the buildings. We meet chickens, goats, and small children along the way, and we greet the adults in their houses and interior courtyards with a friendly smile and, "Bonjour Madame, Bonjour Monsieur, Ca va?" to which they reply "Ca va" amicably with a nod. Sometimes when Amatégué sees someone he knows, he will say to them in rapid-fire rat-a-tat-tat Dogon, "How's your mother, how's your father, how's your brother, how's your sister?" while they answer him simultaneously with the same inquiries. Just being friendly, he tells me.

We pass the house of one of the most respected men in Sangha, a gentleman ninety years old. He waves and smiles at us, uttering a greeting. What a thrill it is when, in our meanderings through the village, we suddenly come across a small carved granary door with attached lock, or, even more exciting, see a full-sized door on a house with relief-carved rows of ancestor figures, a serpent, a mask, and other typical symbolic decorations.

While standing and looking at the door, it opens slowly, and a woman peeks out with a quizzical look. I explain I am simply admiring the beautiful carving, and she seems to understand. Even the unadorned house doors and courtyard gates made of old weathered and worn flat wooden planks pieced together with forged iron staples have a simple elegance and dignity. Equally graceful and beautiful are the weatherworn Y-shaped timbers with notched grooves along one side, which, when leaning against a building, become excellent ladders and take on a wonderful, abstract, sculptural quality.

Amatégué and Anagalou show me the sacred mud shrines resembling ovenlike structures or tall cylindrical mud columns with rounded

tops, all of which have a liquid white millet sacrifice poured over them, like a whitewash dripping and flowing down the sides. To obtain permission to photograph one of these highly revered places, it is necessary to pay proper homage by giving a present of some coins to the elder in attendance, who is wearing a beautifully polished and finely mottled gray, black, and white tubular granite pendant, the badge that designates him as one of the respected elder statesmen of the community. We pass the house of the hunter with its special marking of small bird skulls, bones, horns, teeth, and other relics and amulets embedded in the mud over the threshold. We see the village blacksmith in his dark compound with his glowing forge and bellows at work and the weaver sitting on the ground at his loom with his legs outstretched in front and his toes manipulating the heddles. The special house in which all women are required to live while menstruating is pointed out to us.

One of the most honored places in the village is the *toguna*, a low structure of either piled up rocks or large Y-shaped carved timbers supporting a thick canopied roof of multilayers of branches and millet stalks crisscrossed one atop another, providing insulation against the heat of the sun. These special open-air buildings are usually adjacent to the wide clearing where communal masked dances are performed, and they are the meeting house for the elder men to gather each day to discuss the affairs of the village, current problems, and philosophical matters. Amatégué explains the logical reason why the structures are so low. Standing up in them is impossible, he says; therefore, fights are prevented, for as anyone knows, no one can physically fight sitting down.

After our tour of the village, Amatégué invites me to his house. Behind its weathered door is a tiny vestibule with carved wooden crooks wedged into the ceiling rafters to ward off thieves. There is an open courtyard with a Dogon ladder and a tin bucket planted with flowers and covered with wire mesh (protection from the nibbling animals). There are two doors, one leading to two small rooms, one after the other, which are Amatégué's living quarters. He never does show me what is behind the second door, and I do not ask. The courtyard door to his house is decorated with photographs of Michael Jackson, whom, he says, he admires a great deal. In the first tiny room are dusters of

pinup photos of movie stars, athletes, musicians, cars, all clipped from magazines and attached to the walls. The second, windowless room is even smaller and lower, only large enough to contain a center post with his wardrobe hung on it and a simple raised bed on short poles and covered with a worn straw mat.

While I sit on the ground with the boys in the courtyard, the sound of the older boy's voice changes dramatically from gentleness to one of stem authority when he frowns and admonishes the little children who cannot resist peeking through the open cracks in the door or over the wall to stare at the foreigner. Both Anagalou and Amatégué are artists, and they offer to make drawings in my journal. Amatéegué shows me his drawings and watercolors of Dogon masks, houses, and sacred shrines. One unusual drawing shows a Dogon Great Mask on a television screen. He explains that he once saw that on television when he was in Bamako. When asked if he had any traditional Dogon carvings, he pulls out a small Walu mask and a door lock from under his bed. After he gives me a drawing, the two boys walk back to the Campement where I am staying to have a cool drink, and say our good-byes for the day. When I tell them I will send them presents of art books, they say they would prefer shoes, eagerly giving me their shoe sizes (in Malian, not American, standards alas) or clothes I did not use anymore.

It's early to bed and up before dawn at five for one of the most extraordinary experiences of my life, a visit to the remote Dogon villages on the inhospitable rocky cliffs of Mali. It is like a walk back into another age, to a tranquil world devoid of modern society.

Meeting my guide, I walk across a barren flat rock plateau as the sun first appears over the horizon throwing long gray shadows on the orange-streaked granite. A distant donkey brays and a rooster crows at a faraway house. The brisk, cool breeze quickly turns warm as the sun rises higher in the sky, and we approach a rocky canyon. Descending, we pass small groups of young children with tablets and notebooks in hand going up the path on their way to school on the plateau. We see the ancient Tellem cylindrical adobe buildings which have been abandoned for hundreds of years, but are in remarkably good condition. The morning is heating up quickly as we approach the Dogon villages of Sangha

(there are a total of fifty-six separate communities in Sangha—ten on the high plateau where Amatégué and Anagalou live and forty-six on the escarpment). They cling precariously to the steep, rough ledges below the high, red, sandstone, vertical cliffs where the Tellem had chosen to live. The villagers are aware of my alien presence, and infants gather around with outstretched hands asking for "bon bons," hard candies in cellophane. Walking through the villages over rocky terrain, we notice the *togunas*, the granaries with their carved doors, the weaver and the blacksmith at work, and the spirit house with sacrifices poured over it like an ice-cream sundae.

During the last two days, I have been approached by numerous people inquiring if I have any medicine to cure a toothache. One man was particularly pathetic as he sat huddled up against a shaded wall, holding his very swollen jaw and cheek. Luckily, I am carrying some acetaminophen, which I suggest should be taken with water or crushed up into a power to place around the infected area. Other extremely popular items I have brought along to give away to the children are small colored plastic pins and self-stick Velcro cloth badges that spell out "Louisiana" and depict the state emblem of the pelican.

At first, the little boys and girls shyly and politely hold out their sea of dirty hands but in their eagerness and fear of not receiving one of these treasures, inevitably begin pushing and shoving. I help them attach the insignia to their soiled shirts, pants, and dresses but definitely have a problem with those who are not wearing any clothes at all. This becomes a predictable occurrence throughout my travels in West Africa. On another occasion when I return to a village where I previously had distributed Louisiana trinkets, I am amused to spy my gifts adorning the clothes of those in the crowd. I can't help but wonder if, someday, some future ethnographer will report the discovery of a new secret society of Louisianans among the sub-Saharan tribal peoples.

After traversing several communities along the cliffs, we finally reach the flat valley floor. We walk for an hour along the dirt paths at the foot of the beautiful escarpment, through dusty fields interspersed with baobab and other trees. The sun is now overhead and beating down with great intensity. After a short rest, we resume our walk, now ascending the

steep rocky cliffs through several more Dogon villages. The climb scaling the escarpment is difficult, causing shortness of breath and fatigue, not to mention a deep fear of the precarious heights. We are out of water, and my mouth and throat become dry and parched. At last we reach the summit. Just at that moment, I see a most welcome sight. Coulou is driving our vehicle across the plateau toward me. Coulou is cool.

Later in the afternoon, with a gigantic grin on his face and clasping his palms together over his head in a sign of warm affection and triumph of our newly established friendship, Amatégué is back at the Campement to see me off as we drive away from Sangha on our trip back to Mopti. Little Anagalou is in school studying, no doubt, his English "copy book."

March 1, 1987

Crossing the Lake on the Way to Djenné

On my way to the ancient Malian city of Djenné, the unpaved road leads to a small lake and just disappears into the water. There is a ferry, but it does not appear to be working. What to do? My driver waits for the bevy of young boys anticipating our arrival to come up to the truck. He selects one who then eagerly runs ahead, raising his legs high through the water, leading our four-wheel-drive vehicle on a circuitous route through the shallowest portion of the lake, until we have safely reached the other side. We pay the boy a few coins for his needed service, and off we go. I wonder—what was the ferry for?

March 6, 1987

A Memorable Visit to the Court of Bonoua

I arrive in Grand Bassam, the first French colonial capitol of the Côte d'Ivoire and now an oceanfront resort with the distinct character of a setting for a Graham Greene novel. Louis Guirandou-N'Diaye, ambas-

sador of Côte d'Ivoire and inspector of diplomatic and consular posts in Abidjan, the current capitol, puts me in the capable hands of two cousins, Georges Kouamé, twenty-eight, and Pierre Agneby, twenty-seven. They call themselves brothers as there is no concept of cousins in Africa. They operate a beachfront open-air restaurant that caters to the weekend vacationers from nearby Abidjan. The young men engage a car and driver for the day and proceed to give me "the cook's tour" of the town and countryside.

Because I have expressed an interest in seeing art in general and what we Americans call folk art in particular, they decide I should see the Royal Court of Bonoua. Bonoua is a small town with a few paved streets and sidewalks. Inhabiting the community are the Aboure people, who are a division of the larger Akan family of peoples originating in Ghana to the east. Without much fanfare or special indicators of its important royal presence, the court is set off the street some distance behind two low walls, with a walkway and open yard in between.

We arrive in the late afternoon near sunset. Pierre tells me he must obtain permission for us to enter the courtyard as there is some kind of meeting in progress. With permission granted, we take off our shoes as required and walk toward an open courtyard where we can see many large, brightly painted concrete or plaster sculptures in a hierarchical configuration. As we approach, we quickly become aware of much shouting, scuffling, and agitated behavior of the eight to ten men present in the roofed shelter to one side of the courtyard. It seems a man has just admitted his guilt to a crime before this royal tribunal and is receiving his punishment. Stripped of his clothes, he is being held by the others as one of them beats him savagely with an automobile fan belt. He has large bloody welts on his body and legs. He protests vehemently, and there is great fear in his eyes. Suddenly, he breaks away from them, running past us down the walkway. They follow, bumping us as they pass. Quickly, they catch him, bringing him back for more punishment and angry shouting.

By this time, a crowd of townspeople has gathered outside the second low wall to see what all the commotion is about. And here I stand in the midst of all this in my stocking feet with my camera in hand,

attempting to ignore what is going on, taking pictures of the sculptures instead. What a queer sight the whole thing must be!

Georges and Pierre are amused and reassure me it is alright for us to be there and that I should just continue my shooting. When I am finished, I give one of the members of the court a "present" of a 1000 CFA franc note. Then I shake each of their hands in greeting and thank them for the opportunity to photograph the art. They ask me to send them copies when I have my film developed. I inquire from Georges and Pierre which one is the chief and am told he is not there. He is inside the house. Somehow, this whole surreal scene is not what I would have imagined a visit to a chief's royal court would be, and it is only after we return to the car and drive away that we all laugh, and my blood pressure begins to return to normal.

March 14, 1987

An Unexpected Poro Society Dance in a Senufo Village

When I arrive in the remote village of Niofouin, in northern Côte d'Ivoire, I am taken first to pay my respects to the village chief, an elderly man with few teeth. My presence creates great interest. A group of people crowd around while I sit with the chief on the front veranda of his house, having an amicable "discussion" that consists of a lot of smiling and nodding since he speaks no French and certainly no English.

He assigns one of his court members to show me around his village. First, we visit the shrine, with its thick conical roof. This is where the sacred objects are housed. It is a round, mud building with raised, relief figures and a long white-spotted black serpent decorating the entire circumference. An old gentleman guards the door, and immediately shuts it as he notices me approaching. Adjacent to it is a *toguna*-type building with a cluster of short, barrel-shaped and tall tubular drums lying nearby. Another man is taking a torch to a small pig, burning off its hair and turning its skin black with ugly white blisters. At first, I think that it is being burned alive as it is squirming as it is torched, but then I realize it had already had its throat slit.

After paying money to several people standing around, I am allowed to take photos of this sacred area. When asked if I want to photograph a performer, I say yes, and more money is paid. Shortly afterward, a dancer appears wearing a rough cloth "jumpsuit" costume and inverted triangular cloth head covering. Both pieces of clothing have many brown circles painted on them. They remind me of a leopard's spots. He is holding branches in each hand. When I aim my camera toward the canopied meeting house, I am advised not to shoot the pile of drums stacked up next to it.

After leaving this area, I come back out onto the road. My driver, Ya Ya, spots a masked Poro group approaching from down the road. It is a funeral procession. Ya Ya is a Poro himself, and he says I can stay and watch the ceremony. But, he adds, I will not be allowed to take any photos. What a shame. We return to the shrine in the sacred area we had just visited as the Poro group enters.

They appear to be young men in their late teens or early twenties, "leopard hunters" carrying facsimile wooden rifles. They wear unfinished burlap draped loosely over their bodies and drawn together by a cord at their necks. The burlap flares out toward the top of their heads in inverted triangles crowned with turkey feathers and porcupine quills. They gesture wildly, asserting their authority and announcing the arrival of the musicians and the maskers.

When the "hunters" become aware of my alien presence, they protest and advance toward me, waving their arms and demanding I leave. Ya Ya explains to them who I am and that I promise not to take any photos. He tells me I must pay them if I want to stay. They continue their protestations, but Ya Ya quietly giggles and tells them to relax. Satisfied with my small gift of money, they retreat back to the area in front of the shrine and meeting house where the musicians and dancers have already arrived.

The musicians, twelve to fifteen in number, are all barefoot. They wear shorts and no shirts. A majority of them are drummers, playing either the short barrel or long tubular variety. In addition, three or four play horns, tall, vertical, tubular instruments that are blown into at the bottom, and there are four or five bell ringers who wave double iron

shells with clappers. Following them are three or four crocodile fire-spitter-type maskers with wooden horizontal masks, string fiber fringe, spotted animal-fur capes, and gunny-sack costumes.

The maskers make a short appearance and exit the area, as do the "hunters." They leave behind the musicians who drum certain patterns in synchronization, walking in circles around the meeting house. They then stand in a single row facing the house, only to spread out in different directions and disappear from view. Finally, they come back together to repeat the various patterns over and over. The "hunters" and maskers make short appearances and disappear again from view, possibly inside another meeting house that we cannot see. After a while, the drummers conclude their drumming, walk around, put down their instruments, and leave. The funeral performance of the Poro is over.

And I didn't get a single picture.

March 14, 1987

A Miserable Trip from Ferkessedougou

Early one afternoon, my driver, Ya Ya, takes me to Ferkessedougou to check on the train and bus schedules going to Bobo Dialasso the next morning. We plan to return afterward to Korhogo to see the Poro dances, which will be performed later that afternoon. Finishing our mission in Ferke, Ya Ya stops several times on the return trip to pick up people thumbing a ride to Korhogo (for a small fee, of course). Each group piles into the back of our truck except for a pretty, young girl and her infant, who climb into the cab of the truck between us. I joke with Ya Ya, telling him he is becoming a taxi-brousse. He laughs.

It is dusk, and in the distance, the western sky is dark blue, indicating there is some rain in the area. What a welcome relief a shower would be from the heat the country has been experiencing for the past months. A breeze comes up, and there are a few large drops of rain on the dusty windshield. Far-off lightning announces that the dry season indeed may be coming to an end.

As we reach the outskirts of Korhogo, the wind becomes quite brisk, making it difficult for the bicyclers and other travelers along the road to keep their balance. The wind intensifies, and suddenly the rain comes in torrents. It becomes difficult to see the road as the rain continues to drive down, noisily clattering on the metal roof of the truck. We try to roll up the window, but the crank is broken. The window doesn't budge. By this time, the intensity of the storm has magnified. Lightening is illuminating the darkness. Thunder is cracking and crashing around us. The wind becomes gale force, blowing the rain horizontally through the impossible-to-close window. It begins to hail, pelting down, flying into the cab, painfully striking us on the face and body. With hail flying about and water streaming through the windows as well as gushing in from under the dashboard, we are quickly and completely drenched. The floor becomes flooded, and water is sloshing about. The young girl desperately attempts to hold up a thin cloth she has offered to block the water and ice coming through the open window. The wind is decidedly cold, and we shiver uncontrollably in our soaked-to-the-skin clothing. The ferocity of the storm is something I have never experienced in my life. Unlike the proverbial heaven's opening, this feels more like hell unleashed. How quickly conditions have changed. They have gone from the discomfort of the stifling heat to the misery of freezing wetness. In an instant, we witness the bone-dry, terracotta-colored dirt roads become red rivers rushing downhill, creating deep gullies and small rapids, recalling my whitewater rafting experience a few summers ago.

Ya Ya drives slowly through the neighborhoods of Korhogo on nearly impassable streets to deliver all his acquired passengers. Finally, I am deposited at my hotel as the wind and the rain subside somewhat. The rain continues, sometimes gently, sometimes more forcefully, throughout the night.

The dry season is finished. There are no Poro dances performed in Korhogo this afternoon.

March 17–19, 1987

The Funeral Dances of Pala

To see dancing of masks in African villages is not easy to accomplish. It is catch as catch can, not unlike the unpredictability of our own jazz funerals. (In fact, this is but one of a number of analogies to be made between the two individualized performances.) Although masked dances take place during particular seasons of the year, there are no specific dates, and certainly no announcement in the newspaper. There aren't any newspapers in the bush. When I arrive in the large Burkina Faso town of Bobo-Dioulasso, I make my initial contacts and inquiries, only to learn that the important annual funeral dances of the Bobo-Fing people in the nearby village of Pala had taken place the very day of my arrival. Not to fret for I learn there are to be more dances, although not as extensive and elaborate, the next day. I am told I can probably hire a local taxi to drive me out to Pala to see them. Later I'm told that won't work out because the taxi drivers are either unwilling to go or their fee is so exorbitant it will make it impossible. Finally, I am introduced to a member of the Bobo who will take me on his motor scooter. His name is Prospéré Sanou, a thirty-year-old converted Christian now teaching New Testament classes in the local Protestant missionary school. Over the next few days, we are to become good friends.

The next day, we leave for Pala. Even though this village is only six kilometers off the main road from Bobo-Dioulasso to Ouagadougou, the capitol and largest city of Burkina Faso, it is like going through a time warp. The rough dirt road winds down a rocky, arid hillside populated with low scrub bushes. Pala is a village of blacksmiths, a community with deep traditions and customs. Here, the old men in the community vehemently objected, on aesthetic and climatic grounds, to the introduction of corrugated tin instead of the customary wood for exterior building doors. Here, only animistic beliefs prevail; Christian and Muslim religions are not permitted to be practiced. Today, it is unusual for any community to remain so pure in this regard.

The village is made up of many mud-brick, small structures attached to one another. The result is a maze of narrow "streets" or walkways twisting and turning throughout, revealing on occasion small individual courtyards behind closed walls. There are no telephones, cars, toilets, running water, electricity, or any of the other modem conveniences. On the opposite two sides of the village are ancient baobab trees in large open areas that serve as the "town square." They are the places for villagers to congregate and visit. Several secondary clearings at the entrance to the village and at other village crossroads have shrines dedicated to Man and Woman. Two six-foot-high posts hold in their branched cradles (four branches for men, three for women) and round terracotta pots with flared lips. Over them, the traditional white millet liquid and chicken blood has been poured and chicken feathers attached. Nearby is a tall, domed mud structure, approximately twelve to fifteen feet high, that serves as the sacred shrine of the village. With a series of flat stone steps leading up one side, the shrine, with its sun-dried crizzled surface, streaked white from its many millet beer libations, is the heart and soul of the community. The saying goes: "If the shrine is destroyed, the village is destroyed." Prospéré informs me that the Bobo, when the occasion arises, will make sacrifices of sheep, goats, and chickens, but never pigs.

I take a leisurely walk with Prospéré through the village, greeting the men, women, and children we meet along the way. They are friendly, happy to see us visiting their community. A small, dark room, where a group of men are talking in agitated, raised voices, is pointed out to me as the "local bar." Further along, I am told that another equally dim room is the brewery. On the wall in a courtyard is a series of paintings of the three types of Bobo-Fing masked dancers. I am allowed to photograph this wall, behind which I suspect the masks themselves are housed. Later, I see the open field where the fine, large terracotta pots are fired. At this point, it is announced there will be no dances today. They will take place, instead, late tomorrow afternoon.

Disappointment.

We ride back to town. Prospéré says he can bring me again the next day.

Joy.

Each year, there are two specific times that communal funerals are celebrated: during the wet and dry seasons. I am to witness a dry funeral that will continue with dances and feasts for many days and is in recognition of all those village people who have died throughout the past year. The spirits of these departed individuals have been wandering aimlessly since the moment of burial, causing trouble and being an irritant to the living. With the funeral ceremonies, these spirits are finally placated and removed to their ancestral resting place.

When we arrive the following day, the village people are complaining because the funeral feasts have cost them too much money. They have depleted their food supplies for the year. Again, we are told that the musicians have decided the dance scheduled for today must be postponed until early the next morning. Disappointment again. Prospéré informs me he will be unable to take me. Seeing my frustration and deep disappointment, he acquiesces. He says he will rearrange his schedule and pick me up early the following morning. Joy again!

As we ride down the hill towards Pala shortly after dawn the next day, Prospéré comments that he thinks we are in luck. Sure enough, as we drive up on our scooter, the dances are already in progress. The whole community—men, women, children—is gathered in one of the village open areas, dominated by a large, old, gnarled baobab. The rough bark of the tree is like tough, old crocodile hide. Its exposed serpentine roots are worn and polished from their use as bleacherlike seats. Other roots have large, smooth, flat, red rocks laid upon them as places to sit. While everyone is crowded around the perimeter of the dance area, sitting against the walls of the house, standing on the roofs and in the tree, I am ushered in with Prospéré. We are invited to sit on the ground in front, giving us an excellent view of both the dancers and the musicians. Prospéré informs me it is not a problem to take photographs of the proceedings.

The costumed Kokoro dancers are lounging and resting on their sides on one side of the performance area. The drummers are sitting at the base of the tree. One drummer and a flutist walk around the area, stopping in front of one of the masked dancers lying on the ground. He responds by jumping up quickly and performing, running in a circle,

making gigantic, difficult leaps, twisting his body halfway around in midair. At other times, his body twirls in the air while perfectly parallel to the ground. He throws his body forward, then violently backward, catching dust in his long fiber costume.

The funeral masks represent ancestors, not animals or birds, except for one with a red front panel that depicts the rooster. The face coverings strongly resemble ski masks, with embroidery-decorated openings for the eyes and mouth. Protruding in front is a double beaklike mouth similar to a duck's bill. On the tops of the heads are quarter-moon-shaped high crests with cutout openings in the form of stars and crescent moons. The fibrous costume covers the arms, legs, and body in a series of thick layerings, leaving only the hands and feet exposed. The fiber is colored in muted primary colors, with individual costumes sometimes monochromatic, sometimes multicolored. Series of anklet rings with attached brass bells complete the costumes. The dancer carries a coiled-up whip and sometimes his long stick, stripped of its bark and striped in alternating black. There is a large pile of these special sticks behind the tree, one for each young man in the village.

As each dancer completes his one- to two-minute solo performance, he either falls down on the ground where he was lying or runs off through an opening in the crowd. The flutist and drummer designate another to go "center stage." The dancers take turns. Then the cycle is repeated again and again. Occasionally, a male spectator not in costume will get up and "take the stage" to dance. The wild gyrating makes the dancers shed strands of their thick fiber costumes which the young boys, running out from the sidelines, clean up periodically. Without any apparent special indication, the dances are suddenly over. The performers all disappear, and the crowd breaks up and wanders off in various directions through the village.

Because of my perseverance and Prospéré's generosity, I will long remember the funeral dances of Pala.

March 25, 1987

The West African Market

If there is anything that is central to the West African society and economy, it is the *marché*. From dawn to late afternoon, it is the pulse and heartbeat of any community, teeming with activity like a swarm of bees in a beehive—trading, bargaining, meeting, eating, discussing, gossiping. It is a farmers' market, a cafeteria, a department store, a drug store, a bakery, a meat market, a hardware store, a dry goods store, a shoe repair shop all wrapped up into one enormous multifaceted emporium much like our shopping malls. Every African community has one, from the major capitals with their westernized metropolis of modem skyscrapers and broad thoroughfares to the small villages consisting of a cluster of mud houses with thatch roofs. In the larger cities, the *marché* is active every day, while in the smaller towns and villages, where its location is easily identifiable by the rows and rows of canopied stalls held up by poles, one particular day is designated. These outdoor *marchés* are a labyrinth of narrow aisles with stalls lining each side. Occasionally in the larger ones there is, in addition, an area of tightly compacted stalls under a common roof into which sunlight never penetrates, and I wonder if I will ever find my way out-of-doors again.

Often, the vendors offer the same merchandise or service. Usually, they are found together in one particular section of the *marché*. There are areas for printed and woven cloths, aluminum, tin, and plastic containers and utensils; large yellow calabashes, fruits, and vegetables; herbal medicines; packaged toiletry articles; arts and crafts; glass beads; and jewelry. Women on little stools behind woks filled with hot oil or large kettles resting on a nest of four or five rocks over small fires or next to grills and hibachis cook a wide assortment of deep-fried pastries or beignets, shish kebab meats, grilled fish, chicken or bananas, soups, stews over rice and a variety of unidentified delicacies. From big enameled dishpans, vendors ladle a milky tapiocalike liquid in which chunks of ice are floating to keep it cool. Clear, red Kool Aid–like liquids or ice slushes are sold in small transparent bags that are knotted at one end. They are

consumed by sucking on the punctured bag. An encyclopedic inventory of beautiful fruits and vegetables is offered either in large baskets, on flat round trays, or in neat little individual piles. Especially attractive is the wide range of pretty crimson-red, canary-yellow, or emerald-green hot peppers, both fresh and dried. Cashews and peanuts are available in judiciously arranged equal portions or in recycled old liquor bottles with screw lids. From tiny minnows to medium-sized perch, a variety of dried, black-smoked fishes is available for purchase from large hampers or from a series of small mounds in a tidy arrangement.

Particularly fascinating are the things you find at the medicine or gris-gris shop including such unusual and bizarre offerings as dried lizards and iguanas; parrot and owl's heads; dried head of a small spotted cat; small bundles of feathers; pelts of spotted fur; snake skins; crocodile skins and teeth; animal skulls and jaws; porcupine quills; various bird heads, feet, talons; goats' horns; tortoise shells; assorted dried, colored powders in small open bags; and chunks of veined rocks.

Along the roads out in the countryside, people in the rural areas take their special wares to the *marché* in donkey-drawn carts as the sun rises in the morning, returning home down the long road as dusk approaches. Women, and at times men and even small children, carry things on their heads. It is so common a custom it's as if it's a required means of transport or a way of appearing fully attired. Vast volumes and great weights are transported easily long distances, often without the aid of an upraised arm and hand to support and balance the load.

A little round cloth "nest" or platform is placed atop the head upon which rests a tin bucket, tied bundle, wicker basket, enameled platter or dishpan, or wooden crate. Also, the cargo conveniently provides shade for the head and face from the hot sun. While carrying things on the head, women simultaneously often will have a small baby in a cloth sling on their backs. What if the baby cries and needs to be fed? No problem—simply swing the child around to the front and let him nurse as mother, hardly breaking her stride, proceeds along her way to sell her product at the *marché*.

As it has been for centuries, so the West African market-place flourishes today. It is an integral element in the African system and

environment. Everyone uses it and depends on it. It works well for all. As an indicator of its success and the people's dependence upon it, one of the first major new developments of the four-year-old revolutionary government of Burkina Faso is to spend an enormous amount of money rebuilding the completely torn out city-block-wide *marché* in the center of the national capitol, Ouagadougou. An army of gigantic earth movers and bulldozers is creating impressive sloped walls of dirt several stories high upon which the *marché* will be built. Already constructed—perhaps to give everyone an idea of the completed project and enlist their approval—is a huge canopy of prestressed concrete on gargantuan pylons with its roof gracefully turning upward, reminiscent of the Dulles Airport outside Washington, DC, designed by Eero Saarinen. It's a testament to the fact that the West African *marché* likely will continue to live long into the future, and, as a consequence, the culture will as well.

March 31, 1987

Palace Intrigue in Bafut

Having met my friend Charlie Davis in Abidjan, Côte d'Ivoire, and flying with him to Douala, Cameroon, Charlie makes arrangements for us to travel by van north to the Grasslands to visit the area where much great art has been produced in areas in and around the cities of Foumban and Bamenda.

Late one afternoon, while driving in the light rain through the winding and rough back roads around Bamenda in the mountainous, dense tropical forests of the Northwest Province of Cameroon, our driver, Ismyil, a talented brass caster himself, stops in a flat clearing surrounded by walls and neat buildings. We are informed that we have arrived in the famous royal compound of Bafut. In the distance, the *fon* (king) is seen walking away from a building under construction. It is a museum to house the royal collection of art. Because of the late hour and bad weather, it is decided we will return the next morning for a tour through

this important palace complex, to meet the *fon* and discuss with him his admirable plans for his museum.

First thing the next morning, a distinguished man appears at our hotel in Bamenda. He announces he is the *fon*'s brother. Our driver has asked him to take us for an introduction to His Majesty, the *fon*. Delighted with this news, we return to Bafut as the sun is rising. From the wide plaza where we were the day before, we are ushered through an archway in the palace wall into a broad open yard, carefully landscaped with mowed green lawn and majestic old trees. We are told the *fon* is presently busy but expecting us, and it will be necessary for us to wait. The *fon*'s brother generously points out the functions of the various royal buildings, explaining he has a compound in the palace complex but chooses instead to live in Bamenda some thirty kilometers away. We are taken through the closed section of the court, where each of the *fon*'s many wives has a small house facing a courtyard.

Sometime later, we are led through an arched corridor in a gatehouse decorated with painted wall murals of lions, a symbol of the *fon*. While standing and waiting in the inner courtyard, we are briefed on the proper protocol and respect to be observed in the royal court. After a short while, we are escorted through several empty reception rooms to yet another courtyard in which we see an imposing shrine house with a tall conical thatch roof, long slender wooden pillars around a narrow veranda, and a beautifully weathered, ancient stone staircase in front. Again, we are told we must wait. After passing the time photographing, we are taken without explanation back through the maze of buildings and courtyards to the plaza where our car is parked. Confused, we look at our driver, who is also wondering what is happening. Timidly, we ask if we are going to have an audience with the *fon* this morning. No, we are told.

Reluctantly, we get into the car and drive off, returning to Bamenda. What happened, we wonder? That evening, Ismyil explains that the *fon* refused to receive us because we were accompanied by his brother. It turns out, Ismyil says, the brother has been banished from the palace because the *fon* believes he will attempt a coup to depose him.

Had we been used somehow in such an attempt? We will never know.

Addendum 2

"I Found Marie!" Email

Again, my apologies for the mass e-mail, but this is the best way to do it for now.

For those of you who did not receive the last chapter of this continuing kitty soap opera, my apologies as well, but I think you will get the drift of what is going on.

After contacting every animal rescue agency known to man and registering with them while in Houston, I arrive in Gonzales, La., to live in a convent (!!! . . . who knew?). While there, I heard about a place called the Lamar-Dixon Expo Center in town that was taking in human evacuees. That name sounded familiar from my hunting on the internet for animal rescue operations. Sure enough, I had written their name down while I was in Houston, so what a coincidence that I was staying in the small Louisiana town where the Humane Society of the United States had set up their rescue headquarters. Soooo, I went to Walmart and had a set of keys made for my house and went to Lamar-Dixon. (This is the most amazing place . . . hundreds and thousands of dogs, cats, horses, mice, snakes, potbellied pigs, you name it . . . all there barking, meowing, whining . . . with hundreds of volunteers and veterinarians, wearing HSUS T-shirts efficiently doing their work. There are brigades of animal rescue trucks from all states in the country.) I registered with them, filled out forms and instructions on how to get in the house and find Marie. They were not accustomed to accepting keys to houses but took them, and we taped them to the handwritten forms that had to be typed out and computerized. This was at 11:30 at night on Wednesday.

As I was being helicoptered into the museum every day, there was no way for me to go to the FQ to get her myself, and even if I had a

vehicle, there was flooding and many downed trees making such a trip impossible.

On Friday, our NYPD command post for the security of NOMA was transferred from a shopping center parking lot in the suburbs to the front of the museum. I drove my car in their convoy on a very circuitous route (for those of you who know NO: down Clearview Parkway to the base of the Huey P. Long Bridge, Jefferson Highway to River Road to Saint Charles Avenue and Carrollton down St. Charles to Canal Street to Decatur through the Quarter to Esplanade and up Esplanade to City Park and NOMA) After finishing my work at NOMA, I was finally going to get an opportunity to go rescue Marie myself.

Fearful of what I would find, I opened the door, and Marie was nowhere in the house. (I did discover she had a nice fresh sparrow dinner, however, as there were feathers scattered on the rugs.) I concluded all the animal rescue agencies I had registered with online could not have been the ones who took her as the keys I told them that were hidden in the alleyway between my house and the neighbor's were still there and had not been moved. That left one answer . . . The HSUS at Lamar-Dixon had gotten her. Therefore, I hightailed it back to Gonzales (fifty miles away) to Lamar-Dixon.

When I arrived, I went to the desk and said that I wanted to pick up my cat and inquired how that was done. They told me that I should go through all the horse stalls where all the cats were being kept in stacked up individual cages. So off I go looking for Marie, calling her name over and over. (Such beautiful cats all sitting in their cages looking at me or curled up in their kitty litter box asleep.) There was one cage on the ground, and when I peered in, there was a cat that looked like it could be Marie, but I wasn't sure as it was dark and she is dark gray. I looked at the papers attached to the cage, and it said "915 ST. Philip" Eureka!! that's Marie!

I went back to the desk and said, "I have found my cat." With that, everyone stopped what they were doing, looked up, smiled, and started cheering and clapping! It seems they have rarely heard those words spoken. When I sheepishly admitted I had inadvertently left her carrying case at my house, they said not to worry . . . they had one for me.

After I collected Marie in her case and was walking away happy as a lark, a guy came up and introduced himself as the editor of the HSUS newsletter. He asked if he could interview Marie and me for a story as this was such a rare occurrence. We sat on the ground, and I unfolded this same story to him. He took our picture and said the story should appear in a forthcoming issue online at hsus.com.

So, look out for it and GIVE A NICE BIG DONATION TO THE HUMANE SOCIETY OF THE UNITED STATES for all the fine work they are doing.

RECOGNITIONS

I've thoroughly enjoyed writing my memoirs; however, I could not have accomplished it without the generous assistance of many of those people I've written about. When solicited, they and others have provided necessary facts and information to improve my descriptions and stories. Among those wonderful friends is the late Bill Borah, who read my piece on the Vieux Carré Riverfront Expressway, heartily approved it, and supplied me with additional information from the Washington, DC, phase of that episode. Along with that, Bill's friend and keeper of his archives, Sandra Stokes, generously provided the photograph of "the Fagaly gang" atop the railroad car with our bamboo pole and balloons.

I would be horribly remiss if I did not recognize my friend and author Howard Philip Smith, who has made this publication possible. He first introduced me and my project to this press, who subsequently approved its publication. At a recent function here in New Orleans, I was introduced to Craig Gill, director of the University Press of Mississippi, whose immediate response was, "Oh my lord, you're Bill Fagaly. Our board just approved publishing your book *this afternoon* in Jackson!" To him and his staff, I owe my eternal gratitude to make my dream a reality.

The editors at the press have been of invaluable help throughout this endeavor, and I am so very grateful for all their encouragement, guidance, and assistance. My deep appreciation to both Katie Keene and Mary Heath for their leadership and support through this whole publishing process. Thanks also to Jordan Nettles, Todd Lape, Victoria Washington, Camille Hale, Shane Gong Stewart, and Courtney McCreary.

I am deeply indebted to my dear friend Lynda Benglis, who made it possible for all the illustrations in this book to be printed in color. She shares my sentiments that color would make a world of difference.

Others who have helped in one way or another are Mary Degnan, who gave technical assistance to this technologically challenged art his-

torian. Thank you, Mary. Also, my appreciation for the learned advice, support, and encouragement of my friend and former boss John Bullard is immeasurable. Thank you, John. I also want recognize my friend Taylor Murrow, who read the initial draft of these pages several years ago. Her suggestions were most meaningful to me and gave me affirmation to continue. My sincere thanks to David Johnson for publishing advice and Michael Carbo, who was most gracious in guiding me through some legal issues. For that, I salute them both.

Last, very special thanks to my long-time dear friend and accomplished artist Dawn DeDeaux for offering the photograph on the cover of this book. I also want to give her credit for the title of this book. In the distant past, I was describing writing my memoirs and told her about me being known as the nightcrawler king in Dearborn County, Indiana, and she instantly said, "That's the title of your book!"

NOTES

Overture

1. Sometimes, crossing paths with celebrities was a fleeting, one-time encounter, but those brief experiences enriched my life. Among the memorable are spending an enchanting afternoon with Man Ray's widow, Juliette, in her Paris apartment near the Jardin du Luxembourg; meeting with Madame Chennault, the widow of Lieutenant General Claire Chennault of Flying Tigers fame, in her Watergate penthouse apartment when her good friend and close advisor to Presidents FDR and LBJ, Tommy Corcoran, arrived and serenaded us playing her grand piano; dancing with Sarah Vaughn at an afterhours jam session during the French Lick Jazz Festival in Indiana; dancing with James Brown and Tina Turner on the dance floor in front of the stage when each was the headliner at the Blue Room in the Fairmont; having dinner with Paul Simon and Lorne Michaels at soul-food restaurant Chez Helene and being so impressed with Lorne's knowledgeable interest in contemporary art; years later, visiting with Paul again alone in his dressing room as his guest with his dear friend Dickie Landry after Paul's farewell tour concert in New Orleans; giving Linda Ronstadt and Ginger Rogers each a personal tour through the *Treasures of Tutankhamen* exhibition; visiting with Joyce and George Wein at their apartment in New York and getting a tour of their impressive art collection; helping arrange and attending Marilu Henner's wedding to Frederic Forrest at Lillian Pulitzer's French Quarter house on Barracks Street; dancing at Marilu's reception at the Prince Conti Hotel with other stars of *Taxi* including Tony Danza; sitting next to Mike Wallace, who was alone, for a couple of hours on the Hampton Jitney returning to New York City; spending the evening at the opening of a new New Orleans high-rise building chatting with Wolfgang Puck before he became a famous chef; being a groupie with a musician friend playing with Johnny Mathis on a road trip for his appearance at the high school gymnasium in Golden Meadow, Louisiana; doing a public gallery interview with Herb Ritts at Arthur Roger Gallery; escorting fashion designer Pauline Trigère to a black-tie function and her being most disagreeable the entire evening; taking jazz pianist Teddy Wilson to Galatoire's in the mid-1960s and receiving a very cool reception by the management and the other diners; being invited to attend several private parties with Allen Toussaint, particularly one he gave for Eric Clapton on July 30, 1974, at his Sea-Saint studios in a former movie theater in Gentilly with Sarah and Roger Dickerson; hanging out with John Waters in New Orleans and Vienna and taking him with Arthur Roger on a memorable evening to the Saturn Bar on Saint Claude Avenue; spending several hours discussing art and the art world with the elusive artist Neil Jenney at the Odeon bar in the late 1970s; sitting on the floor with David Byrne and smoking together at a birthday party in Keith Sonnier's studio; hanging out and madly

dancing for a couple of hours at a black-tie gala at the toney Metropolitan Club in New York with artist Hannah Wilkie; taking artist Jacob Lawrence to lunch several times at the original Buster Holmes Restaurant in the French Quarter; chauffeuring *New York Times* art critic John Russell and his glamorous wife, author, and lecturer Rosamond Bernier, around New Orleans during their visit to New Orleans; chauffeuring National Gallery Director Carter Brown around New Orleans; having dinners at Ed Weigand's loft with artist Ralston Crawford during his frequent visits to the city he loved and attending the jazz funeral given for him; annoying artist Jennifer Bartlett when she gave me a mid-1970s exclusive sneak preview in her studio of her now-famous painting in the permanent collection of MOMA of nearly one thousand gridded, enameled steel plates, *Rhapsody*, during a small raucous dinner party including Paula Cooper, Lynda Benglis, Jennifer, her Asian boyfriend, and me as guests; my on-going friendship over the years with artist Judy Chicago; hanging out with and being a groupie on Laurie Anderson's road trip from New Orleans, Cecelia (with Tina Girouard and Dickie Landry), and Houston; helping out frantic photographer Eve Arnold when her camera broke while on assignment in India by my finding for her and borrowing another camera acceptable to her needs in exchange for her giving NOMA some photographs for its permanent collection, which she ultimately failed to keep as her part of the bargain; another friendship with archaeologist Merle Greene Robertson gone sour when she asked me for multiple big favors over time, which I dutifully produced for her, and then she proceeded to always fail to keep her part of the bargain; my on-going long friendship with artist Emerson Woelffer and our mutual love of ethnographic art; hosting and hanging out with artist James Rosenquist during his visit to NOMA; spying the artist Ellsworth Kelly lingering in the last gallery of his retrospective at the National Gallery, introducing myself, and in the conversation mentioning to him I had bought a large print of his that had faded, to which he offered to replace it if I would send it to him (I never did); enjoying a very crowded Claes Oldenberg retrospective at MOMA and noticing a man rushing from one group of people to another eagerly overhearing their comments to realize this unusual behavior belonged to the artist himself; on another occasion having to call Oldenberg to inform him that unfortunately NOMA would be unable to take an exhibition of his from the Walker which we had previously booked (he was not happy); meeting eighty-nine-year-old vaudevillian comedienne and male impersonator Claire Romaine, who sat every day dressed up and with heavy makeup as a female in the lobby of the London hotel where I was staying, learning the Astor Hotel in New York named a salad after her during her appearances as the "toast of New York" and her reminiscences of her old pal Sophie Tucker; meeting Frank Sinatra, Dean Martin, and Shirley MacLaine in Madison, Indiana, on the set of their 1959 movie *Some Came Running*; making the acquaintance of former well-known Los Angeles DJ Magnificent Montegue ("Burn Baby Burn") and ultimately visiting him in Las Vegas to view his extraordinary warehoused collection of African American memorabilia; being abruptly rebuffed by Sir Alex Guinness in India when I asked if I could take his picture; meeting and visiting with Malcom Muggeridge in the Green Room on the set of NBC's *Today Show* while my friend Bruce Brice was being interviewed on air; after sitting next to him at a

dinner at which he was being honored, visiting artist Geoffrey Holder and his wife, Carmen De Lavallade, at their home in New York's Soho to see their incredible collection; being the houseguest of John Deere heiress Connie McCormick Fearing at her grand house in the exclusive Montecito section of Santa Barbara and being the guest of honor at a large dinner party there; exchanging polite smiles and hellos with Ernest Hemingway with a nurse and IV bag hanging from a wheeled stand as he passed my doorway in the hallway of Saint Mary's Hospital at the Mayo Clinic while we were both patients there and shortly before his suicide; sharing love of contemporary self-taught art and visiting with artist Roger Brown in Chicago, New Orleans, and his Lake Michigan summer place in New Buffalo, Michigan; my long friendship with artist Hunt Slonem, beginning in the early 1970s, while he was a painting and art history student at Newcomb College at Tulane and often visiting him at his aviary/ studio on Houston Street in Manhattan and later his two newly acquired Louisiana plantation mansions, Albania (formerly owned by Isaac Delgado), on the Bayou Teche in Saint Mary Parish just outside Jeanerette and Lakeside in the small community of Bachelor in Pointe Coupee Parish; artist Nick Cave and I giving a surprise birthday party for Dawn DeDeaux at an artists' meeting about better race relations in the local artistic community shortly after Katrina; being aboard Mike Jagger's posh, private river cruise on the riverboat *President* and attending Stevie Wonder's private birthday bash at Rosy's Jazz Hall; visiting Alexander Liberman after work at his Condé Nast offices in New York and his raving over my long black military coat I got at the thrift shop; becoming friends with Brooke Hayward Duchin during her frequent trips to New Orleans and the Cajun country and going to art openings and lunches in New York, visiting at her and her then husband Peter's apartment the day of the tragic Oklahoma bombing, having dinner with Brooke and Peter at Upperline in New Orleans; my long curatorial and personal friendship with art historian Walter Hopps; being photographed by Gary Winogrand at the Whitney opening of Mac Doty's exhibition *Extraordinary Realities* with him and Peter Burnell; telling Lucy Lippard there is no such thing as feminine art; cojudging a weekend sidewalk art fair in St. Petersburg, Florida, in 1972 with the legendary art historian and museum director Adelyn Breskin; hanging out with art historian Robert Rosenblum and his wife, Jane Kapowitz, whenever they came to New Orleans; hosting New York DJ Spencer Sweeney and legendary Colin De Land at my house during Jacqueline Humphries and Tony Oursler's wedding; Martin Friedman calling on the phone as I had forgotten to pick Mildred and him up at the airport because I passed out drunk, and then I took them to Jazz Fest the next day; my long friendship with African art dealer Bryce Holcombe visiting at his house on Fire Island and our many movable feasts in New Orleans from one restaurant to another for first course, second course, third course and final course; my long friendship with Muriel and Leo Haspel—Muriel was my faithful volunteer assistant for many years at the museum, always wearing seamed nylon stockings, and Leo who hand carried on a commercial air flight (in the old days!) a Degas bronze sculpture the museum had just purchased at auction in New York; at KID smART kneeling on all-fours with Peter Beard as he instructed a group of small children and me about the pleasures of drawing with colored crayons; at the request of Dottie

Coleman, giving a tour of the French Quarter art galleries to one of Donald Trump's totally disinterested older sons; and meeting Hillary Clinton at a reception at the White House when NOMA lent an Elizabeth Catlett sculpture there; just to name a few.

Episode 2

1. A couple of postscript notes about Al Elsen. When he was doing his research on Rodin, he was aware that the attic of the museum was a treasure trove of written documents by the artist and other important papers pertaining to his work and life. However, the director of the museum at that time was an ogre, and under no circumstances would he allow anyone access to this valuable resource. But Al was determined and resourceful. He managed to hide in the museum, and when it closed for the day, he gained access to the attic and spent the entire night up there reading and recording information, hitherto unknown by anyone. The director never knew what he had done that would eventually make him the world authority on this giant in the history of art.

2. During those college days, my next-door neighbors on North Fess Street were friends Bill and Emily Harris who later in California were leaders of the Symbionese Liberation Army and kidnapped Patty Hearst, committed armed bank robberies, and killed innocent people. Emily belonged to Chi Omega at IU.

3. Jane's daughter, Carol, married Jimmy Coleman Jr. of New Orleans, and their son, Jamie, married Monique McKenna. Their daughter is named Jane Owen for her grandmother.

4. "Art museums, like all human endeavors, begin as ideas. In the case of the Indiana University Art Museum, the impetus for a dedicated space where the university's art collection and special exhibitions could be displayed came from IU's legendary president, Herman B Wells (1902–2000). The visual arts played a key role in Wells's concept of Indiana University as a cultural crossroads for the state and the region, and, in his estimation, no university could make a claim to greatness without a great art museum nearby. In order to help bring this vision to life, Wells hired Henry Radford Hope (1905–1989) in 1943. Hope had just completed his PhD at Harvard University, where he had studied under Paul Sachs in what was considered the most successful American training program for museum directors and curators of the twentieth century." *Indiana University Art Museum Events Calendar* 12, nos. 1 & 2 (January & February 2016), p. 1.

Episode 3

1. Philip Glass, *Words without Music* (New York: Liveright, 2015), p. 384.

2. Mel (Mary Ellen Meehan) was dating and later married my roommate, Tom Solley, heir to the Eli Lilly fortune, and became director of the Indiana University Art Museum. After their divorce, she lived in his former penthouse apartment on Fifth Avenue overlooking Central Park and married Richard Oldenburg, the former director of the Museum of Modern Art and chairman of Sotheby's North and South America

operations. Mel and I remained friends after Tom's tragic death, when, in April 2018, he leaned over and fell off the balcony of his house in Italy while directing on his cell phone his museum successor as she drove the circuitous, winding road there for a visit.

3. Mimi, her adopted name, died at eighty-nine in New York January 27, 2018.

4. The Brancusi sculpture was acquired by the Staffords during a rare visit to the artist's studio in 1955. Brancusi was known to never allow visitors in, let alone sell from, his place of work. However, he and Fred were both native Romanians, and the artist became enchanted with Mimi and succumbed to the sale. After being on loan to the Delgado for an extended time, the sculpture was lent to the Metropolitan Museum of Art in New York. After Mimi's death, it was put up for auction at Christie's on May 15, 2018, and brought $71 million, a world record for the artist.

5. Nell Nolan, "Patrons Honored for Dedication to Arts, NOMA," *Times-Picayune*, March 13, 2013, p. C-5.

6. William Fagaly, "What a Wonderful World" (New Orleans: Contemporary Arts Center, 2003).

7. I have always had an aversion to NOMA's identification of that space as the Great Hall. During my early years at the then Delgado, I attempted to correct this misnomer by calling it by its correct identification, Center Court, which I knew from my Ancient Greek and Roman art history studies at IU. In Greek architecture (upon which the Delgado was inspired), the large area in the center of a building is called Center Court. Unfortunately, I was overruled by a determined administrator who had no art history background but who had more authority than me in spite of my incessant objection to her ruling. Yes, today that space continues to be called the Great Hall, while I continue to refer to it by its proper name, Center Court.

8. "2017 Schwartz-Gage Awards Luncheon Honoring William E. Borah" program, Vieux Carré Property Owners, Residents & Associates, May 21, 2017, p. 2.

9. Lawrence Weschler, *Seeing Is Forgetting: The Name of the Thing One Sees* (Los Angeles: University of California Press, 1982), pp. 192–93.

10. William A. Fagaly, "The Christmas Bonfires of St. James Parish," *Folk Art*, Museum of American Folk Art 10, no. 4 (Winter 1995/96), pp. 54–61.

11. Jay Weigel, "Who Is Bill Fagaly?" "*What a Wonderful World*," *An Art Installation by Bill Fagaly* (New Orleans: Contemporary Arts Center, 2003).

12. William Dunlap, invitation letter to participants, September 20, 1976.

13. Dunlap.

Episode 4

1. This beautiful 2001 building was sold to next door neighbor Museum of Modern Art and torn down by them in 2014 to expand its facilities. This action was very controversial not only in New York.

2. Unfortunately, the phrase was later commandeered by the gangs during the Los Angeles riots, which had a much different meaning and upset Montague.

3. Holland Cotter, "Sister Gertrude's Revelations," *New York Times*, September 7, 2003, p. 93.

4. Michael Kimmelman, "With an Ear for God and an Eye for Art," *New York Times*, February 27, 2004, pp. B25 and B29.

5. Tessa DeCarlo, "Art," *New York Times*, February 22, 2004, p. 37.

6. Hilarie M. Sheets, "Shouting in Color," *New York Times Book Review*, August 15, 2004, p. 13.

7. Jenifer P. Borum, "Sister Gertrude Morgan" *Artforum International* 43, no. 1 (September 2004), pp. 272–73.

8. Also, there was no loading dock for bringing crated art in and out of the building, and there was no closed to the public staging space necessary for working on the installation, two essential features for a functioning museum.

9. William A. Fagaly, "Tools of Her Ministry: The Art of Sister Gertrude Morgan" (New York: American Folk Art Museum and Rizzoli International Publications, 2004), p. ix.

10. Fagaly, p. xi.

11. I first learned of his album in early September 2005, when I received a cell-phone call from NPR one week after Katrina and the levee failures had devastated my beloved New Orleans. Jackie Sullivan and I had just received permission from the state police and the National Guard to enter the paralyzed city and were in a rented car navigating through the debris and high water. I was badly shaken by the sights of the damage and the isolation of a moribund city. It was not a good moment for me. The caller from Philadelphia wanted me to comment on King Britt's new album, in which he combined his music with Sister Gertrude Morgan's original soundtrack "Let's Make a Record." I was not in a good frame of mind and was horrified at this outrageous news and told them so. I told them to my mind it was like gilding the lily or improving a Van Gogh with over paint. They said they would get back to me. They didn't. Much later, I had the opportunity to hear King Britt's album and surprisingly liked it. Later, I heard that he and his group would be performing at the CAC in New Orleans. I went early that night, found him, introduced myself, and told him the history of that fateful telephone call. I told him I just wanted to meet him and apologize for my past behavior and let him know that after hearing his recording I liked it a lot.

12. Rosemary Kent, "'A New World in My View': The Art of Sister Gertrude Morgan," *Andy Warhol's Interview* 1, no. 1 (September 1973), pp. 40–41, ill.

13. NOMA received $130,000. from the insurance company. These funds were used to buy important self-taught artworks, including a rare fan by Sister Gertrude and one of Henry Darger's mural-sized, double-sided works.

14. Phyllis Kind Gallery, "Phyllis Kind Gallery to Close," July 2009.

15. Phyllis Kind Gallery.

16. This was an outgrowth and expansion of a similar exhibition I had done earlier at the Arthur Roger Gallery in New Orleans.

17. Nick and I knew each other previously when he had contracted cerebral cancer, was on chemotherapy, and apparently was dying. I was supportive of him at this critical stage in his life. Miraculously, he went into remission and today is the successful host and producer of *American Routes* on National Public Radio.

18. The attending NEA panelists were artists Robert Mangold, Robert Colescott, Elmer Bischoff, Chuck Close, and curator Linda Cathcart.

Episode 5

1. Prescott N. Dunbar, *The New Orleans Museum of Art: The First Seventy-Five Years* (Baton Rouge: Louisiana State University Press, 1990), p. 20.

2. However, when NOMA curator Katie Pfohl contacted the Oppenheim estate in 2015 about this, it had photos and made them available to Katie. This is in contradiction to what Dennis had told me. He said he didn't have any documentation. I have a suspicion the footage and photographs the Delgado Museum commissioned were given, in fact, to Dennis and not the museum. It's only a supposition on my part.

3. "A small, darkly-glittering 'found object' rates top art honors in the Delgado Museum's current *Moon Rock and Earthworks* exhibition; photographs and diagrams of huge man-made 'earthworks' seem dull by comparison." Alberta Collier, "The World of Art: A 'Found Object' Is Top Attraction at the Delgado," *Times-Picayune*, February 26, 1970, section 2, p. 8.

4. Nearly forty years later, when Tompkins came to NOMA to speak, I gave him a copy of the newspaper catalog, he read and said he wouldn't change a word. He was still pleased with what he had written.

5. Katy Reckdahl, "St. Joseph's Night Gone Blue," *Gambit Weekly*, March 29, 2005, p. 9.

6. Other distinguished art museum curators and directors who agreed to serve as the guest curator for this series are Walter Hopps (1971), Maurice Tuchman (1973), Jane Livingston (1975), Jack Boulton (1977), Marcia Tucker (1980), Linda Cathcart (1983), Douglas Schultz (1986), John Szarkowski (1992), Dan Cameron (1995), Charlotta Kotik (1998), and me, and thirty-seven artists cocurated in 2001.

In 1989, my guest-curated Corcoran exhibition *The 41ˢᵗ Biennial Exhibition of Contemporary American Painting* was presented in lieu of the *New Orleans Triennial* since both exhibitions were based on contemporary Southern art. The 1992 focusing exclusively on photography was the result of the normal large exhibition space usually used for this series was not available due to the expanded building construction in progress.

7. His installation in the 1980 exhibition impressed me to commission him to paint the walls of my dining room at home. But what would be the theme or subject of the four hand-painted walls? After much thought and consideration, I suggested that since both he and I were born and raised and went to college at the same university in Southern Indiana, that would be our subject. While he included basketball, Indiana limestone, the revered chancellor of Indiana University, the Indianapolis 500 speedway race, the "Little 500" bicycle race at IU, the state bird, a covered bridge, the state seal, Soldiers and Sailors Monument in Indianapolis, a bottle of Seagram's 7 Crown (for my home, Lawrenceburg) and other cherished objects of our esteemed state. However, one day I came home, where he had been working all day, to question one

particular object—the spires of Churchill Downs racetrack. He quickly explained that he was born in Jeffersonville, Indiana, just across the river from Louisville.

8. Luis Cruz Azaceta, "Nominator's Statement," *2001 New Orleans Triennial* (New Orleans Museum of Art, 2001), p. 77.

9. A lidded wooden bowl from South Africa and a bronze *Head of an Oba* from the Benin Kingdom were the extent of the collection, both acquired by gift. The Benin head gifted anonymously in 1953 (most likely from a prominent New York dealer at the time) was subsequently found to be fraudulent and taken off view.

10. The Delgado presented two pioneering exhibitions, the traveling *Spotlight on Africa* in 1952 and, three years later, the famed Helena Rubinstein collection of African sculpture. The museum's fiftieth-anniversary exhibition in 1961, *Masks and Masquerades*, devoted a section to borrowed African works.

11. Rosyln Adele Walker, "Mounted Warrior Veranda Post," *Ancestors of Congo Square: African Art in the New Orleans Museum of Art*, ed. William A. Fagaly (London: Scala, 2011), p. 162.

12. Among those who came were Ben Heller, an influential New York art collector and dealer, and Jacques Kerchache, an influential Parisian collector and dealer, and they had a plan in mind. Ben had acquired a large group of encrusted wood figures, and they wanted me to curate an exhibition of vodou sculptures of the Fon peoples in then Dahomey and relate them to the vodou found in New Orleans. Ben at that point had become a dealer, and I thought the premise was weak. Therefore, I declined their suggestion of my involvement in such a venture, which did not please them to say the least.

13. The San Antonio Museum of Art, the Arkansas Arts Center, the Albuquerque Museum, the University of Wyoming Art Museum, the National Museum of African Art, Smithsonian Institution in Washington, DC, the Middlebury College Museum of Art in Vermont, and the Palmer Museum of Art at Pennsylvania State University.

Episode 6

1. Nancy Reagan, "The Kay We Loved," *Newsweek*, July 29, 2001

2. Among others who were active were Phyllis Dennery, Shirley Schlesinger Kaufmann, Margie Stich, Rena Godchaux, Justine McCarthy, and Harriet Blum.

3. When the museum discovered this painting had become available for sale from the New York private dealer Eugene Thaw, it was Edith who invited many prominent New Orleans civic leaders to lunch at the Delgado and told them to bring their checkbooks. After a po-boy repast, they were informed of the importance of "Bringing Estelle Home" and urged that they write a check for $5,000. to initiate a city-wide fund drive to acquire the painting for the museum. The asking price was $220,000, and the museum's acquisition fund was as bare as Mrs. Hubbard's cupboard. The drive slowly went forward, and it was feared it would not be able to reach its goal in time for the set deadline. Thaw acquiesced and lowered the price to $190,000. As time grew short, at telethon was broadcast, and canisters were passed in the public schools for children to contribute their pennies. At the last minute, the citizens of

the city were successful, and Estelle came home to stay just down the street from where she originally lived on Esplanade Avenue and where her cousin painted her. This citywide communal effort precipitated the local Ella West Freeman Fund to challenge the museum to raise an additional $200,000 within two years, and they would match it to create, for the first time in the museum's history, an acquisition fund for future purchases.

4. After the museum adopted the policy to focus on the acquisition of an Arts of the Americas collection, Jim Byrnes decided to begin with acquiring pre-Columbian art. Because of New Orleans's location geographically, the museum saw much of what was coming out of Central and South America before anyone else. We soon had visits with many of the dealers bringing out material, especially in addition to Jax, Edward Merrin, Evert Rassiga, Alain Schoffel, and Giselle Chirat. In fact, in some instances, boats carrying art cargo left the Yucatan Peninsula for the south shore of Louisiana. We would joke, "Dumbarton Oaks got our rejects" much to the chagrin of Elizabeth Boone, formerly at Dumbarton Oaks, presently professor at Newcomb College, Tulane Unversity.

5. William A. Fagaly, "Thomas B. Hess: A Man for All Art, Especially the New," *Arts Quarterly*, New Orleans Museum of Art, October/November/December, 1985, 7, no. 4, pp. 32–35. The following is a fascinating incident concerning my friendship with Tom I have related earlier. "Tom was urbane, witty, erudite and, during the third quarter of this century, became universally recognized as one of the leaders of the New York (and, consequently, international) art world. It is all the more surprising that at the time when he was contemplating whether to accept the invitation of The Metropolitan Museum of Art and begin an altogether new career as Consultive Chairman of their Department of 20th-century Art (filling the vacancy left by Henry Geldzahler to become Curatorial Affairs Commissioner for the City of New York) he had a need to talk with someone currently in the museum field (preferably a curator who was removed geographically from New York) about the inner workings of an art museum. At dinner one evening a few blocks from his Beekman Place house, he quizzed me about various aspects of museum work—the interrelationships between fellow curators within an institution and with colleagues elsewhere; how much freedom curators had in museum purchases and latitude in establishing policies and programs within their area of expertise. In short, this influential editor and critic admitted he had little knowledge of the day-to-day operations within museum walls. It was apparent he wanted to fully understand what was to be expected from him and what limits he should anticipate in shaping the future of this relatively new department in one the great museums of the world."

6. Megan Twohey and Jacob Bernstein, "Scrutiny for 'Lady of the House' at the Heart of a Financier's Life," *New York Times*, Tuesday, July 16, 2019, pp. A1, A18. In 2000, Jeffrey Epstein, the rich New York financier turned indicted sex trafficker and abuser of women and young girls, bought Muriel's seven-thousand-square-foot town house for $4.5 million for his new girlfriend, Ghislaine Maxwell, where she gave lavish parties. The town house sold in 2016 for $15 million.

7. "Muriel Bultman Francis," editorial, *Times Picayune*, May 3, 1986.

8. Kathleen L. Housley, *Emily Hall Tremaine: Collector on the Cusp, 2001* (Meridan CT.: The Emily Hall Tremaine Foundation).

9. John Pope, "Sunny Norman, Arts Activist, Dies at 94," *Times-Picayune*, January 29, 2006, p. B-4.

10. Andrew Vanacore, "Outside the box: Socialite throws one last party—for her own memorial," *The New Orleans Advocate*, April 23, 2014, p. 1.

11. Leah Chase, personal conversation with the author, December 4, 2018.

12. Kim Severson, "A Creole Chef to Freedom Riders and Presidents," *New York Times*, Monday, June 3, 2019, p. A1.

13. "Leah Chase Fed More Than Hungry Stomachs. She Fed Souls," *The New Orleans Advocate*, Monday, June 3, 2019, p. 4B.

14. Ina McNulty, "A Funeral for the Ages for Epic Chef Leah Chase," *The New Orleans Advocate*, Tuesday, June 11, 2019, p. 1A.

15. John Richardson, "New York Review of Books," November 19, 1992.

16. Luba Glade, "Year End Wrap Up," *Vieux Carré Courier*, December 29, 1972 to January 4, 1973, pp. 11–12.

17. http:///www.casa.org/groups/art-mob.

Episode 7

1. Richard Tuttle and Joyce Hoffmann, "Emily Tremaine and Friends," *Northeast Magazine, The Hartford Courant*, November 6, 1988, p. 13.

2. Janice Blackburn, "Le Corbusier's 'painted sculpture'" *Financial Times*, February 14, 2009.

Episode 8

1. William Middleton, *Double Vision: The Unerring Eye of Art World Avatars Dominique and John de Menil* (New York: Alfred A. Knopf, 2018), p. 4.

2. Contemporary Arts Center 2003.

3. "This small, three square mile rocky Greek island in the Aegean Sea is the easternmost outpost of Europe. As the crow flies, Kastellorizo, which has been known as Megisti since ancient times, it is just a mile from the coast of Turkey and situated midway between Rhodes and Cyprus. Consequently its history is rich and complex; its people intriguing and resilient following centuries of encounters with the occupying forces of nature and men." William A. Fagaly, "A Perfect Greek Island," *Times-Picayune*, Sunday, May 18, 2003, D-1, 8.

4. Ernie Mickler interview by Cal Yeomans, Crescent Beach, Florida, October 7–8, 1988, University of Florida Archives, Gainesville, Tape 4, Side A.

5. Alastair Sooke, "How Georgia O'Keeffe Left Her Cheating Husband for a Mountain: 'God told me if I painted it enough, I could have it,'" *The Telegraph*, June 30, 2016.

6. Dominic Molon, RISD curator, telephone conversation with the author, July 25, 2018. The exhibition was ultimately not well received in Providence when it traveled there after New Orleans.

7. Alan Katz, "Andy Warhol Art Exhibit Is Big Hit at Delgado," *New Orleans States-Item*, January 17, 1970, p.1.

8. Blake Gopnik, telephone conversation with author, November 19, 2018. The Warhol Museum in Pittsburgh has possession of the six thousand tapes and plans to release them in 2035. I would be ninety-seven.

9. Blake Gopnik, telephone conversation with author, November 19, 2018. For discussion of my visit with Andy in New Orleans in 1970, see Blake Gopnik, *Warhol* (New York: HarperCollins, 2020), p. 673.

10. Several years later, Smokey was brutally murdered in his house at the age of ninety-nine.

11. Penelope Green, "Between Apocalypse," *New York Times*, October 15, 2014, pp. D1, 5, 6, 7.

12. Nell Nolan, "A Wild Time Was Had by All at Party Called 'Wilde Ball,'" Social Scene, *Times-Picayune/the States-Item*, July 26, 1982, section 3, p. 2.

13. Elizabeth Shannon, telephone conversation with the author, December 3, 2018.

14. Steve Garbarino, "The Last of the French Quarter Characters," *New Orleans Advocate*, Sunday, April 13, 2014, p. 5A.

15. The debate continues. Recently I spoke to photographer Tina Freeman on the subject. She, who personally knew both George in New Orleans and Robert in New York at that period, contended that George's work did influence Robert. She said that his work was not advancing at that stage and was drifting and not dealing with the subject of Black male nudity. She felt George's work was a strong influence on Robert's future direction.

16. Eric Bookhardt, *Gambit*, June 18, 2013, p. 40.

17. Jim Richard was often included in the guest-curated New Orleans Triennial at NOMA. After a number of years, as a publicity ploy to advertise that year's exhibition, I had two highway billboards installed in the city that read *"CLAUDE MONET AND JIM RICHARD WILL NOT BE IN THE 2001 NEW ORLEANS TRIENNIAL."* (Claude Monet had entered this century old series in 1906 and 1909 but was not selected for inclusion in either exhibition at the old Delgado Museum.)

Episode 9

1. Will Coviello, "Window on the World," *Gambit*, July 30, 2007.

2. Dan Cameron, "It Takes a Village," *East Village USA* (New York: New Museum of Contemporary Art, 1981), p. 43. That landmark exhibition featured an emerging generation of artists, including Nan Golden, Robert Mapplethorpe, and Jean-Michel Basquiat.

3. *New York Times*, cover of book *The Mudd Club* by Richard Boch (Port Townsend, Washington: Feral Press, 2017).

4. Keith Haring organized a show of graffiti-inspired works, *Beyond Words*, at the Mudd Club with Afrika Bambaataa DJing the opening party on April 9, 1981.

5. William Fagaly, "Personal Recollections: Contemporary Art in New Orleans," *Pride of Place: The Making of Contemporary Art in New Orleans* (New Orleans Museum of Art: Four Color Print Group, 2017), p. 30.

6. He was forced recently to cease having his beloved pigeons because of neighbors' complaints.

7. At the same time Eddie was trying to promote Fess, he told me he had a rival—Quint Davis. When Fess died, Eddie abandoned the music business to pursue a career in advertising. He is the author of the popular and controversial book *Dr. Mary's Monkey: How the Unsolved Murder of a Doctor, a Secret Laboratory in New Orleans and Cancer-Causing Viruses are Linked to Lee Harvey Oswald and the JFK Assassination and Emerging Global Experience* published in 2007.

8. Keith Spera, "Full Circle: Tipitina's to host 100th birthday bash for patron saint Professor Longhair," *The Advocate*, Thursday, December 13, 2018, pp. 12–13.

Episode 11

1. The piece was finished posthumously in 1973 by his widow, Nancy Holt, along with Tony Shafrazi and Richard Serra.

2. "'White Trash' Author Dies as New Book Issues," *Times-Picayune*, November 18, 1982.

3. Ernest Matthew Mickler, *Sinkin Spells, Hot Flashes, Fits and Cravins* (Berkeley: Ten Speed Press, 1988), pp. vii–xii.

4. Susan Heller Anderson, "Ernest Matthew Mickler, 48, Dies; Author of Best-Selling Cookbook," *New York Times*, November 18, 1988, p. B8.

5. Michael Adno, "Ernie's Potluck: How Ernest Matthew Mickler Reconstituted the South," *The Bitter Southerner*, July 2017.

6. A recent National Geographic on-line article revealed, "Now, Peruvian archaeologists armed with drones have discovered more than 50 new examples of these mysterious desert monuments in adjacent Palpa province, traced onto the earth's surface in lines almost too fine to see with the human eye. In addition, archaeologists surveyed locally known geoglyphs with drones in never-before-seen-detail.

"Some of the newfound lines belong to the Nazca culture, which held sway in the area from 200 to 700 A.D. However, archaeologists suspect that the earlier Paracas and Topará cultures carved many of the new found images between 500 B.C. and 200 A.D.

"Unlike the iconic Nazca lines—most of which are only visible from overhead—the older Paracas glyphs were laid down on hillsides, making them visible to villages below. The two cultures also pursed different artistic subjects; Nazca lines most often consist of lines or polygons, but many of the newfound Paracas figures depict humans . . ." Michael Greshko, "Exclusive: Massive Ancient Drawings Found in Peruvian Desert." *National Geographic*, April 5, 2018, https://news.nationalgeographic.com/2018/04/new-nazca-nazca/lines/discovery/peru/archaeology/html.

See also Iliana Magra, "More Than 140 Nazca Lines Are Discovered in Peruvian Desert," November 18, 2019; Max Williams, "Ancient Emojis? Archeologists Have Discovered Epic New Nazca Lines in Peru, Thanks to an Assist from A. I.," November 20, 2019. https://news.artnet.com/about/maxwell-williams-920.

Episode 14

1. Louis Armstrong, "What a Wonderful World," Bob Thiele and George David Weiss, Memory Lane Music Group, Carlin Music Corp., BMG Rights Management, 1967.

2. I was the recipient of a National Endowment for the Arts Fellowship designed to allow art history scholars to travel to enrich themselves in the environment and culture of their special training and interest. The recipients were not allowed to work on a specific project while traveling. The premise of my grant application was that I had been the curator of African art for twenty years and had never been to Africa. My goal was to just hang out with Africans and to visit sculptors who were making fraudulent art objects to be sold in the western world.

3. Holland Cotter, "Under an African Sky, Gazing Up with Awe," *New York Times*, August 30, 2012.

Episode 16

1. Other notables sharing Superman's and my natal day are Frederic Chopin, Oscar Kokoschka, and Justin Bieber! By chance, I have celebrated my birthday in far-away places: Aurangabad, India (1983), Karachi, Pakistan (1986), Djenné, Mali (1987), and Hanoi, Vietnam (2010).

Episode 17

1. William A. Fagaly, "Beleaguered City," *Art in America* 10 (November 2005), pp. 45–49.

2. Anne Pasternak, "Introduction," *Waiting for Godot by Samuel Becket* program, p. 2.

Episode 18

1. Will Coviello, "Window to the World," *Gambit*, July 30, 2007.

2. The Carnegie International, established in 1896 in Pittsburgh, is indeed the oldest North American exhibition of contemporary art in the world. However, it does not meet all the current criteria for worldwide contemporary biennials/triennials.

3. In 2016, the board of Prospect New Orleans formally changed to a triennial format.

4. Dan Cameron, "Acknowledgments," *Prospect.1 New Orleans* (Brooklyn, New York: PictureBox, 2008), p. 7.

ABOUT THE AUTHOR

William Fagaly is curator emeritus at the New Orleans Museum, where he served for fifty years as curator of African art, contemporary art, and self-taught art, as well as assistant director for more than twenty years. He organized more than ninety exhibitions, most with accompanying catalogs.